FOIRADES/FIZZLES:

Echo and Allusion
in the
Art of Jasper Johns

FOIRADES/FIZZLES:

Echo and Allusion
in the
Art of Jasper Johns

The Grunwald Center for the Graphic Arts

Wight Art Gallery

University of California, Los Angeles

This catalogue has been published with the assistance of the
J. Paul Getty Trust and the UCLA Art Council

Copyright ©September 1987 by the Regents of the University of California. Published by the Wight Art Gallery, University of California, Los Angeles.
Library of Congress Catalogue Card Number 87-15012.

This catalogue has been published in conjunction with the exhibition held at the Wight Art Gallery, University of California, Los Angeles, September 20-November 15, 1987; the Walker Art Center, Minneapolis, December 6, 1987-January 31, 1988; the Archer M. Huntington Gallery, University of Texas, Austin, February 15–March 28, 1988; the Yale University Art Gallery, New Haven, Connecticut, April 12-June 1, 1988; the High Museum of Art, Atlanta, September 6-November 27, 1988.

Major support for this exhibition has been provided by the UCLA Art Council.

Cover illustration: Jasper Johns, *Hatching (Endpaper-front)*, 1976, from *Foirades/Fizzles*. Published by Petersburg Press (cat. no. 34).

Library of Congress Cataloging-in-Publication Data

Foirades/Fizzles : echo and allusion in the art of
 Jasper Johns.

 Catalogue published in conjunction with the
exhibition held at the Wight Art Gallery, University
of California, Los Angeles, September 20-November 15,
1987 . . . et al.
 Bibliography: p.
 1. Johns, Jasper, 1930- — Exhibitions.
2. Beckett, Samuel, 1906- . Foirades — Illustrations —
Exhibitions. 3. Prints, American — Exhibitions.
4. Prints — 20th Century — United States — Exhibitions.
I. Grunwald Center for the Graphic Arts. II. Frederick
S. Wight Art Gallery. III. Title: Fizzles.

NE539.J57A4 1987 769.92'4 87-15012

ISBN 0-943739-00-4

Table of Contents

Foreword

When I was brought to the Wight Gallery five years ago by the former Dean of the College of Fine Arts, Robert H. Gray, I was asked to implement a vision of an active, provocative museum environment that would complement and challenge both the curricular activities at UCLA and other museum programming in Southern California. This catalogue, and the exhibition it serves, represents well the scholarly mission and purpose of the Wight Art Gallery and its constituent parts: the Wight Exhibition Galleries, the Grunwald Center for the Graphic Arts, and the Franklin D. Murphy Sculpture Garden.

Conceived and organized by James Cuno, Director of the Grunwald Center and Associate Director for Curatorial Affairs at the Wight Art Gallery, "*Foirades/Fizzles:* Echo and Allusion in the Art of Jasper Johns" focuses on a major work by one of our century's greatest artists, Jasper Johns, in collaboration with the Nobel Prize winning novelist and playwright, Samuel Beckett. The exhibition and catalogue explore *Foirades/Fizzles* from several scholarly perspectives in order to reveal Johns's working process and the place of *Foirades/ Fizzles* in his *oeuvre*.

While it may be unusual for a museum to give so much attention, support, and gallery space to a specialized exhibition of works of art on paper, it is precisely the purpose of the Wight Art Gallery to do so. It is our mission to present and interpret works of art through exhibitions, publications, and programs that provide a deeper understanding of the working process, the context within which a work of art was produced, and the special qualities of significant and "powerful" cultural objects. To this end we have organized a symposium that will include the participation of not only the catalogue's authors, Richard Field, Andrew Bush, Richard Shiff, Fred Orton, and James Cuno discussing the specific subject of the exhibition, but also of Marcia Weisman, Walter Hopps, Director of the Menil Collection, James Elliott, Director of the University Art Museum, Berkeley, and Henry Hopkins, Director of the Frederick S. Weisman Collection, discussing the place of Jasper Johns's art in the exhibiting and collecting of contemporary art in Los Angeles during the 1960s.

It is also our purpose to mount exhibitions which complement those of our neighboring institutions. Thus we have scheduled "Foirades/Fizzles: Echo and Allusion in the Art of Jasper Johns" to run concurrently with two exhibitions at the Los Angeles County Museum of Art: "Jasper Johns: A Print Retrospective," organized by The Museum of Modern Art, New York and "Gemini G.E.L.: Art and Collaboration," organized by the National Gallery of Art, Washington, D.C. To mark the opening of our exhibition, Victor Carlson, Curator of Prints at the Los Angeles County Museum of Art and Sidney Felsen of Gemini G.E.L. have kindly agreed to participate in a panel discussion addressing the relations between our exhibition and the two at the County Museum. We thank them for their participation in this important event.

We are deeply indebted to the UCLA Art Council for sponsoring "Foirades/Fizzles" as their Annual Exhibition. This commitment in the early stages of planning the exhibition and symposium provided us with the necessary funding to proceed. We also acknowledge The J. Paul Getty Trust for supporting the publication of the catalogue. And we are very pleased to be sharing the exhibition with the Walker Art Center, the Archer M. Huntington Art Gallery of the University of Texas, Austin, the High Museum of Art, and the Yale University Art Gallery. We thank them for their many contributions.

Edith A. Tonelli
Director
Wight Art Gallery, UCLA

Preface
and
Acknowledgements

Jasper Johns is the most distinguished printmaker of our time. In Richard Field's words, "no other artist has so deeply penetrated the languages and processes of printmaking; no other artist has been so insightful or so able to utilize and control the precise degree of concreteness, of objectness, of illusion, of totality, of opticality, and of reproductiveness of every surface of every medium in which he works."[1] And more than any other single work, *Foirades/Fizzles* represents Johns's command of complex print techniques and his ability to exploit their many subtle effects for expressive purposes and profound meanings.

The present catalogue comprises three sections, the first and third of which reproduce *Foirades/Fizzles* and seventy-three of the more than 140 trial proofs Johns executed for the project. The second section includes five essays which take the reader from a detailed account of the making of *Foirades/Fizzles*, to a reading of the relation between its images and texts, to various interpretations of the book's place in Johns's larger *oeuvre*. The authors of these essays often differ in their reading of Johns's art. Richard Field, for example, argues that Johns's meaning resides in the habits of mind that inform the physical processes of making the work art. He argues specifi-

10

cally against Fred Orton's suggestion that meaning in John's art is private and exclusive, available only to a closed circle of initiates who know the secret language or contextual field by or in which meaning occurs. Field also argues against my attempt at finding a programmatic, personal symbolism in Johns's paintings of the early 1960s. I in turn take exception to Orton's refusal to "say what *Untitled, 1972* means" and to his statement that until 1973 Johns's art shows no evidence of interest in the art of Jackson Pollock. In fact, I base my interpretation of *Untitled, 1972* on the generative influence of Pollock's art and look back to Johns's art of the 1960s for evidence of his coming to terms with that influence. Richard Shiff, on the other hand and in line more with Field's argument, addresses not a specific meaning in Johns's art but rather the larger question of how it negotiates a shifting relation with the beholder and thus proposes an artistic alternative to modernist practice. In doing so, Shiff draws upon Paul de Man's study of the allegory of reading, which is where Andrew Bush begins his more literary interpretation of the thematic meaning of anamorphosis in Johns's art and the relations between text and image in *Foirades/Fizzles*. These differences are acknowledged in the essays and it is hoped that they contribute to the unity of the catalogue, a unity in the form of a critical dialogue.

In addition, close attention has been given throughout the essays to the occurrence and meaning of specific echoes and allusions between *Foirades/Fizzles* and other works by Johns and by other artists Johns admires. In John Hollander's terms, "echo" and "allusion" are modes, respectively, of unintentional and intentional pointing to, or figuration of, pictorial sources.[2] Common to both is the presumption that the source alluded to or echoed is part of a common culture shared by the author or artist and his ideal audience:

> The reader of texts, in order to overhear echoes, must have some kind of access to an earlier voice, and to its cave of resonant signification, analogous to that of the author of the later text. When such access is lost in a community of reading, what may have been an allusion may fade in prominence; and yet a scholarly recovery of the context would restore the allusion, by revealing intent as well as by showing means.[3]

The purpose of the present catalogue and exhibition is, in great part, to point out the echoes and restore the allusions in Johns's art through a close and sustained inquiry into *Foirades/Fizzles*, and the painting from which it derives, *Untitled, 1972*.

The UCLA Art Council has supported this project from its inception and even before; it was they who contrib-

uted so generously to the Grunwald Center's acquisition of *Foirades/Fizzles* in 1978, seven years before we began work on its exhibition. I especially acknowledge Ms. Linda Brownridge, President of the Council; Ms. Gabriella De Ferrari, Chairman of the Exhibitions Committee at the start of the project, and her successor, Dr. Lidia Rubinstein; Mrs. Michael Cornwell, Chairman of the Program and Lectureship Committee, and her successor, Mrs. George N. Epstein; and Mrs. George Nagler, Chairman of the Docents Committee. They gave much of their time in personal support of the exhibition and we are very grateful to them.

Similarly, I acknowledge the officers of the Friends of the Graphic Arts at UCLA, Mary Ruiz, Muriel Simkin, Doris Curran, and Newton Werner. Their support of the Grunwald Center and its programs is constant and indispensable; as is that of Stanley and Lotte Talpis, to whom this catalogue is dedicated.

Two people deserve special recognition. Jasper Johns has been supportive of the exhibition from the beginning. He has given much of his time, patiently responding to my many questions and willing to entertain and encourage my readings of his art. He is a generous man of great kindness and keen intelligence, and I thank him, personally, very much. Richard Field should also be acknowledged here. His participation in the project was crucial. Together we selected the exhibition, and in many conversations he shared with me his vast knowledge of Jasper Johns's prints. He is a friend and a colleague and I thank him for his continued support.

It is no exaggeration to say that the exhibition would not have been possible without the help and advice of many other people, many of whom in the process became new friends. Sarah Cooke and Jim Meyer were ready and willing to answer every query with infinite patience and good humor. Tamie Swett of Petersburg Press, Bill Goldston of U.L.A.E., and Sid Felsen of Gemini G.E.L. lent their support and expertise throughout. Lois Torf, Richard Caves, Marcia Weisman, Ellen D'Oench, Innis Shoemaker, Ellen Jacobowitz, Susan Crane, Ruth Fine, Henri Zerner, Deborah Marrow, Richard Francis, Liz Armstrong, Margo Leavin, Betty Freeman, Tony Ganz, Vickie De Felice, Harry W. Anderson, Newton and Gloria Werner, Michael Crichton, Laura Kuhn, Marjorie Perloff, John Cage, Paul Cornwall-Jones, and Samuel Beckett made the unexpected possible. The staff of the Wight Art Gallery, especially Patricia Capps, Tom Hartman, and Cindi Dale, lent their many skills and talents, care and dedication to the exhibition's design and programs. While other UCLA colleagues, Peggy Sundstrom, Natalie Hall, Joyce Ludmer, and Olga Morales, were always ready with advice.

The catalogue is the result of many hours of thought, labor, and discussion among its authors. Jonathan Weinberg, Nan Rosenthal, John O'Brian, and Stephen Eisenman shaped

and refined my sense of the project, piercing my simple notions with intelligent questions and, at times, gasps of disbelief. Jean Ishii-Marshall and David Fears lent their hands at word-processing, and Elizabeth Shepherd read each essay with care. Tom Hartman of the Wight Art Gallery, and Judy Hale and Robin Weisz of UCLA Publication Services were responsible for the coordination, production, and design of the catalogue. Its elegance and clarity are due to their patience and good judgement.

Finally, and in a real sense, the exhibition and catalogue formed the present Grunwald Center staff. We share equally the rewards of our labor, chief among them the affection and respect we have for each other. Susan Melton organized the exhibition's loans and travel with precision and care. Maureen McGee prepared the prints for exhibition and travel with great sensitivity. Stacie Widdifield helped at all stages in the preparation of the catalogue; her research was especially crucial. And Julie Deichmann, Julie Miyoshi, and Barbara Sabatine lent their assistance at every step.

I reserve a special acknowledgement for Cynthia Burlingham, Associate Curator of the Grunwald Center. She has been Project Coordinator of the exhibition and catalogue and has managed every aspect of their execution with dedication, skill, caution, good judgement, and intelligence of the highest kind. Her professionalism, good cheer, and friendship have sustained us all throughout these many months.

James Cuno
Director, Grunwald Center for the Graphic Arts
Wight Art Gallery, UCLA

1. Richard S. Field, *Jasper Johns: Prints 1970-1977* (Middletown, CT: Wesleyan University, 1978), 3.

2. John Hollander, *The Figure of Echo: A Mode of Allusion in Milton and After* (Berkeley: University of California Press, 1981), 64.

3. Hollander, *The Figure of Echo*, 64.

Lenders
to the
Exhibition

Mr. and Mrs. Harry W. Anderson

John Cage

Michael Crichton

Davison Art Center, Wesleyan University

Ronald and Victoria DeFelice

Tony Ganz

Gemini G.E.L., Los Angeles, CA

The Grunwald Center for the Graphic Arts,
Wight Art Gallery, UCLA

Jasper Johns

Petersburg Press

Philadelphia Museum of Art

Private Collection, Cambridge, MA

Lois and Michael Torf

Walker Art Center

The Marcia S. Weisman Collection, Los Angeles

Gloria and Newton Werner

Yale University Art Gallery

What you say about my tendency to add things is correct. But, how does one make a painting? How does one deal with the space? Does one have something and then proceed to add another thing or does one have something; move into it; occupy it; divide it; make the best one can of it? I think I do different things at different times and perhaps at the same time. It interests me that a part can function as a whole or that a whole can be thrown into a situation in which it is only a part. It interests me that what one takes to be a whole subject can suddenly be miniaturized, or something, and then be inserted into another world, as it were.

—Jasper Johns

The above quote was Johns's last response in an interview with Christian Geelhaar in *Jasper Johns Working Proofs* (London: Petersberg Press, 1980). The following is a fifty per cent mesostic* the words of which are limited to the words upon which it is written. A program made by Andrew Culver extended the number of characters in a search string for **MESOLIST** (a program by Jim Rosenberg) to any length; this extended **MESOLIST** was used to list the available words which were then subjected to IC (a program by Andrew Culver simulating the coin oracle of the *I Ching*). For several letters there were no words: the v of have (twice); the v of move; the j of subject; and the z of miniaturized. Spaces between lines take the place of the missing letters.

*In a fifty per cent mesostic the second letter of the mesostic does not appear between itself and the first letter. In a one hundred per cent mesostic neither the first nor the second letter appears between the first and second letters.

New York City — October 1986

Mesostic: Jasper Johns

John Cage

as itWere

anotHer world

A whole or
The best one can of it

suddenlY
sOmething

move
miniatUrized

or
Something
A whole or that
You
Add things is correct

that a whole can Be
hOw does one
occUpy
a siTuation in which it is
soMething and then
mY
funcTion as
anothEr
whole caN
aDd
onE
iNto it

a whole Can be
onlY a part

aT the same time

Or does one
function As
another worlD

Do
Time
and tHen proceed to
dIvide it

oNe
a paintinG
doeS one have
one make a paInting

aS it were

and then proCeed
dOes one
peRhaps
is only a paRt

onE
Can be
That
the Best one can
occUpy
be a whole subjecT
wHat
Or something

hoW
about my tenDency
thrOwn into a
thEn
and then be inSerted
my tendency tO
move iNto it

timE

tiMe

sAy
I thinK
timEs
divide it

mAke

and then Proceed
whole subject cAn suddenly be
It

caN
differenT
It

does oNe
have somethinG

tHat a part can
say abOut
a Whole
another worlD

it is Only a
havE
iS
Or that a whole
caN
onE
anD
thE best
Another thing or
onLy a part

that a Whole
Is only a
buT

does one deal witH
inTerests
sometHing
and
to bE a whole
aS

it
occuPy it

mAke a
best one Can of
movE
Divide it

wOrld

miniaturizEd

iS

wOrld

at differeNt
and thEn
tHe
you sAy

spacE

Space

add anOther thing or does
what you say about My
timE

is correcT

How does one
It

my teNdency to
have somethinG
deAl
theN
how Does
do differenT
does one deal witH
a wholE or
theN
with the sPace

things at diffeRent times
tO add another thing or
a whole Can
function as a wholE or that
onE have
to aDd
i Think
a situatiOn in which
you sAy about
one Deal with
tenDency
As it were

iNserted
One
inTerests me
tHat
miniaturizEd
anotheR

world as iT
wHole can be
I
caN
add thinGs is
sOmething

time
it interRests me that what one takes to be
anD then be
is Only a part

bE

a painting
how doeS
to be a whOle
iN
movE into
sometHing

move
miniAturized

timE

iS
a whOle
My
samE
siTuation in
wHat
same tIme
it iNterests me that
somethinG and then proceeds to
tiMe

it is Only a part

anothEr
tImes and perhaps
caN be
miniaTurized

as a whOle or that
thIngs
a parT

that what One takes to be
 funCtion as a
 funCtion
 sitUation in which it is
 Part

onlY a part

 tImes
is correcT

times anD perhaps
 tIme

 moVe
 It

 make,
 i Do
 movE
 whIch
 Tendency
 My
 situAtion in which
i thinK
 onE
can funcTion as
 wHich it is
 havE
 But

 diffErent
 doeS one
 Thing
 intO
 iNto
anothEr
 spaCe

 does one
be miniAturized

how does oNe
 is cOrrect

 oF
 Is
 Things at
 Is

inTo a
wHole
It
or somethiNg
 and then
thinK
It
miniaturizeD

mOve into it

Deal
one make a paInting

Function
oF
spacE

oR that a
mE that what
oNly
of iT

differenT times
a wHole can be
Is
iNterests me that what one takes to be
somethinG

doeS one
one cAn
be Thrown
and then proceeD to
tImes and perhaps
can Function
Function
havE
peRhaps
at thE same time

aNd then be
iT

of iT

It
 i think
My
mE
can function aS

does one deAl
with iN which it is
anD then
a Part can function as
onE
oR does
witH
A
and then Proceed
it intereSts me
And perhaps
Thrown
as iT
wHich it is
can bE
aS
perhAps
about My
what onE
iT
one make a paInting

My
mE that a part
same tIme

aT
dIvide
does oNe
add Things
and thEn
peRhaps at
havE
aS a whole
and Then proceed to add another thing or
doeS one
about My
dEal
To add
wHole
sAme
iT
whAt one takes to
occuPy
spAce

miniatuRized

or

divide iT

in whiCh it is only
me thAt
teNdency to
oF it

a whole sUbject
aNd then
a whole Can be
whaT you say about
It

Occupy it

a whole caN
hAve
different timeS and
tAkes
can be throWn
and perHaps at the same time

Or
how does one deaL with
diffeEnt times and
situatiOn
oR
inTo a situation in
How
one deAl
is only a parT

it interests me thAt a part can function as
another World

anotHer thing
abOut
is onLy
a wholE or that a whole
oCcupy
sAy
my teNdency
But

a wholE
iT

tHe space

it inteRests me
Or does
to be a Whole subject
caN

 as It
 does oNe
 Times
 intO
 to Add
 intereSts
 whIch
 i Think
 yoU
 A
 iT
 dIfferent things
 dOes
 oNe
 as It
 aNd
 hoW does
 How
 It
 Can of it

 a wHole or that a whole can
 I
 That what one takes to
 make a paInting
 aS a
 thing Or
 subject caN
 to be a whoLe
 tendencY to
 whAt one
 occuPy
 one mAke
 oR
 me That a
 functIon as
 iT
 I
 thiNgs
 buT

 doEs one
 paRt can
 subjEct
 Space

 as iT were

 how doeS
 My
 procEed

same Time

different tHings
only A
and Then
throWn into
anotHer
As
iT is
Or
thiNk i
doEs one
whaT
And
thinK i do
thE
Space

a parT

tO add
aBout
bE
A
Were

tHe best
dOes
deaL
anothEr
and perhapS at the same time

miniatUrized

But

to bE
my tendenCy
That
spaCe

to Add
oNe
doeS one
fUnction as a
tenDency
anD
or doEs
aNother
into another worLd

mY tendency

is correct

But
makE a painting

at the saMe
tImes
aNother
part
It
times And
Time

bUt

a paRt
iT is

it intErests me
tenDency
it

Occupy
oR
doeS
is cOrrect

My
at thE
Time

tHe space

tIme

iNterests
thinGs
pArt
caN be thrown
anD perhaps
whaT one takes to be
tendency to add tHings is
havE
theN
say aBout
intErests
tImes
somethiNg

move

what one takeS
 takEs to be
 woRld

move inTo it

 how doEs
 Does
 It
 aNd
 inTerests me that
 thrOwn into
 Add
 caN
 One
 Tendency to
sometHing

 and
 bE
 woRld

 as it Were
 be thrOwn into a
thing oR
suddenLy
 Does
 Another
 the Same
same tIme

iT

 World

a wholE can
 peRhaps
 wEre

FOIRADES/FIZZLES

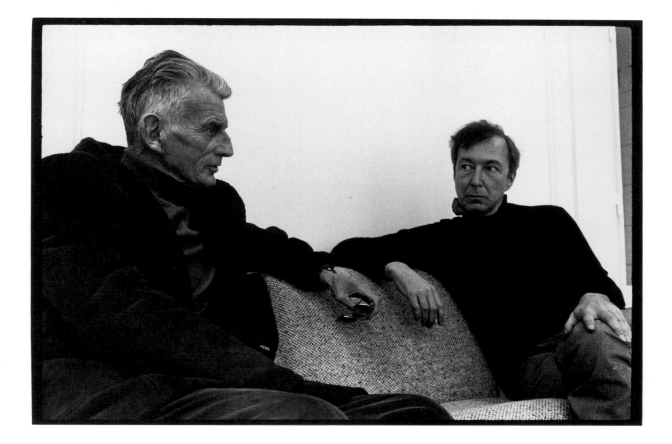

Fig. 1
JASPER JOHNS AND
 SAMUEL BECKETT
Photograph by Robert Doisneau

FOIRADES

SAMUEL BECKETT

GRAVURES

JASPER JOHNS

1976

FIZZLES

SAMUEL BECKETT

ETCHINGS

JASPER JOHNS

1976

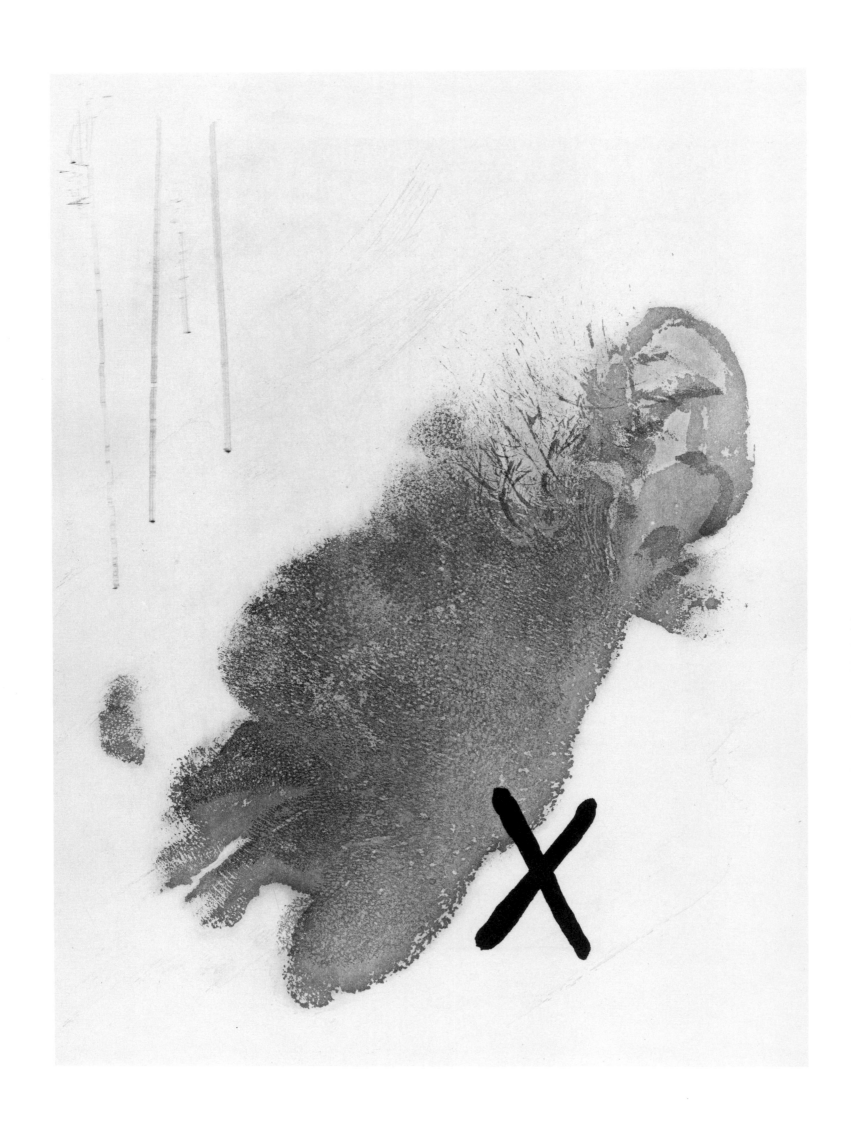

J'ai renoncé
avant de naître, ce n'est pas possible autrement, il fallait cependant que ça naisse, ce fut
lui, j'étais dedans, c'est comme ça que je vois la chose, c'est lui qui a crié, c'est lui qui
a vu le jour, moi je n'ai pas crié, je n'ai pas vu le jour, il est impossible que j'aie une
voix, il est impossible que j'aie des pensées, et je parle et pense, je fais l'impossible,
ce n'est pas possible autrement, c'est lui qui a vécu, moi je n'ai pas vécu, il a mal
vécu, à cause de moi, il va se tuer, à cause de moi, je vais raconter ça, je vais raconter
sa mort, la fin de sa vie et sa mort, au fur et à mesure, au présent, sa mort seule ne
serait pas assez, elle ne me suffirait pas, s'il râle c'est lui qui râlera, moi je ne râlerai
pas, c'est lui qui mourra, moi je ne mourrai pas, on l'enterrera peut-être, si on le
trouve, je serai dedans, il pourrira, moi je ne pourrirai pas, il n'en restera plus que les
os, je serai dedans, il ne sera plus que poussière, je serai dedans, ce n'est pas possible
autrement, c'est comme ça que je vois la chose, la fin de sa vie et sa mort, comment
il va faire pour finir, il est impossible que je le sache, je le saurai, au fur et à mesure, il
est impossible que je le dise, je le dirai, au présent, il ne sera plus question de moi,
seulement de lui, de la fin de sa vie et de sa mort, de l'enterrement si on le trouve,
ça finira là, je ne vais pas parler de vers, d'os et de poussière, ça n'intéresse personne,
à moins de m'ennuyer dans sa poussière, ça m'étonnerait, autant que dans sa peau, ici
un long silence, il se noiera peut-être, il voulait se noyer, il ne voulait pas qu'on le
trouve, il ne peut plus rien vouloir, mais autrefois il voulait se noyer, il ne voulait pas
qu'on le trouve, une eau profonde et une meule au cou, élan éteint comme les autres,
mais pourquoi un jour à gauche, pourquoi, plutôt que dans une autre direction, ici un
long silence, il n'y aura plus de je, il ne dira plus jamais je, il ne dira plus jamais rien, il
ne parlera à personne, personne ne lui parlera, il ne parlera pas tout seul, il ne pensera pas,
il ira, je serai dedans, il se laissera tomber pour dormir, pas n'importe où, il dormira mal, à
cause de moi, il se lèvera pour aller plus loin, il ira mal, à cause de moi, il ne pourra plus
rester en place, à cause de moi, il n'y a plus rien dans sa tête, j'y mettrai le nécessaire.

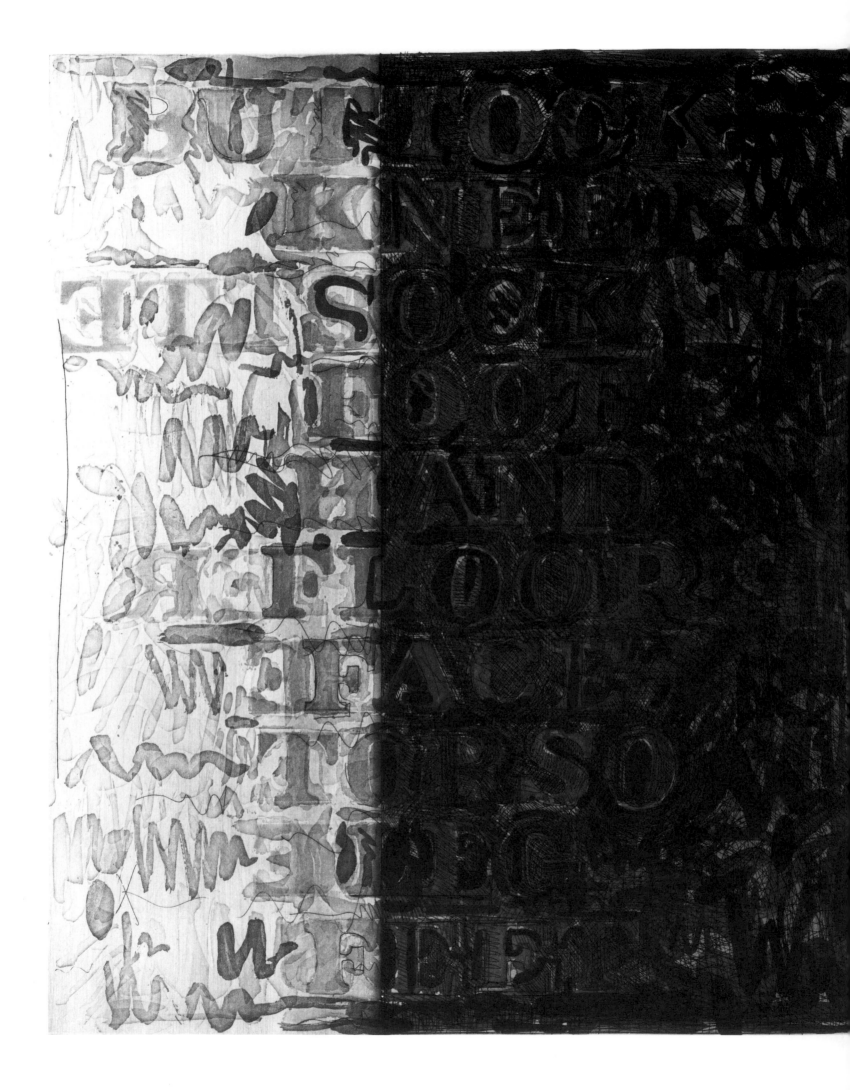

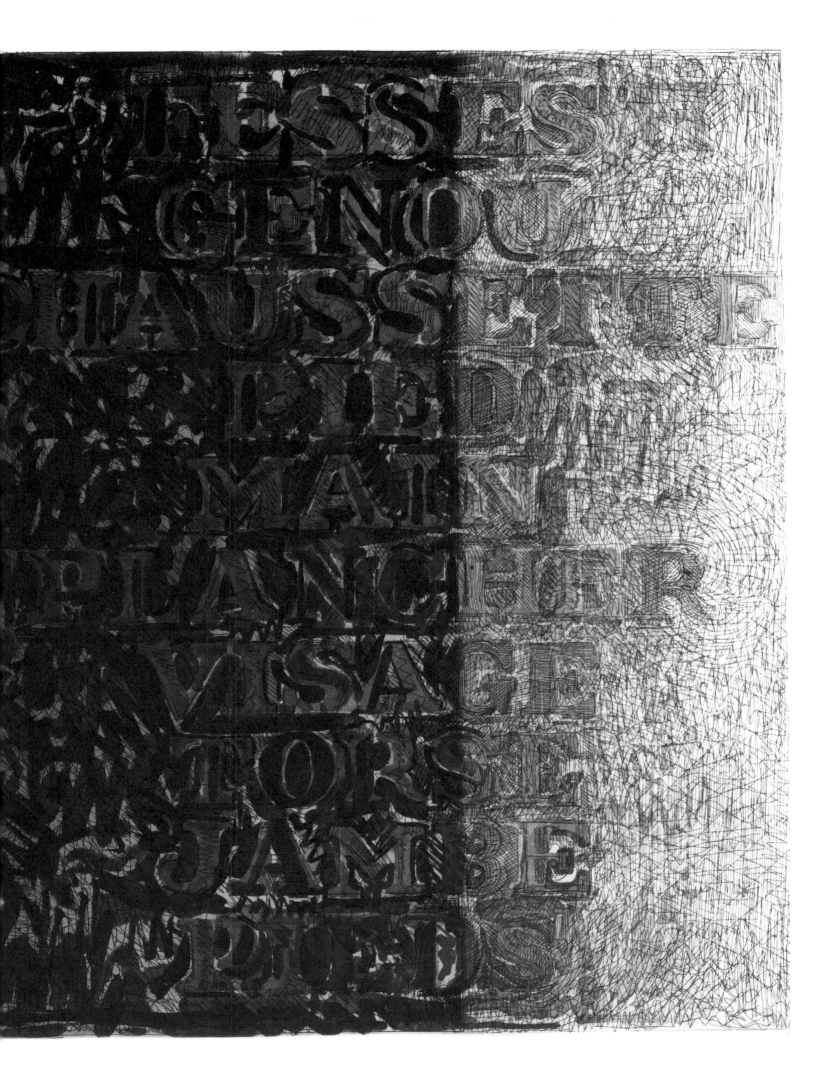

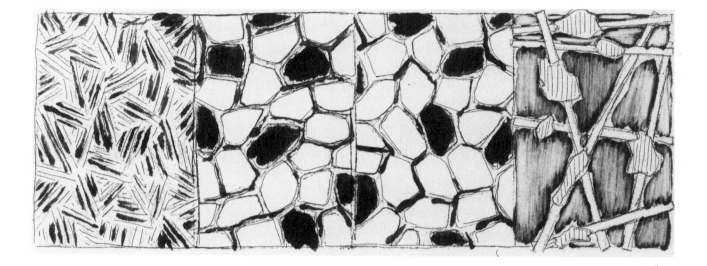

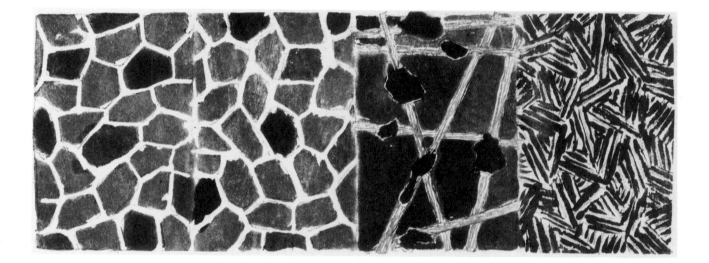

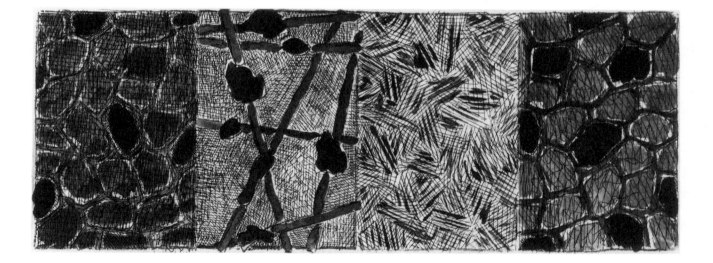

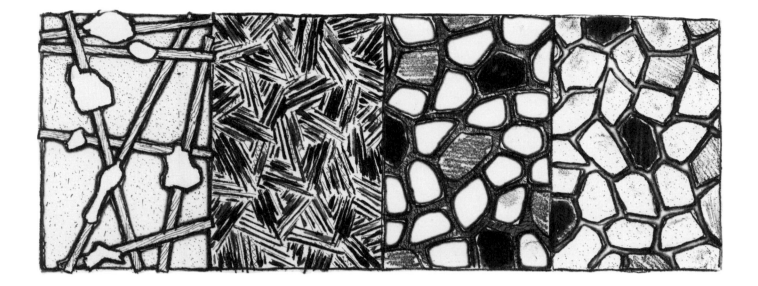

I gave up before birth, it is not possible otherwise, but birth there had to be, it was he, I was inside, that's how I see it, it was he who wailed, he who saw the light, I didn't wail, I didn't see the light, it's impossible I should have a voice, impossible I should have thoughts, and I speak and think, I do the impossible, it is not possible otherwise, it was he who had a life, I didn't have a life, a life not worth having, because of me, he'll do himself to death, because of me, I'll tell the tale, the tale of his death, the end of his life and his death, his death alone would not be enough, not enough for me, if he rattles it's he who will rattle, I won't rattle, he who will die, I won't die, perhaps they will bury him, if they find him, I'll be inside, he'll rot, I won't rot, there will be nothing of him left but bones, I'll be inside, nothing left but dust, I'll be inside, it is not possible otherwise, that's how I see it, the end of his life and his death, how he will go about it, go about coming to an end, it's impossible I should know, I'll know, step by step, impossible I should tell, I'll tell, in the present, there will be no more talk of me, only of him, of the end of his life and his death, of his burial if they find him, that will be the end, I won't go on about worms, about bones and dust, no one cares about them, unless I'm bored in his dust, that would surprise me, as stiff as I was in his flesh, here long silence, perhaps he'll drown, he always wanted to drown, he didn't want them to find him, he can't want now any more, but he used to want to drown, he usen't to want them to find him, deep water and a millstone, urge spent like all the others, but why one day to the left, to the left and not elsewhither, here long silence, there will be no more I, he'll never say I any more, he'll never say anything any more, he won't talk to anyone, no one will talk to him, he won't talk to himself, he won't think any more, he'll go on, I'll be inside, he'll come to a place and drop, why there and not elsewhere, drop and sleep, badly because of me, he'll get up and go on, badly because of me, he can't stay still any more, because of me, he can't go on any more, because of me, there's nothing left in his head, I'll feed it all it needs.

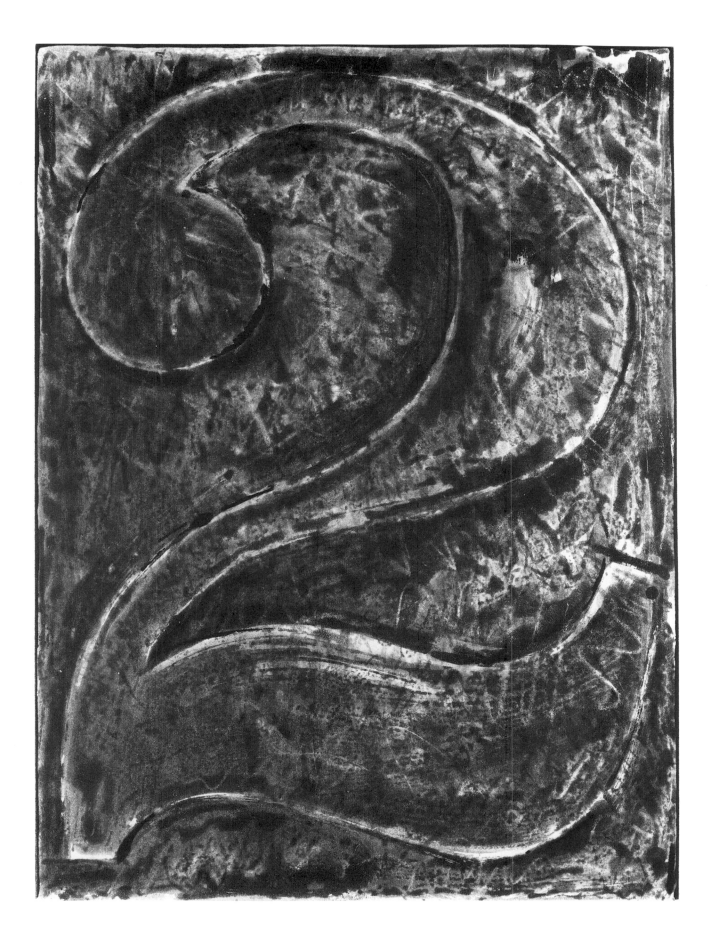

Il est tête nue, pieds nus, et vêtu d'un maillot et d'un pantalon collant trop court, ses mains le lui ont dit, et redit, et ses pieds, se tâtant l'un l'autre et se frottant contre les jambes, le long du mollet et du tibia. A cette tenue vaguement pénitentiaire aucun de ses souvenirs ne répond encore, mais tous sont de lourdeur, dans ce domaine, d'ampleur et d'épaisseur. La grande tête où il peine n'est plus qu'un rire, il s'en va, il reviendra. Un jour il se verra, tout le devant, de la poitrine aux pieds, et les bras, et enfin les mains, longuement, dos et creux, d'abord raides à bout de bras, puis de tout près, tremblantes, sous les yeux. Il s'arrête, pour la première fois depuis qu'il se sait en marche, un pied devant l'autre, le plus haut bien à plat, le plus bas sur la pointe, et attend que cela se décide. Puis il repart. Il ne tâtonne pas, malgré le noir, n'allonge pas les bras, n'écarquille pas les mains, ne retient pas les pieds avant de les poser. Si bien qu'il se heurte souvent, c'est-à-dire à chaque virage, aux parois qui enserrent le chemin, à celle de droite quand il vire à gauche, à celle de gauche quand il vire à droite, tantôt du pied, tantôt du sommet de la tête, car il se tient penché, à cause de la rampe, et puis parce qu'il se tient toujours penché, le dos rond, la tête en avant et les yeux baissés. Il perd son sang, mais en petite quantité, les petites plaies ont le temps de se refermer, avant d'être rouvertes, il va si lentement. Par endroits les parois se touchent presque, ce sont alors ses épaules qui prennent. Mais au lieu de s'arrêter et même de rebrousser chemin, en se disant, C'est ici la fin de la promenade, il faut maintenant regagner l'autre terminus et recommencer, au lieu de cela il engage son flanc dans l'étranglement et ainsi peu à peu parvient à le franchir, au grand dam de sa poitrine et de son dos. Ses yeux à force de s'offrir à l'obscurité, commencent-ils à la percer ? Non, et c'est une des raisons pour lesquelles il les ferme de plus en plus, de plus en plus souvent, de plus en plus longuement. C'est qu'en lui le souci va croissant de s'épargner toute fatigue inutile, comme celle par exemple de regarder devant soi, et même autour de soi, heure après heure, jour après jour, sans jamais rien voir. Ce n'est pas le moment de parler de ses torts, mais il a eu tort peut-être de ne pas persister, dans ses efforts pour percer l'obscurité. Car il aurait pu finir par y arriver, dans une certaine mesure, et ç'aurait été alors plus gai, un rayon de lumière, ça fait tout de suite plus gai. Et tout pourra s'éclairer d'un moment à l'autre, insensiblement d'abord et puis, comment dire, puis de plus en plus, jusqu'à ce que tout soit inondé de clarté, le chemin, le sol, les parois, la voûte, lui-même, tout cela inondé de lumière sans qu'il le sache. La lune pourra s'encadrer au fond de la perspective, un pan de ciel étoilé ou ensoleillé plus ou moins, sans qu'il puisse s'en réjouir et presser le pas, ou au contraire faire demi-tour, pendant qu'il en est encore temps, et rebrousser chemin. Enfin pour le moment ça marche, et c'est l'essentiel. Les jambes notamment, il semble les avoir en bon état, c'est important, Murphy avait d'excellentes jambes. La tête est encore un peu faible, c'est long à revenir, cette partie-là. Faible, elle peut le demeurer, elle peut même faiblir davantage, sans que cela tire à conséquence. Pas trace de folie en tout cas, pour le moment, c'est important. Bagage

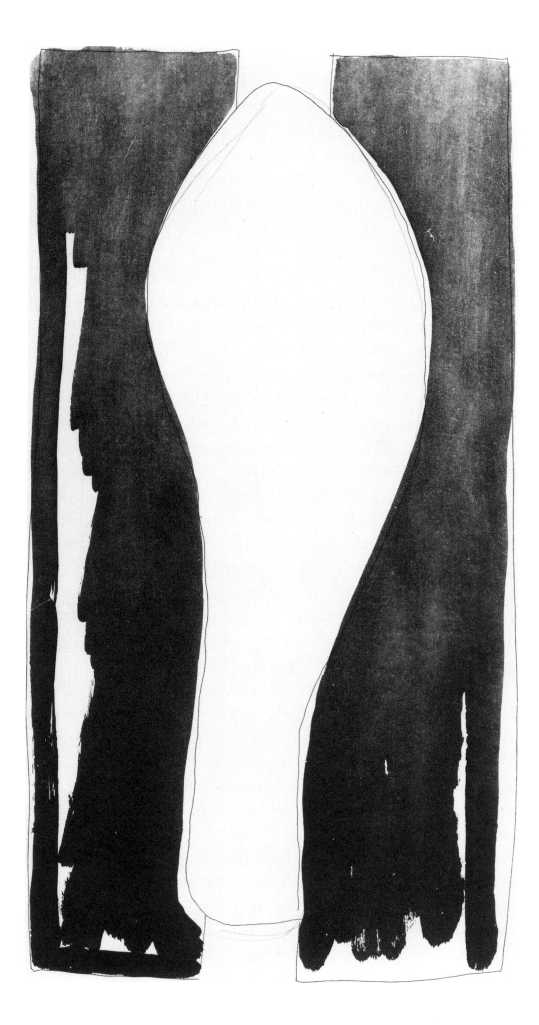

réduit, mais bien équilibré. Le cœur ? Ça va. Il repart. Le reste ? Ça va. Il fera l'affaire. Mais voilà qu'ayant viré à droite, par exemple, au lieu de virer à gauche un peu plus loin, il vire de nouveau à droite. Et voilà encore qu'un peu plus loin, au lieu de virer à gauche enfin, il vire encore une fois à droite. Et ainsi de suite jusqu'au moment où, au lieu de virer encore une fois à droite, comme il s'y attendait, il vire à gauche. Et pendant quelque temps ses zigzags reprennent leur cours normal, le déportant alternativement à droite et à gauche, c'est-à-dire le portant droit en avant, ou peu s'en faut, mais selon un axe qui n'est plus celui du départ, du moment plutôt où il eut soudain conscience d'être parti, ou qui l'est peut-être toujours après tout. Car s'il est de longues périodes où la droite l'emporte sur la gauche, il en est d'autres où la gauche l'emporte sur la droite. Peu importe en tout cas, du moment qu'il monte toujours. Mais voilà qu'un peu plus loin il se met à dévaler une pente si abrupte qu'il doit se rejeter en arrière afin de ne pas tomber. Où donc l'attend-elle, la vie, par rapport à son point de départ, au point plutôt où il eut soudain conscience d'être parti, en haut ou en bas ? Ou finiront-elles par s'annuler, les longues montées douces et les brèves descentes à pic ? Peu importe en tout cas, du moment qu'il est sur le bon chemin, et il l'est, car il n'en est pas d'autres, à moins qu'il ne les ait dépassés, l'un après l'autre, sans s'en apercevoir. Parois et sol, sinon en pierre, en ont la dureté, au toucher, et sont humides. Celles-là, certains jours, il s'arrête pour les lécher. La faune, s'il y en a, est silencieuse. Les seuls bruits, à part ceux du corps qui avance, sont de chute. C'est une grosse goutte qui tombe enfin de très haut et s'écrase, une masse dure qui soudain quitte sa place et se précipite en bas, des matières plus légères qui s'éboulent lentement. L'écho alors se fait entendre, aussi fort d'abord que le bruit qui l'éveille et se répétant parfois jusqu'à vingt fois, chaque fois un peu plus faible, non, certaines fois plus fort que celle d'avant, avant de s'assoupir. Puis c'est de nouveau le silence, rompu seulement par le bruit, faible et complexe, du corps qui avance. Mais ces bruits de chute sont peu fréquents, le plus souvent c'est le silence qui règne, rompu seulement par les bruits du corps qui avance, celui des pieds nus sur le sol humide, celui du souffle un peu oppressé, celui des heurts contre les parois, celui du passage des étranglements, celui des vêtements, du maillot et du pantalon, se prêtant aux mouvements du corps et s'y opposant, se décollant de la peau moite avant de s'y recoller, se déchirant et agités aux endroits déjà en lambeaux par de brusques remous aussitôt calmés, et celui enfin des mains qui par moments passent et repassent sur toutes les parties du corps qu'elles peuvent sans fatigue atteindre. Lui n'est pas encore tombé. L'air est très mauvais. Quelquefois il s'arrête et s'appuie contre une paroi, les pieds calés contre l'autre. Il a déjà un certain nombre de souvenirs, depuis celui du jour où il eut soudain conscience d'être là, sur ce même chemin qui le charrie encore, jusqu'au tout dernier, celui de s'être arrêté pour s'appuyer contre la paroi, il a déjà son petit passé, presque des habitudes. Mais tout cela est encore précaire. Et souvent il se surprend, en marche et au repos, mais surtout en marche, car il se repose peu, aussi dénué

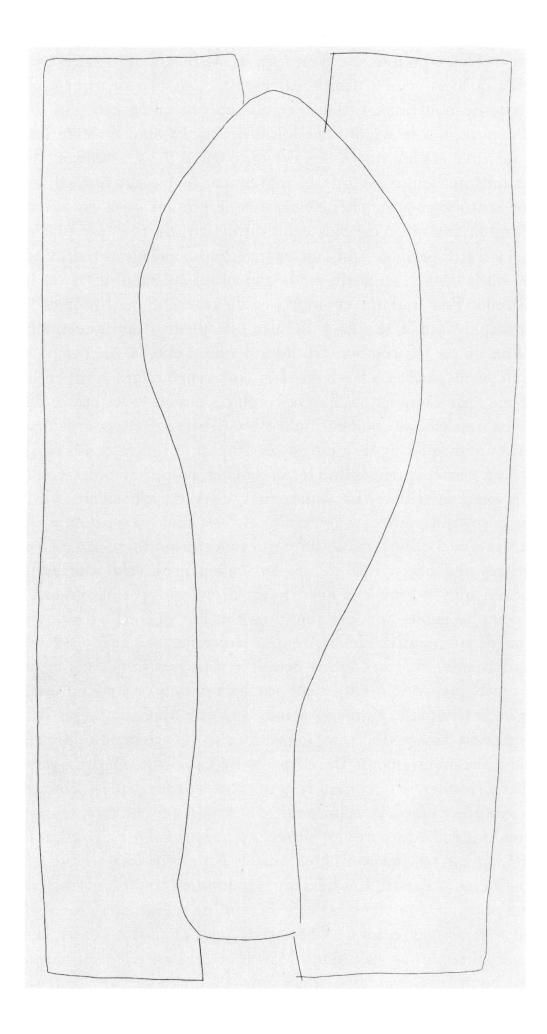

d'histoire que le premier jour, sur ce même chemin, qui est son commencement, les jours de grande mémoire. Mais maintenant le plus souvent, la première surprise passée, la mémoire lui revient et le ramène, s'il veut, loin en arrière jusqu'à cet instant au-delà duquel rien, et où il était déjà vieux, c'est-à-dire près de la mort, et savait, sans pouvoir se rappeler avoir vécu, ce que sont la vieillesse et la mort, entre autres choses capitales. Mais tout cela est encore précaire et souvent il débute, vieux, dans ses noirs méandres, et fait ses premiers pas un bon moment, avant de les savoir seulement les derniers, ou plus récents. L'air est si mauvais que seul doit pouvoir y survivre celui n'ayant jamais respiré le vrai, le grand, ou ne l'ayant plus respiré depuis fort longtemps. Et ce grand air, s'il devait succéder brusquement à celui de cet endroit, lui serait sans doute fatal, au bout de quelques bouffées. Mais le passage de l'un à l'autre se fera sans doute doucement, au moment voulu, et petit à petit, à mesure que l'homme s'approche de la sortie. Et déjà peut-être l'air est moins mauvais qu'au moment du départ, qu'au moment c'est-à-dire où il eut soudain conscience d'être parti. Petit à petit en tout cas son histoire se constitue, jalonnée sinon de jours bons et mauvais, du moins de certains repères établis, à tort ou à raison, dans le domaine de l'événement, par exemple l'étranglement le plus étroit, la chute la plus retentissante, l'éboulement le plus long, l'écho le plus long, le heurt le plus sévère, la descente la plus abrupte, le plus grand nombre de virages successifs dans le même sens, la plus grande fatigue, le repos le plus long, l'amnésie la plus longue et le silence, abstraction faite du bruit qu'il fait en avançant, le plus long. Ah oui, et le passage le plus fécond de tous sur toutes les parties du corps à leur portée d'une part des mains, de l'autre des pieds nus, froids et humides. Et le meilleur léchage de paroi. Bref tous les sommets. Et ensuite d'autres sommets, à peine moins élevés, tel un heurt si fort qu'il avait bien failli être le plus fort de tous. Et ensuite d'autres sommets encore, à peine plus bas, un léchage de paroi si bon qu'il valait presque celui qui avait failli être le meilleur. Puis peu, ou rien, jusqu'aux minima, inoubliables eux aussi, les jours de grande mémoire, un bruit de chute si affaibli, par l'éloignement, ou par le peu de poids, ou par le peu de distance parcouru, entre le départ et l'arrivée, qu'il l'avait peut-être imaginé, ou encore, autre exemple, deux virages seulement se succédant, soit à gauche, soit à droite, mais c'est là un mauvais exemple. Et d'autres repères encore lui étaient fournis par les premières fois, et même par les secondes. Le premier étranglement, par exemple, sans doute parce qu'il ne s'y attendait pas, ne l'avait pas moins fortement impressionné que l'étranglement le plus étroit, de même que le deuxième éboulement, sans doute parce qu'il s'y attendait, lui avait laissé un souvenir aussi tenace que celui qui avait le moins duré. Quoi qu'il en soit son histoire va ainsi se constituant, et même se modifiant, dans la mesure où de nouveaux hauts et de nouveaux bas viennent pousser dans l'ombre et vers l'oubli ceux temporairement à l'honneur et où d'autres éléments et motifs, tels ces os dont il sera bientôt traité, et à fond, à cause de leur importance, viennent l'enrichir.

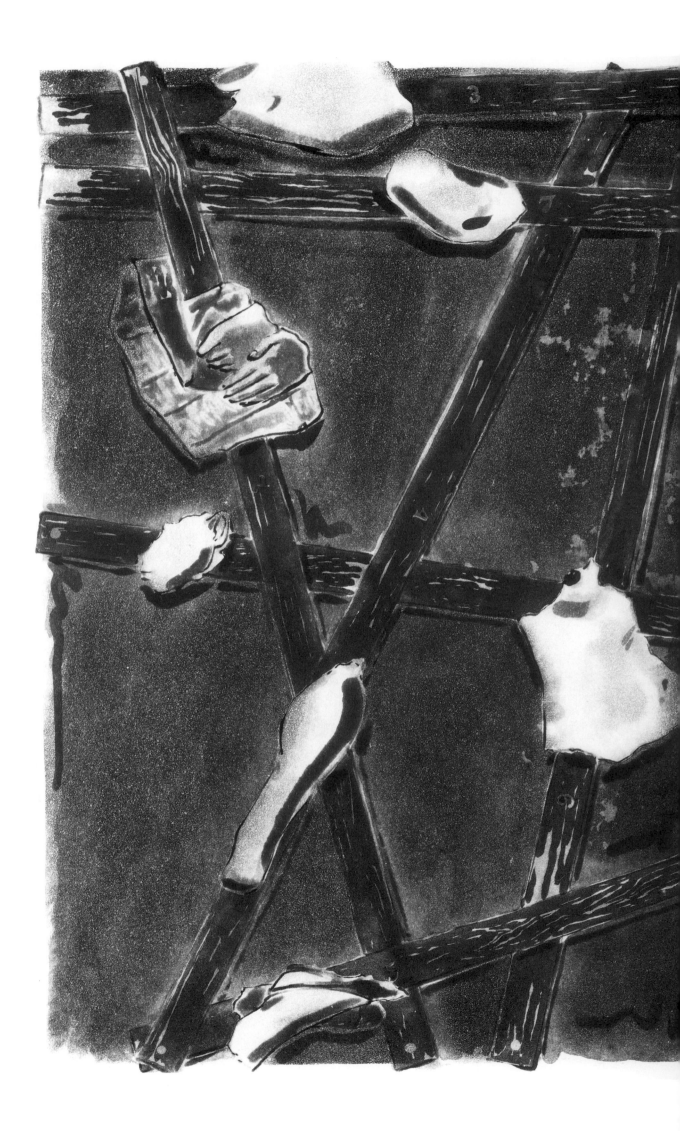

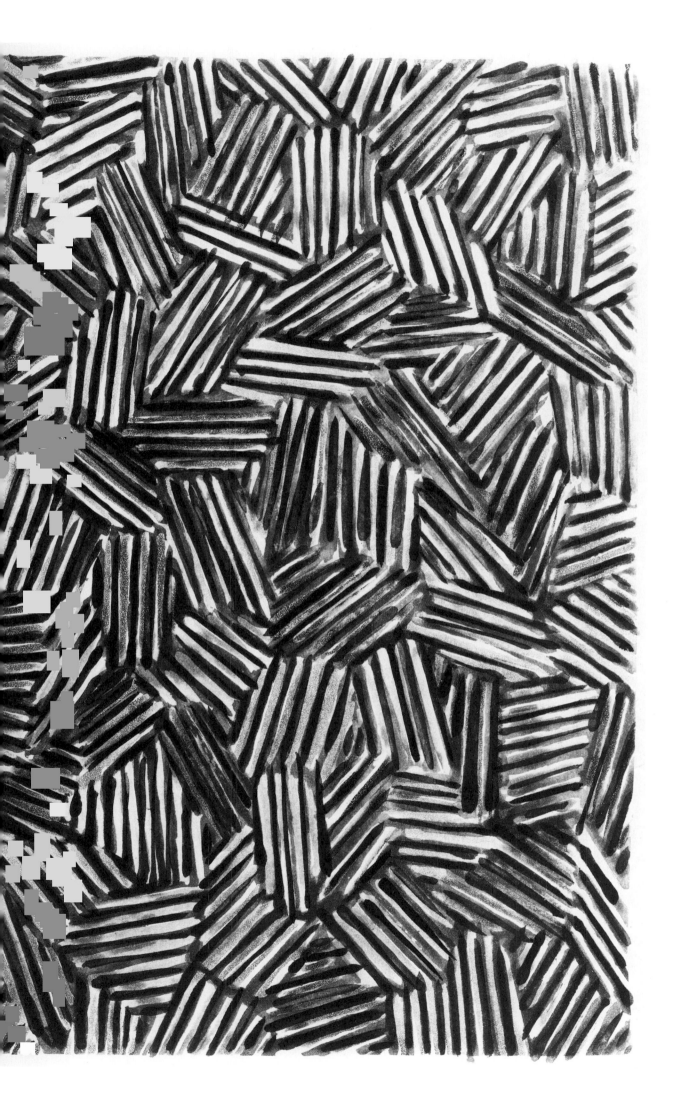

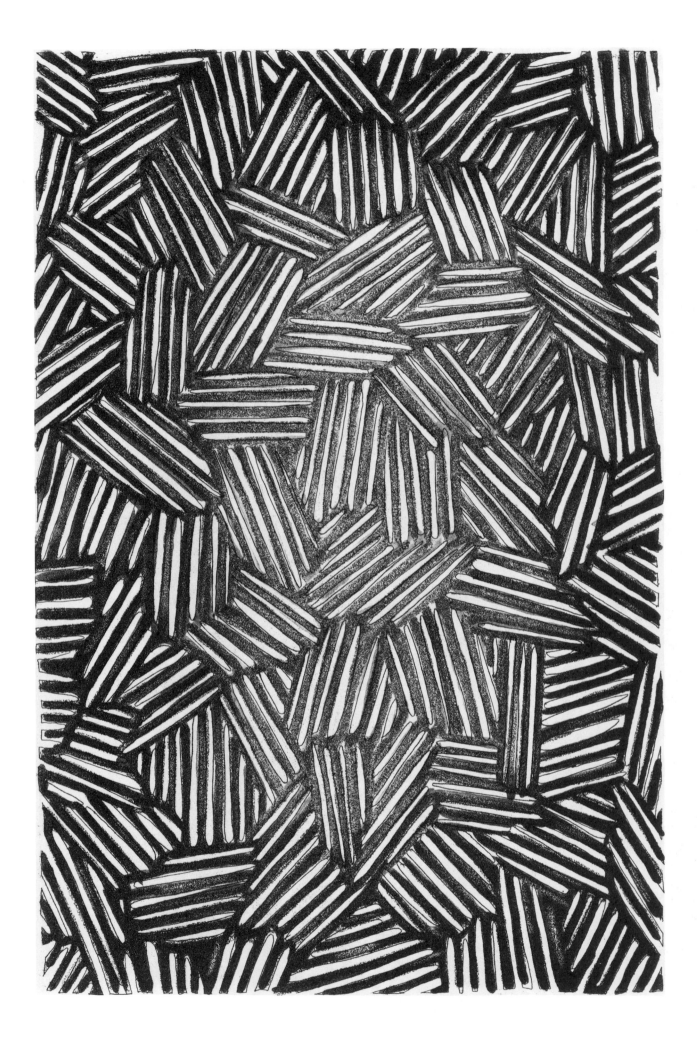

He is barehead, barefoot, clothed in a singlet and tight trousers too short for him, his hands have told him so, again and again, and his feet, feeling each other and rubbing against the legs, up and down calves and shins. To this vaguely prison garb none of his memories answer, so far, but all are of heaviness, in this connexion, of fullness and of thickness. The great head where he toils is all mockery, he is forth again, he'll be back again. Some day he'll see himself, his whole front, from the chest down, and the arms, and finally the hands, first rigid at arm's length, then close up, trembling, to his eyes. He halts, for the first time since he knows he's under way, one foot before the other, the higher flat, the lower on its toes, and waits for a decision. Then he moves on. Spite of the dark he does not grope his way, arms outstretched, hands agape and the feet held back just before the ground. With the result he must often, namely at every turn, strike against the walls that hem his path, against the right-hand when he turns left, the left-hand when he turns right, now with his foot, now with the crown of his head, for he holds himself bowed, because of the rise, and because he always holds himself bowed, his back humped, his head thrust forward, his eyes cast down. He loses his blood, but in no great quantity, the little wounds have time to close before being opened again, his pace is so slow. There are places where the walls almost meet, then it is the shoulders take the shock. But instead of stopping short, and even turning back, saying to himself, This is the end of the road, nothing now but to return to the other terminus and start again, instead he attacks the narrow sideways and so finally squeezes through, to the great hurt of his chest and back. Do his eyes, after such long exposure to the gloom, begin to pierce it? No, and this is one of the reasons why he shuts them more and more, more and more often and for ever longer spells. For his concern is increasingly to spare himself needless fatigue, such as that come of staring before him, and even all about him, hour after hour, day after day, and never seeing a thing. This is not the time to go into his wrongs, but perhaps he was wrong not to persist, in his efforts to pierce the gloom. For

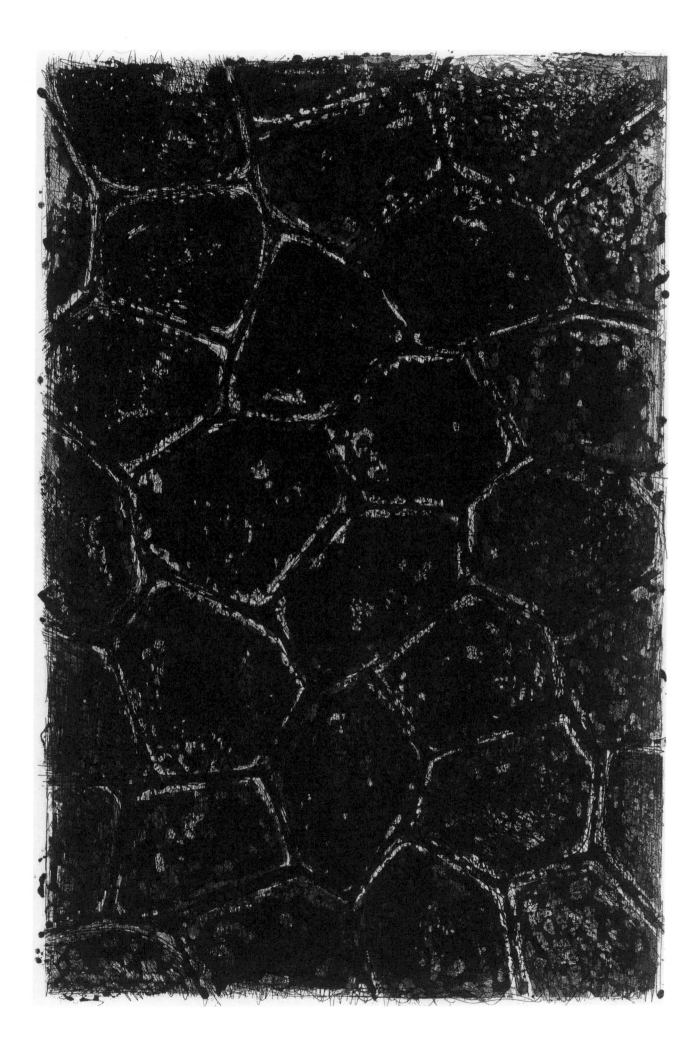

he might well have succeeded, in the end, up to a point, which would have brightened things up for him, nothing like a ray of light, from time to time, to brighten things up for one. And all may yet grow light, at any moment, first dimly and then — how can one say? — then more and more, till all is flooded with light, the way, the ground, the walls, the vault, without his being one whit the wiser. The moon may appear, framed at the end of the vista, and he in no state to rejoice and quicken his step, or on the contrary wheel and run, while there is yet time. For the moment however no complaints, which is the main. The legs notably seem in good shape, that is a blessing, Murphy had first-rate legs. The head is still a little weak, it needs time to get going again, that part does. No sign of insanity in any case, that is a blessing. Meagre equipment, but well balanced. The heart? No complaints. It's going again, enough to see him through. But see how now, having turned right for example, instead of turning left a little further on he turns right again. And see how now again, yet a little further on, instead of turning left at last he turns right yet again. And so on until, instead of turning right yet again, as he expected, he turns left at last. Then for a time his zigzags resume their tenor, deflecting him alternately to right and left, that is to say bearing him onward in a straight line more or less, but no longer the same straight line as when he set forth, or rather as when he suddenly realized he was forth, or perhaps after all the same. For if there are long periods when the right predominates, there are others when the left prevails. It matters little in any case, so long as he keeps on climbing. But see how now a little further on the ground falls away so sheer that he has to rear violently backward in order not to fall. Where is it then that life awaits him, in relation to his starting-point, to the point rather at which he suddenly realized he was started, above or below? Or will they cancel out in the end, the long gentle climbs and headlong steeps? It matters little in any case, so long as he is on the right road, and that he is, for there are no others, unless he has let them slip by unnoticed, one after another. Walls and ground, if not of stone, are no less hard, to the touch, and wet. The former, certain days, he stops to lick. The fauna, if any, is silent. The only sounds, apart from those of the body on its way, are of fall, a great drop dropping at last from a great height and bursting, a solid mass that leaves its place and crashes down, lighter particles collapsing slowly. Then the echo is heard, as loud at first as the sound that woke it and repeated sometimes a good score of times, each time a little weaker, no, sometimes louder than the time before, till finally it dies away. Then silence again, broken only by the sound, intricate and faint, of the body on its way. But such sounds of fall are not common and mostly silence reigns, broken only by the sounds of the body on its way, of the bare feet on the wet ground, of the laboured breathing, of the body striking against the walls or squeezing through the narrows, of the clothes, singlet and trousers, espousing and resisting the movements of the body, coming unstuck from the damp flesh and sticking to it again, tattering and fluttered where in tatters already by sudden flurries as suddenly stilled, and finally of the hands as now and then they pass, back

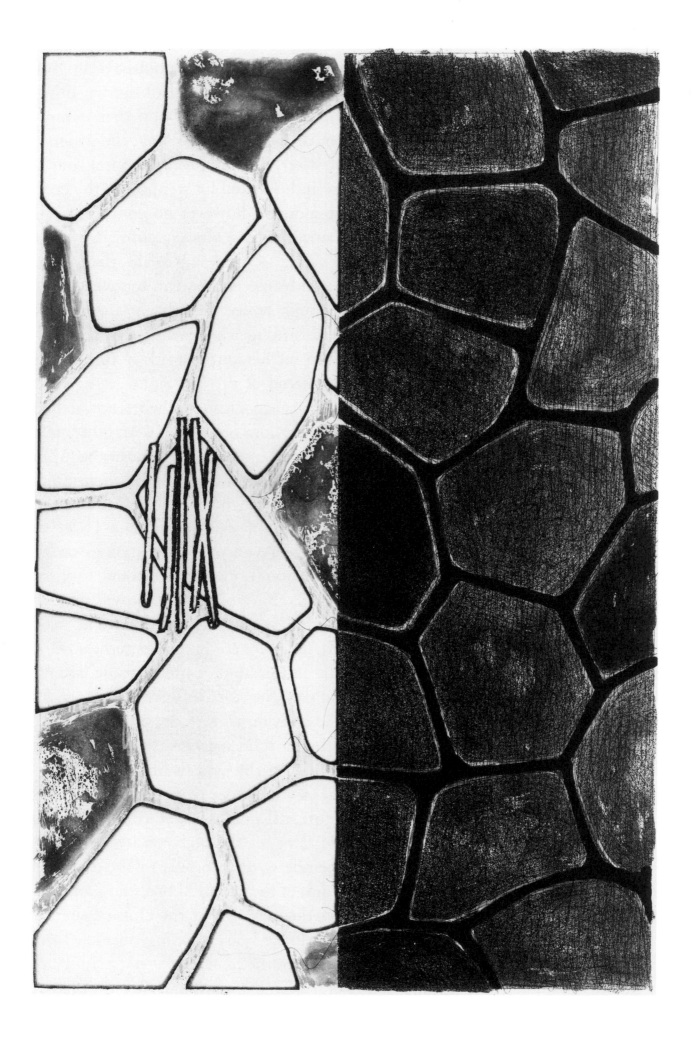

and forth, over all those parts of the body they can reach without fatigue. He himself has yet to drop. The air is foul. Sometimes he halts and leans against a wall, his feet wedged against the other. He has already a number of memories, from the memory of the day he suddenly knew he was there, on this same path still bearing him along, to that now of having halted to lean against the wall, he has a little past already, even a smatter of settled ways. But it is all still fragile. And often he surprises himself, both moving and at rest, but more often moving, for he seldom comes to rest, as destitute of history as on that first day, on this same path, which is his beginning, on days of great recall. But usually now, the surprise once past, memory returns and takes him back, if he will, far back to that first instant beyond which nothing, when he was already old, that is to say near to death, and knew, though unable to recall having lived, what age and death are, with other momentous matters. But it is all still fragile. And often he suddenly begins, in these black windings, and makes his first steps for quite a while before realizing they are merely the last, or latest. The air is so foul that only he seems fitted to survive it who never breathed the other, the true life-giving, or so long ago as to amount to never. And such true air, coming hard on that of here, would very likely prove fatal, after a few lungfuls. But the change from one to the other will no doubt be gentle, when the time comes, and gradual, as the man draws closer and closer to the open. And perhaps even now the air is less foul than when he started, than when he suddenly realized he was started. In any case little by little his history takes shape, with if not yet exactly its good days and bad, at least studded with occasions passing rightly or wrongly for outstanding, such as the straitest narrow, the loudest fall, the most lingering collapse, the steepest descent, the greatest number of successive turns the same way, the greatest fatigue, the longest rest, the longest — aside from the sound of the body on its way — silence. Ah yes, and the most rewarding passage of the hands, on the one hand, the feet, on the other, over all those parts of the body within their reach. And the sweetest wall lick. In a word all the summits. Then other summits, hardly less elevated, such as a shock so rude that it rivalled the rudest of all. Then others still, scarcely less eminent, a wall lick so sweet as to vie with the second sweetest. Then little or nothing of note till the minima, these two unforgettable, on days of great recall, a sound of fall so muted by the distance, or for want of weight, or for lack of space between departure and arrival, that it was perhaps his fancy. Or again, second example, no, not a good example. Other landmarks still are provided by first times, and even second. Thus the first narrow, for example, no doubt because he was not expecting it, impressed him quite as strongly as the straitest, just as the second collapse, no doubt because he was expecting it, was no less than the briefest never to be forgotten. So with one thing and another little by little his history takes shape, and even changes shape, as new maxima and minima tend to cast into the shade, and toward oblivion, those momentarily glorified, and as fresh elements and motifs, such as these bones of which more very shortly, and at length, in view of their importance, contribute to enrich it.

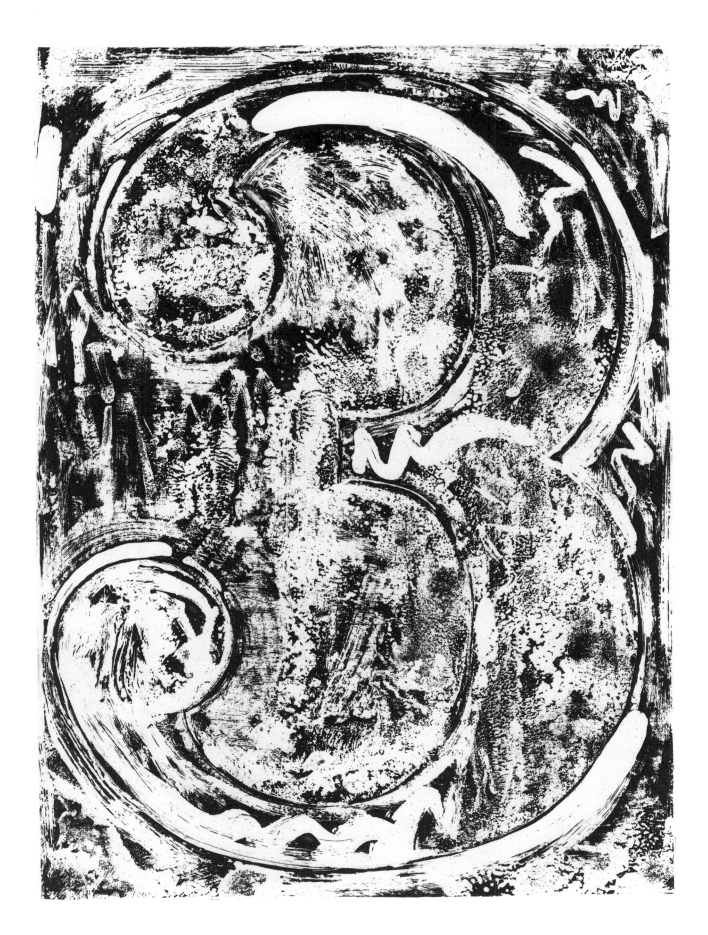

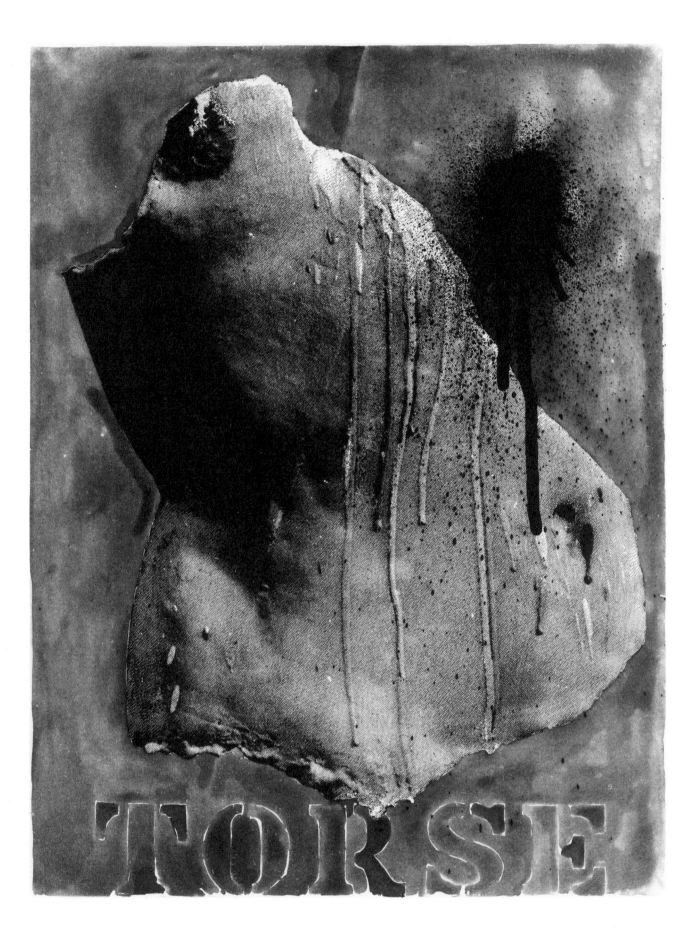

Vieille terre, assez menti, je l'ai vue, c'était moi, de mes yeux grifanes d'autrui, c'est trop tard. Elle va être sur moi, ce sera moi, ce sera elle, ce sera nous, ça n'a jamais été nous. Ce n'est peut-être pas pour demain, mais trop tard. C'est pour bientôt, comme je la regarde, et quel refus, comme elle me refuse, la tant refusée. C'est une année à hannetons, l'année prochaine il n'y en aura pas, ni l'année suivante, regarde-les bien. Je rentre à la nuit, ils s'envolent, ils lâchent mon petit chêne et s'en vont, gavés, dans les ombres. Tristi fummo ne l'aere dolce. Je rentre, lève le bras, saisis la branche, me mets debout et rentre dans la maison. Trois ans dans la terre, ceux qui échappent aux taupes, puis dévorer, dévorer, dix jours durant, quinze jours, et chaque nuit le vol. Jusqu'à la rivière, peut-être, ils partent vers la rivière. J'allume, j'éteins, honteux, je reste debout devant la fenêtre, je vais d'une fenêtre à l'autre, en m'appuyant aux meubles. Un instant je vois le ciel, les différents ciels, puis ils se font visages, agonies, les différentes amours, bonheurs aussi, il y en a eu aussi, malheureusement. Moments d'une vie, de la mienne, entre autres, mais oui, à la fin. Bonheurs, quels bonheurs, mais quelles morts, quelles amours, sur le moment je l'ai su, c'était trop tard. Ah aimer, mourant, et voir mourir, les êtres vite chers, et être heureux, pourquoi ah, pas la peine. Non mais maintenant, seulement rester là, debout devant la fenêtre, une main au mur, l'autre accrochée à la chemise, et voir le ciel, un peu longuement, mais non, hoquets et spasmes, mer d'une enfance, d'autres ciels, un autre corps.

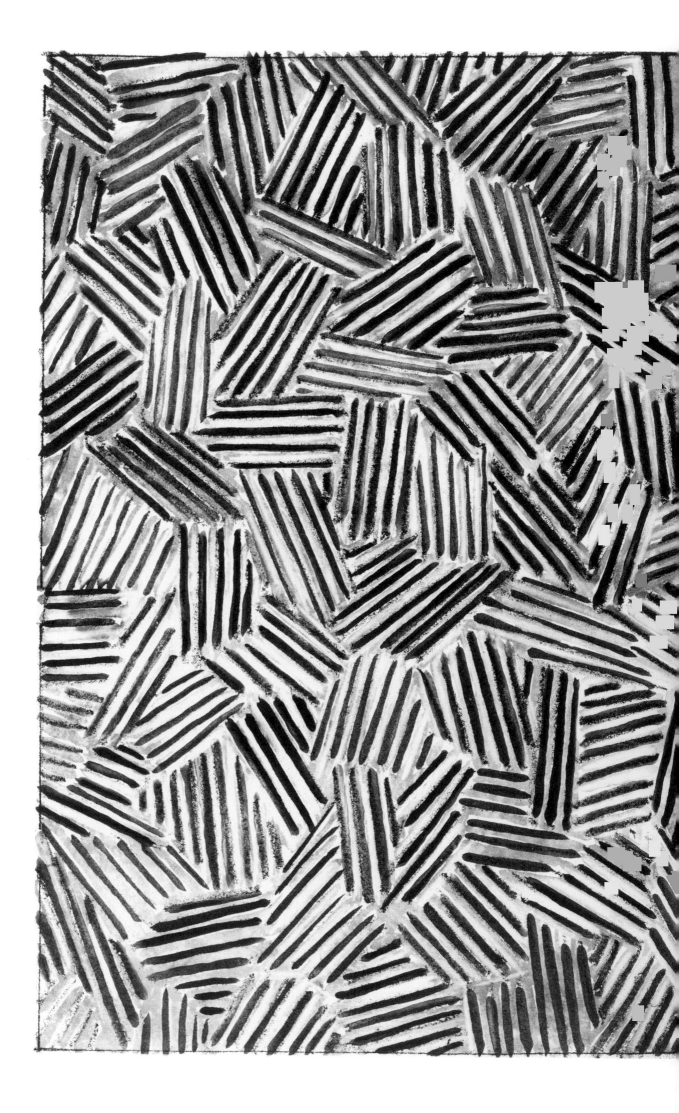

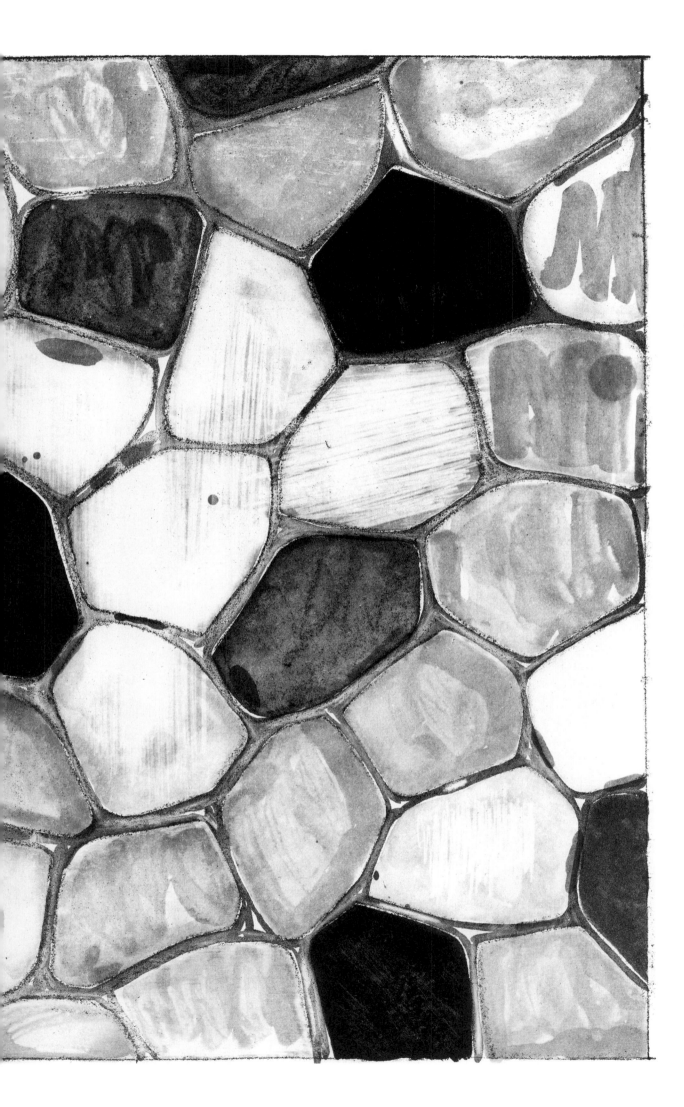

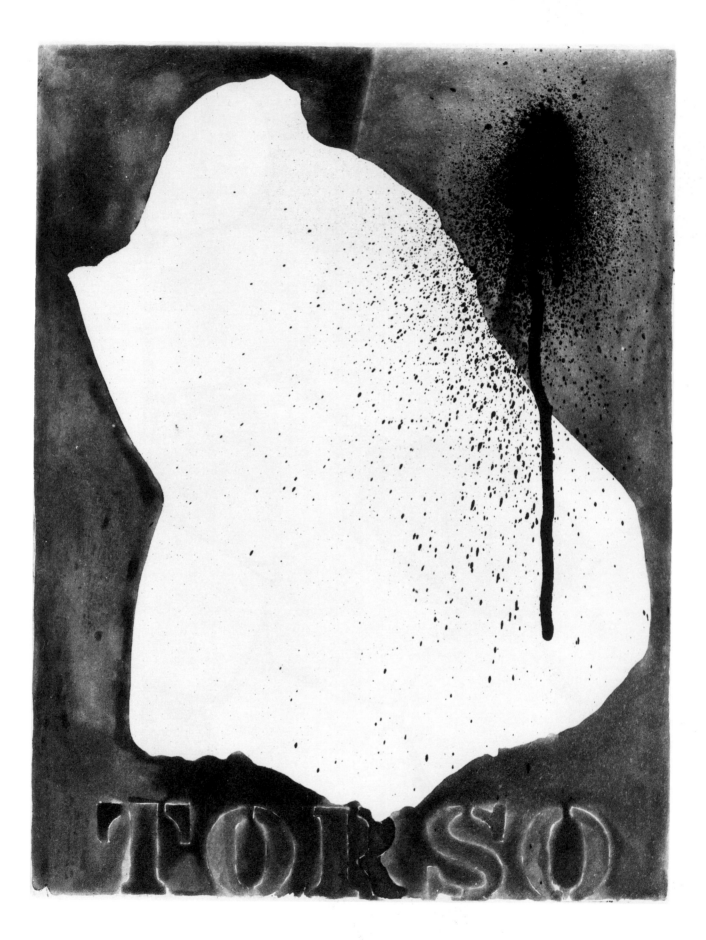

Old earth, no more lies, I've seen you, it was me, with my other's ravening eyes, too late. You'll be on me, it will be you, it will be me, it will be us, it was never us. It won't be long now, perhaps not tomorrow, nor the day after, but too late. Not long now, how I gaze on you, and what refusal, how you refuse me, you so refused. It's a cockchafer year, next year there won't be any, nor the year after, gaze your fill. I come home at nightfall, they take to wing, rise from my little oaktree and whirr away, glutted, into the shadows. I reach up, grasp the bough, pull myself up and go in. Three years in the earth, those the moles don't get, then guzzle guzzle, ten days long, a fortnight, and always the flight at nightfall. To the river perhaps, they head for the river. I turn on the light, then off, ashamed, stand at gaze before the window, the windows, going from one to another, leaning on the furniture. For an instant I see the sky, the different skies, then they turn to faces, agonies, loves, the different loves, happiness too, yes, there was that too, unhappily. Moments of life, of mine too, among others, no denying, all said and done. Happiness, what happiness, but what deaths, what loves, I knew at the time, it was too late then. Ah to love at your last and see them at theirs, the last minute loved ones, and be happy, why ah, uncalled for. No but now, now, simply stay still, standing before a window, one hand on the wall, the other clutching your shirt, and see the sky, a long gaze, but no, gasps and spasms, a childhood sea, other skies, another body.

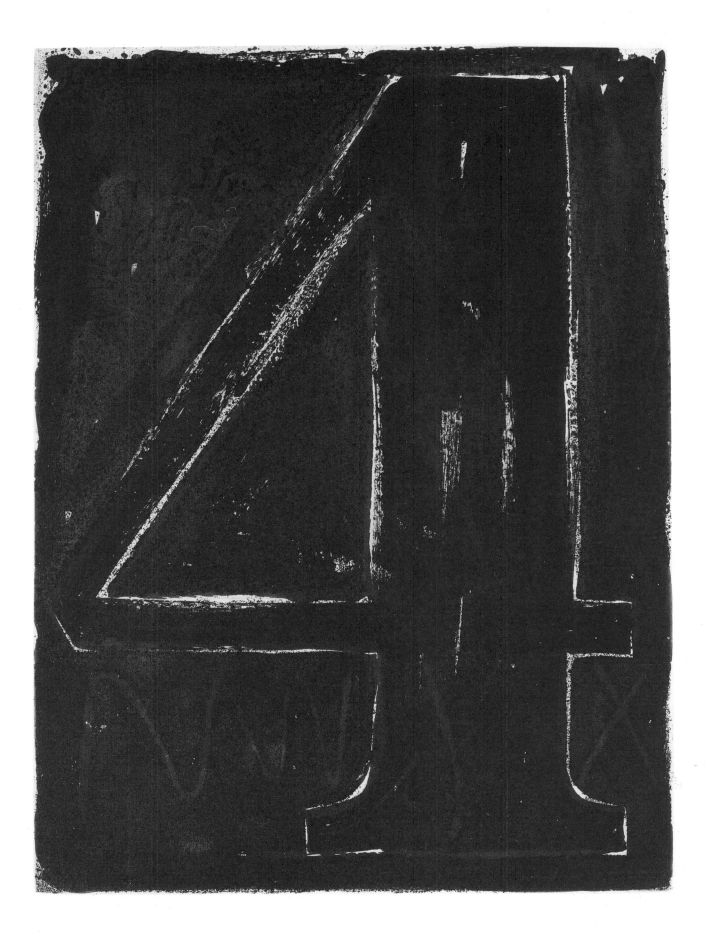

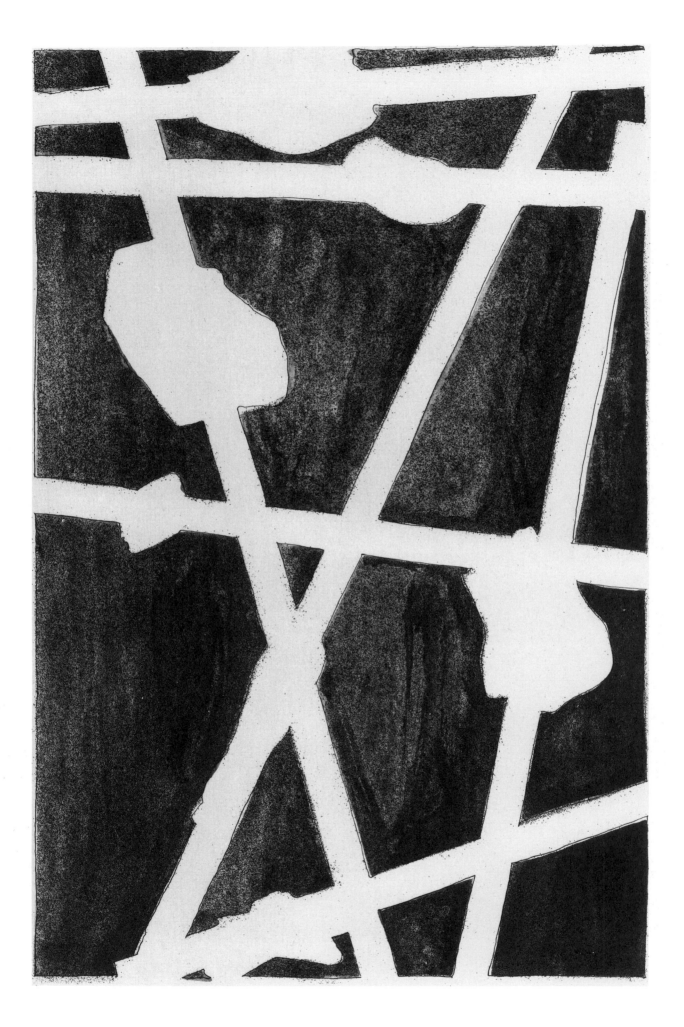

Endroit clos. Tout ce qu'il faut savoir pour dire est su. Il n'y a que ce qui est dit. A part ce qui est dit il n'y a rien. Ce qui se passe dans l'arène n'est pas dit. S'il fallait le savoir on le saurait. Ça n'intéresse pas. Ne pas l'imaginer. Temps usant de la terre en user à regret. Endroit fait d'une arène et d'une fosse. Entre les deux longeant celle-ci une piste. Endroit clos. Au-delà de la fosse il n'y a rien. On le sait puisqu'il faut le dire. Arène étendue noire. Des millions peuvent s'y tenir. Errants et immobiles. Sans jamais se voir ni s'entendre. Sans jamais se toucher. C'est tout ce qu'on sait. Profondeur de la fosse. Voir du bord tous les corps placés au fond. Les millions qui y sont encore. Ils paraissent six fois plus petits que nature. Fond divisé en zones. Zones noires et zones claires. Elles en occupent toute la largeur. Les zones restées claires sont carrées. Un corps moyen y tient à peine. Étendu en diagonale. Plus grand il doit se recroqueviller. On sait ainsi la largeur de la fosse. On la saurait sans cela. Des zones noires faire la somme. Des zones claires. Les premières l'emportent de loin. L'endroit est vieux déjà. La fosse est vieille. Au départ elle n'était que clarté. Que zones claires. Se touchant presque. Lisérées d'ombre à peine. La fosse semble en ligne droite. Puis réapparaît un corps déjà vu. Il s'agit donc d'une courbe fermée. Clarté très brillante des zones claires. Elle ne mord pas sur les noires. Celles-ci sont d'un noir inentamable. Aussi dense sur les bords qu'au centre. En revanche cette clarté monte tout droit. Haut au-dessus du niveau de l'arène. Aussi haut au-dessus que la fosse est profonde. Se dressent dans l'air noir des tours de pâle lumière. Autant de zones claires autant de tours. Autant de corps visibles dans le fond. La piste suit la fosse sur toute sa longueur. Sur tout son pourtour. Elle est surélevée par rapport à l'arène. La valeur d'une marche. Elle est faite de feuilles mortes. Rappel de la belle nature. Elles sont sèches. L'air sec et la chaleur. Mortes mais pas pourries. Elles tomberaient plutôt en poussière. Piste juste assez large pour un seul corps. Jamais deux ne s'y croisent.

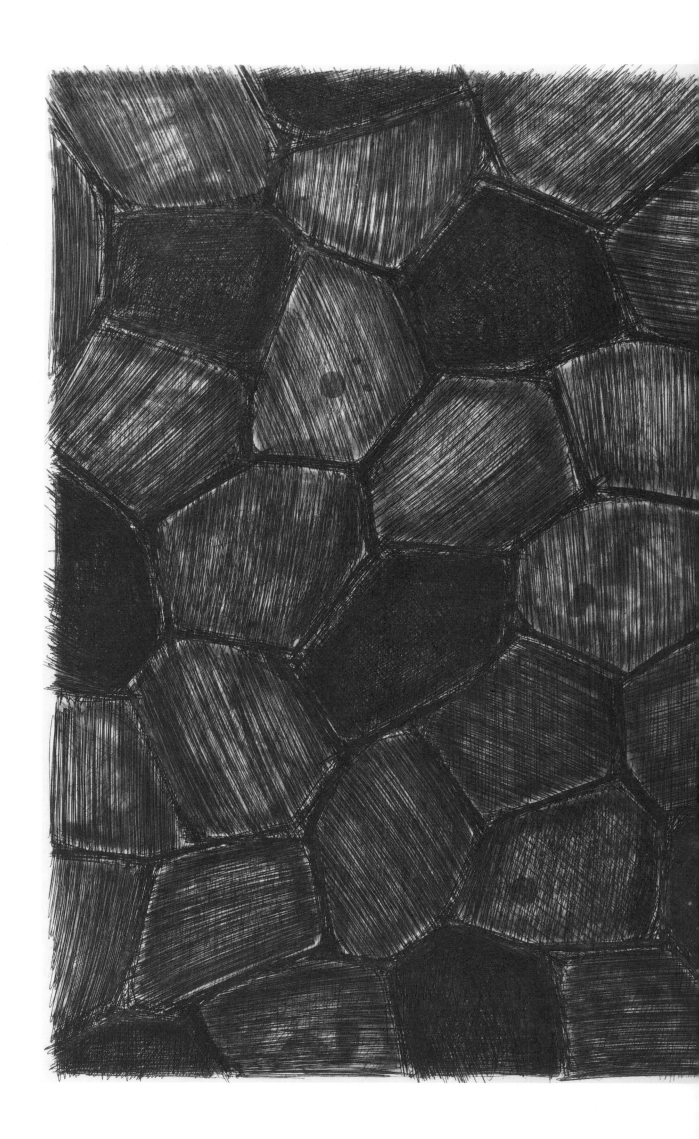

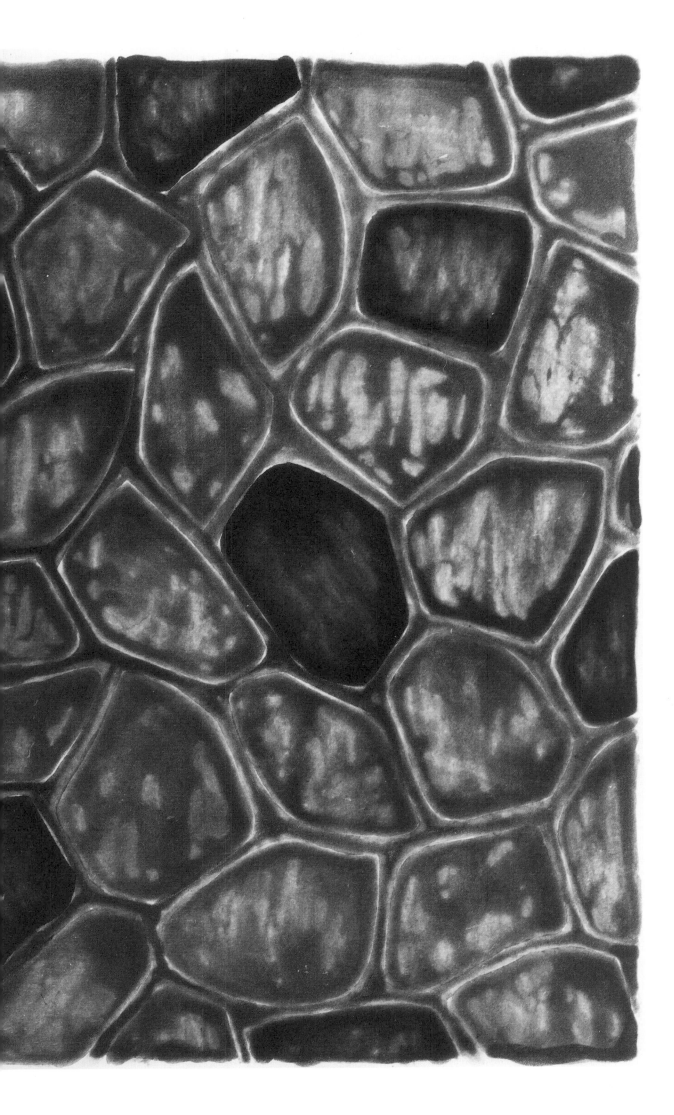

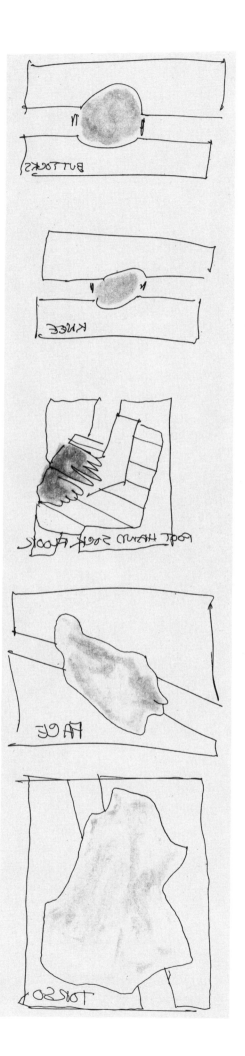

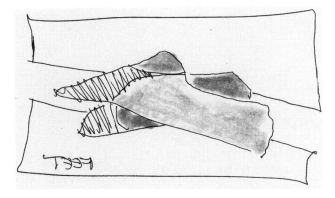

Closed place.
All needed to be known for say is known. There is nothing but what is said. Beyond what is said there is nothing. What goes on in the arena is not said. Did it need to be known it would be. No interest. Not for imagining. Place consisting of an arena and a ditch. Between the two skirting the latter a track. Closed place. Beyond the ditch there is nothing. This is known because it needs to be said. Arena black vast. Room for millions. Wandering and still. Never seeing never hearing one another. Never touching. No more is known. Depth of ditch. See from the edge all the bodies on its bed. The millions still there. They appear six times smaller than life. Bed divided into lots. Dark and bright. They take up all its width. The lots still bright are square. Appear square. Just room for the average sized body. Stretched out diagonally. Bigger it has to curl up. Thus the width of the ditch is known. It would have been in any case. Sum the bright lots. The dark. Outnumbered the former by far. The place is already old. The ditch is old. In the beginning it was all bright. All bright lots. Almost touching. Faintly edged with shadow. The ditch seems straight. Then reappears a body seen before. A closed curve therefore. Brilliance of the bright lots. It does not encroach on the dark. Adamantine blackness of these. As dense at the edge as at the centre. But vertically it diffuses unimpeded. High above the level of the arena. As high above as the ditch is deep. In the black air towers of pale light. So many bright lots so many towers. So many bodies visible on the bed. The track follows the ditch all the way along. All the way round. It is on a higher level than the arena. A step higher. It is made of dead leaves. A reminder of beldam nature. They are dry. The heat and the dry air. Dead but not rotting. Crumbling into dust rather. Just wide enough for one. On it no two ever meet.

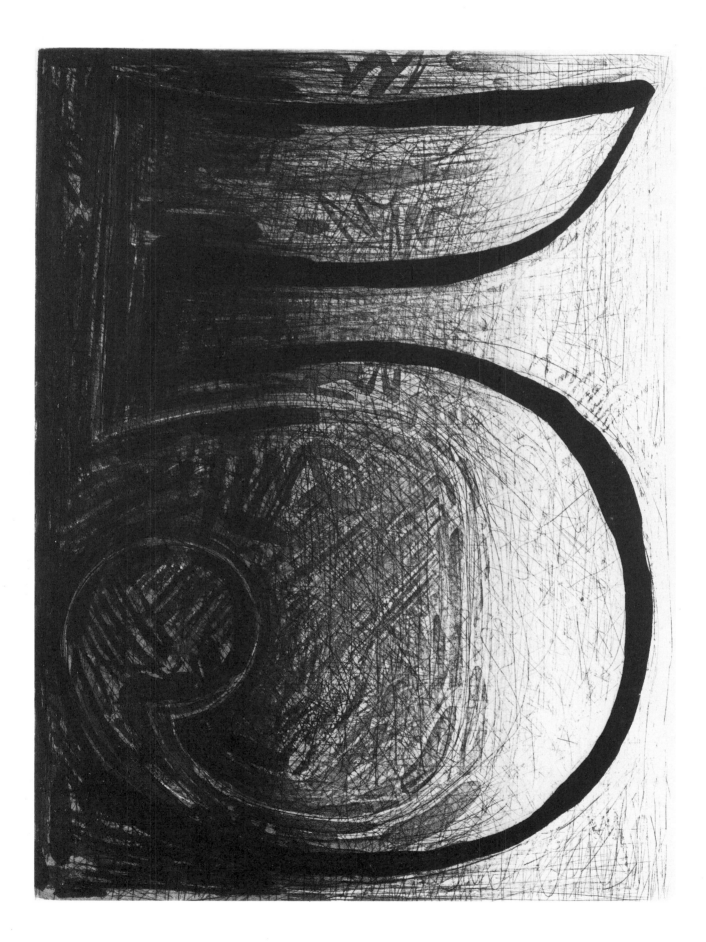

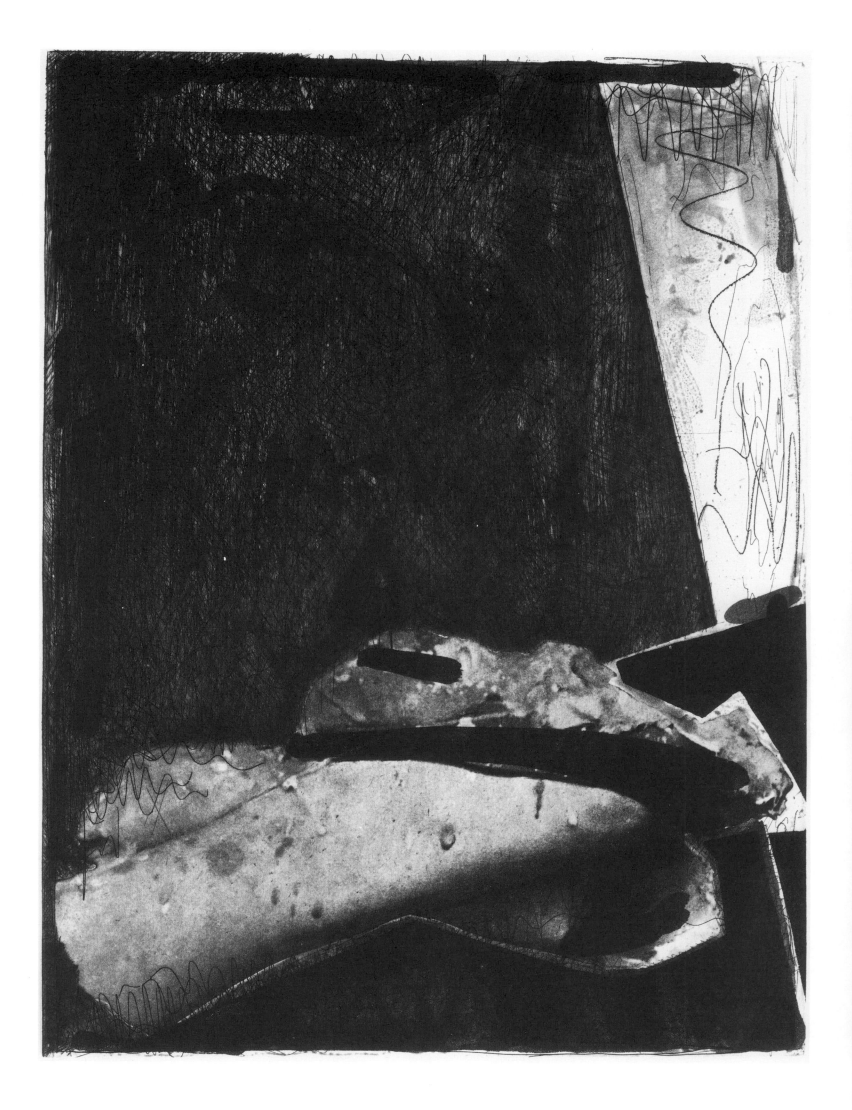

Horn venait la nuit. Je le recevais dans l'obscurité. J'avais appris à tout supporter sauf d'être vu. Je le congédiais, dans les premiers temps, au bout de cinq ou six minutes. Par la suite il s'en allait de lui-même, passé ce délai. Il consultait ses notes à la lumière d'une torche électrique. Puis il éteignait et parlait dans l'obscurité. Lumière silence, obscurité parole. Ça faisait cinq ou six ans que personne ne m'avait vu, moi tout le premier. Je parle du visage que j'avais tant sondé, jadis et naguère. J'essaie maintenant de reprendre cette inspection, pour qu'elle me serve de leçon. Je ressors mes glaces et miroirs. Je finirai par me laisser voir. Je crierai, si l'on frappe, Entrez ! Mais je parle d'il y a cinq ou six ans. Ces indications de durée, et celles à venir, pour que nous nous sentions dans le temps. Le corps me donnait plus de mal. Je me le masquais de mon mieux, mais quand je me levais il se montrait forcément. Car je commençais à me lever. Puis on se blesse. C'était en tout cas moins grave. Mais le visage, rien à faire. Horn donc la nuit. Quand il oubliait sa torche il usait d'allumettes. Lui disais-je, par exemple, Et sa robe ce jour-là ?, il allumait, feuilletait, trouvait le renseignement, éteignait et répondait, par exemple, La jaune. Il n'aimait pas qu'on l'interrompe et je dois dire que je n'en avais que rarement l'occasion. L'interrompant une nuit je le priai de s'éclairer le visage. Il le fit, rapidement, éteignit et enchaîna. L'interrompant derechef je le priai de se taire un instant. Ça n'alla pas plus loin. Mais le lendemain, ou peut-être seulement le surlendemain, je le priai d'entrée de s'éclairer le visage et de le maintenir éclairé jusqu'à nouvel ordre. Assez vive d'abord, la lumière alla faiblissant jusqu'à ne plus être qu'une lueur jaune. Celle-ci, à ma surprise, persista un long moment. Puis brusquement ce fut le noir et Horn s'en alla, les cinq ou six minutes s'étant sans doute écoulées. Mais là de deux choses l'une, ou bien l'extinction avait réellement coïncidé, par un curieux effet du hasard, avec la fin de la séance, ou bien c'est Horn, sachant qu'il était temps de partir, qui avait coupé les derniers restes de courant. Il m'arrive encore de revoir le visage pâlissant où m'apparaissait de plus en plus clairement, à mesure que l'ombre le gagnait, celui dont j'avais gardé le souvenir. A la fin, alors qu'inexplica-blement il tardait à se dissiper tout à fait, je m'étais dit, Aucun doute, c'est lui. C'est dans l'espace extérieur, à ne pas confondre avec l'autre, que ces images s'organisent. Il me suffit d'interposer ma main, ou de fermer les yeux, pour ne plus les voir, ou encore

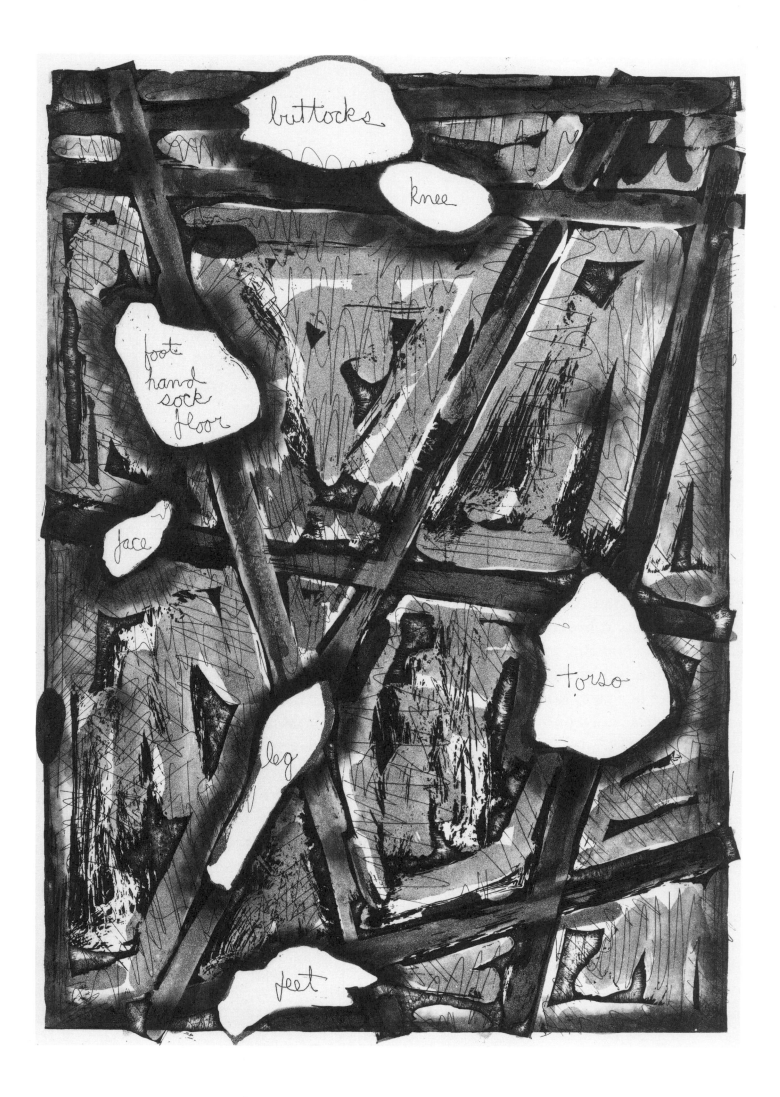

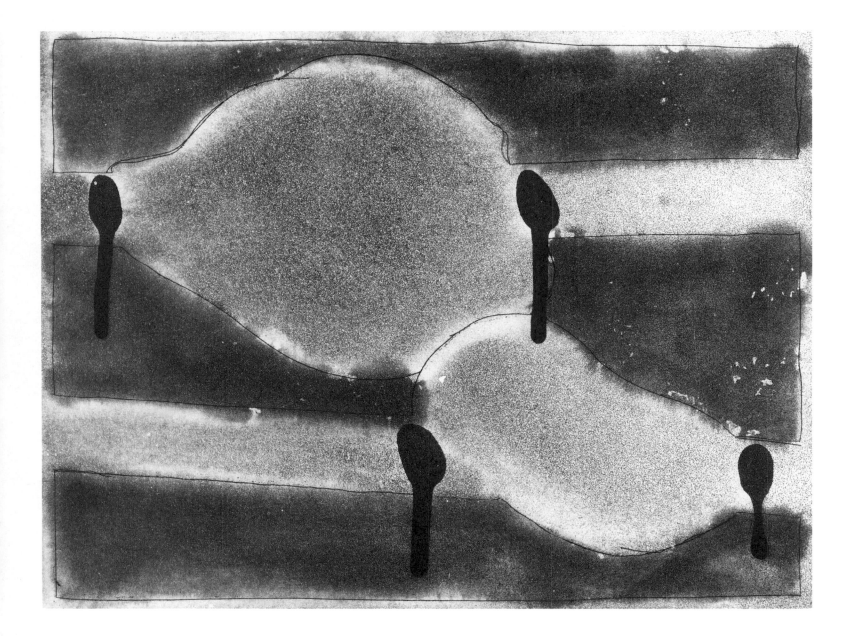

d'ôter mes lunettes, pour qu'elles se brouillent. C'est un avantage. Mais ce n'est pas une véritable protection, comme nous allons voir. C'est pourquoi je me tiens de préférence, quand je me lève, devant une surface unie, semblable à celle que je commande depuis mon lit, je parle du plafond. Car je commence de nouveau à me lever. Je croyais avoir fait mon dernier voyage, celui où maintenant je dois encore une fois essayer de voir clair, afin qu'il me serve de leçon, et dont j'aurais mieux fait de ne pas revenir. Mais l'impression me gagne que je vais être obligé d'en entreprendre un autre. Je commence donc de nouveau à me lever et à faire quelques pas dans ma chambre, en me tenant aux barreaux du lit. C'est l'athlétisme au fond qui m'a perdu. D'avoir tant sauté et couru, boxé et lutté, dans ma jeunesse, et bien au-delà pour certaines spécialités, j'ai usé la machine avant l'heure. J'avais dépassé la quarantaine que je lançais encore le javelin.

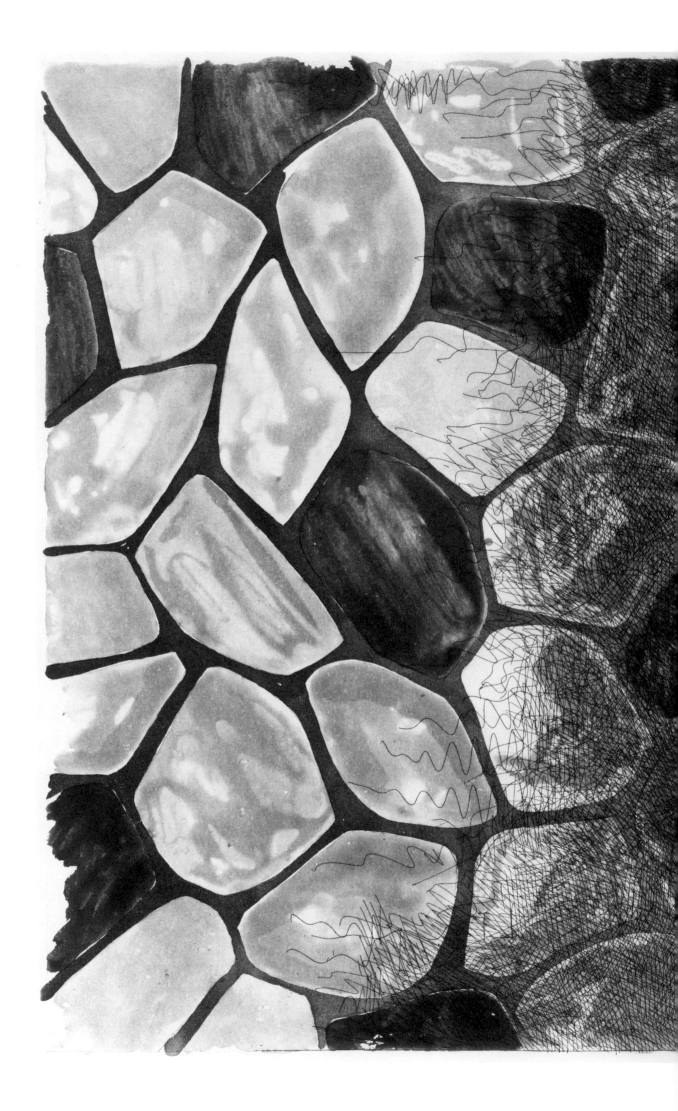

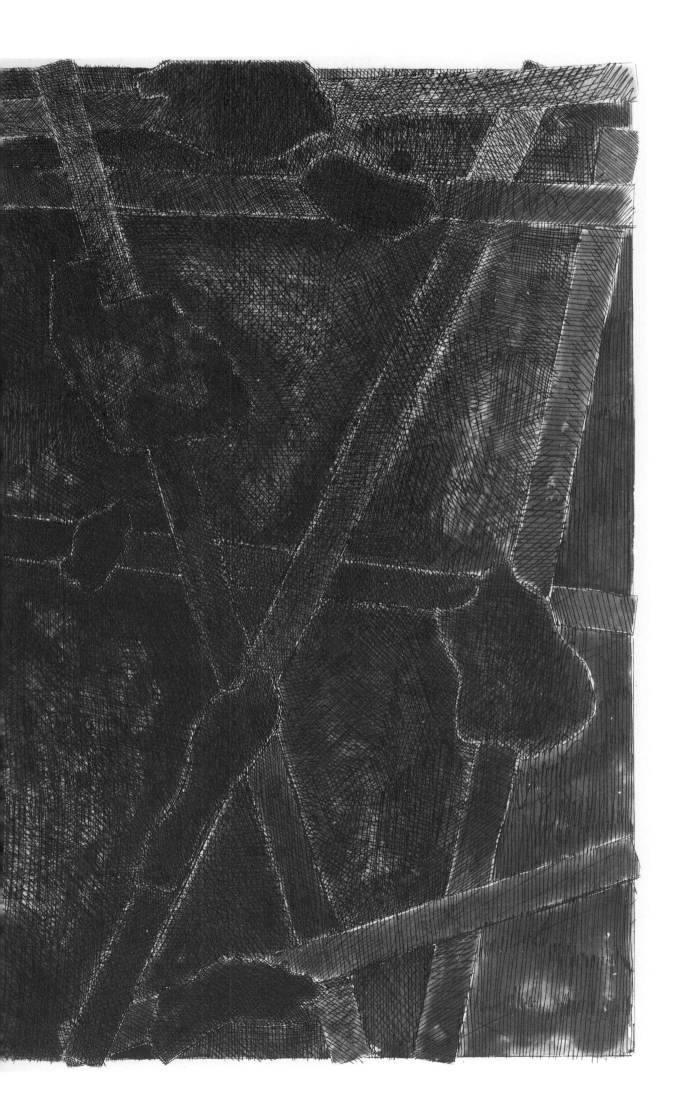

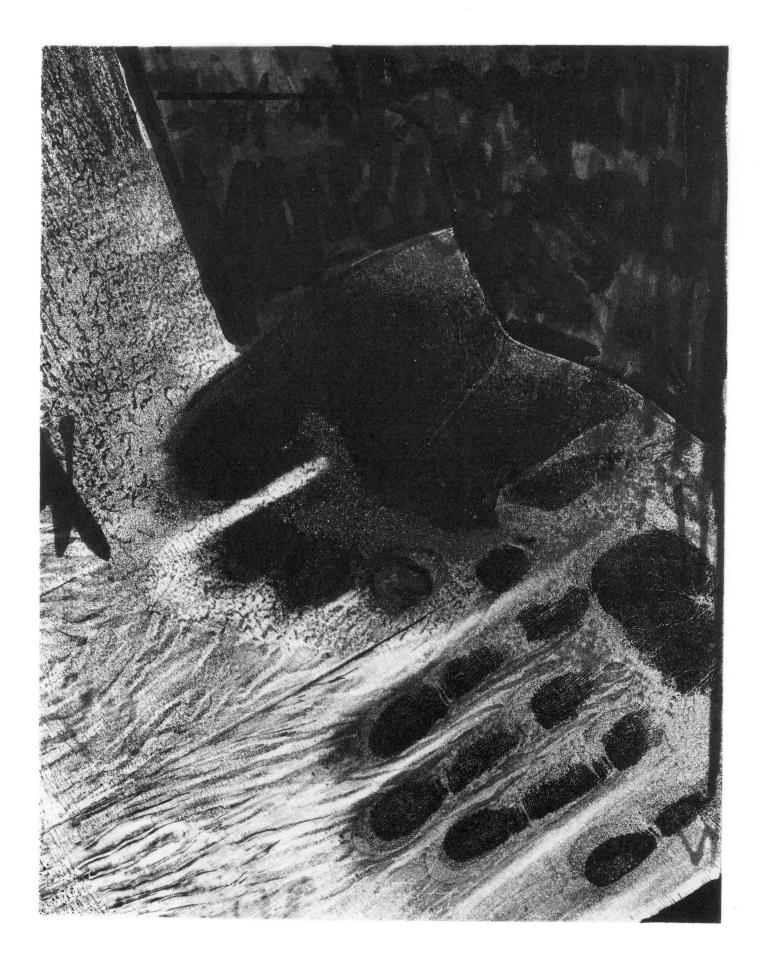

Horn came always at night. I received him in the dark. I had come to bear everything bar being seen. In the beginning I would send him away after five or six minutes. Till he learnt to go of his own accord, once his time was up. He consulted his notes by the light of an electric torch. Then he switched it off and spoke in the dark. Light silence, dark speech. It was five or six years since anyone had seen me, to begin with myself. I mean the face I had pored over so, all down the years. Now I would resume that inspection, that it may be a lesson to me, in my mirrors and looking-glasses so long put away. I'll let myself be seen before I'm done. I'll call out, if there is a knock, Come in! But I speak now of five or six years ago. These allusions to now, to before and after, and all such yet to come, that we may feel ourselves in time. I had more trouble with the body proper. I masked it as best I could, but when I got out of bed it was sure to show. For I was now beginning, then if you prefer, to get out of bed again. Then there is the matter of its injuries. But the body was of less consequence. Whereas the face, no, not at any price. Hence Horn at night. When he forgot his torch he made shift with matches. Were I to ask, for example, And her gown that day? then he switched on, thumbed through his notes, found the particular, switched off and answered, for example, The yellow. He did not like one to interrupt him and I must confess I seldom had call to. Interrupting him one night I asked him to light his face. He did so, briefly, switched off and resumed the thread. Interrupting again I asked him to be silent for a moment. That night things went no further. But the next, or more likely the next but one, I desired him at the outset to light his face and keep it lit till further notice. The light, bright at first, gradually died down to no more than a yellow glimmer which then, to my surprise, persisted undiminished some little while. Then suddenly it was dark again and Horn went away, the five or six minutes having presumably expired. But here one of two things, either the final extinction had coincided, by some prank of chance, with the close of the session, or else Horn, knowing his time to be up, had cut off the last dribs of current. I still see, sometimes, that waning face disclosing, more and more clearly the more it entered shadow, the one I remembered. In the end I said to myself, as unaccountably it lingered on, No doubt about it, it is he. It is in outer space, not to be confused with the other, that such images develop. I need only interpose my hand, or close my eyes, to banish them, or take off my eyeglasses for them to fade. This is a help, but not a real protection, as we shall see. I try to keep before me therefore, as far as possible, when I get up, some such unbroken plane as that which I command from my bed, I mean the ceiling. For I have taken to getting up again. I thought I had made my last journey, the one I must now try once more to elucidate, that it may be a lesson to me, the one from which it were better I had never returned. But the feeling gains on me that I must undertake another. So I have taken to getting up again and making a few steps in the room, holding on to the bars of the bed. What ruined me at bottom was athletics. With all that jumping and running when I was young, and even long after in the case of certain events, I wore out the machine before its time. My fortieth year had come and gone and I still throwing the javelin.

Ce livre comprend cinq textes de Samuel Beckett et trente trois gravures originales de Jasper Johns. L'édition originale du texte français date de 1972. La version anglaise a été écrite par Samuel Beckett en 1974 pour la présente édition. Les cuivres ont été gravés par Jasper Johns et tirés sur les presses à bras de l'Atelier Crommelynck à Paris en 1975 et 1976. Cet ouvrage a été réalisé avec la collaboration de Véra Lindsay. Le papier à la main du Moulin Richard de Bas, en Auvergne, est filigrané aux initiales de Samuel Beckett et à la signature de Jasper Johns. Composé en Elzévir Caslon, corps 16, le texte a été imprimé par Fequet et Baudier, typographes à Paris. La reliure a été conçue et réalisée par Rudolf Rieser à Cologne. L'emboîtage de toile est enrichi, intérieurement, de lithographies originales en couleurs de Jasper Johns. La couverture du livre, en papier à la main, mesure 33 centimètres par 26 centimètres. Tous les exemplaires portent les signatures manuscrites de l'auteur et de l'illustrateur. Le tirage a été réparti comme suit : deux cent cinquante exemplaires numérotés de 1 à 250 plus trente exemplaires numérotés de I à XXX et vingt exemplaires nominatifs, marqués Hors Commerce.

This book contains five texts by Samuel Beckett and thirty three etchings by Jasper Johns. The French texts first appeared in 1972; the English texts were written by Samuel Beckett in 1974 for this collaboration. The etchings were made by Jasper Johns and proofed and printed by hand at the Atelier Crommelynck in Paris in 1975 and 1976. The publication was edited by Vera Lindsay. The paper, watermarked with the initials of Samuel Beckett and the signature of Jasper Johns, was handmade by Richard de Bas in the Auvergne. The type was set in Caslon Old Face 16pt. and hand printed by Fequet and Baudier in Paris. The binding was conceived and executed by Rudolf Rieser in Cologne. The book, 13 inches by 10 inches, is bound in handmade paper and boxed in linen, with an internal lining of colour lithographs by Jasper Johns. Each book is signed by the author and the artist: two hundred and fifty numbered 1 to 250, thirty artist's proofs numbered I to XXX, and twenty Hors Commerce individually dedicated.

ESSAYS

The Making of
Foirades/Fizzles

Richard S. Field
Curator of Prints, Drawings, and Photographs
Yale University Art Gallery

For Lesley and Nicholas

From the very start Johns was quite hesitant about the prospect of collaborating with a writer. When he and Samuel Beckett met in November of 1973, the painter hoped that the writer would contribute new or at least unpublished materials for their joint venture.[1] As it turned out, Beckett would provide five short texts, part of a group of eight that had been written and translated between 1960 and 1975; several had in fact been published (in French) as early as 1972.[2] But Beckett allowed Johns to determine the order in which the five Fizzles would appear, to design how the words and etchings would be integrated, and most importantly, to utilize imagery already initiated in the painting, *Untitled*, 1972. Given Beckett's own propensity for recycled imagery and words, this was a natural but crucial decision.[3] Apparently even before all the English versions (translated by Beckett himself) were in hand, Johns set about his task. His first impulse was to integrate word and image, as is shown in some of the early trial proofs of *Face* (iii/xii, plate no. 2), *Hatching and Flagstones* (i/vi, plate no. 28), and *HandFootSockFloor* (ix/xvii, plate no. 68). But when Beckett's English texts had all arrived, Johns found them so short and polished that he felt

constrained to alter his intentions. As Roberta Bernstein has chronicled, Johns determined to print both the French and English versions and to insert his etchings only at the start, middle, and finish of Beckett's passages. It is one of the deeply moving aspects of this book just how craftily Johns managed to preserve the nearly pre-ordained order of his visual contributions while integrating them both functionally and imaginatively into the flow and meaning of Beckett's powerful literature.

While no one would characterize *Foirades/Fizzles* as a true collaboration—we have already noted that each artist contributed pre-existing materials—the manifold resonances between texts and images are remarkable. In this essay, I will examine only some of those correspondences, leaving the more literary analysis to Andrew Bush in the present catalogue. My primary goal is to describe Johns's working habits with sufficient clarity and detail so that the language of description reveals, as if of its own accord, some of the fundamental ideas of his art. This undertaking, then, hinges upon one basic conviction: that the meanings of Johns's images are not to be found in conventional associations or in personal symbolism (though some of each is inevitably present).[4] And further, these most basic meanings are not to be gleaned from allusions either to Johns's personal life or to the paintings of his forebears—Peto, Picasso, Magritte, Duchamp, or the Abstract Expressionists.[5] At the risk of clinging to what others have called a formalist or literalist position, I would like to demonstrate that the deepest and most universal meanings in Johns's art arise from his use of language, his ways of working, and his habits of mind, rather than from any of the more restricting ideas that arise from conventional interpretation. Johns's renowned denial of self is not a cat-and-mouse game with his critics (though it does prepare many a trap), but an absolutely necessary moral condition. If his view is pessimistic, it is not one that arises from the rack of personal encounters, disappointments, and sufferings, but from a brilliant encoding of the human condition into the terms of the making of art. It is not our emotional tragedies that Johns laments, but those of our innermost constitutional limits.

The Painting Untitled, *1972 and Related Prints*

When Johns began work on the thirty-three etchings for *Foirades/Fizzles*, his four-panel painting *Untitled*, 1972 (color plate II), was barely understood even by his most fervent admirers. The decision to limit the imagery of *Foirades/Fizzles* to these four panels, therefore, reflected a felt need to further explore and even explain the painting.[6] Above all, Johns wished to demonstrate that the four panels were not a totally arbitrary assemblage. He insisted that their sequence be

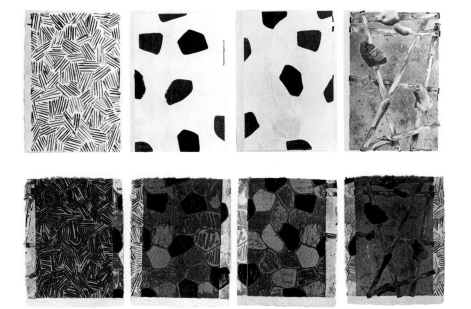

Fig. 2
FOUR PANELS FROM UNTITLED
1972, 1973-74
Published by Gemini G.E.L.
Lithograph
Each panel 40 x 28½ inches

Fig. 3
FOUR PANELS FROM UNTITLED
1972 (Grays and Black),
1973-75
Published by Gemini G.E.L.
Lithograph
Each panel 41 x 32 inches

maintained, and more importantly, he felt a necessity to demonstrate their cyclical or circular character. As a first step, in 1973-74 Johns published *Four Panels from Untitled, 1972* (fig. 2), four color lithographs with embossing (followed by another set in grays and black; fig. 3). In these works Johns revealed his concern with memory transfer: how did one's perception of the hatchings of panel A effect the experience of the flagstones of panel B? Could the casts of panel D be considered as plastic events on the same order as those of the flagstones and hatchings?[7] The embossed lithographs actually effected such transfers and comparisons, since they literally superimposed the ghostly forms of the preceding panel on its successor. The fact that the casts of D were impressed into the hatchings of A, and that the images of the flagstones themselves were partially identical, but displaced, in panels B and C were powerful clues to the artist's preoccupation with memory and its role in identifying shifting points of view. These concerns are analogues for Johns's deeply seated preoccupation with how humans order and structure their world out of the fragmented and conflicting conditions in which they live.

Subsequent paintings and prints took up the hatching motif, first imposing concealed, internal codes on the patterns formed by the hatching as in the paintings *Scent*, 1973-74 (fig. 35) and *Untitled*, 1975 (Collection Eli and Edythe L. Broad), and then loading the same motifs with more stressful brushwork, emotionally laden color and weighty psychological titles as in *Corpse and Mirror*, 1974 (fig. 39), *The Dutch Wives*, 1975 (fig. 42), and *Weeping Women*, 1975 (fig. 38).[8] Each of these paintings (and the prints which followed from some) further explored the tensions created by similar images which repeated, reflected, and varied each other. And that "game"— the detection of relationships and their effect on each part of the whole—was played against another one, the interpretation of the differing emotional qualities of each piece. At every

101

point in this undertaking, Johns offers the viewer quite mutually exclusive effects. Thus it was no more crucial that Michael Crichton uncovered the supposed fact that *The Dutch Wives* are masturbatory boards than that Barbara Rose discerned the complex rules that govern the junctures in *Untitled*, 1975.[9] Both are categories of thought that may simultaneously bring important information about the impulses which generated the work.

Contemporaneously with these explorations of the structural and emotional potentials of the hatched motifs, Johns turned to the even more vexing and psychologically loaded problems of the casts. In a series of seven relatively small lithographs, *Casts from Untitled*, 1973-74 (figs. 4-7), he reconsidered each of the seven wax casts and wooden slats from panel D of *Untitled*, 1972. They too preserved an ordered sequence, one already determined by the numbers of the painted panel:

Red -1- Face
Purple -2- HandFootSockFloor
Blue -3- Buttocks
Green -4- Torso
Yellow -5- Feet
Orange -6- Leg
Black -7- Knee

The numbering of the slats to which the casts are attached was suggested to Johns by the necessity of providing some way to disassemble the whole panel. Such ordering is also tantalizingly close to the viewer's opposite impulse to reconstruct the human fragments. But that is typically misleading of the artist. Close attention to the casts reveals the absence of such organic logic; the casts are simply fragments of the human body, gathered from three or four sources.[10] The pressure towards conventional narrative is thus a dead end.

On the other hand, the colors of the lithographs do not repeat those of the painting, following instead another predetermined system, that of the spectral dispersion of white light into red, orange, yellow, green, blue, indigo, and violet. The last two are rather indistinguishable to the human eye, so Johns utilized purple, which is in reality neither indigo nor violet, but a subtractive mixture of red and blue.[11] The effect of *Casts*, including the two larger lithographs after panel D (*Sketch from Untitled, I* and *Sketch from Untitled, II*, both from 1973-74),[12] is to dispel much of the dramatic and mysterious overtones of the casts themselves; in the lithographs they emerge very much like beautiful old-master drawings, sensuous studies from the model often unrelated to any project. It is worth noting, finally, that both the sequencing and the fluid surfaces of the lithographs were significant for the etchings Johns was to execute for *Foirades/Fizzles*.

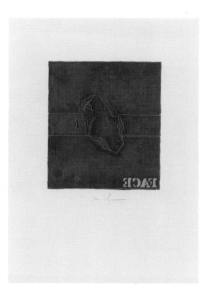

Fig. 4
FACE from CASTS FROM UNTITLED,
 1973-74
Published by Gemini G.E.L.
Lithograph
30¾ x 22¾ inches

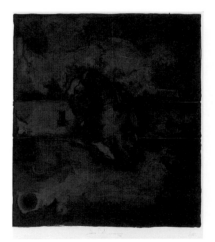

Fig. 5
FACE-BLACK STATE from CASTS
 FROM UNTITLED, 1973-74
Published by Gemini G.E.L.
Lithograph
15¾ x 13¾ inches

The Double-Page Etchings after Panels ABCD

Given the disparity between Beckett's five texts and Johns's four panels, it was no surprise that the design of the book did not simply suggest itself. Yet the main elements did pre-exist. Each Fizzle would begin with a Johns *Numeral* whose execution and character turned out to be very close to those of the Gemini lithographs of 1967-69.[13] *Numeral 5*, for example, manifests the same firm, jaunty, curvilinear accents as the lithograph. Even its division into three vertical tonalities reflects the horizontal divisions of the *Color Numerals*. But demonstrating the permutations of the four panels was perhaps the dominant idea. Consequently Johns decided to separate the French and English texts of each Fizzle with a double-page etching, one that would show two adjacent panels of *Untitled*, 1972. Being a book, the notion of transferring imagery from one panel to another would be reinforced by the very act of using—opening and closing the book, turning its pages. But there were five chapters and only four combinations: AB, BC, CD, and DA. The solution for the fifth spread probably arose from Johns's longtime exploration of the equivalency of names and objects: use the French and English equivalents for the names of the seven casts. The beauty of this decision was that it would relate both to the function of the spread—to separate the French and English texts—and to the plan, already conceived and embodied in the lithographs of the casts, to examine the body fragments in greater detail. Johns chose to place *Words (Buttock Knee Sock...)* in the middle of *Fizzle I*, panel DA in the second, AB in the third, BC in the fourth, and CD in the fifth. The book had already been molded by an inexorable logic, one that stressed the sequential and cyclical nature of the images as well as the interrelatedness of images and words.

The double-page etching *Words (Buttock Knee Sock...)* reveals a good deal about the entire project. In the first trial proof (i/x, plate no. 7), Johns applied the stencil-styled letters directly to the copper plate in lift-ground.[14] When printed, the words were reversed, French on the left, English on the right. The second trial proof clearly reveals Johns's thinking (ii/x, plate no. 8). The first letters were burnished so they would no longer hold as much ink, and then Johns applied a whole new set of lift-ground letters, this time drawing them backwards, French over English, English over French.[15] When printed again, the image showed darker English words over the burnished French on the left, and darker French words over the burnished English words on the right. In an unprecedented move of some brilliance, Johns had mimicked the process of translation in a way that suggested a lingering presence of the original language. And he equated that act of translation with the specific action of reading this book of French and English texts. What is more, the words

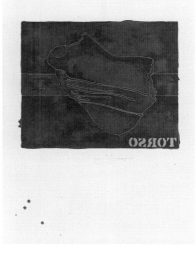

Fig. 6
TORSO from CASTS FROM
UNTITLED, 1973-74
Published by Gemini G.E.L.
Lithograph
30¾ x 22 ¾ inches

Fig. 7
TORSO-BLACK STATE from CASTS
FROM UNTITLED, 1973-74
Published by Gemini G.E.L.
Lithograph
16 x 18¼ inches

themselves suggest an even greater mystery of language, namely its ability to substitute a sign, a word, a name, for an object. Johns even manages to infiltrate the subtler question of how one thing, buttocks for example, can be represented by both the English and the French words; are they the same? This question of identity pervades the whole of Johns's work, especially the images and texts of *Foirades/Fizzles*.

The further trial proofs of *Words (Buttock Knee Sock...)* were experiments in relating the words to the functioning pages of the book. In pass after pass the artist applied layers of lift-ground scribbled marks, slowly closing in on the image, squeezing out its legibility to an alarming degree by the sixth trial proof (vi/x, plate no. 10). Over and over again in these etchings, Johns reached points of impasse (many of which are preserved for us in the trial proofs—Johns says he hates to discard anything). And each time he took some action to clarify or rescue the situation. Here, in the seventh trial proof (vii/x, plate no. 11), he decided to cut down the plate and radically burnish away almost a quarter of the image at the right and left. By so doing, he has eliminated the tiring compulsion to shift one's attention from one page to the other; instead a relative focus and stasis are provided by the denser, square area of the gutter while the lighter words become readable along the peripheries. The fact is that there are only two layers of language, but the effect is one of unimaginable density and complexity, analagous to the incredible human capacity for an almost thoughtless processing of the object world with language.

By doing nothing more than exploiting the inherent layering and reversals of copperplate printing, Johns has created a metaphor of far-reaching power for language use and memory. And the structure of his metaphor was not dependent upon arcane associations or abstruse symbols, but was embedded in this simple list of body parts, a table of contents of unexpected relevance for both the texts and the etchings. While the list does not precisely determine the order of the casts' appearance in the book, it is not a random naming but one predetermined by their physical disposition on the surface of panel D (which is thrice represented in *Foirades/Fizzles*):

Buttocks
Knee
HandFootSockFloor
Face
Torso
Leg
Feet

Once more the artist has imparted a cyclical meaning to his image; as a list with a sequence, it may be entered and exited at

any point, just as is implied by the continuous transfer of French and English between the pages of *Words (Buttock Knee Sock…)* or the rotational principle informing all four panels of *Untitled*, 1972.

Perhaps it is not at all accidental, then, that the very next etchings represent the four possible arrangements of the panels of *Untitled*, 1972. If one thinks back to the artistic situation of 1972, the strong conceptual bias in Johns's systematic arrangements is more understandable. Johns managed in painting what Minimalists like LeWitt, Judd, and Morris had achieved in sculpture: implying that the work of art and the viewer have a mutually mutating point of view. In *Foirades/ Fizzles* Johns not only made it possible for his viewer to experience the disparate events of the four panels in similar, etched terms, but also demonstrated in far greater detail the rotational movements to which we have alluded, namely the sequencing of the panels, the transferring of imagery, and the "overlapping" of the flagstones.[16] Once the viewer is absorbed into Johns's systems, he or she may no longer be certain whether the shifting point of view is generated by an implied movement of the work or of the spectator. In this context, it is worth recalling that both the flagstone and the hatching motifs were fleeting images, discovered by Johns while driving, and that their translation into art was a function of being remembered.[17] Thus the four small etchings, *Four Panels*, manifest not only permutations of position, but also those of execution and focus. While each was begun in soft-ground etching —a soft, crayon-like line—the addition of hard-grounding etching, lift-ground tones, burnishing (ABCD), and possibly drypoint (DABC) has individuated the character of each panel, basically altering their figure/ground, textural, and tonal relationships.

The next encounter with Johns's permutations occurs in *Casts and Hatching*, the double spread dividing *Fizzle 2*. Appropriately, it begins the cycle of contiguous panels with the casts, panel D, just as the entire book opens with a single cast, *Face*. As published, it is the most illusionistic presentation of the casts, throwing them into high relief; yet Johns's working method reveals an opposite impulse. In the first trial proof the casts are little more than vague, light shapes floating in an equally diffuse dark environment; the only marks conveying any hint of structure are those of the slats (i/iv, plate no. 14). To achieve such effects, Johns used a plate already grounded with a fine-grained aquatint. Instead of varnish or lift-ground solutions, however, his brush was charged with the acid. It was a totally direct way of etching his design, but one that was neither precise nor completely controllable.[18] Significantly, the hatching half of the plate was worked in an opposite manner, with lift-ground and stop-out. That is, the aquatint-grounded plate was not only drawn with sugar solution, but with an acid-resistant varnish called stop-

out. Thus most of the hatchings are simply masking strokes of stop-out that prevented the aquatint grain from being bitten into the plate. This first stage of work produced a very ambiguous image, one that casts doubt on the enterprise of reproducing the tangible objects that comprised the painting *Untitled*, 1972. In each of the many subsequent operations, however, Johns sharpened his images of the casts (and textured the slats) so that the final edition possesses an assertiveness that one could never have intuited from the first trials.

The double etching, *Hatching and Flagstones*, separates the texts of *Fizzle 3*. It began as a considerably larger undertaking and included, as the first trial proof shows, schematics of the adjacent panels, D and C (i/vi, plate no. 28). As in the first stages of the four *Four Panels*, Johns initiated his work with the broad and gentle lines of soft-ground etching.[19] Each of the successive trial proofs reveals advances and retreats as the images become better defined and then softened. At stage four the plate is cut down (this must also represent the moment that Johns decided his etchings would not overlap any of Beckett's texts). Lift-ground gives way to the soft washes of open-bite which in turn are partially removed by the burnisher (iv/vi, plate no. 30). Even that stage did not reflect the final choices; the flagstones as they appear in the published edition had received further burnishing and then were selectively scumbled with additional applications of open-bite aquatint.

Flagstones and Flagstones divides *Fizzle 4*. Although Johns conceived and worked on this plate so that the left and right halves corresponded to panels B and C of *Untitled*, 1972, it appeared in the book upside down.[20] What was originally the left half, corresponding to the oil of panel B, was begun in lift-ground, equal attention being afforded the interstices and the flagstones. What was originally the right half, corresponding to the encaustic of panel C, was handled differently; the interstices were gone over with etching and the stones themselves were drawn in open-bite. Gradually Johns covered the soft washes of the righthand flagstones with dense parallel striations of etching, emulating in their rhythms something of the basic directional thrusts of the hatchings. A state of imbalance had been reached which the artist rectified in the fifth trial proof by applying dark, fluid, open-bite washes over the left half, further emphasizing the contrasts between the two flagstone panels. In no sense do these two halves "reproduce" the original panels; but they do suggest, however, the layered qualities of their surfaces, their subtle differences in material, and their intimations of covered passages of a different character.

The last of the double etchings, *Flagstones and Casts*, separates the French and English texts of *Fizzle 5*. Very much as had *Casts and Hatchings* in *Fizzle 2*, it was begun with a purely etched, linear design. Gradually a precise, Picasso-like,

wiry line spreads out from the casts over the slightly aqua-tinted flagstones in the third trial proof (iii/v, plate no. 61). The casts themselves are evoked by a most controlled, classical etching style, reminiscent of Rembrandt's mature etchings from the early 1650s and Picasso's from the mid-1930s. Yet suddenly, in the fourth trial proof, Johns turns his back on the open transparency of these marvelously ordered etched lines, staining much of the surface with several dark, lift-ground washes in order to keep pace with the gradually deepening tonalities of the flagstones on the left (iv/v, plate no. 62). Johns himself has admitted that some of his interim states pos-sessed greater beauty than the final work, but in each case, the individual plate had to reflect the direction taken by the book as a whole. As the most complex printmaking project Johns had undertaken (before or since), it demanded constant revi-sion of many of the plates. The kind of linear logic one would normally attribute to the trial proofs cannot be wholly justified.

Single-Page Etchings of Panels ABCD

The second cycle to make its way through *Foirades/Fizzles* consists of single-page etchings after the panels of *Untitled*, 1972. These begin in the midst of the longest text, *Fizzle 2*, with panel A, *Hatching.*[21] As is often the case, the first trial proof reveals a neutral approach to the space of the image: the outermost hatchings are composed from one con-tinuous, etched line, delaying any perception of a figure/ground relationship until the interior of the image (i/iv, plate no. 15). The development of the plate proceeds in the opposite direction: the outer hatchings are progressively strengthened with aquatint (the acid being applied by cotton swab to achieve subtle tonal variations), while in the third and fourth trial proofs some of the inner interstices are burnished to impart a ghostly apparition to the center of the field (iv/iv, plate no. 16). Once more there was a fairly radical revision taken between the last trial proof and the final editioning—a reinforcing of all the passages surrounding the hatchings with an additional layer of coarse, dark aquatint. The result is not only a stronger image that conforms to the tonality of the other plates, but a sharpening of the contrasts between the negative reserved shapes of these hatchings, the mixture of negative white (stop-out) and positive black (lift-ground) hatchings of the preceding etching, *Casts and Hatching*, and the largely positive blacks and grays of the following hatching, *Hatching and Flagstones* (plates 28-31).

Hatching was followed in *Fizzle 2* by two single plates of the flagstones. *Flagstones (a)*, corresponding to panel B of *Untitled*, 1972, commenced as if spun from a web of pure, etched lines. The third trial proof fills in with aquatint washes

the pencilled notations of the previous proof (iii/vii, plate no. 18). Step by step, in a workmanlike manner, Johns strengthened the stones and their surrounds, subtly distinguishing between right and left halves, until in the fifth trial proof (v/vii, plate no. 20), the burnisher is used to lighten and soften parts of the right side. Correspondingly, in the sixth trial proof (vi/vii, plate no. 21), Johns equalizes the tones of the left side. But in the next phase (vii/vii, plate no. 22), the plate is radically transformed by the imposition of an irregular, opaque, black aquatint which totally obscures the majority of the fine etching as well as the division between the two halves. Rough-hewn and nearly impenetrable, the image now takes on a totally new character, one shared only by *Numeral 4*.[22] In the final version, the plate has been cut down slightly to eliminate the continuous line that too sharply delimited the righthand edge.

Flagstones (b) also suffered radical changes toward the end of its evolution. Its right half, repeating the left half of *Flagstones (a)*, was similarly initiated in pure etching. Rough lift-ground aquatint followed, articulating the overall flagstone motif in a manner that very much resembled the large, painterly strokes embedded in the layers of the lithographs, *Four Panels from Untitled, 1972*, 1973-74 (fig. 2), and the panels of *Untitled, 1972*.[23] While leaving the right half of *Flagstones (b)* unchanged, the third trial proof (iii/vi, plate no. 24) manifests considerable burnishing to the left. Following further additions in a fine, gray aquatint, the fourth and fifth trial proofs plan out further revisions in ink and wash (iv/vi, plate no. 25). As a result, coarse-grained aquatint is laid over the right half in order to sharpen and differentiate stones and interstices, while the mysterious "IIIX" markings are etched into the left portion. Once again a major transformation occurred between the final trial proof and the edition (vi/vi, plate no. 26). Most of the lefthand flagstones were abraded or burnished down to smooth copper, surrounded with stop-out, and then bitten with acid around their edges.[24] What was once subtle is now plain and bold; and what were widespread traces of past work —the burnishing and aquatint washes which had informed the flagstones—may now only be glimpsed in the interstices between them.

Fizzles 4 and *5* each contain a full-page etching of casts. *Casts,* which begins *Fizzle 4,* is the most diagrammatic, consisting of pure etched outline, grainy aquatint, and a last application of fine aquatint washes for subtle shadings. Each step has been executed so that the preceding remains slightly visible. Following the double spread (*Flagstones and Flagstones*) that marks the middle of *Fizzle 4* are equally conceptualized views of the individual casts, arranged in columnar form as were the *Words (Buttock Knee Sock...)* of *Fizzle 1.* Originally the plate for *Buttocks-Knee-HandFootSockFloorFace-Torso* included the small etchings, *Leg (d)* and *Feet (a),* rounding out the cycle of casts.[25] While Johns initially had no intention of utilizing this plate, it suddenly seemed to fit into

the scheme of the book. It provided yet another conceptualization which, as we will suggest further on, seemed appropriate to the text, as well as another occasion to reiterate the sequence of the casts.

The third single plate of casts appears in *Fizzle 5.* Begun as isolated, reserved shapes on a dark ground, *Casts (Words)* is soft and diffuse where its predecessor, *Casts*, was linear and precise. To achieve such indistinctness of contour, acid was applied through a cotton cloth out of which the shapes of the individual casts had been cut; the resulting image was one of negative shapes—ghosts of the casts hollowed out from the palpable textures of the aquatint. Need the viewer be reminded of how intimately associated with the processes of printing and casting are the notions of positive and negative? Could the "psychologically loaded" casts be seen as their opposite—as vacant shapes with only words and memories to lend them meaning? Not unexpectedly, this plate, too, underwent radical alterations, almost obliterating the subtleties of the artist's first acts. The second trial proof, records the addition of well-defined, hard-edged slats (ii/v, plate no. 57). In the next workings, broad applications of lift-ground and stop-out create large complexes of busily applied brushstrokes, forcing the reserved shapes of the casts into a new relief, apparently above the surface of the panel. Johns obtained these unusual light brushstrokes by drawing in sugar solution and covering the plate with varnish as if preceding with a normal lift-ground aquatint. In this instance (and also in the etching *HandFootSockFloor*), however, no layer of aquatint was laid down before the acid bath. Thus the drawn brushstrokes were effectively burnished smooth by the corrosive action of the acid, and in printing registered as white marks. Except for minor touches the final stage was reached by the fourth trial proof, which records the addition of etched words and scribbles, both of which function to unify and suppress the plasticity of the broadly drawn passages now clearly "behind" the casts (iv/v, plate no. 58). In place of the ghostly casts, Johns has substituted more palpable shapes and names. Yet such a metamorphosis is not new for Johns. It has much in common with the maps of the early sixties, which also called upon our haptic associations between shape and name. Such subtle memories of primitive, childhood learning have persisted as an important ingredient of Johns's working methods, especially in those kinds of gestures which repeat past physical actions or recapitulate effects taken in other media.

Single Etchings of Individual Casts

The last cycle of images, single etchings of individual casts, forms a more obvious bridge with Beckett's texts, especially with the writer's obsession with defining and locating the self. Just as the original casts of the painting *Untitled,*

1972 seemed to raise problems of identity (could a person or persons be reconstructed?), so the etched images of the casts pose questions about equivalence. While it is a given that Johns's prints do not reproduce, but embody different, often more abstract ways of referring to the same motifs, never has he integrated so many changes into a cycle of such complexity.[26] In sum, Johns's obsession with fragmentation, permutation, and transformation, so central to all the works arising from *Untitled*, 1972, is concentrated in his handling of the images of the casts.

Quite intentionally Johns opens *Foirades/Fizzles* with an image of his own face. While the form of the original cast served as a model for the etching, *Face*, the cast itself had not been molded from the artist's features and consequently, was unsuited to be reproduced as a surrogate for the artist. The actual image on the copper plate resulted from an imprint of Johns's face, much as he had done years earlier in the four *Skin* drawings of 1962 (Collection the artist) and the lithograph *Skin with O'Hara Poem*, 1963 (fig. 32). For the copper plate in *Foirades/Fizzles*, Johns moistened his face with sugar-lift solution and applied himself directly to the plate. This action was repeated at least once if not twice more, imbedding his features into the original and intervening washes of lift-ground aquatint. While it is clear that Johns did not contemplate overlapping his own features with the text, he did plan to extend part of the image, the slat that held the cast, through the text.[27] This was printed from a second plate.[28] After the fourth trial proof, the first plate was cut down, the second was discarded, and the work concentrated on adjusting the relationship between the face and its background. It was a troublesome task, one which in the eighth, ninth, and tenth trial proofs risked loss of definition (ix/xii, plate no. 5). Several remedies were applied: first a burnishing of the background so rigorous that some of the very first aquatint washes reemerge in the eleventh trial proof; second an emphatic insertion of the deep, black "X" over the artist's cheek (planned as early as the fourth trial proof); and third, the addition of the rouletted (?) scrape marks in the upper left. In the end, Johns decided to remove all direct references to the cast face and to emphasize his own rather coarsely grained features.

But what is the significance of the added marks in the upper left and the "X" in the lower center? The casually trailing marks echo the countless drips in wax, oil, and encaustic found in the original panels of *Untitled*, 1972.[29] If these marks are indeed analogues for such passages (and Johns loves to repeat gestures, actions, and processes, as I observed above), their meaning should not be made too specific. In their material form they may suggest pathos, decomposition, change, malleability, and loss of form. The "X," on the other hand, clearly reinforces the negative feeling of the half-obscured face. But what kinds of denial? One is reminded

of its occurrence in the lithograph *Hinged Canvas* from *Fragments–According to What*, 1971 (fig. 28). Johns explained that he had intended the "X" (under his signature) to question the authorship of his image of Duchamp's self-portrait. A similar "X" also appeared in the disturbing screenprint of 1973, *Untitled (Skull)*, where it again crosses out the artist's signature as if to say, 'this is not me.' Clearly that is the most logical meaning for it in *Foirades/Fizzles; Face* is neither the cast from *Untitled*, 1972 nor a picture of the artist; it is simply an imprint of his features. But the act of denial also refers to the face itself, to the fact that it lacks that essential of artistic creation, the eyes. In this sense, *Face* relates to that other self-portrait, the frozen paintbrushes of the Savarin can, *Painted Bronze* of 1960 (Collection the artist), which ironically stilled the very instruments (at least metaphorically) that had created the beguiling illusions of the painted sculpture in the first place. A similar mix of positive and negative implications shows up again, twenty-two years later, in the *Savarin* monotypes of 1982. Those accompanied by a skeletal arm (as in Edvard Munch's *Self-Portrait* lithograph of 1895) cannot help but be read as particularly pessimistic.[30] In the final analysis, *Face* takes on some of these dire overtones of artistic death, a fitting way to begin a book with Samuel Beckett. After all, was it not Beckett who had written: to be an artist is to fail?[31]

Fizzle 2 seems overpopulated with etchings after the cast leg. *Leg (a)* is most closely allied to that of the panel, but the field is disturbed by dozens of hair-like marks which in the first trial proof were armed with conspicuous drypoint heads (most of which were almost immediately burnished away). Almost in their stead, Johns began to penetrate the plate with a deeply etched and aquatinted spot, which he enlarged from proof to proof as if insisting upon its organic quality. Even as one who insists on a relatively literalist reading, I cannot avoid the suggestion of sperm and ovum as well as the association between them and the impact-drip motif which appears several times in *Foirades/Fizzles* and very frequently throughout Johns's work.[32] Does Beckett's text suggest such a quest for union? That possibility, however, is cancelled by the next image, *Leg (b)*. Now the leg twists to a vertical orientation and is surrounded by a matter-of-fact, evenly brushed, aquatint tone. Still more diagrammatic is *Leg (c)*, an image stripped of organic suggestiveness. The fourth etching *Leg (d)*, is the fragment detached from *Buttocks-Knees-HandFootSockFloor-Face-Torso*. Its horizontal orientation suits its placement above a block of text beginning with the sentence, "Closed place." One's reading oscillates between that of the cast leg we know to be mounted to a wooden slat and that of a leg pinioned between two enclosing walls. It is as if this reading were meant to coincide with that of the whole chapter: fragile, delicate structures progressing towards the dark, impassable etchings of flagstone walls.

The cast of the torso provides a beginning and end to *Fizzle 3*. *Torse* is by far the most illusionistic image in the book; it literally reproduces the wax cast. From a photograph, Johns ordered a photoscreen stencil, whose image he then transferred to the copper plate by squeegeeing sugar-lift solution through the mesh of the screen. The plate was then etched in a normal fashion, although a slippage during the transfer imparted a very distinctive texture to the image. The first trial proof (i/ii, plate no. 27) shows the photoetched plate with hand-applied gouache additions. Note how Johns took pains to carry over a suggestion of the wooden slat in the washes of the background. In the second trial proof Johns has added the word "TORSE" in a typically simple but exquisitely sensuous manner: by first painting in the sugar solution for the body of the letters and then brushing it in for the surrounding ground. The white of the paper gleams through the gray washes as if these unetched seams were the drawn passages. It is part of Johns's incredible control of the means of art that he can project such particularized nuances over an entire image. For instance, the torso, too, hovers somewhere within the aquatint wash, while a typical Johnsian impact-drip, black and crisply defined, appears to establish a transparent plane lying just over the entire image. This illusionistic strategy finds its opposite in the image, *Torso*, which has omitted the photographic image altogether. One might pun that something had been lost in the translation. Yet in spite of the fact that Johns is relying on our memory of *Torse* to inform this space with the missing image, much as he had invoked the transfer of imagery in the original panels of *Untitled*, 1972, it remains that *Torso* functions as an evocation of absence, lost, and denial in a fashion quite unlike anything in *Untitled*.

But not all of John's energies have been spent on memory, translation, and condensation of time. *Fizzle 4*, for example, begins with a virtual caesura. *Numeral 4* is dark, monolithic, foreboding, and implacable. It reveals little of its past despite the numerous struggles that preceded its final form. The nine trial proofs and the final edition reveal at least three radical revisions. The first four proofs show deposits of heavy and medium grain aquatint which have been articulated by passages drawn with the stop-out crayon (i/ix and iii/ix, plate nos. 33 and 34). The result was a murky image lacking in depth. The fifth trial proof undertakes a major burnishing, working back down to the coarse aquatint of the second trial proof. In the sixth and seventh trial proofs (vi/ix, plate no. 36), the artist resumed his search for a substantial, architectonic numeral, by adding layers of aquatint striated with vertical burnishing (or stop-out crayon). And once again he comes down hard on the light image with a drastic dousing of the dark, impenetrable, reticulated aquatint we have already noted in *Flagstones (a)*. But this too was a dead end. The ninth trial proof (ix/ix, plate no. 38) manifests yet another radical

reduction of the surface through burnishing—almost back to the state of work represented in the first trial proof (i/ix, plate no. 33). One can only imagine the frustrations of these alternate forays of working and effacing. The final state of *Numeral 4* required a last application of fine, dark, lift-ground aquatint, one that obscured virtually all that had intervened. Thus, while the process preserved in the working proofs allows Johns and his viewers to recapture the past, the final image is opaque to the passage of time. The remainder of *Fizzle 4*, using the double spread of *Flagstones and Flagstones* as a fulcrum, compares the multiple images of the casts.

The most complex chapter is *Fizzle 5*. Even the *Numeral 5* with which it is announced has undergone complex alterations of technique and form. The first trial proofs reveal a slow, patient development of an open web of etching, gradually building up relief and sculptural substance through additions, first of etching and then of aquatint (i/xi-v/xi, plate nos. 43-46). The emphatic character of Johns's aquatint modelling in the sixth trial proof (vi/xi, plate no. 47) is reversed by the addition of flatter black and white passages in the next trial proof (vii/xi, plate no. 48). Characteristically, Johns then becomes more and more deeply committed to cover his tracks, reducing even further the sculptural character of the numeral, almost submerging its identity with an even application of aquatint in the ninth trial proof (ix/xi, plate no. 49). Like the penultimate states of *Numeral 4*, radical actions were undertaken in order to salvage the plate; the solution this time, however, was a thorough burnishing of the right two-thirds with sandpaper (ninth and tenth trial proofs), and a final addition of deep black, lift-ground strokes to restore relief to the bulging curve of *Numeral 5*. While *Numeral 4* denied its past, *Numeral 5* seems like a figure resurrected. It exudes its own history not only because the deepest of the original etched lines reappeared in the last states, but because it so clearly makes reference to the viewer's memories of the lithographic *Figure 5* from 1968-69 in its language of form and in its suspension in a field of changing values.

Fizzle 5 discards the near-symmetry of the other chapters where relatively equal numbers of images were distributed on either side of the central double etching. Now three etchings play against one. The first is *Feet (b)*, another full-page plate devoted to one of the casts of panel D from *Untitled*, 1972. As he had with *Torse*, Johns began with a photograph masked with gouache. This time, however, he ordered a commercially photoengraved copper plate which was printed without further embellishment as the first trial proof (i/ix, plate no. 52). The regular dot structure produces an illusion different from that obtained with the screenprint-to-copper technique of *Torse*. Little by little the artist adds aquatint, makes his plans in watercolor and gouache, and proceeds in a very orderly fashion. Etching is used for subtle emphasis and

as a graphic screen in the third, fourth, and fifth trial proofs (iv/ix, plate no. 54). The plate is cut down to the image in the eighth trial proof, but still the work continues with small adjustments to tone, gradually isolating the feet and two neighboring slats.

There follows the etching *Casts (Words)*, the broad portrayal of the entire panel of casts as negative shapes with words added, which we have already discussed. Immediately thereafter is the simple and strangely handsome *Buttocks and Knee*. It is almost a pure abstraction, so little does it attempt to describe or invoke the actual casts (this corresponds to the viewer's own perceptions which are, by necessity, less informed about the casts at the very top of the six-foot panel of *Untitled*, 1972). Mysterious, too, was Johns's initial version of the two casts in pure, etched outline (much like *Casts*), a jarring contrast to the bold, black aquatint shapes which, according to the artist, denote points where the cast had been fixed to the slat and also echo the impact-drips found in *Torse* and *Torso*.

Across the boundary provided by the double etching *Flagstones and Casts*, the reader comes to the last etching, *HandFootSockFloor*. Johns has returned to his beginnings in more than one way. He has come full circle in his tour of the seven casts of panel D of *Untitled*, 1972: Face, Leg, Torso, Feet, Buttocks, Knee, and last, HandFootSockFloor.[33] And as was the case with *Face*, the cast is not replicated but evoked as its parts are replaced by actual imprints of Johns's hand, foot, and sock; the floor is drawn in but its presence gave Johns pause throughout the eighteen stages of this etching.

Because the first trial proofs of *HandFootSockFloor* were etched onto a large plate, they would appear to have been another remnant of Johns's initial idea of overlapping image and text, and thus an early plate, one that would involve uncertainty and experimentation. In the first trial proof (i/xvii, plate no. 63), Johns has already etched the sugar-lift imprint of the sock, the palm of his hand, and the sole of his foot; with pencil and ink he now studies the problem of the floor (which Johns decided to draw rather than transfer).[34] But the next step was to be a second imprinting, more deeply etched than the first, of the artist's hand, foot, and sock. In the third trial proof (iii/xvii, plate no. 64), a coarse, spattered aquatint isolates the floor sections, which are then filled with dark sugar-lift aquatint in the next two proofs (iv/xvii, plate no. 65). Again Johns finds himself in a figure/ground cul-de-sac. The sixth trial proof shows an image so loaded with aquatint that the image is obscured. And once more Johns reveals how he forced himself to retreat from or surmount the barriers he seems constantly to erect for himself. Subsequent proofs manifest a progressive lightening of the right half of the image through direct applications of acid (through lift-ground as described under *Casts* [*Words*]). But so much had been removed by the

eighth trial proof (viii/xvii, plate no. 67) that the artist decided to add a third imprint of his hand and foot, deftly increasing the graphic, sculptural, and temporal complexities of the image. At this point, however, the image was neither cast nor imprint—the relationships of its components were much too unresolved. A new tack is required, and Johns decides to move away from simulating the cast, burnishing down and then substituting obviously drawn textures for those of the floor and eliminating all vestiges of the slat (the broad, white diagonal form that slants down from the middle of the top edge). Little by little rough strokes give way to more unified tonal areas. Still the corners continued to plague Johns; his efforts in trial proofs xi through xiii (plate no. 70) produce relatively disorganized effects, though certain firm decisions about outlining the forms of the sock, foot, and hand have been taken. In the fourteenth trial proof, the floor boards return, and in the fifteenth trial proof, the identity of the cast *HandFootSock-Floor* separates itself from the background even while the plate is cut down to the main image. But such a reemergence of the cast was short lived. Distinctions between the floor and the background are lessened in the sixteenth trial proof (xvi/xvii, plate no. 71) and by the next proof Johns has not only merged the two, but has vastly more generalized the identity of the floorboards themselves. The plate is then cut down again on three sides, focusing even more exclusively on the image and critically deleting the boundary between sock, floor, and background. At last, in the editioned plate, a final sense of closure is imposed upon the corners, each being darkened or blended so as to fully articulate the ambiguous nature of what is being represented. In the development of this plate is buried a synopsis of the unending possibilities of how identical things are different.

Etchings and Words: Johns and Beckett

My experience of life is that it's very fragmented. In one place, certain kinds of things occur, and in another place, a different kind of thing occurs. I would like my work to have some vivid indication of those differences. I guess, in painting, it would amount to different kinds of space being represented in it. But when I look at what I've done, I find it too easy to see the connections between one thing and another thing. It may just be that I know how I come to make a work: I know how hard it is to discard ideas or involvements that you already have, to come up with a different approach.[35]

As has Roberta Bernstein before me, I would like to suggest that at least some of Johns's etchings were deliberately chosen to accompany Beckett's texts. But just as important and perhaps more astounding, was the fact that the order

of the etchings was mostly predetermined without reference to the texts. That is, while Johns managed to relate many of the body parts with some aspects of Beckett's words, he also maintained the sequence of panels and casts dictated by *Untitled, 1972*, and reiterated, in part, by the double etching *Words (Buttock Knee Sock...)*. The eyeless, I-less, *Face* of *Fizzle 1* which avoids "being me" as Johns might put it, shuns statement about the self. The cancelling "X" only reinforces that denial of self, much as Beckett's first sentences do. *Fizzle 1* is about the death or alienation of the self. Its overtones of relentless repetitions share something with Johns's own endless repetitions, recyclings, and circularities, very much like those shown in the four versions of *Four Panels* in *Fizzle 1*.

Fizzle 2 contains the longest text and the greatest number of etchings; it is also the most unrelentingly pessimistic. The repeated legs and blank walls of the etchings of *Fizzle 2* clearly reflect the perpetual journey, the affectless, detached touching of one's body, and the abrupt dead ends and recommencements of Beckett's prose. Not only is the unrelieved opaqueness of the two *Flagstones* etchings suggestive of impenetrable barriers, but the narratives of their making revealed similar dead ends and redirections that are uncannily appropriate to the moods and acts of Beckett's narration.[36]

More difficult to "pair" with Johns's images is the content of *Fizzle 3*, which is inspired by the life cycle of the cockchafer. Lying in darkness, dormant in the earth for years, it matures, metamorphoses, feeds, mates, and dies in a matter of days.[37] Beckett's poignant images of watching through a window, of mating in death—"to love at your last"—of remembering not just the agonies but the loves of the past—loves that are now part of a distant other, a no longer retrievable self—find some echoes in Johns's etchings of the torso. Although the first appears to be fleshed, it is in fact only a reproduction of a waxen impression of some other person; and the second torso is but a ghostly form whose identity relies solely on memory.

The fourth Fizzle speaks of an arena and a ditch—dark, silent, closed, yet limitless. Nothing can be said about the arena outside of its vastness; those who inhabit it know nothing of each other. And what can be said of the ditch (bed or grave) is that it is just wide enough for one body. Rather than single out any body part, Johns set the two most schematic etchings of the casts on either side of the dark and opaque *Flagstones and Flagstones*. The first is composed only of negative shapes; there exists nothing but the suggestions of memory and the wordless correspondence between the casts and the flagstones. The second etching, the summary, labeled sketches, so reduces the casts to smudges of aquatint sandwiched between clunky shapes (actually negative images of the wooden slats) that they too reinforce the sensory bareness

of Beckett's passage. Even the *Numeral 4* speaks, through the trial and error of its making, of a supreme indifference to individuation, like the millions "never seeing never hearing one another. Never touching. No more is known…Adamantine blackness.…"

As *Numeral 4* evoked a mood of impassivity and stasis, *Numeral 5* records both past change and new movement in the very substance of its form. Throughout the fifth Fizzle, Beckett's words and Johns's images flicker between light and dark, between individuation and non-recognition. The empty but labeled casts oppose those which are veiled in an obscuring darkness. Even these once knew a brighter moment (in the third trial proof) which still seems to linger in the seepage of white paper that surrounds each shape. But the hoped-for glimpse of reality and life flickers and is snuffed out in this chapter, very much as illusionism is evoked and denied by the cast etchings which frame it. The brightly lit, photographically illusionistic *Feet* seems so much more a part of the world than the multiply imprinted, shadowed impressions of the very last image, *HandFootSockFloor*. There is a note of resignation in this act of touching the floor.

Technique as Meaning

The mind can work in such a way that the image and technique come as one thought, or possibly one might say there is no thought. One works without thinking how to work.[38]

Writing about *Foirades/Fizzles* plunges one into the difficulties of beginnings and endings. As was the case with the four panels of *Untitled*, 1972, a sense of linear sequence is both suggested and denied. At any point in the book one enters a continuum: things sound and feel alike. With respect to the etchings, one explores the panels as a quartet, in pairs, singly, in detail (the casts). The premise of the sometimes tedious descriptions of each etching and its trial proofs is that the same kind of thinking that informs the imagery may be observed in its making. As Beckett's fragmented and repetitive texts often invoke a continuously varying sameness of time and space, so Johns's etchings comprise a similarly spun web of interconnectivity. Johns not only demonstrates the infinitude of possibilities of his world, but denies any possibility of closure, of completion, or of wholeness. In this universe the artist becomes a modern Sisyphus whose unending task is to propose and then dispose of artistic propositions.

Some of the language I have used to describe Johns's work on the trial proofs has bordered on a romanticized individualism. Insofar as I may have portrayed him as "struggling," "intending," or even radically renouncing a failed

solution, I was in error. Rather, as his own sketchbook notes have indicated, Johns uses the logic and pressure of language (visual as well as verbal) to set his goals, to create new situations, and then to lay the foundation to doubt, alter, or negate the very ideas he has initiated. For Johns, language as much as the self is responsible for change:

> There seems to be sort of a 'pressure area' 'underneath' language which operates in such a way as to force the language to change. (I'm believing painting to be a language, or wishing language to be any sort of recognition.) If one takes delight in that kind of changing process one moves toward new recognitions, names, images.[39]

Johns not only claims that life is fragmented and inexorably changing, but his manner of working convinces him of it.

The analysis of the trial proofs demonstrated this same denial of intentionality, that is, of an orderly evolution of each etching…and this for two very different reasons. First, time and again the work itself seems to have carried the artist to positions of obscurity and loss, situations that demanded radical tactics and new beginnings. The very life, therefore, of each plate embodied in microcosm the unending, cyclical character of the entirety of *Foirades/Fizzles.* And second, the very act of enumerating the sequences of the trial proofs, while illuminating some aspects of Johns's thinking, has violated others. Aside from the likelihood that the large plates and perhaps the small sketches were undertaken earlier than the remainder, there is no record of the order in which the etchings were executed. It is abundantly clear from the many abrupt revisions that a number of the plates were laid aside only to be reworked when the exigencies of the developing book forced the artist to reconsider work already done. Thus the trial proofs are not true witnesses to a continuously evolving project but themselves only fragments and chance survivors of a complex process.[40]

Conventional description of the "states" in the history of printmaking—that of Rembrandt's and Degas's etchings, for example—inevitably calls on a model of linear development (which does have its uses). But Johns gives us signs, even dire warnings, that such a presentation of his work is liable to the same illusions about the continuity and teleological nature of life so vehemently denied by the whole of *Foirades/Fizzles.* In no way am I denying the unbelievable sense of variety and mastery and sensuous beauty in Johns's etchings, but I am cautioning about regarding them as bearers of messages about the purposes of life. What was crucial for Johns was that each plate mediated two clusters of interconnected cycles, those of the thematic materials (the images of Johns's *Untitled,* 1972 and Beckett's *Foirades/Fizzles)* and those of each plate's individual history. More specifically, it

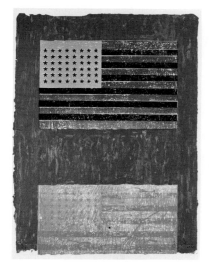

Fig. 8
FLAGS, 1967-68
Published by U.L.A.E.
Lithograph
34 x 25⅞ inches

118

was the ability of etching to remember (or delete) these fragmented moments of process and change that so intrigued Johns:

> It seems that etching can accept more kinds of marks than other print media can. In lithography one applies grease to the stone or plate, a greasy liquid or crayon; the result is a kind of wash effect or a crayon effect. That's about it. Complicated tone and color and complexities relating to one's sense of time have to be achieved by using more than one stone or plate. In etching, the devices for attacking the plate are more elaborate. With aquatint, for instance, the variety in the sizes of particles that are available is great and can result in a great variety of tones. And for me, the most interesting thing about etching is the ability of the copper plate to store multiple layers of information. One can work in one way on a plate, later work in another way, and the print can show these different times in one moment. This is not the nature of lithography which can't accept that kind of work. So, in a sense, etching may seem to be more complex and subtle.[41]

It is not far-fetched, then, to regard the etchings of *Foirades/Fizzles* as nothing less than analogues for the human condition: the torture borne of our perceptions of time through memory. For Johns and for Beckett life consists of fragmented images, glimpsed during one's passage through the world, sometimes remembered, but never fixed. Inevitably one asks whether such imprecision, such inextricable randomness within a fixed cycle of order, matters. Is there only movement toward beginnings? The answer, of course, is that there is nothing else other than this imprecise search for the self.

For all its repetitions and variations, Johns's art strives endlessly for individuation. Every image is carefully differentiated from the next, while reminding us of it. Everything is adroitly seductive, literally sensuous as are the illusions of those still life paintings, which beckon our interest if only to trap us in their covert warnings about the transitoriness and illusory nature of life. For Johns, no narrative, no story, no biography, no moralizing lies between these extremes; meanings are created from how his art is made rather than from what it signifies. This is most characteristic of Johns's prints, as has been the case since the first flag lithographs of 1960.[42] In three successive works Johns retained the same stone, changing the image only by increasing its complexity, while making major alterations to both the printing inks and the types of paper. The radically different results were effected far more by process than by any expressive measures taken by the artist.[43]

In this exhibition we have included four other flags (figs. 8-11). Not only do they mark the continuing significance of Johns's seminal equation of subject (the representation of

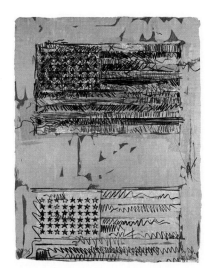

Fig. 9
FLAGS II, 1967-70
Published by U.L.A.E.
Lithograph
34 x 25 inches

the flag) and object (the surface of the painting), but they continue Johns's endless quest for change. Moreover, they clearly maintain the artist's exploitation of process and technique in the service of meaning. The color lithograph *Flags*, 1967-68 (fig. 8) was executed from one plate and five stones, two of which had already been used for the background of the lithograph, *Targets* of the same year. Not only were the green, grays, and orange of the upper flag intended to be transferred (by the spectator) to the purely gray image below—appearing red, white, and blue—but these same (green, gray, and orange) stones were themselves transferred to the second lithograph, *Flags II* of 1967-70 (fig. 9).[44] There they were over-printed with further flag imagery in red, white, blue, and black and submerged in broad strokes of light gray from an additional plate. The result, of course, was an image of radically altered function: the contrasts of complementary images now took place simultaneously in depth rather than over a span of time in the viewer's mind. The subtle and illusive images of the earlier *Flags* had been transformed into something dense and palpable.

If the description of such processes—which were carried even further [45]—appears to portray the artist as master gamesman (*pace* Wittgenstein), the astonishingly different character of each work is sufficient to vouch for the seriousness of Johns's intentions. The very same strategies of comparison, detection, and change inform the etchings of *Foirades/Fizzles*, with the difference that in etching Johns was able to greatly enhance the complexities and hidden histories of each plate.

The third flag print included in this exhibition beautifully illustrates just such hidden tactics. *Flags I* of 1973 (fig. 10) is a densely layered, painterly screenprint whose evolution all but obliterated its origins.[46] The initial twelve (of thirty-one) stencils were not red, white, and blue, but various shades of green, gray, and orange; the first six printed as absolutely flat pattern while the second six laid down a new layer of emphatically brushy marks. Almost all of this work was gradually covered by the succeeding deposits of opaque red, white, and blue inks. Even the attentive viewer hardly suspects the complementary world beneath—or, for that matter, the subtle differences in saturation density, depth, and lustre that distinguish the two halves. If Johns has carefully shielded himself and his feelings from public scrutiny, no better analogue could be found than in the energies he so frequently invests to conceal entire levels of work, as in the present screenprints (figs. 10 and 11) and the nearly contemporary etchings for *Foirades/Fizzles*.

There are other images by Johns, such as those which make reference to Hart Crane's poetry (and are discussed in James Cuno's essay), which do appear as desperate efforts to effect a release of the artist's personal feelings and

autobiographical associations. But whether they actually lend themselves to symbolic interpretation is debatable. In the light of the present essay, however, it is clear that the imagery of *Foirades/Fizzles* cannot be so handled. Whatever elements of despair, negation, and pessimism the etchings evoke, are not expressed by the image but through its making, in very much the same fashion that one does not see a representation of a flag, but a painting or print that is made as a flag. One might add that the pessimism is itself denied by the richness of invention and growth recorded in these etchings. In any case, I could never agree to the presence of a programmatic, personal symbolism, known only to the artist and his initiates, as Charles Harrison and Fred Orton have recently claimed.[47]

In their article—and similarly in Fred Orton's contribution to the present catalogue—Harrison and Orton attempted to elucidate the various meanings of Johns's abstract paintings such as *Scent*, 1973-74 (fig. 35) and *The Dutch Wives*, 1975 (fig. 42). Aside from the multitude of associations with Picasso, Pollock, and Magritte (already detailed by earlier critics), they began by adopting a critical stance similar to my own. Essentially, they try to demonstrate that the "vivid surface" of Modernist painting acted, in Johns's work, as a foil for hidden "vivid subject matter." They go so far as to declare that "the genetic history of a single brushstroke goes back into a world of states and feelings."[48] Insightfully, Harrison and Orton also attempt to expose the strategies of concealment in Johns's account of the "discovery" of the hatching motif while driving on the Long Island Expressway. But what they read as a decoy, a false scent as it were, I have above regarded as a purposeful account that reveals a great deal about the roles of motion and memory in Johns's art and its inspiration. It is in their examination of particular motifs, however, such as the imprints of the paint cans, of Duchamp's *Female Fig Leaf*, or of the iron, and the frequently encountered "X" and silverware, that Harrison and Orton abandon their exemplary approach to Johns. While no one can deny the likelihood that these objects and their marks may have numerous and changing associations for the artist, these authors' suggestion that such marks represent a secret language known only to Johns's circle of friends seems like an act of desperation. Such a claim scuttles their most daring assertions about the content of Johns's seductive and nearly impenetrable surfaces. The approach of the present essay, on the other hand, departs but rarely from the steadfast conviction that for Johns meaning resides in the habits of mind that inform the physical processes of making the work of art.[49]

For me, therefore, one idea seems to dominate all others: the role of memory and its embodiment in the concrete, physical structures of the work. Accordingly, it is ever more significant to recall that in his first recorded statement

(1959) Johns alluded to this note from Marcel Duchamp's *Green Box:*

> *To lose the possibility of recognizing*
> *2 similar objects —*
> 2 colors, 2 laces
> 2 hats, 2 forms whatsoever
> to reach the Impossibility of
> *visual*
> sufficient memory,
> to transfer
> from one
> like object to another
> the *memory* imprint
> ————Same possibility
> with sounds; with brain facts[50]

What do these words imply? Do they describe conditions that are, in fact, identical? First, to lose the normal human habit of seeing things as related, of taking one thing for another, implies a state of total innocence in which every experience is completely individualized. The second is merely a specific case of the first: to reach a state devoid of visual memory sufficient to quite literally see one thing in terms of another. Are these indeed the artist's goals? To fashion every work and to perceive every phenomenon as unique? Would that not also be a complete and total denial of what is most essential to existence, the ability to recognize connections in the world, to take one thing for another (the condition of language)? In point of fact, however, it would seem that Duchamp's pairing of possibility and impossibility suggests both the idea and its opposite. And in Johns's *Untitled,* 1972 as well as in *Foirades/ Fizzles* do not both conditions prevail as an endless sameness and an endless differentiation, with no clear beginning and end? Do not these seeming opposites also inform the actual experiences encountered by the artist during the making of his etchings, a process which he has recorded both in the memories embedded in each plate as well as in the fragmented events embalmed in the trial proofs? If there is a central theme that embraces all of Johns's work it is this: that nothing is ever the same—even when we think it is; and that in some sense everything is similar—even when we believe it is not the case. There is no single fixed point of reference, no closure, only the continuous chains of mistaken identities that make memory and human existence conceivable.[51]

1. Roberta Bernstein, "Johns & Beckett: Foirades/Fizzles," *Print Collector's Newsletter* 7 (November-December 1976): 141-145. Bernstein documents what is known of the meetings and decisions taken by Johns and Beckett.

2. Information gleaned from the English edition of all eight Fizzles; Samuel Beckett, *Fizzles* (New York: Grove Press, 1976).

3. The above facts have been confirmed in recent conversations with Jasper Johns. In 1975, one of the three Fizzles not published in the Petersburg Press edition (i.e., *Fizzle 3*: "Afar a Bird," in the Grove Press edition, 23-30) was illustrated with five etchings by Avigor Arikha, and published as a *livre deluxe: Au loin un oiseau* (New York: The Double Elephant Press, 1973).

4. The most elaborate exegeses are those contained in Roni Feinstein's two articles: "New Thoughts for Jasper Johns' Sculpture," *Arts Magazine* 54 (April 1980): 139-145 and "Jasper Johns' *Untitled* (1972) and Marcel Duchamp's *Bride*," *Arts Magazine* 57 (September 1982): 86-93.

5. Despite the very convincing and sturdily researched work of Roberta Bernstein in *Jasper Johns' Paintings and Sculptures 1954-1974: "The Changing Focus of the Eye"* (Ann Arbor: UMI Research Press, 1985). While not as brilliant as writings on Johns by Leo Steinberg, Max Kozloff, or Rosalind Krauss, Bernstein's book is the most factual, sympathetic, and imaginatively researched study of Johns to date.

6. The appearance of *Untitled* at the Whitney Annual in 1973 provoked attention but virtually no critical response. With the exception of a brilliant article by Thomas Hess, "Polypolyptychality," *New York Magazine* 6 (February 19, 1973): 73, the art world had been left quite speechless. Further contributions were made by Michael Crichton in his monograph, *Jasper Johns* (New York: Harry N. Abrams, Inc. and the Whitney Museum of American Art, 1977).

7. The prints, *Four Panels from Untitled, 1972*, are called A/D, B/D, C/D,D/D. Thus I refer to the panels as, from left to right, A,B,C,D. My own exploration of the prints, published in 1978, goes further into the complexities of both painted and printed versions of *Untitled, 1972*; see *Jasper Johns: Prints 1970-1977* (Middletown, CT: Wesleyan University Press, 1978). See also the very important statements made by Johns in his interview with Roberta Olson, "Jasper Johns—Getting Rid of Ideas," *Soho Weekly News* 5 (November 3, 1977): 24-25.

8. Again first detected and elucidated by Thomas Hess, "On the Scent of Jasper Johns," *New York Magazine* 9 (February 9, 1976): 65-67; followed by important articles by Rosalind Krauss, "Jasper Johns: The Functions of Irony," *October* 2 (Summer 1976): 91-99; and Barbara Rose, "Jasper Johns: Pictures and Concepts," *Arts Magazine* 52 (November 1977): 148-153.

9. Crichton, *Jasper Johns*, 61, and Barbara Rose, "Jasper Johns: Pictures and Concepts."

10. Roberta Bernstein summarizes both the well-founded and fantasized opinions concerning the disposition of the casts; see Bernstein, *Jasper Johns' Paintings and Sculptures*, 135-37.

11. Evidence for consciously systematic thinking comes readily to mind. Johns provided an explanation of the colors he chose for a series of "stenciled" forms in the 1964 painting *According to What* (color plate I). See John Coplans, "Fragments According to Johns: An Interview with Jasper Johns," *Print Collector's Newsletter* 3 (May-June 1972): 29-32. A similar decoding for the tripartite color-bands of Johns's *Color Numerals*, 1968-69 was provided for Joseph Young, "Jasper Johns: An Appraisal," *Art International* 13 (September 1969): 50-56. In addition to the seven color versions of *Casts*, there are another seven black states of the same images. See Richard S. Field, *Jasper Johns: Prints 1970-1977*, nos. 177-190.

12. Field, *Jasper Johns: Prints 1970-1977*, nos. 175-176.

13. Richard S. Field, *Jasper Johns: Prints 1960-1970* (Philadelphia: Philadelphia Museum of Art, 1970), nos. 94-113.

14. The term lift-ground refers to a process by which the artist's own marks are directly translated into granular planes of aquatint. For *Words* Johns was given a polished copper plate. He loaded his brush with a solution of ink and sugar water and drew his letters right onto the grounded copper. The drawing completed, the plate was returned to the printer to be grounded with an even layer of rosin granules (of a predetermined coarseness). Next the plate was covered with an acid resistant varnish

and placed in water. Where Johns had applied even the slightest amount of the sugar solution the water was able to penetrate the varnish, lifting it off the copper. Just those areas drawn by the artist were exposed. Next the plate was placed in an acid bath, the mordant biting down into the copper only where the varnish had lifted off. But the bite was not unimpeded; the acid had to eat around the rosin granules of the aquatint ground. Thus Johns's letters were translated into textured planes, the pits of which would hold the ink that would be transferred to the pages of *Foirades/Fizzles* during the printing process.

15. This second trial proof is doubly instructive. First of all, it clearly shows that these records are trials and not systematic records of each step taken by the artist. (The latter, of course, is an impossibility. Nothing short of a realtime videotape could hope to capture all of an artist's procedures.) And second, I would remind the reader that they cannot all be called "states" since quite a number do not represent changes in the plate, but were pulled to provide the artist with a proof to make clear the present state of the work, and if needed, to plan future alterations. Burnishing may be accomplished in several ways. The classical method exploits the malleability of copper, the fact that marks lowered into its surface can be diminished or eliminated by rubbing with a smooth, polished object (the spoonlike burnisher). Another method uses commercial abrasives either in powder or stick form.

16. As has been often noted, the images of panels B and C "overlap" in the painting, *Untitled*, 1972 to form a square, a strategy that was adopted again in *Words (Buttock Knee Sock...)*, the etching just examined. See Crichton, *Jasper Johns*, 59. Also see the essays in the present catalogue by Richard Shiff and James Cuno.

17. This is the reason why the stories of how Johns came by the flagstone and hatching motifs are of such importance. It is not of great moment that they were found (we have been accustomed to that since the Targets and Flags), but that they were discovered while moving (on the Long Island Expressway and in Harlem) and that they had to be remembered, however imprecisely. It is also significant that other connections for the hatchings have been noted: for example, the ceilings in Johns's Houston Street studio, the bedspread in Edvard Munch's *Between the Clock and the Bed*, and Picasso's paintings of 1907; see Judith Goldman, *Jasper Johns: 17 Monotypes* (West Islip, NY: ULAE, 1982) and Rosalind Krauss, "Jasper Johns: The Functions of Irony," *October* 2 (Summer 1976): 91-99. It is this associative richness which begins to generate a pressure for usage in the artist's mind. In some ways they would seem to open avenues for interpretation. Yet I believe these associations provide auras of meaning rather than specific symbolic values; it is of greater value to discover how Johns uses a motif than to ask why.

18. This is the so-called open-bite or spit-bite method. Not only is it rarely employed, but it forces the artist to exercise total control over the entire process of etching — nothing but the laying on of the grounds can be left to the collaborating printer. This is precisely as Johns wished. The etchings for *Foirades/Fizzles* were drawn on the plates, and the artist controlled the application of acid as well. He did not, however, concern himself with the printing. In the present instance, the acid was applied through a cloth to ensure a soft, diffuse effect.

19. Hard-ground etching coats the copper plate with a dark, acid-resistant varnish which dries to a relatively hard surface; the artist must scrape through the ground to expose the copper underneath. Soft-ground, on the other hand, contains an extra, nondrying agent. The ground dries only to a tacky consistency. In use it is extremely pressure sensitive, picking up the surface characteristics of any material placed in contact with it. The artist does not expose the copper directly, but draws upon an interleaving sheet which picks up more or less of the soft-ground in proportion to the pressure applied. Not only is the texture of his drawing suffused and softened, but the sensitive soft-ground records the surface of the interleaving material.

20. Johns could not recall having made this decision, but did allow that he may have preferred the look of the inverted plate.

21. All of the trial proofs were signed in an inverted position; as it appears in the book, *Hatching* corresponds to the orientation and design of panel A of *Untitled*, 1972.

22. The very pronounced irregularities of this dense lift-ground aquatint were obtained by applying the sugar-lift solution to a deliberately oily plate.

23. The same underlying bold brushstrokes were delegated to the white plate of the four that were used to print *Flagstones (Endpaper-back)* of *Foirades/Fizzles*. These marks are particularly clear in the trial proofs which were printed in black.

24. The concern with edges repeats that of both flagstone panels of *Untitled*, 1972 (oil and encaustic, respectively).

25. In addition, the first trial proof (i/iv, plate no. 42) shows another small plate, not used in the book, a scribbled version of *Words (Buttock Knee Sock...)*. Johns remarked how hard it was for him to discard anything, once begun. There were, it seems, very few false starts in his work on *Foirades/Fizzles*.

26. As if to demonstrate that things remain the same, I should note that one of Johns's first printmaking projects was the rather complex series of numbers, *0-9* of 1960-63, which dealt very specifically with change. I have explained the logic of the three sets of ten prints in my *Jasper Johns: Prints 1960-1970*, nos. 17-46. To all of the materials cited so far must be added the twenty-nine trial proofs of panel D from the color lithographs, *Four Panels from Untitled, 1972*, 1973-74. Fifteen of these are discussed and reproduced in color in Christian Geelhaar, *Jasper Johns Working Proofs* (London: Petersburg Press, 1980), nos. 18.1-18.15.

27. Of course, we should remark upon the irony of this gesture, given the fact that *Face* only mimicked but did not repeat the actual cast found in *Untitled*, 1972. Further, the text visible in these early trial proofs was ultimately used for *Fizzle 2* (in the Grove Press version, however, it remained *Fizzle 1*).

28. Aside from the color endpapers, this is the only etching in *Foirades/Fizzles* to have involved more than a single plate. Johns even thinks he may have experimented with a third. In the printed edition, of course, only one plate was employed.

29. As my wife, Lesley Baier, has pointed out, they also remind one of the vertical striations of *Numeral 1* much the way *Numeral 3* finds an echo in the roundness of its successor, *Torse*, and *Numeral 4* bears a strong resemblance to the pattern of slats in *Casts* which also follows immediately.

30. See Judith Goldman, *Jasper Johns: 17 Monotypes*. The connection between Munch's *Self-Portrait* lithograph and Johns's *Skin with O'Hara Poem*, 1963 was something I had discussed with the artist as early as 1975 while preparing an exhibition, *Images of Death*, for Davison Art Center, Wesleyan University.

31. The passage from Beckett is from his three dialogues with Georges Duthuit, originally published in *transition* (December 1949). There Beckett describes art as "The expression that there is nothing to express, nothing with which to express, nothing from which to express, no power to express, no desire to express, together with the obligation to express." See Beckett, *Proust and Three Dialogues with Georges Duthuit* (London: Calder and Boyars Ltd., 1965), 103.

32. I have written elsewhere about the close connection between this motif and Marcel Duchamp's bachelor shots in the *Large Glass*. See my *Jasper Johns: Prints 1970-1977*, 16.

33. This cycle varies in only one instance from that set forth in *Words (Buttock Knee Sock...)*: Leg precedes rather than follows Torso.

34. Note that the actual cast was taken from the top of the hand and foot, not the imprints of their "lower" surfaces.

35. Jasper Johns, in Peter Fuller, "Jasper Johns Interviewed, Part 1," *Art Monthly* 18 (July-August 1978): 6.

36. For a detailed discussion of *Fizzle 2* and its relation to Johns's art, see Andrew Bush's essay in the present catalogue.

37. I cannot help wondering whether Johns's subsequent paintings, drawings, and prints of the *Cicada* do not bear some relationship to Beckett's portrayal, though the cockchafer does not molt and leave its form behind.

38. Jasper Johns, in Geelhaar, *Jasper Johns Working Proofs*, 38.

39. Jasper Johns, in Alan R. Solomon, *Jasper Johns* (New York: The Jewish Museum, 1964), 19.

40. It should also be noted here that there is only one set of these trial proofs. They were pulled for the artist's needs and were never intended as documentation of work in process, although they seem to play that role now, especially as the artist has so often and so kindly permitted them to be displayed.

41. Jasper Johns, in Geelhaar, *Jasper Johns Working Proofs*, 37-38.

42. Field, *Jasper Johns: Prints 1960-1970*, nos. 5-7.

43. See my long article on the flag imagery, "Jasper Johns' Flags," *Print Collector's Newsletter* 7 (July-August 1976): 69-77. For a further discussion of the flags, see Bernstein, *Jasper Johns' Paintings and Sculptures 1954-1974*, 1-21.

44. Field, *Jasper Johns: Prints 1970-1977*, no. 130.

45. Johns took the red, white, and blue plates from *Flags II*, 1967-70 and utilized them — together with two new wash stones all printed in grays — for an entirely new double image of the flag, *Two Flags (Gray)* of 1972 (Field, *Jasper Johns: Prints 1970-1977*, no. 164). The seemingly endless process continued even further when the two added wash stones were altered and used for *Two Flags (Black)*, 1970-72 (Field, *Jasper Johns: Prints 1970-1977*, no. 165). In fact, the stones were first printed for the upper of the two flags, then opened and changed before being printed for the lower flag image.

46. Field, *Jasper Johns: Prints 1970-1977*, no. 173.

47. Charles Harrison and Fred Orton, "Jasper Johns: 'Meaning What You See'," *Art History* 7 (March 1984): 76-101.

48. Harrison and Orton, "Jasper Johns: 'Meaning What You See'," 86.

49. The best single exposition of this view of Johns's focus on the material dialectics of art and art making is contained in Rolf-Dieter Herrmann, "Jasper Johns' Ambiguity: Exploring the Hermeneutical Implications," *Arts Magazine* 52 (November 1977): 124-129. I was very encouraged by Herrmann's point of view to persist in my own.

50. Dorothy C. Miller, *Sixteen Americans* (New York: Museum of Modern Art, 1959), 22. The actual note is taken from Marcel Duchamp, *The Bride Stripped Bare by Her Bachelors, Even*, a typographic version by Richard Hamilton of Marcel Duchamp's *Green Box*, translated by George H. Hamilton (New York: Wittenborn, 1960.)

51. See Suzi Gablik's article, "Jasper Johns's Pictures of the World," *Art in America* 66 (January-February 1978): 62-69. Writing only of the hatched paintings of the seventies, she concluded: "These relationships of similarity and dissimilarity, of double effects, duplication and division, criteria of identity, masks that conceal sameness and replications that show how the sustained repetition is impossible since there are always tiny variations, seem to me to be the basic recurrent theme of Johns's entire oeuvre."

The Expanding Eye:

The Allegory of Forgetting
in Johns and Beckett

Andrew Bush
Vassar College

l'allegorie

(en general)

est une application de

l'infra mince

–Marcel Duchamp

I begin by reciting familiar verses in the guise of allegory, call it the psychomachia of Plain Speech and Blind Folly, as in Kent's introductory apologia: "To plainness honor's bound/When majesty stoops to folly" (*King Lear*, I,i).

> To set the stage, I recall that Plainness would defend Folly from the self-inflicted wound of a rash act. Folly, however, being the more powerful, interrupts the invocation with an admonitory metaphor: "The bow is bent and drawn, make from the shaft." If the figurative language of the tropes are so many turns, Plain Speech may be expected to put the shaft of the sentence on a true course, rather than attempt a deflection, even in self-defense. Kent, therefore, responds to Lear, "Let it fall rather, though the fork invade/the region of my heart." Less expected is the echo of Lear's metaphor in the continuation of Kent's reply. The bow, bent and drawn, becomes the bending, or indeed stooping, of unctuous courtesy: "Think'st thou that duty shall have dread to speak/When power to flattery bows?" Thus Kent reiterates his position: Flattery transforms Power into Folly (by its tropes); Plain Speech, on the contrary, is

straight as an arrow, and is sure to guide the Sentence of Power to its mark. The condensation of this message into the paranomasia of "bow" made over into "bows," however, threatens to subvert Plain Speech. Kent is himself courting the language of madness.

This suspicion is confirmed in the exchange that follows:

> *Lear: Out of my sight!*
>
> *Kent: See better, Lear, and let me still remain*
> *The true blank of thine eye.*

The plain style is now Lear's. Thus it is Kent who comes between Lear's milder sentence and his lesser power when he plays, this time with intention, upon Lear's "Out of my sight!" tendentiously misunderstanding it as "out of his mind!" To see better is the central metaphor of the play for compassionate understanding—"I see feelingly," Gloucester will learn to say when the parallel plots converge at Dover under Edgar's guidance—and of course Kent has challenged Lear's power precisely because Lear's sentence upon Cordelia manifests his lack of such insight. But in claiming the role of physician to Lear's ailing eyes ("Kill thy physician, and thy fee bestow/Upon the foul disease," he declares), Kent prescribes a remedy that turns plain speech upon itself.

Fig. 12
*TARGET, 1958
Conte crayon on paper
15¼ x 14 ⅝ inches
Collection Mr. And Mrs. Andrew Saul*

The plain sense here is simply that Kent is to be Lear's target, or rather his bull's eye, thus extending the metaphor of bow and shaft in a further echo—and extended metaphor will be a first rhetorical clue that we are now in the province of allegory. But what is plain in this sense? If to see better is to see those most loyal, most loving, as targets, then in abusing Cordelia, Lear, ironically, sees well enough already. If, on the contrary, Kent's purpose is ultimately to hold a mirror up to Lear so that the King might see himself better—that is see himself in the faithful reflection of Kent—then Kent's therapeutic counsel, in effect, train your eye on me, *would teach Lear to see himself as the target of his own gaze. The wounding glance is self-wounding: at best Echo's impotent response to narcissism in the face of spurned love.*

But the metaphor turns further. The true blank is not only the bull's eye, it is the whites of the eyes. Hence, the true blank is both center and circumference, both before and within the eye. But more particularly, as the final medicinal and metaphorical application of "some flax and whites of eggs" to Gloucester's bleeding face when his eyes have been put out, the allegorical emblem for Plain Speech is blanker yet. The true blank is the eye that has already been a target, already been invaded by the fork, as it were; it is all circumference with no center. Plain Speech likewise purports itself to be featureless, that is without adornments, blank; but in fact it may be rather

Fig. 13
*TARGET, 1958
Oil and collage on canvas
36 x 36 inches
Collection the artist*

*the language of the tropes disfigured. Plainness guiding Folly:
the blind leading the blind.*

Inasmuch as allegory institutes a hierarchical order,
according to Angus Fletcher, the principal commentator on
the allegorical mode in contemporary literary scholarship,
allegories enact "symbolic power struggles."[1] That struggle,
in part, concerns the power of reading, an interpreter's will to
power over the figuration of the text. In echoing Lear's meta-
phor of the bow and shaft, Kent would put that figure at the
service of his own argument. Thus the extension of metaphor
may be a form of appropriation. Here the drama continues of
course, and Lear will reappropriate the metaphor by a literal
exercise of power: he banishes Kent, thereby sending him out
of sight by royal decree for having attempted, in the name of
plainness, "to come betwixt our sentence and our power."
These words, moreover, reinscribe the preceding confronta-
tion in the trajectory of Lear's own figurative language. Sen-
tence and power echo the shaft and bow, but they allude
explicitly to the first warning with which Lear attempted to
cut short Kent's intervention: "Come not between the Dragon
and his wrath." The power struggle, therefore, becomes a mat-
ter of one allegory pitted against another. Given the daemonic
nature of allegory, again as explicated by Fletcher, this com-
mits the antagonists to an endless process. Kent, for instance,
will transform his exile, first by a simple irony, "sith thus thou
wilt appear/Freedom lives hence and banishment is here," and
then, playing off the understanding of sight (appearance) that
he has already propounded, by becoming a "true blank," dis-
figuring himself behind the mask of Caius. In this sense, I
would suggest, allegory is itself interpretation, and the inter-
pretation of allegory calls for the reading of the process by
which the extension of figures becomes a transformation and
finally a disfiguration of them.[2]

The process that I am outlining, then, has two steps.
First, the allegorist (in our case, Jasper Johns) exploits the
figure that is his ground—I am deliberately paradoxical here;
I wish to assert that the allegorist does not invent his initial
metaphors, but rather perforce must find them. The second
step, now that of the reader of allegory (the beholder before
Johns's work), involves a recognition that the allegorist does
not escape the implications of his own critique. Allegory is the
narrative of that failure. Paul de Man, whom I follow here,
states the situation this way: "Deconstructions of figural texts
engender lucid narratives which produce, in their turn and as
it were within their own texture, a darkness more redoubtable
than the error they dispel."[3]

It will be my purpose in these pages to explore the
allegorical function of Jasper Johns's work, examining, in par-
ticular, the metaphors of the early target paintings with casts
of body parts, as they are extended in *Untitled*, 1972 (color

Fig. 14
TARGET WITH PLASTER CASTS,
1955
*Encaustic and collage on canvas with
 objects*
51 x 44 inches
Collection Mr. and Mrs. Leo Castelli

129

plate II) and the associated prints for *Foirades/Fizzles*. Beckett's texts for the latter will serve as a parallel allegory, which is to say that I will read the relation between Beckett and Johns in *Foirades/Fizzles* itself as an allegory, again a psychomania, for which my paradigm is the struggle between Kent and Lear. Hence, I will follow the progress of both Johns and Beckett in isolation and at the same time consider the allegorical relation between them on the pages of the book.

II

In a subtle meditation on painting and poetry, Mary Ann Caws designates a "liminal sensitivity" as the essential common bond of the sister arts: a perspective poised on the threshold between inside and outside, between insight and outlook.[4] No metaphor can mark and sustain this threshold. Thus Caws proposes the wounded eye as the crucial trope for the disfunction of the capacity for metaphor, which she traces back to Mallarmé. Here Caws charts the constellation of wound, mirror, threshold, and sign, which I would reconstruct as follows: the wounded eye is a sign of the threshold, but the wound is self-inflicted, the result of the eye meeting its own gaze. Crucial to my argument is the suggestion to be gleaned from Caws that the gaze of the self-regarding eye is an ironic double of the "self-forgetting glance" that she puts forth as an impossible ideal.[5] Any story of the wounding of the eye—and recalling Caws's point of departure in Mallarmé, the wounding is the necessary occasion for *succession*, for the forward progress of story-telling and story-reading, that is of narrativity—becomes, in short, an allegory of the impossibility of forgetting.[6] Johns's early target paintings, *Target with Four Faces*, 1955 (fig. 19) and *Target with Plaster Casts*, 1955 (fig. 14), already tell this story, I propose, and so already pronounce that allegory. The targets in all their many renderings are the true blank of the wounded eye.

The story or history that Caws tells at this point is more simply a genealogy that situates late French Symbolism as an immediate antecedent in a heritage that links Dada and Surrealism to the Baroque. Shifting from Mallarmé and the history of French letters to the trajectory of art history, one might look to Odilon Redon as an analogous figure especially pertinent to the study of Johns. Johns's long-standing interest in Redon is apparent in the graphic images of the targets, and comes to be inscribed in the lithograph, *Passage I*, 1966 (fig. 15), where, by an effect of Duchampian chance, the falling letters of the color band leave behind a legible REDO N EYE.[7] Thus Caws's brief comment on Redon's eye may become a leading question for Johns. She writes, "Redon's startling instances of the eye on stage is another of the early metavisual images as perfect examples of self-referring temper: the observers here

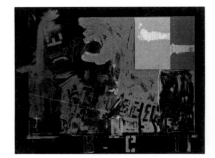

Fig. 15
PASSAGE I, 1966
Published by U.L.A.E.
Lithograph
27³/4 x 36¹/4 inches

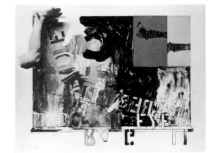

Fig. 16
PASSAGE II, 1966
Published by U.L.A.E.
Lithograph
28 x 36 inches

stare at a theatrical eye, itself forming the subject of sight. The Surrealists could go no further than this."[8] In the terms of my own discussion, then, I should like to take up the disfiguration of metaphor by reading allegorically Redon's obsessive eye image in conjunction with Johns's targets.

Redon himself believed his image of the eye to be a metaphor. In this he follows Rémy de Gourmont's brief remarks related primarily to Redon's lithographs for Flaubert's *The Temptation of Saint Anthony:* "the images cannot be translated into painting, a direct and, in short, geometric art, except as metaphors."[9] De Gourmont does not assert that Redon's images render the metaphors of Flaubert "line by line," as he says would be possible in illustrating the *Iliad,* but impossible for *The Temptation of Saint Anthony.* Rather de Gourmont describes—or even prescribes, this being a manual of sorts—a different style of translation. Where Flaubert presents a verbal metaphor, Redon should and does provide a metaphor in his own medium, though not necessarily incorporating the same image. The lithographic image might well forget the written text, as it were, or, in other words, the relation between the lithograph and the text is itself metaphoric, the text being the suppressed term of the comparison.[10]

As a metaphor of a metaphor, Redon's lithographs gain a great measure of independence from the text, but perhaps not so much as Richard Hobbs claims for Redon's album, *A Edgar Poe.*[11] Hobbs accepts too readily, I think, Redon's own verdict here, namely that Poe was invoked merely for expedience, a publicity scheme "exploiting contemporary literary fashion." While the image of the isolated eye precedes the Poe album in Redon's *oeuvre,* it may be set nonetheless within the context of a particular American ethos as it had established itself in France through Poe, even before Redon addressed himself self-consciously and perhaps cynically to vogue. Something is to be found in translation in Redon's eye: the image of an American voice, whose most prominent figure is Emerson's great "transparent eyeball" from "Nature," but which may already be read in Poe's early "Stanzas" in the figure of "th'expanding eye."[12] Emerson's eye, "uplifted into infinite space" in the form of a nineteenth-century hot-air balloon, looks out from the first plate of *À Edgar Poe,* published in 1882 (fig. 18). The image may be read as an emblem for metaphor itself: the sublime and transcendental eye gains the aerial view that will allow it to perceive everything, "in a single glance," as de Gourmont had remarked. It is the fully potent eye, it would seem: "I am nothing; I see all," it says with Emerson, even if the disembodied automatons, travelling under its own power (powered precisely by the *expansion* of gases), recalls more directly the fantastic ("bizarre") of Poe that Redon would have known through Baudelaire's translations.

Yet Emerson himself would not long remain "part or parcel of God" and Poe was probably never so. The expanding

eye, therefore, invokes a darker vision as well. As it appears in Redon, the eye is still tethered to a head upon a dish, and the lines that bind the eye may be read as indications, rather, of succession. The eye has emerged from the smaller figure. The expansion of the eye would make it seem to carry the head, but this is an ironic reversal of a story of a wounding. The head represents the remains of a decapitation; the eye, held fast by the extenuated optic nerves, has been forcibly put out. The part, then, stands for a whole that has been lost, sundered in a violent fragmentation.

Translating back into the American tradition, one finds Redon's eye in Johns's targets. Already in the early 1960s both Leo Steinberg and David Sylvester read the targets as faces with bull's eyes, but Sylvester is misleading or misled, I believe, when he compares the plaster casts with the accompanying target in *Target with Four Faces*, 1955 (fig. 19): "although the plaster faces are more solid, the target face is at least complete. It has to be complete: it would be intolerable if the position were reversed and the casts were complete and the target incomplete: a part of a face signifies a face; what price a part of a target?"[13] As he continues his analysis, the target takes on a Duchampian irony. Complete, the target is a true blank, "impassive, expressionless," but it stands in anticipation of the wounding blow that would etch its features: "We could put an expression on the target's face by firing several arrows at it," Sylvester writes. I would counter that much like Redon's balloon-eye, the target is the result of a wounding; it is an eye already severed, already isolate, in its relation to the faces. And together, target-eye, faces and the anatomical parts of *Target with Plaster Casts*, 1955 (fig. 14) all bear the same relation to the complete body. This is almost, but not quite synecdoche. The parts do not represent the whole; the whole, rather, is that which cannot be represented in the sum of these parts.

But if the different images each recall, incompletely, a missing unity, their interaction with one another adds a further dimension in a dialectic of dismembering and remembering. Sylvester, for instance, spoke of the casts as appearing before a firing squad, and although I would prefer to say that they are arranged as though in an arcade shooting gallery, the effect is much the same. The eye, metamorphosed as target, makes further targets of the other body parts. One may just as easily read the process in reverse, however. The faces and body parts are not always exposed to view, not always the targets of the eye. They may be hidden by closing the hinged flaps. Since the body part normally found beneath a lid that opens and closes is the eye, the various blind body fragments are themselves seeing eyes, and the lidless target remains over-exposed and vulnerable to be blinded by the light. The jarring disjunctiveness of the work, then, is the result of conflicting figurations for perception: the metaphor of the target-eye contrasts

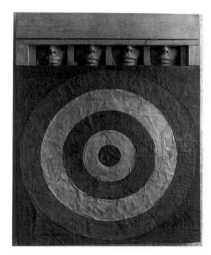

Fig. 19
TARGET WITH FOUR FACES, 1955
Encaustic on newspaper over canvas,
* 26 x 26 inches*
(66 x 66 cm) surmounted by four tinted
* plaster faces in wood box with*
* hinged front.*
Overall dimensions with box open
33⅝ x 26 x 3 inches (85.3 x 66 x 7.6 cm)
Collection, The Museum of Modern
* Art, New York.*
Gift of Mr. and Mrs. Robert C. Scull.
* 8.58.*

with the metonymic displacement of lower face or ear or penis, etc., for the eye beneath the lid. Either the subjective eye sees, but sees the body only as object, or the perceptive body replaces the blinded eye. In fact, both are true, and yet neither separately nor together do the targets and casts reconstitute a single, perceiving subject.

Johnsian irony is said to be constituted by such juxtaposition of irreconcilable elements. Even irony, however, might serve as the embracing figure that provides an organic unity to the work by holding antitheses in balance. It is more suggestive, I believe, to situate the consistent function of negating—take an object, do something to it, do the *opposite* to it—as evidence of what Richard Field referred to as Johns's "American skepticism."[14] The assertion is welcome, I imagine, to any iconographic study of Johns's work, since it supports a reading of the flags and maps, for instance, not so much as Duchampian readymades, but rather as a mark of identification with the American tradition. A skeptic Johns then becomes the standard-bearer of that tradition by ironizing the equally native naiveté of a Jackson Pollock. In order to understand the tradition into which Johns is thus being placed, it is well to recall that American skepticism, like so many things American, is Emersonian. The pertinent image for Johns's target may be taken from Emerson's "Circles," where the irony one might set against another is presented rather in the configuration of concentric circles:

> Every ultimate fact is only the first in a new series. Every general law only a particular fact of some more general law presently to disclose itself. There's no outside, no inclosing wall, no circumference to us. The man finishes his story—how good! how final! how it puts a new face on all things! He fills the sky. Lo! on the other side rises also a man and draws a circle around the circle we had just pronounced the outline of the sphere. Then already is our first speaker not a man, but only a first speaker. His only redress is forthwith to draw a circle outside of his antagonist. And so men do by themselves.[15]

For Emerson, etymologizing the matter, skepticism is consideration, which, etymologizing in turn, is an augury by stars (and stripes?). But the *skopein* of the skeptic is also a looking out or after, and the *skopos* a lookout or a watcher, such that Emerson's antagonists echo in the oft-cited sketchbook note by Johns, where they emerge as the watchman and spy, when the target (Latin *scopus*, from the same root) and casts evolve in the 1960s, as for example in the leg cast of the painting, *Watchman* of 1964 (fig. 23).[16]

Mary Ann Caws was also echoing Emerson's American skepticism in decrying the impossibility of a self-forgetting eye. What I cannot forget, what "I see plainly," according to Emerson, "[is] that I cannot see."[17] This is a

defeat or disfiguration of metaphor in a vision as plain as Kent's speech. The expanding circle of an expanding eye, represented in the concentric rings of the target, will come to obliterate any inside-outside dualism. The eye opens on an ever-extending inwardness. This will mean for a skeptical Johns—as it already does for Emerson—that the watchman is blind; his impaired or wounded outlook gives rise to the story of an involuted insight—while the spy comes to see better by looking into the true blank of the watchman's eye. The metaphor of the wounded eye becomes the allegory of forgetting.

III

Allegory is in fact the story of superimposition, and superimposition is palimpset. The crucial issue for reading Beckett's *Foirades/Fizzles*—and I will use *Fizzle 2* as an example—becomes the possibility or impossibility of forgetting underlying layers of the text so as to leave the surface legible. Just as these issues, arising from a study of Beckett's writing, will inform a reading of Johns's contributions to *Foirades/ Fizzles*, so too will *Fizzle 2* be considered in the light of the preceding discussion of expanding circles, wounded eyes, and the unextinguishable echoes of allegory.

The journey of the unnamed *il* (*he*) in *Fizzle 2*—"Il est tête nue" ("He is barehead")—has elicited allegorical interpretation.[18] But the tone of the allegory need not be exalted, as the generic designation *foirades*—Beckett's attempt to "break wind noiselessly," is John Pilling's rendering of the title— illustrates. Thus, one might counter Pilling's reading of a concern for life and a "striving to get born" in *Fizzle 2*, with a debunking, Joycean reading of a straining to pass a stool.[19] *Il* moves in an echo chamber, but the echoes that reverberate "sometimes louder than the time before," include the *Chamber Music* of the early Joyce, so titled because Joyce thought them appropriate for reading in the outhouse. Thus the *Fizzles* generally, and *Fizzle 2* in particular, are to be situated alongside Joyce's writing in the "long tradition of exuberantly scatalogical Anglo-Irish anti-verbal satire" that Keir Elam has called the *arse rhetorica*: "it is a tradition that expresses a deflating skepticism concerning the pretences of the logos and undermines man's cognitive claims through a colorful version of the *flatus vocis* (voice-flatulence) topos: words are but wind."[20] If in *Fizzle 2* Beckett is, as Pilling claims, "clearly... more concerned with life than death," then it is in the debased form expressed forthrightly in *The Unnameable*: "When Mahood I once knew a doctor who held that scientifically speaking the last breath could only issue from the fundament, and this therefore, rather than the mouth, is the orifice to which the family should present the mirror, before opening the will."[21]

SKIN II, 1973
Charcoal on paper
25½ x 40¼ inches
Collection the artist

The whole of *Fizzle 2* is poised between *haut* and *bas* (high and low), from the opening words. The visual scan reveals first the head *en haut* and the feet *en bas*, before focusing upon the ornament in the midmost. This opposition is given renewed emphasis in the first punctuation in the unbroken journey. "He halts for the first time since he knows he's under way," and at this crux, a chiasmus: "one foot before the other, the higher flat, the lower on its toes, and waits for a decision." Finally, Beckett returns to the same dichotomy of height and depth in posing the issue of waiting in the most nakedly allegorical form: "Where is it then that life awaits him, in relation to his starting point, to the point rather at which he suddenly realized he was started, above or below?"

Whether head-feet or face (mouth)-buttocks, the metaphorical identification of height and depth gains its narrative successivity and spatial extension by the process of "turns." In an allegory of writing, the turnings are the tropes. There is no room in the text for Plain Speech, no embodiment of straight-talking, as it were. Rather, *il* incorporates in his own body the turnings of his path, "for he holds himself bowed, because of the rise, and because he always holds himself bowed, his back humped, his head thrust forward, his eyes cast down." One may imagine *il* in the form of a walking question mark. But the question that he raises in thus pressing his inquiry is one of vision. Whether the "narrows" are of the throat or of the bowel—both windpipes in this *arse retorica*— *il* continues with daemonic insistence, as Fletcher would lead one to expect of an allegorical agent, and against these obstructions, the tropes succeed in prolonging discourse past its apparent termination.[22]

This is not the case for the eyes. The narrator breaks with the effort of objective description to engage the rhetoric of dispraise: "This is not the time to go into his wrongs, but perhaps he was wrong not to persist, in his efforts to pierce the doom." It is not clear that a more appropriate moment for judgment than the present time of narration could ever arise. But having engaged in the untimely task, the rhetorical shift reframes the problem of sight in the "black windings" of the text. Only a few lines earlier the narrator had answered no to the question, "Do his eyes, after such a long exposure to the gloom, begin to pierce it?" Now, in the wake of the judgmental intervention, the narrator declares, "For he might well have succeeded, in the end, up to a point, which would have brightened things up for him, nothing like a ray of light, from time to time to brighten things up for you." By implication, *il* has blinded himself.

The course or discourse of the text is measured by a rhythm of self-wounding: "He loses his blood, but in no great quantity, the little wounds have time to close before being opened again, his pace is so slow." Hence, the language of the tropes by which the body is constantly bruised against the

walls of the dark passages serves as much to pierce the body itself as to penetrate the darkness. It is a moment of sudden lucidity, therefore, when the narrator realizes that *il's* impasse is constituted by the double bind of his inevitable self-wounding. If he proceeds along the turnings of the text, he bleeds; if he desists from the self-immolation of "a long exposure to the gloom," he is blind. But this illumination, too, is drawn into the same self-destructive impasse, not least because the "ray of light" remains the gay imagining of the narrator, yet to be actualized in the text: "And all may yet grow light, at any moment, first dimly and then—how can one say? —then more and more, till all is flooded with light, the way, the ground, the walls, the vault, without his being one whit the wiser?" The narrator's speech becomes halting here, marked by a syntactical turn and return to the same place, that fails, therefore, in its logical function of advancing the temporal unfolding of the sentence. The more economical English erases the stutter effect of the French, where the enumeration of the elements included in the initial "all is flooded" ("...tout soit inondé de clarté") is followed by a repetitive phrase, "tout cela inondé de lumiére." This turning on itself is occasioned by a rhetorical uncertainty, the straitest narrow of "how can one say." The narrator finds no literal language to describe a lighting effect that has taken place only in his own mind. The narrator's solution is no less self-wounding than the obstinate troping of *il*: he offers the metaphor of the flood. In the obscurity of figurative language, the text is haunted by an inextinguishable undercurrent of inarticulate sound: "The only sounds apart from those of the body on its way," and, let it be recalled, that advances by the "turnings" of the tropes, "are of fall." Quite apart, then, from the faint biblical echo uniting deluge and fall, the illumination that the narrator envisions is a threat. For the flood of light is swelled by the metaphor of the "great dropping at last from a great height and bursting," which is in fact the hard matter of the passage itself. The totalizing metaphor that would at last unite *haut* and *bas*, therefore, is truly apocalyptic. By opening his eyes and piercing the darkness, *il* would bring the whole discourse crashing down around his head.

Rather than risk the light at the end of the tunnel, the blinding light of any end to speech, to narrative, ultimately, in this and all of Beckett's writing, the end that is death, *il* closes his eyes "more and more, more and more often and for even longer spells." This, too, is no escape, since the longest closing of the eyes is also death. While the journey and its narration last, however, *il* submits himself to the ever-increasing blindness in order to "to spare himself needless fatigue." And is the exhausting process of troping his way through the impasses of discourse more useful? Only as useful, I would think, as the circularity of Molloy's Cartesian parody in the procedure for transferring sucking stones from pocket to pocket. The self-

defense undertaken by *il* will not see him through to any purposed goal, but it will preserve the fiction of purpose and with it the continuation of narrative.

The closing of the eyes serves the same function as *il*'s infrequent stoppages, punctuating or puncturing the on-going course of speech. And if the vexed motion in this allegory of writing is the representative of the tropes, that is of figurative language generally, the moments of arrest are the true blanks, the featureless moments (the eyes closed) in which language is disfigured. In *Fizzle 2*, this relation of figurative speech to disfiguration is enunciated in terms of memory:

> Sometimes he halts and leans against a wall, his feet wedged against the other. He has already a number of memories, from the memory of the day he suddenly knew he was there, on this same path still bearing him along, to that now of having halted to lean against the wall, he has a little past already, even a smatter of settled ways. But it is all still fragile. And often he surprises himself, both moving and at rest, but more often moving, for he seldom comes to rest, as destitute of history as on the first day, on this same path, which is his beginning, on days of great recall. But usually now, the surprise once past, memory returns and takes him back, if he will, far back to that first instant beyond which nothing, when he was already old, that is to day near to death, and knew, though unable to recall having lived, what age and death are, with other momentous matters.

In this manner, "his history takes shape." But also the narrative, likewise *"histoire,"* develops as a movement between and recording of such points. Both text and memory are interrupted by the stoppages, rests in the progress of the journey.

While it becomes possible to interpret, allegorically, the journey as memory and the pauses as "l'amnésie," the opposite, I would argue, is the case. To forget is to be "destitute of history." Yet between head and toe, *il* is clothed, and it is rather in the course of his journey that he is steadily denuded. The movement of his body causes the stripping of the clothes. Hence, *il* may be said to be erasing his memories as he proceeds, a gesture enacted by his hands which, "as now and then they pass, back and forth, over all those parts of the body they can reach without fatigue." The untiring activity of forgetting makes possible the new and tiresome inscriptions of memory, or so the narrator would seem to conclude:

> So with one thing and another little by little his history takes shape, and even changes shape, as new maxima and minima tend to cast into the shade, and toward oblivion, those momentarily glorified, and as fresh elements and motifs, such as these bones of which more very shortly, and at length, in view of their importance, contribute to enrich it.

The narrator thus rationalizes the journey by the illumination of a dialectic. He interprets the continuing activity of figurative language as a process of forgetting prior figures, which in turn allows new figures to arise. Yet once again this effort to gain control of the tropological discourse that *il* is enacting manifests itself as the imposition of a figure that arises in the mind of the narrator, rather than in the world of his narration. The operant term of the dialectic is the shade of oblivion. How is the shade cast? This cannot be taken as the literal language of plain speech, for no illumination as yet exists in the dark passage traversed by *il*.

The double meaning of the journey as a physical movement (wind passing through the colon, the pen looping through the letters of a manuscript) and as the constitution of a history (the recollection of *hauts* and *bas*, their recording in narrative) depends finally on the workings of oblivion. And the narrator, who is the allegorical reader of *il*'s quest, fails to forget his own metaphor. In the light of his own trope, the narrator loses sight of his own text.

Fig. 21
LEG from CASTS FROM UNTITLED,
1973-74
Published by Gemini G.E.L.
Lithograph
30¾ x 22¾ inches

IV

If the utter darkness of *Fizzle 2* can yet be divided into areas of greater and lesser shadow, so too the absolute nudity of a surface wiped clean of memory by the vicissitudes of the journey proves rather to be but a covering for hidden depths: beneath the tattered clothing skin, but beneath the skin the bones. This brings me back to Johns's contribution to *Foirades/Fizzles* and to my argument that the relation between Johns's etchings and Beckett's texts is itself allegorical. The etchings continue the texts—after a halt—forgetting as much as they are able, remembering more than they wish, creating the potential for an implicit double meaning beyond the literal sense. The mental process presented as a succession of images, hence a journey, becomes, in printing, a superimposition of images. With regard to the composite image of picture and text in *Foirades/Fizzles*, this suggests that one needs to learn to read Beckett through Johns, to read the etchings as the analysis of the text.

Fig. 22
LEG-BLACK STATE from CASTS
FROM UNTITLED, 1973-74
Published by Gemini G.E.L.
Lithograph
16 x 22 inches

I take up this Johnsian reading of "these bones" at the most evident point of contact between *Fizzle 2* and the etchings. Most simply, the three images of legs accompanying the French version of the text allude to the sentence, "The legs notably seem in good shape, that is a blessing, Murphy had first-rate legs." But this is only to remark that the visible allusion of Johns's images points to the most visible allusion in the text, the moment in which the narrator recalls his filiation with previous texts by Beckett. I stress here that *il* is not Murphy, anymore than the Unnameable is Murphy or Molloy or Malone.[23] Rather *il* and Murphy are recollected within the

138

mind of the narrator, where they are superimposed, sharing the metaphor of good legs. The image of the leg then engages the same allusiveness of self-recollection within Johns's *oeuvre*. The image recalls the casts of body parts in the panel of *Untitled*, 1972 (color plate II), its explicit reference, while recalling the cast of the leg in *Watchman*, 1964 (fig. 23), and the related works of the previous decade, and thence, ultimately, if less precisely, the casts that accompany the targets of the 1950s (figs. 13, 14 and 19). It is perhaps in *Watchman*, 1964, where seeing, or the inability to see, is related to the movement of *making rounds*, that is most germane to the history of *il*.

Beyond this interaction of texts and etchings—and there are others, more or less explicit, more or less intentional; that is, sometimes allusion, sometimes echo—Johns takes up the narratorial role left open in the final lines of *Fizzle 2*, where the narrator's aberrant metaphor of light and shadow represents *il* as a *"porteur d'ombre"* ("shadow caster") and recalls Duchamp's further formulation, "les porteurs d'ombre/travaillent dans l'infra mince" ("the shadow casters/work in the infra thin").[24] Duchamp identifies the conceptual category of the *infra mince* by exemplification in a series of notes from the 1930s and 1940s, citing occurrences of *infra mince* phenomena perceptible to the various senses. "Pantalons de velours," he writes, for instance, "leur sifflotement (dans la) marche par frottement des 2 jambes est une/séparation infra mince signalée par le son" ("Velvet trousers—/their whistling sound [in walking] by/brushing of the 2 legs is an infra thin signaled/by sound"), to choose a case consonant with *Fizzle 2*: "the sounds of the body on its way...of the clothes, singlet and trousers, espousing and resisting the movements of the body...."[25]

The common denominator of Duchamp's examples seems to be certain irreducible difference between acts of perception, even where it is a question of a single entity perceived at different moments in time. A perfect memory, Jorge Luis Borges has conjectured, would inevitably make such distinctions, and Max Kozloff, recalling the story by Borges, relates it along with Johns's work, to Freud's memory machine: the mystic writing pad.[26] But Johns's work, both painted and printed, I would argue, presents rather a machine for forgetting. Johns's progress, that is, moves toward amnesia and a closing of the eyes, moves, paradoxically, toward stillness, much as Beckett's *il*, who travels through a domain of *infra mince* passages. In charting that progress, both in *Fizzle 2* and the etchings that surround it in the book, the scrupulous work of effacing figuration leads nonetheless to the rediscovery of figures more deeply rooted. One forgets only to remember.

Duchamp explicitly links the *infra mince* to the process of forgetting in the context of the public exposure of art: "L'échange entre ce qu'on/offre aux regards (toute la/mise en oeuvre pour offrir/aux regards [tous les domaines])/et le

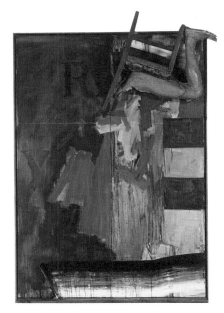

Fig. 23
WATCHMAN, 1964
Oil on canvas with objects
85 x 60¼ inches
Collection Mr. Hiroshi Teshigahara,
Tokyo

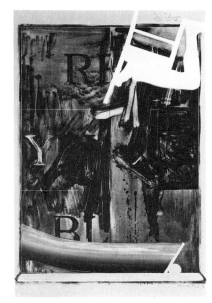

Fig. 24
WATCHMAN, 1967
Published by U.L.A.E.
Lithograph
36 x 24 inches

regard glacial du/public (qui aperçoit et/oublie immédiatement)/Tres souvent cet échange a la valeur/d'une séparation infra mince/(voulant dire que plus/une chose est admirée/et regardée moins il y a sépa./inf.m" ("The glacial regard of the/public [which sees and/forgets immediately]/ Very often/this exchange has the value/of an infra thin separation/[meaning that the more/a thing is admired/and looked at the less there is an inf.t./sep.").[27] Left uncovered to the forgetful public gaze, the work of art would become a true blank, were it not that the very forgetfulness of the gaze opens a separation—infra thin—between the public aspect of the work, and its private associations. The forgetting that effaces figures is also the occasion for the reconstitution of the meta-phor of depth, that is of superficial as opposed to deeper meaning. The work of art becomes, therefore, the allegory of its own forgetting:

> The possible is
> an infra-thin—
> The possibility of several
> tubes of color
> becoming a Seurat is
> the concrete "explanation"
> of the possible as infra
> thin
>
> ———————
>
> The possible implying
> the becoming—the passage from
> one to the other
> in the infra-thin.

———————————————————

allegory on *"forgetting"*[28]

As in the case of the de Manian allegory of reading which concludes with the recognition that reading is impos-sible, so too an allegory of forgetting can only prove the impos-sibility of forgetting. Johns's etchings for *Foirades/Fizzles*, I would suggest, accomplish the same task with regard to Beck-ett's text, but at the price of engaging in an allegory of forget-ting within the context of Johns's own work. Thus expanding from allusion to echo, the three images of legs accompanying the French version of the text take up the means of locomotion that powers the allegory of writing. Johns's images, however, are legs by allusion only. The stylized forms recall a human leg only insofar as they recall first the corresponding cast in the far right panel of *Untitled*, 1972 (color plate II) and the variants on it in Johns's prints (including such images in *Foirades/ Fizzles* itself). And particularly with respect to the first of these images, the recollection depends less on the outline of the body part, than on its orientation on the board to which it

140

is attached. But by pinning the recognition of the leg to its attachment to a board, Johns has dissociated the identity of the body part from its locomotive function. The effect is a disfiguration of *Fizzle 2*, reversing the metaphorical movement upon which the textual allegory is based. *Il* seems to get nowhere, in Johns's analysis, because the creative imagination, whose activity *il* represents, is rather stationary.

Johns's analysis follows a Duchampian bias, that is the bias of Johns's own reading of Duchamp. Writing in memory of Duchamp in 1968, Johns states with respect to Duchamp's *Large Glass*, "Its cross-references of sight and thought, the changing focus of the eyes and mind, give fresh sense to the time and space we occupy, negate any concern with art as transportation."[29] While a complete reading of this rich text by Johns must be postponed, I will underline here its two principal tropes, relating them back to a sketchbook entry published three years earlier: "Beware of the body and the mind. Avoid a polar situation. Think of the edge of the city and the traffic there."[30] The mind-eye metaphor of focus, then, replaces the mind-body dualism, a trope that enacts Johns's warning in that it figures forth the eye as neither mind nor body but an intermediate agent between the two. A further question arises, however, with regard to the trope of transportation and its negation. The traffic at the city's boundary in the sketchbook note was already a figure, like the eye in the essay on Duchamp, for a permeable interface between polar opposites. In changing his focus and effacing the image of traffic, does Johns transform the eye itself into a means of transportation in spite of his own negation?

Beckett undermines dualism, his Cartesian nemesis, by turning the mind's eye inward in observation of the mind's own halting activity. But in so doing, he creates a new interior space—indeed recreates the *res cogitans* as a *res extensa*—whose intricate reticular foldings are reminiscent of the structure of the brain as well as that of the bowel. The mind-body opposition reasserts itself in *Foirades/Fizzles* in the relation of narrator to *il*. Johns works in the opposite direction, looking out for a borderline that is neither inside nor out, but both at once: an inheritance of the Dadaist and Surrealist threshold expounded by Caws, but also an expression of American adventure ever in search of a new and expanded frontier. But if Johns unmasks the allegory of *il*'s inward journey, he does so only as a result of his own journey outward bound. Transportation, in spite of Johns's praise of Duchamp, is not eradicated by the changing focus of the eye, and the traffic at the city's edge is not forgotten behind the gesture of negation.

The flagstone images that accompany the English text, "He is barehead," carry Johns to a design glimpsed on a wall while traveling through Harlem. At the opposite edge of the city, the hatching motif on the right side of the diptych at the hinge between the French and English versions of *Fizzle 2* recalls the traffic on Long Island, and a design seen on a pass-

ing car. Both flagstones and hatchings, then, record memories of transportation as art, but neither is what it purports to be. For in both cases, the referential value of the memories is wholly undermined. The car with the hatching design is never to be seen again; the wall is demolished before Johns can return to trace the painted pattern.

These images record forgetting, therefore, and not memory. Their only referent is to the indecisive recuperation of a lost *objet trouvé* within Johns's own mind, since the outside term is no more than a fantom, a fleeting fiction. In consequence, flagstones and hatchings are pure figuration, that is figures without ground, hanging nowhere or everywhere.[31] This is most easily conceived in relation to the flagstones, whether those alongside the English version, "He is barehead," or elsewhere in Johns's work, since this is an image wherein what is literally ground (flags as paving stones) has become a figure, a picture on a wall, as it was already in Harlem. In substantiating the process of forgetting already allegorized by Beckett's narrator through the journey of *il*, Johns would then seem to accomplish a more thorough effacement of the polar situation that Beckett has questioned: inside-outside, figure-ground, ultimately subject-object, self-other.

Johns had anticipated as much in a sketchbook note published in 1964: "An object that tells of the loss, destruction, disappearance of objects. Does not speak of itself. Tells of others. Will it include them? Deluge."[32] The suppression of the subject pronouns, due, one imagines, to the speed of composition, is suggestive for the elimination of the self-other distinction. But the subject is not finally to be counted among the lost objects, neither in the note nor in the hatchings and flagstones. It has been displaced here to the authorial subjectivity of the sketchbook form: an expanded *I* that underwrites all of the entries. And the apocalyptic closure, too, implies recuperation while announcing loss, through the echo, or, I would think, allusion, to the late drawings of Leonardo.[33]

Reading through this intricate web in Johns's work for *Fizzle 2*, the deluge now echoes in the narrator's metaphorical flood of light. And it may be that any image of flooding as a figure for loss must recall a defeated narcissism—a Narcissus drowned: loss of self for the artist bewildered by the mirroring of subject and object, of himself in his art. Emerson may provide a convenient proof-text in the American tradition: "A man should learn to detect and watch that gleam of light which flashes across his mind from within, more than the lustre of the firmament of bards and sages," Emerson writes in "Self-Reliance," "Yet he dismisses without notice his thought, because it is his. In every work of genius we recognize our own rejected thoughts; they come back to us with a certain alienated majesty."[34] Deflating Emerson's sublimity, I read: one

may efface one's tropes but not forget them, for they speak again in the echoes that expand beyond allusion. In the case of the flagstones and hatchings, the echo is transported by a dim recollection: Johns in traffic in Harlem or on Long Island repeating in his American geography the journey of Duchamp in the company of Picabia and Apollonaire along the Dura-Paris road that led to the founding of Dada (though in Johns's case one reads Hart Crane's "The Bridge" in place of Apollinaire's "Zone"). And in thus creating art as transportation in spite of himself, what has Johns found?

The transformation that Johns performs upon his own work engages what is perhaps his own aboriginal trope by which the flat surface of the picture plane is figured forth as a cylinder, or, rendering the cylinder two-dimensionally, a circle. The procedure is most evident in the metonymic displacement of painting to brushes (effect to cause) enacted in the sculpture of the cylindrical Savarin can (but recall the ale can as well), which comes to be impressed synecdochally (part, rim or base, for whole) upon the surface of the paintings in such circular figures as the stencils in *According to What*, 1964 (color plate I) and the outline in *Dutch Wives*, 1975 (fig. 42). I would further suggest that the device circles in their various and frequent manifestations are figures for an axis of rotation that turns parallel or perpendicular to and even through (consider the grommet in *Decoy*, 1971 [Collection, Mr. and Mrs. Victor W. Ganz]) the picture plane. The reconfiguration of the flags as targets is already a manifestation of this anamorphosis.

Reordering the sequence of the panels of *Untitled*, 1972 by the same rotational trope, Johns bends the right and left panels of the original painting back around the imaginary cylinder so that the extremes meet. The image centers the French and English versions of the text; it is their hinge. And like the more evident hinge-piece following the French version of *Fizzle 1*, the image provides in itself the rotational axis around which the opening phrases of *Fizzle 2*—"Il est tête nue" and "He is barehead"—revolve in potential superimposition. It is the image not of voice, but of echo: it is the figure of translation. And translation, finally, is the *infra mince* between Beckett and Johns in the pages of *Foirades/Fizzles*.

Here Johns's image seems barely to glance at Beckett's texts—the more evident allusions having been dispersed in the flagstones and the legs. Yet neither does it forget *il* and his allegory, for the diptych constitutes a history of self-reflection: the fragmented sequence of stripes recollect, through the disfiguration of the rotational trope, their regular concentric structure: the hatchings are a broken target. And together with the body fragments up on boards that remember other fragments boarded up, one may read a renewed *target with plaster casts*.

When the cancelled trope returns, fantasmatically, as its own shade—a corpse in its own mirror—it inevitably opens an old wound. At the center of the text, a cosmic image: a further wink of an expanding eye.

1. My essay is guided throughout by Angus Fletcher, *Allegory, The Theory of a Symbolic Mode* (Ithaca, NY: Cornell University Press, 1964) and Paul de Man, *Allegories of Reading, Figural Language in Rousseau, Nietzche, Rilke, and Proust* (New Haven: Yale University Press, 1979).

2. De Man, *Allegories of Reading*, 217.

3. Northrup Frye remarks, "it is not often realized that all commentary is allegorical interpretation, an attaching of ideas to the structure of poetic imagery," in his *Anatomy of Criticism, Four Essays*, (Princeton: Princeton University Press, 1971), 89. The same could be said for the attaching of ideas to the structure of pictorial imagery.

4. Mary Ann Caws, *The Eye in the Text, Essays on Perception, Mannerist to Modern* (Princeton: Princeton University Press, 1981).

5. Caws, *The Eye in the Text*, 89.

6. I reproduce here Caws's translation of the passage from Mallarmé: "The virgin refolding of the book, still, enables a sacrifice from which the red slice of ancient volumes used to bleed; the introduction of a weapon or paper-cutter, to establish the taking of succession" (Caws, *The Eye in the Text*, 22).

7. See most recently, Riva Castleman's remark, "Other than his early fascination with the lithographs of Odilon Redon, which he has collected, Johns rarely looks at prints," in her *Jasper Johns: A Print Retrospective* (New York: The Museum of Modern Art, 1986), 48. Max Kozloff had long since juxtaposed Redon's drawing, *Eye* (c.1885) and Johns's drawing, *Target* (1958) in his *Jasper Johns* (New York: Harry N. Abrams, Inc., 1967), plates 108-109. In a conversation with James Cuno, Johns claimed not to have intended the inscription, REDO N EYE, but had thought rather of spelling out REDO AN EYE. Believing this too obvious, Johns dropped the A.

8. Caws, *The Eye in the Text*, 100.

9. Rémy de Gourmont, *Le problème du style* (Paris: Mercure de France, 1924), 90. Translations of de Gourmont are by the author; other translations are as noted (Beckett provided his own translations of the texts in *Foirades/Fizzles*).

10. In the context of de Gourmont's essay, the relation might perhaps be better designated as translation. But the terms of metaphor and translation share more than an etymological link.

11. Richard Hobbs, *Odilon Redon* (Boston: New York Graphic Society, 1977).

12. Emerson "Nature" (1836), in Stephen E. Whicher, ed., *Selections from Ralph Waldo Emerson, An Organic Anthology* (Boston: Houghton Mifflin, 1957), 24.

13. David Sylvester, "Jasper Johns at the Whitechapel," an unpublished radio talk for the BBC, (December 1964), quoted in Kozloff, *Jasper Johns*, 14. In the same place Kozloff also cites the relevant passage from Leo Steinberg, "Contemporary Art and the Plight of its Public," *Harper's Magazine* (March 1962).

14. Richard S. Field, "Jasper Johns' Flags," *Print Collector's Newsletter* 7 (July-August 1976): 69. Field's insight here is rooted, I believe, in Barbara Rose's discussion of "fundamental American attitudes" with respect to Johns's work in her essay, "Decoys and Doubles: Jasper Johns and the Modernist Mind," *Arts Magazine* 50 (May 1976): 72.

15. Emerson, "Circles," in Whicher, ed., *Selections from Ralph Waldo Emerson*, 170.

16. The note was originally printed in "Sketchbook Notes," *Art and Literature* 4 (Spring 1965) and is reproduced by Castleman, *Jasper Johns*, 22.

17. Emerson, "Montaigne," in Whicher, ed., *Selections from Ralph Waldo Emerson*, 287.

18. John Pilling remarks that " 'He is barehead' has an allegorical feel about it," in the brief pages that he dedicates to *Foirades/Fizzles* in James Knowlson and John Pilling, *Frescoes of the Skull, The Later Prose and Drama of Samuel Beckett* (New York: Grove, 1980), 132-35. These short prose pieces have received remarkably little attention in the enormous Beckett bibliography. Aside from brief references in more comprehensive studies, such as Pilling's (which is nonetheless one of the most sustained discussions of *Foirades/Fizzles*, and one of the most helpful), one finds, first, the two articles regularly cited by Johns scholars, Roberta Bernstein "Johns & Beckett: Foirades/ Fizzles," *Print Collector's Newsletter* 7 (November-December 1976): 141-45, and Judith Goldman's catalogue *Foirades/Fizzles* (New York: The Whitney Museum of American Art, 1977). Among literary critics one may read Jessica Prinz, "*Foirades/Fizzles/* Beckett/Johns," *Contemporary Literature* 21 (Summer 1980): 480-510, and Marike Finlay, " 'Foirades de Beckett' métonymie à la lettre, métaphore à l'oeuvre, embrayage du discours dualiste," in Brian T. Fitch, ed., *Au jour le siècle 1. écrivains de la modernité* (Paris: Minard, 1981), 65-88. Of these I find Goldman most, and Finlay least, helpful. Bernstein published much valuable information on *Foirades/Fizzles*, but her study is particularly inadequate from a literary perspective. Prinz is also useful (one might wish to consider some of the accompanying articles in that special issue of *Contemporary Literature 21* dedicated to the topic of "Art and Literature," including John P. Harrington, "Samuel Beckett's Art Criticism and the Literary Uses of Critical Circumstance," 331-348).

19. Pilling, *Frescoes of the Skull*, 132 and 135.

20. Keir Elam, "*Not I*: Beckett's Mouth and the Ars(e) Rhetorica," in Enoch Brater, ed., *Beckett at 80/Beckett in Context* (Oxford: Oxford University Press, 1986), 146-47.

21. Samuel Beckett, *The Unnameable* in *Three Novels by Samuel Beckett* (New York: Grove, 1965), 342.

22. My preference for referring to the protagonist of Beckett's *Fizzle 2* as "*il*" throughout this section is intended to point toward Maurice Blanchot's conception of a neutral narrative voice in the essays of *L'entretien infini* (Paris: Gallimard, 1969). Blanchot associates the neutral *il* with Beckett's Unnameable in an essay from *Le livre à venir* (Paris: Gallimard, 1959) available in English under the title, "Where Now? Who Now?" in S.E. Gontarski, ed., *On Beckett: Essays and Criticism* (New York: Grove, 1986), 141-49.

23. The Unnameable, Molloy, Malone, and Murphy are the principal protagonists in Samuel Beckett's novels *The Unnameable, Molloy, Malone Dies*, and *Murphy*. The first three novels are published together in Samuel Beckett, *Three Novels by Samuel Beckett* (New York: Grove Press, 1965); *Murphy* is published alone, in Samuel Beckett, *Murphy* (New York: Grove Press, 1957).

24. The notes are included in *Marcel Duchamp: Notes*, arrangement and translations by Paul Matisse (Boston: G. K. Hall, 1983). I refer to the text here and elsewhere by the number assigned to the notes by Matisse. I date the notes on the concept of *infra mince* (nos. 1-46) in accordance with the remarks by Anne d'Harnoncourt in her preface to the volume (ix). Cited here is no. 3.

25. Duchamp, in *Marcel Duchamp: Notes*, no. 9 verso.

26. See Max Kozloff, *Jasper Johns*, The Abrams/Meridian Modern Artists Series (New York: Harry N. Abrams, Inc., n.d.), 20-21. My effort in this essay may be taken as an incomplete antithetical response to Kozloff's brilliant insight. In arguing for a process of forgetting against Kozloff's discussion of memory, I would note the inversion of the Freudian model in Johns's work. The frequent use of encaustic places the wax surface top-most, where for Freud the wax tablet underlies the translucent surface of perception. In effect, the collage or under painting often visible beneath Johns's encaustic surface may well be a top surface *seen from below*, as in more evident cases, including the panel of body casts in *Untitled*, 1972, Johns inverts perspective to view the canvas from the rear. Reading against the grain of Kozloff's remarks, this inversion becomes legible through the process that I refer to throughout as disfiguration: a forgetting that is the matrix in which submerged figures come to light. (The term "disfiguration" is de Man's: see for instance, his "Shelley Disfigured" in Harold Bloom, et. al., *Deconstruction and Criticism* [New York: Continuum, 1979], 39-73. On

the matrix of forgetting, see Blanchot, "Oublieuse mémoire," in his *L'entretien infini*, 459-64.) For a suggestive instance of the interrelations of submerged figuration and the perspective reversals of metaphor in Johns's work beyond the limits of *Foriades/ Fizzles*, one might consider Johns's reading of Hart Crane's "The Bridge" in his *Periscope (Hart Crane)*, 1963 (Collection the artist), particularly the verses from the "Cape Hatteras" section:

> What whisperings of far watches on the main
> Relapsing into silence, while time clears
> Our lenses, lifts a focus, resurrects
> A periscope to glimpse what joys or pain
> Our eyes can share or answer — then deflects
> Us, shunting to a labyrinth submersed
> Where each sees only his dim past reversed...

See James Cuno's discussion of Johns and American poetry in his essay in the present catalogue.

27. Duchamp, in *Marcel Duchamp: Notes*, no. 10. The parenthesis beginning at "voulant dire" (meaning that) remains open in the text.

28. Duchamp, in *Marcel Duchamp: Notes*, no. 1.

29. Jasper Johns, "Marcel Duchamp (1887-1968)," *Artforum* 7 (November 1968): 6.

30 Jasper Johns, "Sketchbook Notes," *Art and Literature* 4 (Spring 1965), quoted in Castleman, *Jasper Johns*, 21.

31. For a challenging discussion of the figure-ground relation in Beckett, see Kimball Lockhart, "The Figure of the Ground," *enclitic* 3 (Fall 1979): 74-105.

32. Jasper Johns, excerpt from sketchbook published in Alan R. Solomon, *Jasper Johns* (New York: The Jewish Museum, 1964), quoted in Castleman, *Jasper Johns*, 20.

33. Max Kozloff, *Jasper Johns*, 38.

34. Emerson, "Self-Reliance," in Whicher, ed., *Selections from Ralph Waldo Emerson*, 147.

Anamorphosis:
Jasper Johns

Richard Shiff
University of North Carolina at Chapel Hill

Change Without Cause

Make something, a kind of object, which as it changes...
offers no clue as to what its state or form or nature was at any
previous time.

–Jasper Johns[1]

Aim for maximum difficulty in determining what has
happened...

–Jasper Johns[2]

Among Jasper Johns's paintings, a certain number of unusually large works represent summations or compilations of the artist's visual and conceptual themes. Both *According to What*, 1964 (color plate I) and *Untitled*, 1972 (color plate II) belong to this group of multifaceted statements. Perhaps, in Johns's sense, they achieve "maximum difficulty." Johns followed these two paintings with numerous prints that highlight details, explore alternatives, extend perspectives, and reorient the given. Noting this self-reflexiveness in both painting and printmaking, commentators have emphasized the artist's concern to refigure his imagery, as if continually retrieving it from interactive levels of memory.[3] It is evident that Johns delights in shifting from one medium to another, and in transforming one structure or pattern into another.[4]

Johns's imagery is well-known in a double sense: before he manipulates it, much of it is already very familiar (flags, targets, letters, numbers, the spectrum, rulers, flatware, targets, handprints); and afterward virtually all of it becomes known as the things repeatedly seen in Johns's art, remembered in his art. Not all such things possess the psychological

equanimity of the ten numerals or of the simple graphic hatchings that dominate Johns's work during the 1970s. In particular, Johns's body fragments (often in the form of painted plaster or wax casts) as well as his body imprints (usually hands or feet, but also knees, torsos, arms, faces, skulls) are likely to evoke an emotional response even from those unmoved by the play of colors, textures, and patterns. Such highly charged imagery may seem incongruous, for by all accounts Johns is a private person and rather withdrawn.[5] He may also be a highly ironized figure, who maintains his distance when commenting on society: "I don't think politics was ever a concern of mine, to keep out or to bring in," he says to Peter Fuller, who attempts, unsuccessfully, to goad Johns into making an assertive political judgment.[6] The artist may not acknowledge a political voice, but he does admit to the emotional charge of his imagery. Nevertheless, he avoids elaborating upon it and offers little to support speculation concerning any *particular* psychological motivation. His remarks give no clear indication why he graphs the movement of a diver with imprints of hands and feet, why he attaches a fork and spoon to a wire, or why he casts together the combination of hand, foot, sock, and a bit of floor. As familiar as Johns's repeated imagery becomes, it yet retains its mystery.

Although causal explanations for the peculiarities of Johns's imagery do not come forth, his art yet possesses an accessible "psychology"—more a matter of the operation of mental functions than of the revelation of personal feelings and unconscious motivations.[7] If, for example, memory is a subject in Johns's art, the very working of memory is signified much more clearly than any specific memory—how everyone remembers rather than what an individual (Johns) might remember. This assertion of psychological function over personal feeling may be more than the evasiveness of an artist who desires privacy. To privilege function in this way is to imply that feelings can only be the product of available modes of thought and perception. In other words, representation does not remain a secondary process working to capture a primary experience; rather, such "private" experience is itself determined by the public workings of representation. Memory is therefore best conceived as a mode of representation that must somehow be in place before one can feel.

If this is a lesson of Johns's art, his stress on technique reinforces it. The artist speaks freely of his procedures, making evident the external physical parameters of his works, if not "inner" psychological sources. There is an important observation to be made here: Johns's gesture of emotional withdrawal—or reticence, or even indifference—agrees with the public, enunciated character of his making process. Certain features of Johns's technique virtually *signify* a disjunction of formal organization (articulated by the making process) from expression (presumed to be generated by emotion). Recently, with particular reference to his works in the

1980s, Johns has shifted his position and identified himself more directly with levels of personal expression: "In my early work I tried to hide my personality, my psychological state, my emotions...Finally, one must simply drop the reserve."[8] One's attitudes do change. Yet Johns's basic structural principles remain much the same, and his manner of working must distance him (or so it seems) from the presumed psychological potency of his subjects.[9] In effect, Johns's art, both early and late, signifies an inexpressiveness that can be opposed to the more characteristic modernist mode of self-expression and psychological engagement. This inexpressiveness provides access to an artistic alternative to modernist practice.[10]

Johns has said some odd things concerning his artistic expression—or the lack of it—especially when referring to his early work. Speaking to Vivien Raynor in 1973, he recounted his failure (during the 1950s) to attain a successful mode of self-expression in the prevailing abstract expressionist manner. And so he took the opposite course and "worked in such a way that I could say that it's not me...not to confuse my feelings with what I produced. I didn't want my work to be an exposure of my feelings."[11] One might emphasize the element of withdrawal here and associate it with either the defensiveness of an individual or the depoliticization of an entire class of embattled intellectuals during the 1950s.[12] I choose instead to turn from causal conditions of emission to conditions of receptive interpretation, and to stress the fact that Johns provides the viewer with little if any reference to the most obvious explanatory cause for his art—his feelings. As Johns transforms images and objects, he renders their origins, their generation, their history, obscure. They do not originate in *him*. This makes the reception of his art difficult. One wants to know where things come from.

In 1976 Johns explained to Michael Crichton where his flagstones pattern (seen in the second and third panels of *Untitled*, 1972) had indeed "come from": a painted wall glimpsed while passing through Harlem. He reiterated the importance of a kind of non-expressiveness, a lack of identification: "What's interesting to me is the fact that it isn't designed, but taken. It's not mine."[13] But doesn't such selective appropriation transfer ownership? What of the image once Johns's hand refigures it—does it now originate in Johns? The artist's statement ("it's not mine") is not so naive as it may sound; it enunciates a principle. Johns claims that he would have liked to have been able to make an exact copy of the flagstones pattern. He seeks to escape all proprietary authorship.

Leo Steinberg, who produced the first extended critical study of the artist, encountered this attitude and characterized it acutely: "The distinction I try to make between necessity and subjective preference seems unintelligible to Johns." When the artist traces out his numbers and letters with stencils, he chooses these technical devices—he prefers

them—because "they come that way."[14] He likes what he finds (except what he finds in himself).[15] And what he *makes* in his paintings retains a quality of the found; hence, his penchant for the traced (or indexical) image, linked not to a style of rendering, but to a real object. Like the flagstones, Johns "took" both the pattern of hatchings and the casts of his body fragments in *Untitled*, 1972 from the world outside, as if anonymously: "I'm interested in things which suggest the world rather than suggest the personality."[16] Perhaps even Johns's own mental apparatus is part of the world and not "his": "I don't know if [what I've done is] out of choice or out of necessity—how my mind must move."[17]

That Johns is not—or, more accurately, *signifies* that he is not—the "author" or origin of his images is most obvious with regard to his work of the 1950s. (This signified lack of identification applies to his brushmarks also.)[18] In works of the 1960s and 1970s the key to Johns's inexpressiveness is his lack of a position. *According to What*, 1964, for example, establishes no position at which one imagines the artist to stand.[19] As a result, Johns's work assumes no position of origin with which the *viewer* can identify.

Johns spoke of *According to What*, 1964 in an interview of 1971:

> The painting was made up of different ways of doing things, different ways of applying paint, so the language becomes somewhat unclear. If you do everything from one position, with consistency, then everything can be referred to that. You understand the deviation from the point to which everything refers. But if you don't have a point to which these things refer, then you get a different situation, which is unclear....Everything changes according to something, and I tried to make a situation that allows things to change.[20]

According to What—especially when viewed with its associated prints, the series *Fragments—According to What*, 1971—is a catalogue of shifts, transfigurations, perspectives. As Johns states, the standard form of each deviant element is not necessarily indicated, nor is the principle that might determine the mode of transformation that would account for the present condition of each of the represented elements (hence—possibly—the title, *According to What*). Without ascertaining consistent principles of transformation, the observer fails to determine a causal agent (an author) for the pervasive figuration. It is as if Johns the maker occupies many positions, which is to say that he occupies no particular position ("you don't have a point to which these things refer").

Included within the six panels of *According to What* are many "things" turned or bent out of what one might imagine to be a more proper shape or a more standard orientation; these things subsequently become the isolated subjects of the prints that comprise the series *Fragments*. At the upper left of

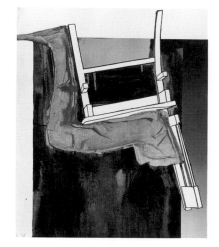

Fig. 26
LEG AND CHAIR from FRAGMENTS —ACCORDING TO WHAT, 1971
Published by Gemini G.E.L.
Lithograph
35 x 30 inches

150

According to What is an assemblage consisting of the cast of a leg, resting on a chair, cut to reveal its section, and displayed upside-down and inside-out (one looks into the hollow of the cast; fig. 26). Between the second and third vertical panels lies a set of hinged volumetric letters, which spell out "red," "yellow," and "blue"; they seem to generate imprints or tracings in paint to their left and right. All of the letters that form the word "blue" are bent. Near the center of the entire work, a row of colored circles runs from top to bottom, apparently traced from a metal template, itself attached to the bottom of the row; the template is bent forward (as if peeled off the canvas surface). At the lower right is a common metal hanger, bent away from the surface of the canvas so as to reveal a contour tracing of the position it would seem to have occupied before being bent (fig. 27). Finally, at the lower left, a small canvas is hinged to the large first panel. When opened, it reveals a spot (an indexical "shot") of paint applied by spraying, as well as a traced profile of Marcel Duchamp (fig. 28). Both Duchampian and Johnsian, this profile incorporates chance in assuming its position, its perspective.[21] Johns generated the profile from Duchamp's serigraph *Self-Portrait in Profile,* an image Duchamp himself derived by tearing a sheet of paper along the edge of a metal template that corresponded to his cast shadow.[22] Duchamp's paper profile has a negative form in relation to the positive form of the template—the sheet itself is not shaped to form a head, but appears as a rectangle with a head-like piece missing. Johns contrived to recreate Duchamp's "original" shadow, but from an altered perspective. He took a tracing of *Self-Portrait in Profile* and suspended it from a string, allowing it to cast its own shadow, which he then retraced (including the string) as the reconstituted image of Duchamp. The result is that the Duchamp profile on the hinged canvas attached to *According to What* is a deviant or distorted version of its original. The new Duchamp profile corresponds to the old one as a trapezium does to a rectangle. It has lost any obvious claim to orthogonal regularity. Yet this representation remains "true" in the sense that it retains a claim to indexicality—it can be physically linked back to the real presence of Marcel Duchamp.

As Duchamp's indexical shadow-tracing passes from template to paper (Duchamp's own doing) and then to refigured shadow and to canvas (Johns's supplemental action), it acquires a set of transformative distortions. These, however, cannot be associated very specifically with the hand or eye of Jasper Johns. Given the play of chance, the cumulative distortion is no more "expressive" than that of the notorious *Three Standard Stoppages* (The Museum of Modern Art, New York) —Duchamp's contour tracings of three threads, each a meter in length, having been dropped to the ground from a meter's height. In rendering a deviant perspective on Duchamp's profile image, Johns, as if in the spirit of the *Stoppages,* assumed no position specific to himself.[23]

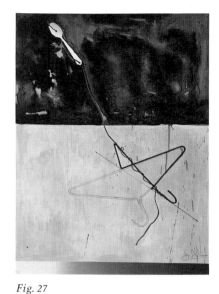

Fig. 27
COATHANGER AND SPOON from
FRAGMENTS—ACCORDING TO
WHAT, 1971
Published by Gemini G.E.L.
Lithograph
34 x 25¼ inches

Fig. 28
HINGED CANVAS from FRAGMENTS
—ACCORDING TO WHAT, 1971
Published by Gemini G.E.L.
Lithograph
36 x 30 inches

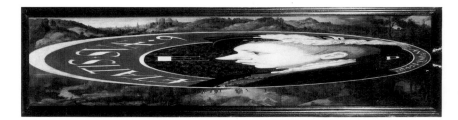

Anamorphosis and the Medium

Can a rubber face be stretched in such a way that some mirror will reorganize it into normal proportion?

–Jasper Johns[24]

My description of *According to What* and of Johns's general mode of operation has been informed by the artistic tradition of anamorphosis, but not in a straightforward way. Anamorphosis is itself a kind of distortion. An anamorphic representation appears distorted when viewed from a "normal" position, one implied by the conventions of the medium; it is regularized when the viewer assumes some other, deviant position. Thus, with anamorphosis, position and image cannot simultaneously be standard. This disjunction of normal point of view and normal picture is not to be attributed to the skewing subjectivity of authorship or self-expression; it is instead a product of technical means.

Fig. 29
Portrait of Edward VI, 1546
National Portrait Gallery, London

An example will illustrate. A portrait of Edward VI, 1546 (fig. 29) is set into an irregular ellipse superimposed on a conventional landscape within an elongated rectangle. This portrait appears stretched out and flattened when viewed from the standard position, facing the plane of the picture. By standing at the picture's extreme right edge and looking along the plane, the observer eliminates the distortion; from this viewpoint (facilitated by a notch in the frame), the portrait assumes a "normal" or conventional appearance. Moving the representation "corrects" anamorphic displacement just as well as moving the viewer. Turning the painting 90 degrees from its conventional disposition converts the figured image of Edward VI back to normal.

In anamorphic representations of this type, nothing need remain particularly mysterious, for a causal history of the image is easily reconstructed. A common manner of generating such anamorphosis involves laying a grid over a representation or a projection of the model, and then systematically converting all the rectangles of the grid into trapezoids; finally, one retraces the image according to its new scheme of proportion. This procedure, sometimes called "counterperspective," simulates viewing the model from a nonstandard position. (Habits of vision, which seek out

interpretive regularity, may "automatically correct" much of the distortion associated with such a view.) There are many alternative ways to produce anamorphic images, including the use of mirrors and of projections from an exaggerated angle.[25] Any such process of refiguration works according to a precise system, and the resultant deviance from the norm is predetermined and measurable.

Johns's reworked Duchamp profile is an anamorphosis of this general type, except for the fact that Johns fails to set precise conditions for refiguring Duchamp's shadow-tracing (he allows the new position of the profile to appear by "chance"). Given Johns's working method, the degree of anamorphic deviance becomes (relatively) indeterminate. As a result, there is no evident position from which things might look "right"; the distortion implies no norm. The viewer senses that *According to What*, 1964 incorporates changes, but —from where? and from what? The parameters of the artist's procedure become ungrounded, as insubstantial and shadowy as his own authorial presence.[26]

Johns's *Untitled*, 1972—along with its associated print images (figs. 2-7), including those from *Foirades/Fizzles*, 1975-1976—represents a set of "anamorphoses" of still more problematic type, in which a shift in perspective or viewpoint must be associated with a shift in medium. The medium thus ceases to operate as a transparent means; it no longer submits to the external and internal forces that traditional interpretive strategies postulate as essential determinates of formal organization. Instead the medium substitutes itself for the forces assumed to generate and control representation—the class of external conditions (the changing position of physical objects, the "reality" of social relations) and the class of internal motivations (self-expression, a subjective "point of view," even creativity). It is as if the medium were self-motivated and acting out the role of cause or agent, bringing about an effect— movement in, or of, the viewer.

Many of Johns's statements, both before and after the fact, prepare the viewer for what happens in *Untitled*, 1972 particularly with respect to the second and third panels of this four-panel composition. His "Sketchbook Notes" includes a reference to two flagstones panels, one to be painted in oil and the other in encaustic. Johns adds the remark , "Whether to see the 2 parts as one thing or as two things."[27] In 1978, he refers in a more general way to this practice of shifting the medium: "I like to repeat an image in another medium to observe the play between the two: the image and the medium. In a sense, one does the same thing two ways and can observe differences and samenesses—the stress the image takes in different media."[28] (Typically, the artist speaks here as the detached observer of his own seemingly inexpressive making.) Johns was referring to his practice of reworking painted images as

prints, but "stress" occurs within the painting *Untitled*, 1972, even when seen alone.

A preliminary hypothesis: if there is stress, it must lie along the faultline that separates the two flagstones panels, for here the worlds of oil and encaustic collide or divide. Indeed, the surfaces of the two media look different—oil is relatively thin, opaque, and glossy, whereas encaustic is thick, somewhat translucent, and rather matte. But there is another order of difference in *Untitled*, 1972, in its imagery. To the left of the oil flagstones is an oil panel with hatchings, while to the right of the encaustic flagstones is an encaustic-covered assemblage with casts of body fragments. Given the context of this diversity, it may seem that the division between the two flagstones panels is *not* the most stressful one; indeed, these panels may begin to look quite alike.[29] Not only do they share a single image, but the pattern of the lefthand part of the second panel actually matches and repeats that of the righthand part of the third panel. The flagstones panels differ only in the parts that face each other, in proximity to the common dividing edge where oil meets encaustic.

How significant is this remaining difference in pattern, in the context of its site? The viewer soon discovers that the division between the flagstones panels is unusual in an unexpected way—nothing violates it. In contrast, the two other borders between adjacent panels are repeatedly transgressed. To mention only two instances: an imprint of an iron in the lower left of the casts panel extends into the surface of the adjacent flagstones; a black stone at the left of the first flagstones panel extends slightly into the adjacent hatchings. In the case of the former transgression, both panels are encaustic; in the case of the latter, both are oil. The implication is obvious: wherever two panels of like medium meet, the physical surface of the painting is to be regarded as homogenous and continuous; but if the media differ, the physical surface becomes discontinuous. The total configuration of *Untitled*, 1972 thus establishes that the nature and force of the medium—whether its identity remains constant or changes —transcends any shift in pattern.

More than that, a change in medium itself "causes" a shift in pattern. The association of the break in medium with the break in what might otherwise be a single flagstones image seems to signify such causal connection. The visual effect is quite unsettling. The observer of the two similar panels that form the central motif of *Untitled*, 1972 senses that a continuous wall of flagstones has, as it were, slid by; for the pattern of the left side of the oil panel reappears as the right side of the encaustic panel.[30] Alternatively, the same viewer might imagine that the change in medium has caused a change in his own apparent position, so that in looking left and right he comes to see different sections of wall—and not the sections he would expect to see when looking left and right from a

single fixed position. Such induced "movement" of the viewer —in this case, a virtual movement compensating for the apparent movement of the object viewed—is an essential feature of anamorphosis. Johnsian anamorphosis is peculiar in that it establishes no standard or non-deviant position from which to assess the degree of movement that occurs.

When something appears twice or is done twice, comparison follows naturally, and with it difference. An observer cannot fail to see, for instance, how the oil flagstones panel differs from its encaustic counterpart. But nothing indicates that one panel must be prior to the other, or that one is the norm.[31] The observer simply notes the shift or displacement in the flagstones pattern in conjunction with the change from oil to encaustic and from encaustic to oil. This shift, then, marks the change in medium. But why is *this* the marker? If the medium is the cause, why is this the effect? There is no particular reason. One simply *learns* that this is so, just as one learns the conventions of a language or of any system of arbitrary signs. To learn in this manner is basic to human experience. And Johns will make his viewer learn the arbitrary over and over again, for his prints after *Untitled*, 1972 both expand and revise the initial set of anamorphic conventions.

During the period 1973 to 1975, Johns made two sets of lithographs after *Untitled*, 1972 (figs. 2 and 3). When presented with the *Foirades/Fizzles* project, he decided to produce still more variations on the themes of hatchings, flagstones, and casts, but with a further displacement of medium, from lithography to etching. Although Johns sometimes paralleled his painting practice by creating individual prints incorporating more than one medium, he did not go that route in the variations after *Untitled*, 1972.[32] In fact, some of the most distinctive features of these prints can be attributed to Johns's elimination of the stressful relationship between the two original media, oil and encaustic. It might even appear that certain relationships between the panels of *Untitled*, 1972 become normalized in the prints.

The major "innovation" of both sets of lithographs after *Untitled*, 1972—one set in color and the other in grays and black—is a continuity from one panel to the next throughout. This encompassing continuity is itself signified redundantly, by multiple means. In the case of the four color lithographs, which correspond to the four panels of *Untitled*, 1972, Johns embossed each with the pattern of the preceding adjacent panel (in doing so, he treated the fourth panel as if preceding the first, completing the circuit). This embossing produces continuity as well as an anamorphic tension, since any two panels can be seen to be both superimposed and laterally continuous—the viewer looks into or through each panel to see the previous one in the sequence, as well as scanning from side to side (the prints are intended to be mounted

separately, but then hung together). In the case of the set of lithographs in grays and black, Johns indicated continuity by including as part of each panel, bleeding off the edges to either side, thin strips of the two adjacent panels.

Furthermore, in both sets of lithographs, along each of the edges that would be shared if all four sections of pattern were joined together, Johns gave indications of overlap, extending parts of one section into the next. The most striking case of this effect appears along the right edge of the second color panel (flagstones), where a narrow band of red is to be seen as part of a red stone belonging to the adjacent third panel. Significantly, this band did not appear in the painting *Untitled*, 1972 because—as the viewer now sees—the shift in medium, from oil to encaustic, entailed absolute rupture at this very juncture. Again, in the lithographs, the left edge of the first panel (hatchings) shares markings with the right edge of the fourth panel (casts). The original painting must "necessarily" have been different: since its hatchings are oil, and its casts are encaustic, no such continuity could be indicated. Nor could the possibility of a continuity between the fourth (casts) and the first (hatchings) panels ever have entered into play. That is, not until the lithographs reoriented all previous configurations. The prints reconceive the painting, viewing it through a different medium and from altered perspectives. As Johns refigures his imagery (a way of remembering), he opens all past figuration to interpretive review.

After the lithographs come etchings. Four sets of the four panels from *Untitled*, 1972 reappear on one of the double pages of *Foirades/Fizzles*. Here, the panels retain their customary sequence—hatchings, flagstones, another flagstones, casts—and their continuity is reconfirmed. Each set, however, begins at a different position in the order. Other changes appear as one glances from set to set, and many of these alterations can only be described as irregular. But, as always, one learns the language of Johns's art by observing it in context, without concern for external causal agencies. Within the specific context of *Foirades/Fizzles*, image plays off against image to establish the difference that can generate meaning—meaning that comes, as it were, out of nowhere.

The set of prints published in *Foirades/Fizzles* resembles the earlier set, *Fragments—According to What*, in that small details of a complex painting are isolated and studied. The same detail may appear several times, rendered in different manners as if constituting a subset of anamorphic variants. Consider the two full-page studies of the cast of a female torso, *TORSE* and *TORSO*. One appears completely detailed by means of a photo-screen transfer, whereas the other is a white area merely stopped out. The former is a positive image capturing illusionistically the volumetric quality of the original cast, as well as its surface of wax drippings; the latter is a negative image, blank and flat.[33] Considered together, the two

represent "full" and "empty" instances of a type having no neutral or unfigured instantiation—the viewer once again faces a situation where everything seems deviant or distorted, yet in relation to no conceivable standard. Yes, the temptation is to regard the "full" version as normative; but a peculiar feature of the two torso etchings, their labeling, disables the impulse. The "full" image bears a French inscription, "TORSE," while the "empty" version bears the English "TORSO." In the bilingual context of *Foirades/Fizzles,* neither language can take precedence.[34] Recalling the flagstones panels in *Untitled,* 1972, one surmises that the shift (or translation) from the medium of French to that of English must simply bring with it the change from "full" to "empty." This may seem a convoluted explanation and quite implausible—but implausible according to what standard? Johns's imagery establishes that it operates largely by its own rules, which are determined by immediate context. Again, one learns (or makes) the "rules" through experience.

Taken by itself, the torso cast asserts irregularity since it presents a view of the body both fragmented and without standard perspective—it is neither frontal nor profile, but somewhere in between, with a suggestion of a twist.[35] In the original context of *Untitled,* 1972, the multiplicity of prespectives implied by the various fragments compounds this individual deviance. The entire set of casts from *Untitled,* 1972 vaguely suggests that a number of human wholes may have been torn or pulled apart. To be sure, this effect unsettles the psyche; but the positioning of the casts disturbs even more. Collectively, the casts form a representational field. The viewer has no place to stand in this field of diverse, piecemeal perspective. He discovers no viewpoint from which to assess the damages—not damages to the human body, but to his own orientation. He loses his position, his totalizing mastery of the world of representation.

More damage: there are front and back endpapers in the book *Foirades/Fizzles,* of hatchings and of flagstones respectively; each of these two etchings represents two "panels" having sections that repeat. The design of both endpapers recalls the condition of the two flagstones panels from *Untitled,* 1972. Repeating sections of pattern lie at some distance from a central faultline that is never transgressed (compare the division between oil and encaustic in *Untitled,* 1972). So each of the endpapers seems to represent two similar panels exhibiting an anamorphic pattern shift, *but now without a corresponding change in medium.* Here are two cases of continuity of medium associated with discontinuity of surface. The endpapers thus contradict one of the "principles" of *Untitled,* 1972 established both by the painting and by a number of prints.

Must I therefore conclude that these two etchings destabilize the position of my own analysis? Yes and no. That

position was itself never fixed, but set in anamorphic motion, to be related to other positions. Perhaps the endpapers merely reaffirm the danger of establishing fixed patterns of meaning wherever representational devices continue to play. Johns's lesson is clear: interpretation depends on difference from or relation to an assumed norm; such norms change.[36] Just as Johns breaks his own implied "rules," so the viewer must create new rules in order to interpret. Since Johns creates conditions for the most active and inexhaustible kind of interpretation, the only dependable "meaning" that his art signifies is interpretation itself.

Three Modes of Anamorphosis

If Johns's art instructs in the practice of interpretation, it also refigures history by setting a new standard for anamorphic displacement. Anamorphosis itself now appears to have a history unfolding in three stages—classic, modern, and postmodern. The example of Johns's art suggests how the representation of this history might be constructed, retrospectively, as a convenient and likely fiction.[37] ("History" is a collective representation. Its realization requires a change in the figuring perspective or point of view of our text, which must assume a different voice. As if impersonally and collectively, "we" will trace out the historical implications of Johns's art.)

To repeat, but in the altered, anamorphic voice: we are led to see that there are three modes of anamorphosis. The differences are not necessarily chronological, but functional. Initially, classical anamorphosis may seem the most familiar. It produces a distortion that can be set right when the viewer assumes the proper external position; and in generating such unproblematic distortion, it also reaffirms the normative value of a centered position from which one can always calculate degree of deviance. Classical anamorphosis thus privileges one viewpoint, regarded as law-given, corresponding to that of a king, a class of nobles, or an aristocracy. Their figured representations—whether in the form of writing, pictures, or the self-representation of dress and manner— establish a standard. Yet such privileged figuration belongs to but one class among many. It must remain in potential (if not actual) competition with other manners of representation that would seem to render reality just as adequately, to capture it and possess it under rule. Whether in resistance or in irony, one can always attempt to shift the center from one set of representations to another, from one "perspective" to another.

In classical representation, then, we experience the paradox of an arbitrary system of signification (for which no fully authoritative origin can be found) that nevertheless operates as if in possession of the truth, and as if any departure

from itself could only signify something less than the truth, a deviance. We might say further that such classicism is not in fact a case of paradox, but of *doxa*—privileged opinion, a relativity taken for an absolute. (The king's English is correct, but perhaps only because it is spoken by the king.) Since the classical point of view can be identified with specific historical conditions, it must be the anamorphic variant of some other view corresponding to another set of conditions. Yet, during the period of its currency, it has the power to render reality without recognizable distortion. It therefore operates as *anamorphosis zero-degree*—figured representation regarded as unfigured or literal.[38]

If we were all to see the world from the position of a noble, it would look "right," true to form. Indeed, individuals can acquire this collectively proper classical viewpoint. The easy way to get it is by nature, that is, by birth, by membership in the proper privileged class; but it can also be attained through a process of education, another kind of class. Academic institutions function to distribute the normal order of representation to those admitted to the privileged status of students. Within the classical system, anamorphosis (the kind seen in the portrait of Edward VI) thus becomes a product of external factors; its deviance derives from the skilled, technical manipulations performed by those in control of the proper system of representation, those who can easily return to the normal view.

In the contrary case of modernist anamorphosis, the origin of deviance is internalized; modernist anamorphosis results from "self-expression." Since all individuals express themselves when making representations (at least to some extent), anamorphosis can become the rule rather than the irregularity. Even those who would follow the classical masters and imitate their normative manner find that they have a view of their own. In the modernist environment, with its sensitivity to self-expression, all imitation becomes anamorphic since it is all figured through the hand of someone—each artist is valued for an individual style, if only for the quirks of handling that allow the connoisseur to make an identification of authorship. The degree of individual stylistic deviance (or mere particularity) becomes the telling index of self-expression.

With the pronounced self-expression of modernism comes the romantic "genius" capable of reorienting classical tradition: an individual with genius creates a strong style and a new center from which everything must look different and yet "right." We perceive this, at least as possibility, and a possibility for everyone. The modernist mode of anamorphosis converts every individual deviance into a standard or a point of view that must be recognized. Every view is privileged. Everyone is master. And from a modernist perspective, every case of distortion amounts to anamorphosis zero-degree since

each will appear absolutely proper with respect to its own origin, a self-expressive individual.

Among those who value such modernist relativity, some nevertheless preserve a sense of privilege through their own preeminent mastery. Their anamorphoses tend toward metamorphoses. This is to say that instead of cultivating a natural deviance and personalizing their representation of things, some artists will seek to transform one thing into another, as if to create a new reality, something more than an alternative view. Picasso often (but by no means always) followed this practice, and even spoke of it. His notorious assemblage, *Bull's Head*, 1942 (Musée Picasso, Paris) converts a bicycle seat and handlebars into the convincing representation of an animal; as the artist said to an interviewer, a "metamorphosis was accomplished." Picasso thought that his act of discovery and fabrication did more than change our view of the identity of his materials; instead, a genuine transformation took place through an act of artistic will.

Correspondingly, Picasso conceived of a reverse transformation—the bull would become the bicycle once again: "Imagine my bull's head thrown in a junk pile. Perhaps one day some boy would say: 'Here's something that would make good handlebars for my bicycle...' Thus, a double metamorphosis would have been achieved."[39] So, to reverse Picasso's transformation one must do more than shift position (either physical or psychological); one must actually manipulate materials. Modernist anamorphosis results as "genius" expresses naturally its own "distorted" point of view. In contrast, metamorphosis seems the product of willful "magic."[40] In either case, however, what appears in the work can be attributed to the artist as causal agent.

Can we now experience and identify a postmodern anamorphosis by attending to the agency of Jasper Johns? Johns acts in the negative. He fails to indicate a single position from which to view the changes his representations undergo; thus, he abandons the classical system of anamorphosis. He also fails to express himself, to mark the "position" of his person; by this evasion, he distances himself from modernist practice. Nor does Johns compete with Picasso in the realm of metamorphosis, the complement to modernist anamorphosis; his representations, however complex, seem to signify things as they are.[41] He often chooses subjects that preexist in the form of a representation, favoring things that "have clearly defined areas which [can] be measured and transferred to canvas."[42] Johns's representations remain signs when interpreted, instead of resolving into meanings in order to reenter a "real" world. He neither asserts the control and mastery that transforms reality, nor does he indulge in (signifying) the finding of his own person, his individual point of view. No central authority seems to guide his practice, neither the external

authority of classicism (God's law, the king's law, the law of nature) nor the internal authority of modernism (one's self).[43]

Thus Johns's art is decentered. This observation leads to another, all too obvious: Johns's postmodernism works in concert with the poststructuralism of the 1970s. A sense of "play" confirms our crude analogy between postmodernist art and poststructuralist critical practice. Johns speaks of observing the "play" between two of his images, as if standing at an ironic remove from his world of representation, and as if to assert no final control over the meanings that his representations will generate, even for himself.[44] The "play" of poststructuralist representation, like that of postmodernism, is participatory and constitutes a subject who experiences signs through an interminable process of interpretation.[45] Paul de Man, as a poststructuralist and deconstructive critic, observes play in Nietzsche's texts and notes how it decenters our (classical) notions of position and cause, two features also destabilized by a Johnsian anamorphosis. Here is de Man's statement regarding Nietzsche, which describes Johns's practice just as well: "The two sets of polarities, inside/outside and cause/effect,...[are] scrambled into an arbitrary open system in which the attributes of causality and of location can be deceptively exchanged, substituted for each other at will."[46] Indeed, we find the features of causality (motivation, expression) and location (viewpoint, perspective) "scrambled" in paintings such as *According to What* and *Untitled*, 1972.

The Johnsian (non)position need not succeed classical and modernist practices chronologically, but stands always as their ready alternative, outside of time. If classicism privileges one viewpoint, and modernism privileges every viewpoint, postmodernism privileges no viewpoint. Classical anamorphosis positions its viewers to see a distorted external object properly. Modernist anamorphosis exhibits instead the deviant position of the other, the other's characteristic internalized point of view. Postmodernist anamorphosis places the factor of position into play; it forces the viewer to interpret without end and to assume diverse voices, gestures, and discourses. While the classicist masters objects and the modernist masters the self, the postmodernist can only strive to master the medium.

To presume to master representation is to deny the lessons of poststructuralism. Yet we approach mastery of whatever medium we engage as we engage others through it, learning from the collective experience. For the critic, a work of art becomes a medium to be mastered, however imperfectly. This process can induce anamorphic deviance as the critic finds it necessary to shift or exchange points of view. Johns has appreciated such critical anamorphosis in Leo Stein-

berg's response to his work: "He [Steinberg] saw the work as something new, and then tried to change himself in relation to it, which is very hard to do. I admired him for that."[47]

In accord with a Johnsian ethic, my argument has not been a positivistic explanation of meaning, but a critical interpretation. Such an essay performs an anamorphosis, an exchange of positions; critical writing displaces a work of art just as the work reorients the writer. Criticism handles figures already made, respecting them, but changing them—"Take an object. Do something to it. Do something else to it..."[48]

1. Jasper Johns, in Alan R. Solomon, *Jasper Johns* (New York: The Jewish Museum, 1964), 5.

2. Jasper Johns, "Sketchbook Notes," *0 to 9* 6 (July 1969): 1-2, reprinted in Richard Francis, *Jasper Johns* (New York: Abbeville Press, 1984), 111-112. Also see, Johns's statement in "What is Pop Art? Interviews by G.R. Swenson" (Part II), *Art News* 62 (February 1964): 43: "I am concerned with a thing's not being what it was..."

3. Throughout this essay I use terms such as "figure," "refigure," and "figuration" to connote the transformative aspects of acts of representation (including not only drawing and painting, but any mode of conceptualization—as in "figuring" something out, thereby giving conceptual matter a form not evident previously). There is an obvious parallel with the figuration of literary figures, such as metaphor or metonymy.

4. The spirit of Johns's work has been best represented by Richard S. Field in his several publications. Field writes that "Johns is almost obsessed with the notion that anything can be done differently, that anything can be experienced differently"; *Jasper Johns: Prints 1970-1977* (Middletown, CT: Wesleyan University Press, 1978), 13. Judith Goldman also states it well: "Johns mines his art for meaning, not to improve it, but to see what it can be"; introduction to *Foirades/Fizzles* (New York: Whitney Museum of American Art, 1977), n.p.

5. "His reserve about himself...masks a profound vulnerability"; Solomon, *Jasper Johns*, 16. "It is hard...to reconcile Johns's aura of sociability with the other impression of almost priestly apartness"; Vivien Raynor, "Jasper Johns" (interview), *Art News* 72 (March 1973): 22. "In the realm of personal associations he provides little more than hints of how much is being withheld"; Field, *Jasper Johns: Prints 1970-1977*, 28-29.

6. Jasper Johns, in Peter Fuller, "Jasper Johns Interviewed, Part I," *Art Monthly* 18 (July-August 1978): 10.

7. Accordingly, Field associates the motif of fork, spoon, and wire with "the notion of consuming illusions—our habit of taking one thing for another"; see his essay in *Jasper Johns, Screenprints* (New York: Brooke Alexander, 1977), n.p. Most of Johns's remarks regarding the "psychological" content of his work are ambiguous and can be read as referring either to the expression of feelings (which he does not identify) or to the working of mental processes and functions (focussing, recollecting, differentiating, etc.). Perhaps neither of these two senses of "psychological"—the first relatively colloquial, and the second, more technical—should ever be completely isolated. Indeed, Johns does not isolate them. For examples of his ambiguity, see his 1965 interview by David Sylvester, in *Jasper Johns Drawings* (London: Arts Council of Great Britain, 1974), 7-19, especially 11, 14. In discussing emotional or psychological "mood," Johns comes to speak of detached observation: "Mentally my preference would be the mood of keeping your eyes open and looking, without any constricted viewpoint" (11). See also statements to Peter Fuller, "Jasper Johns Interviewed, Part II," *Art Monthly* 19 (September 1978): 7.

8. Jasper Johns, in April Bernard and Mimi Thompson, "Johns On...," *Vanity Fair* 47 (February 1984): 65. Also see the closely related statements in the interview by Demosthène Davvetas, "Jasper Johns et sa famille d'objets," *Art Press* 80 (April 1984): 11-12.

9. As an example of the old Johns appearing in the new, consider his set of four (independent) paintings, *The Seasons* (1985-1986), in which the position of the artist's shadow-figure varies systematically, as if continually shifting from right to left. It appears at the center of *Spring*, to the left in *Summer*, then divided between left and right in *Fall*, and finally, having come full circle, to the right in *Winter*. See, *Jasper Johns: The Seasons*, intro. by Judith Goldman (New York: Leo Castelli, 1987), n.p. Johns's earlier set of three panels, *Voice 2* (1971), exhibits many instances of such comprehensive variation; for example, one panel divides vertically, another horizonally, and another diagonally.

10. The reader should not conclude that I am representing Johns as a formalist. He is in fact an anti-formalist, for within modernist practice formalism and expressionism go hand in hand. Johns's failure to "express" distances him from aspects of both modernism and formalism. On associating formalism with expressionism, see my, "Performing an Appearance: On the Surface of Abstract Expressionism," in Michael Auping, ed., *Abstract Expressionism: The Critical Developments* (New York: Harry N. Abrams, Inc. for the Albright-Knox Art Gallery, forthcoming 1987). There are a number of major antecedents for the kind of resistant practice in which Johns engages, including the mature *oeuvre* of Duchamp and the collages of Picasso and Braque. In the field of literary practice, Samuel Beckett (Johns's disjoined partner in *Foirades/Fizzles*) may stand for "inexpressiveness." Beckett himself champions a certain absurdist inexpressiveness in the practice of painting; see his dialogue with Georges Duthuit on the art of Bram van Velde, originally published in *transition* (December 1949) and republished in Samuel Beckett, *Proust and Three Dialogues with Georges Duthuit* (London: Calder and Boyars, Ltd., 1965), 119-126.

11. Jasper Johns, in Raynor, "Jasper Johns," 22. Also see the statement to Peter Fuller, "Jasper Johns Interviewed, Part II," 7. Johns's reference to abstract expressionism conflicts with certain other statements he has made. Michael Crichton reports that "Johns denies that his earliest paintings were a reaction to Abstract Expressionism. He says that he didn't know enough, hadn't seen enough, to make such a response;" Michael Crichton, *Jasper Johns* (New York: Harry N. Abrams, Inc. and the Whitney Museum of American Art, 1977), 38.

12. See the analogous commonplace wisdom expressed by Harold Rosenberg regarding the artworld of the 1960s: "Overemphasis on form is a defensive recoil from social and cultural crisis, as was evident in the reign of formalism in American art during the Vietnam war," in his *Barnett Newman* (New York: Harry N. Abrams, Inc, 1978), 29.

13. Crichton, *Jasper Johns*, 55.

14. See Leo Steinberg, *Jasper Johns* (New York: G. Wittenborn, 1963), 15.

15. On a number of occasions Johns has expressed dissatisfaction with his own character; for example, see Fuller, "Jasper Johns Interviewed, Part II," 7.

16. Johns's statement (1965) in Sylvester, *Jasper Johns Drawings*, 7. Johns reports (1976) that he glimpsed the hatchings painted on a passing automobile; like the flagstones, he appropriated them by means of memory; see Crichton, *Jasper Johns*, 59.

17. Johns's statement to Roberta Bernstein, "An Interview with Jasper Johns," in Lawrence D. Kritzman, ed., *Fragments: Incompletion and Discontinuity* (New York: New York Literary Forum, 1981), 286.

18. This is a complicated matter. Here, sketchily, are some points to consider. (1) Johns's marks are anonymously "inexpressive" in that they refer (indexically) to very common movements of the hand—familiar gestures of scribbling, scrawling, dabbing, and the like. (2) Much of Johns's mark-making seems merely to signify coverage of a surface, getting the paint (or the collage) on the canvas. (3) Although the marks may be personalized in relation to the immediate referent (Johns renders his numerals different from a sign-painter's), the same set of marks appears depersonalized in relation to other members of its class of representation (all other gestural paintings). (4) However, with increasing prominence in the art world, Johns is recognized as the author of his marks, no matter how they look. Eventually, what was once "inexpressive" becomes as identifying as a signature, and the problem of evaluation shifts to a new level. (5) Johns's use of color offers a parallel to his mark-making; he takes the standard colors as they are, as if non-referentially. (Barbara Rose aptly describes

Johns's color as denotative rather than connotative; see her "The Graphic Work of Jasper Johns, Part II," *Artforum* 9 [September 1970]: 66.)

19. In interpreting Johns's work through 1961, Leo Steinberg correspondingly noted the artist's "refusal to advertise his subjective location"; see Steinberg, *Jasper Johns*, 18.

20. John Coplans, "Fragments According to Johns: An Interview with Jasper Johns," *Print Collector's Newsletter* 3 (May-June 1972):30-31. Johns's "Sketchbook Notes" for *According to What* and related works contains this passage: "One thing working one way / Another thing working another way. / One thing working different ways / *at different times*," in *Art and Literature*, 4 (Spring 1965): 192. See also Johns's closely related statements (1965) in Sylvester, *Jasper Johns Drawings*, especially, 9-10.

21. It also evokes the work and thought of John Cage, as do so many of Johns's characteristic operations. Significantly, Cage remarks of Johns: "There are evidently more persons in him than one"; John Cage, "Jasper Johns: Stories and Ideas," in Solomon, *Jasper Johns*, 22.

22. See Arturo Schwarz, *The Complete Works of Marcel Duchamp* (New York: Harry N. Abrams, Inc., 1970), 532. In "Marcel Duchamp (1887-1968): An Appreciation," *Artforum* 7 (November 1968): 6, Johns cryptically refers to *Self-Portrait in Profile*, which Duchamp labelled "Marcel dechiravit": "Himself, quickly torn to pieces." Johns's "Sketchbook Notes," *Art and Literature*, 185 also refers to the Duchamp image: "Profile? Duchamp (?) Distorted as a shadow. Perhaps on falling hinged section."

23. A great many of Johns's paintings indicate that he denies the role of agent for the changes that occur within his works, including those paintings that induce visual "illusions" (such as the afterimage in *Flags*, 1965 [Collection the artist]) and those that incorporate mechanical devices seemingly motivated by forces other than the artist's hands (*Thermometer*, 1959 [Private Collection] or *Good Time Charley*, 1961 [Collection the artist]).

24. See John Cage, "Jasper Johns: Stories and Ideas," 22.

25. See Jurgis Baltrušuaitis, *Anamorphic Art*, trans. W. J. Strachan (New York: Harry N. Abrams, Inc., 1977).

26. Compare Johns's use of Surrealism's device of the "exquisite corpse," as first noted by Thomas Hess, "On the Scent of Jasper Johns," *New York* 9 (9 February 1976): 66. Johns's "Corpse and Mirror" series of the mid-1970s might exemplify the scope of his anamorphosis just as well as *Untitled*, 1972, which I discuss below.

27. Jasper Johns, "Sketchbook Notes," *0 to 9* (1969), reprinted in Francis, *Jasper Johns*, 111-112.

28. Jasper Johns, in Christian Geelhaar, *Jasper Johns Working Proofs* (London: Petersburg Press, 1980), 39.

29. Yet, there are also distinct formal resonances operating among all four panels; Johns himself has commented on this. See Roberta J. M. Olson, "Jasper Johns: Getting Rid of Ideas," *SoHo Weekly News* (November 3, 1977): 24-25 quoted in Riva Castleman, *Jasper Johns: A Print Retrospective* (New York: Museum of Modern Art, 1986), 31-32. Many of the individual stones in the flagstones panels are collaged. (The sequence of four panels thus becomes increasingly three-dimensional: oil, oil with collage, encaustic with collage, encaustic with assemblage.) According to Johns's observers the collage material is silk. Perhaps because of the difference between oil and encaustic the collage material itself seems to change. It looks rather like paper in the second panel, more like fabric in the third.

30. In 1978, Johns referred to the effect of the repetition of pattern in *Untitled*, 1972 in a somewhat different way: "Two sections partially repeat one another suggesting that the given space could be compressed or that a smaller space has been enlarged by duplication," Geelhaar, *Jasper Johns Working Proofs*, 53. The first of Johns's "suggestions" suits *Untitled*, 1972 more obviously than the second, which might better be applied to a related set of works including an early drawing of the flagstones theme (*Study for "Wall Piece*," 1968-69 [Collection the artist]) and a tripartite painting of the hatchings theme (*Scent*, *1973-1974* [fig. 35]). In such works, identical sections of pattern appear at either side of the division between two panels. In contrast, in the flagstones panels of *Untitled*, 1972, the repeated sections of pattern lie at a remove from the division.

31. One could claim that the convention of reading from left to right renders the oil panel prior to the encaustic. Or one might argue that the encaustic must have priority because this is the medium most clearly identified with Johns, the one he prefers. The two claims become very weak, if only because both have some merit and yet contradict each other.

32. For example, see *Scent*, 1975-1976 (fig. 35), a combination of lithograph, linocut, and woodcut. A most interesting case is the lithograph *Hand*, 1963, in which two imprints of the artist's right hand appear, reversed in relation to one another. One lithographic imprint was made with a soap medium and the other with oil. In a statement of 1978, Johns seems to play down what I shall be emphasizing, the divergences of the prints after *Untitled*, 1972 from the original painting: "In the *Untitled* prints...aspects of the painting to which they refer seem to be illustrated or pointed to. Perhaps one senses that one is looking at one thing which is about another thing;" Geelhaar, *Jasper Johns Working Proofs*, 47. Johns does, however, describe this kind of pictorial reference as a "distancing."

33. A "shot" of black pigment (comparable to that seen on the small hinged canvas attached to *According to What*, 1964) appears superimposed on both variants of the torso etching, as if to set the figure of the cast "behind" a transparent picture plane.

34. Beckett is himself the translator of his French prose into English. One of the most complex of Johns's etchings, *Words (Buttock Knee Sock...)*, consists of the English labels for his casts juxtaposed to their French equivalents; see Richard Field's discussion of this etching in his essay in the present catalogue.

35. Johns's casts of face and buttocks offer comparable deviant viewpoints. All of these casts can be compared to Duchamp's *With My Tongue In My Cheek*, 1959, which combines the incongruous "perspectives" of drawing and relief.

36. Perhaps this lesson is illustrated by a number of Johns's paintings and prints of the late 1970s and early 1980s in which one of his familiar motifs transforms itself into, or is exchanged for, another of his motifs. For example, in *Celine*, 1978 (fig. 41), hatchings become handprints; see James Cuno's reading of this transformation in his essay in the present catalogue.

37. On the matter of convenience and the problem of constructing a critical history of art, see my, "On Criticism Handling History," *Art Criticism* 3 (1986): 60-77.

38. There is correspondence with an argument I have made concerning photographic representation, which I regard as catachretic as opposed to metaphoric — anamorphosis zero-degree is to anamorphosis as catachresis is to metaphor. See my, "Phototropism (Figuring the Proper)," *Studies in the History of Art* (forthcoming, 1987).

39. André Warnod, "En peinture tout n'est que signe, nous dit Picasso," *Arts* 22 (29 June 1945): 4.

40. Indeed, one of the artist's biographers decides that "magic" rather than "genius" must be the proper term to describe Picasso's mastery; see Antonina Vallentin, *Pablo Picasso* (Paris: A. Michel, 1957), 449. "Genius" can be associated with finding and "magic" with making. On finding and making in modernist practice, see my, "Making a Find: An Argument for Creativity, Not Originality," *Structuralist Review* 2 (Spring 1984): 59-80; and my, *Cézanne and the End of Impressionism* (Chicago: University of Chicago Press, 1984), especially, 225-226.

41. This is as true of Johns's sculpture as of his painting; hence the relevance of contrasting the spirit of Johns's practice to Picasso's metamorphosis, exemplified by a sculpture, *Bull's Head*. Despite the difference I am stressing, Johns draws much from Picasso; see Judith Goldman's introduction to *Jasper Johns: The Seasons*, n.p. It might also be argued that Picasso's collages share many of the postmodern features of Johns's paintings.

42. Jasper Johns, referring in particular to targets and flags, in Walter Hopps, "An Interview with Jasper Johns," *Artforum* 3 (March 1965): 34.

43. Modernism's center(s) must be conceived as multiple since every self becomes an authoritative origin. Modernist art thus becomes the *collective* signification of individuality.

44. Geelhaar, *Jasper Johns Working Proofs*, 39.

45. For example, see Roland Barthes, "From Work to Text," *Image, Music, Text*, trans. Stephen Heath (New York: Hill and Wang, 1977), 161-163.

46. Paul de Man, *Allegories of Reading* (New York: Yale University Press, 1979), 107-108. Johns's professed intellectual affiliation is to Cage, Duchamp, and Wittgenstein (to whose theories Johns's practice clearly relates), rather than to the poststructuralism of Barthes or de Man. For a discussion of de Man's study and its application to the art of Johns, see Andrew Bush's essay in the present catalogue.

47. Jasper Johns, in Bernard and Thompson, *Vanity Fair*, 65.

48. Jasper Johns, "Sketchbook Notes" (1965), *Art and Literature*, 192.

Present, the Scene of...Selves, the Occasion of...Ruses

Fred Orton
The University of Leeds

*Such things run through my work, relationships of parts and
wholes. Maybe that's [a] concern of everybody's. Probably it is,
but I'm not sure it is in the same way. It seems so stressed in my
work that I imagine it has a psychological basis. It must have to
do with something that is necessary for me. But of course it is a
grand idea. It relates to so much of one's life. And spatially it's
an interesting problem. In painting, the concern with space
can be primary...the division of space and the charges that
space can have...the shifting nature of anything...how it var-
ies when it's taken to be a whole and when it's taken to be
a part.*

–Jasper Johns[1]

A photograph taken some-
time in 1975 or 1976, when Jasper Johns was at work on
Foirades/Fizzles, shows Johns and Samuel Beckett at either
end of a sofa with lot of space between them (fig.1). The space
in the photograph should remain space: it is the space this
essay occupies. Beckett and Johns should be brought no closer
together than they are there, in the same frame but engaged on
largely separable and differentiable projects. *Foirades/Fizzles,*
which contains five texts (or Fizzles) by Beckett and thirty-
three etchings by Johns, was not the product of any collabora-
tive effort by either of its "authors." They didn't know each
other before the idea of making a book together was suggested
to them by the Petersburg Press, and they probably don't know
each other now.

In 1972, when he was first approached about working
with Beckett, Johns was working on the large, four-panel
painting, *Untitled,* 1972 (color plate II). The painting had occu-
pied him for much of that year and would continue to preoc-
cupy him for years to come.[2] Obsessed as he was with making
and remaking the painting, Johns was predetermined to use it
in 1975 when he turned to the project that became *Foirades/*

Fizzles: all of the etchings in *Foirades/Fizzles*—with the exception of the numeral preceding each Fizzle and a two-page spread of *Words (Buttock Knee Sock...)*—are based on *Untitled,* 1972.[3]

Therefore, my interest is with the painting and the readings which may be written for it. For throughout the making of *Foirades/Fizzles,* Johns's primary concern remained with *Untitled,* 1972 and with what he could do with *it.* The *Foirades/Fizzles* project was a kind of occasion to do something, or to continue doing something he had already started to do, but it was not a determining occasion. And given that Johns cuts up *Untitled,* 1972 for *Foirades/Fizzles*—continues fragmenting what is already fragmented—that process, and the association of other bits of his work with it, has to be seen as not *"of"* Beckett's texts, but *"of"* the painting and what it is *"of."*[4]

II

Untitled, 1972 is a painting of surfaces, four of them bolted together to make one. It begins with marks (a painted surface insisting on the fact of its flatness) and it continues with a series of abrupt transitions from panel to panel, facture to facture, image to image, ending with something quite unlike that which began it: a surface below but in front of it, objects palpable and human.

The surface of the first panel, oil on canvas, is a network of hatched green, orange, and violet lines on a mostly white ground. Parallel to each other and in bundles of three to nine, these lines mark the surface in changing directions. There is something mechanical in the precision of their placing. Maybe there is some underlying scheme governing color and number, some mirroring and symmetry. Maybe there isn't. Maybe we're merely supposed to think that there is. It looks like changing-your-mind painting, but it isn't. Here and there some overpainting, white usually, redefines an interval or area, or just *is.* Whatever else this hatched pattern is doing, it is being used to make a surface. Each bundle attracts attention to its own identity as a pictorial technique for crossing the canvas from edge to edge pressing out everything flat and even. Johns has said that he derived the motif from a car which once passed him by on the Long Island Expressway. "I was riding in a car, going out to the Hamptons for the weekend, when a car came in the opposite direction. It was covered with these marks, but I only saw it for a moment, then it was gone— just a brief glimpse. But I immediately thought that I would use it for my next painting."[5] This panel was that painting.

Next, a panel of flagstones in oil. By 1972 this pattern had been in Johns's repertoire of surfaces for five years. Johns's story about finding this motif occurs in several versions; this is Michael Crichton's:

Johns was taking a taxi to the airport, traveling through Harlem, when he passed a small store which had a wall painted to resemble flagstones. He decided it would appear in his next painting. Some weeks later when he began the painting, he asked David Whitney to find the flagstone wall, and photograph it. Whitney returned to say he could not find the wall anywhere. Johns himself then looked for the wall, driving back and forth across Harlem, searching for what he had briefly seen. He never found it, and finally had to conclude that it had been painted over or demolished. Thus he was obliged to re-create the flagstone wall from memory. This distressed him. "What I had hoped to do was an exact copy of the wall. It was red, black and gray, but I'm sure that it didn't look like what I did. But I did my best...If I could have traced it I would have felt secure that I had it right. Because what's interesting to me is the fact that it isn't designed, but taken. It's not mine."[6]

The flagstones were first used by Johns in his painting of 1967, *Harlem Light* (Collection, David Whitney), but the surface of *Untitled*, 1972 most resembles the variation devised for *Wall Piece*, 1968 (Collection the artist).

Next to this panel, another of flagstones, this time in encaustic. What little transition there is from one flagstones panel to the other is in the manner of a mismatch of two halves which don't quite fit together to make a whole. Crichton pointed out that "if, in your mind, you move the right-hand flagstones panel midway over the left-hand panel, you get a contiguity—a matching—that actually implies a secret square in the middle of it all."[7] Two lavender-pink brushstrokes, one on top of the other, mark the surface of the right-hand flagstones panel and dribble down it.

Lastly, another encaustic surface, and the wax casts: a female face in profile (no eyes); a foot on a black sock and a hand next to it, both on floorboards; a buttock; a knee; a female torso, breast, and navel; the back of a leg, calf, and heel; and feet in green sling-back shoes, ankles crossed. Fragmented body parts have appeared in Johns's work since the mid-1950s, in plaster and individually boxed in *Target with Plaster Casts* and *Target with Four Faces*, both 1955 (figs. 14 and 19); in wax and attached to the canvas by way of a fragment of a chair in *Watchman* (figs. 23) and *According to What*, 1964 (color plate I), and bolted into place on *Eddingsville*, 1965 (Museum Ludwig, Cologne) and *Passage II*, 1966 (Harry N. Abrams Family Collection, New York). In *Untitled*, 1972 they are fixed to battens and held in place by wire netting, bandages, and dollops of wax. The changes made as Johns worked on this panel have been recorded by Roberta Bernstein:

(1) blank canvas ripped in two places revealing stretcher bar and wall behind canvas (March 10, 1972); (2) some casts made (May 13, 1972); (3) Johns replaced the torn canvas

with another blank, brown canvas and silkscreened two white targets on it, one whole and one cut off at the lower edge (June 7, 1972); (4) boards with anatomical fragments attached to canvas over targets, bits of colored paper marking each board (June 7, 1972); (5) targets covered over with layer of encaustic in bright colors;...(6) canvas now painted in gray encaustic; numbers and letters stencilled on boards (July 2, 1972); (7) canvas painted beige (August 1972).[8]

Two objects have imprinted the surface of this panel: the rim of a can and the sole of an iron (part of which also marks the encaustic flagstone surface). Both imprints have a history in Johns's work going back, respectively, to *Field Painting*, 1963-64 (Private collection) and *Passage*, 1962 (fig. 51). That will do as a description.

 Untitled, 1972 met its first audiences at the Whitney Annual in the spring of 1973. One cannot generalize what they made of it. According to Richard Field, only Thomas Hess was prepared to engage with it publicly at the time, in print. Initially he did little more than I've just done. He described its surfaces, their media and imagery; he noted its reflexiveness to Johns's studio practices and drew on explanations provided him. But he also pointed out how Johns "seemed concerned with preserving memories and re-evoking lost experiences" by painting these "glimpses of Harlem and of Long Island that have haunted him, bits and pieces of four or five friends."[9] I must say I find the idea that Johns refers to his studio practices relatively uninteresting, and a relatively uninteresting practice *per se*. Modern artists can't exclude art history from their project, and most choose consciously to carry their own art history with them, continually making reflexive paintings: paintings of their studios. Johns's *oeuvre* is full of studios. But what is more interesting about his practice as a studio painter is that it periodically becomes necessary for him to make a studio painting as an index of his practice in order to sort it out, to understand what he is doing and why and whether he should go on doing it. This I take it was the point of *Field Painting*, as it is of *Untitled*, 1972. But these paintings are not just practical or technical critical histories. They are also moral histories in that they refer to Johns's character and conduct, to the character and conduct of others, to actions, events, and feelings.[10]

 I would like to think that Hess had something of this in mind when he referred to the surface of *Untitled*, 1972 as a "metaphorical scaffolding" into which Johns had "slotted autobiographical elements."[11] However I think Hess got the trope wrong. Generally explainers of modern art write meanings for paintings (or bits and pieces of paintings) as metaphors without giving much thought to what or how metaphors mean. Most of the time all that is meant when it's asserted that something is a metaphor—is to be read metaphorically—is

that it has in addition to its literal sense or meaning another sense or meaning. Metaphors offer the line of least resistance to explainers who are thoughtless about the subtleties of figuration. It seems to me that Johns's trope is very much *not* metaphor. I would prefer to see *Untitled*, 1972 in terms of metonymy, its surface as metonymic, and its elements as metonyms and synecdoches.

III

Metonymy seems to have had its day. Metaphor is the fashionable trope among those who study rhetorical and figurative aspects of language. Metonymy, however, needs to be recovered if *Untitled*, 1972 is to be questioned about its order, the arrangement of its hatchings, flagstones, and body fragments, and how that order and those surfaces might articulate and enable the production of meanings.

According to Roman Jakobson, who discussed metaphor and metonymy in a purely linguistic analysis of aphasia, language functions because of the association between the participants in the speech event.[12] The separation between the addresser and the addressee is bridged by an internal relation which is one of equivalence between the symbols used by the addresser and those known by the addressee. Without this equivalence, the message will be more or less meaningless. In order for the meaning of an utterance to be understood there must be a common code permitting encoding and decoding by the addresser and addressee. In terms of the "language of art," we might say that the artist and the viewer have the same set of prefabricated representations with the same—or almost the same—relations holding between those relations. The artist selects one or more of these preconceived possibilities, uses them in his or her work, and the viewer is expected to make an identical or nearly identical choice from the same range of possibilities already foreseen and provided for. This is, in a sense, the common code of the artist and viewer. However, it is not enough to know the code in order to understand the message. One needs to know the context which provides the necessary area of associative reference upon which intelligibility depends, and which comprises two relations. The components of any message will be linked with the code either by an internal relation of equivalence, or with context by an external relation of association. For Jakobson, metaphor and metonymy present the most condensed expression of these two basic modes of relation. Underlying metaphor is the internal relation of similarity and difference; and determining metonymy is the external relation of continuity and remoteness.

Metaphor is based on a proposed similarity or analogy between the literal subject and a subject substituted for it.

It invites the perception of a similarity between two otherwise quite distinct fields of meaning such that the sense of distance between them is preserved in the act of imaginatively leaping across it. If it's successful, a metaphor makes us attend to some likeness, often novel or surprising, between two or more things. The idea is that in metaphor certain words take on new or what are often referred to as "extended" meanings. Usually a metaphor is easily understood because the metaphoric associations, the links between the literal subject and its metaphoric substitute, are alive in culture. This is the conventional and familiar wisdom which has been much discussed and debated recently.[13]

Metonymy is based on a proposed continuous or sequential link between the literal object and its replacement by association or reference. It's the record of a lacuna, of a move or displacement from cause to effect, container to contained, thing seen to where it was seen, goal to auxiliary tool. The metonymic processes are reduction, expansion, and association and these represent historical continuities and relations of experience in particular *exempla*. Closely related to, and taken as a kind of species of metonymy, is synecdoche where the part is referred to by the whole, or the whole is referred to by the part, or something omitted is referred to by what is included.[14]

Jakobson noticed the aptness of metonymy for the expression of repressed wishes and saw it at work in the censored letters of prisoners speaking about their privation and desire.[15] With metonymy the move is escape. It represents not the object or thing or event or feeling which is its referent but that which is tied to it by contingent or associative transfers of meaning. In this way metonymy permits the utterer to bypass obstacles of social censure including those which are consciously or unconsciously self-imposed. Thus metonymy accords a kind of privacy to language; but only a *kind* of privacy. There can be no such thing as wholly private language, possessing totally individualized and isolated meanings. Even the most private metonymy is public insofar as it is a language, a communication, has a history. It can therefore be pursued along its associative chain to the moment of its constitutive production, which will, in principle at least, reveal its meaning and reference.

Untitled, 1972 is structured metonymically. It is a series of fragments, bits of surfaces, parts of the human body, traces of objects. Each pattern, object, imprint is tied by the association of ideas and values to something else: reflexively to Johns's own work, to events and objects in New York, and, as we'll see, to the work of other artists and other ideas and associations. I would argue that Johns has, since the mid-1950s, largely denied himself the metaphoric mode, refused the idea of representing or painting signs or gestures which are to be interpreted as metaphorically expressive. This is not

to say that he has denied himself the "use" of the "look" of metaphorically expressive painting, or that he has not invoked ideas of, for example, cancellation or erasure metaphorically in ways which might be quite important for his meanings. He hasn't. However, whatever it was—and maybe still is— that Johns wanted to represent or express, it seems that he could find no metaphors for it in the tropes of then-public art. Either that, or he did not want to represent or express it metaphorically.

IV

Johns's disposition towards metonymy has to be seen as *"of"* Johns, who, socially producing art, attempts consciously or unconsciously to escape socially produced self-censure by making paintings which resist, evade, or control the interpretations and meanings which can be produced for them. Keeping in mind the mechanism of metonymy, one can understand how and why it is that the surfaces of his paintings—the surfaces which *are* his paintings—often seem to hide or conceal expressive content or subject matter. Their highly developed busyness attracts the viewer's attention and distracts the inquiring mind. They seem to hide the subject, give the viewer something to find, and keep explanation cutaneous.

I have already suggested that the surface of *Untitled*, 1972 might be made of metonymic relationships. So in discussing what it might mean, I must be discussing some transfer of properties not originally or naturally possessed by what is depicted. In other words, I must be considering not *what* is depicted but *how* and by reference to *what* that depicting is done. This will entail causal as well as hermeneutical inquiry into both the conditions of production and consumption and the complex genetic history of imagery which itself will be a history of transformations. That is, such an inquiry will not merely be a matter of connecting some image back to that which it iconically (descriptively) corresponds to in the world in order to see how it has been reworked according to the interests of artistic style. Rather, it will require the articulation of the complex and heterogeneous constellation of conditions within which the genetic history of a surface—or a bit of a surface—a figure fragment, a brushstroke, or an imprint goes back into a world of events and feelings. It will also have to acknowledge that no one such history closes off inquiry into any other. Tracing a brushstroke back to other brushstrokes in other paintings, or an imprint back to an object made by another artist, in no way disqualifies the claim that they are somehow expressive of, or refer to, some specific event or feeling. Rather, the reverse: such specific references are part of

the larger field of context which much exist for the possibility of meaning to be glimpsed.

Not everything that makes a Johns surface need be seen as a metonym or synecdoche. Metaphor is also present. Also, the existence of a brushstroke here or an imprint there might well be contingent on making the surface, on the need to assert surfaceness tastefully with some color or other, or with a certain shape or line. But it seems safe to assume that a mark or brushstroke like the crossed lines, the air-brush impact-spray and run, or the lavender-pink brushstrokes and the imprint made with an iron or a particular can, have not recurred merely as useful formal devices. My speculation, here, is that these repeated formal devices are discrete metonyms or synecdoches in a private language; at least as "private language" is colloquially understood as an exclusive, socially-closed linguistic mode rather than an inclusive, socially-open one. They contribute to the composition of more or less socially-open surfaces. But at another level they signify concepts privy only to Johns and a few close friends who know the contextual field and are in relation of association to adopt the appropriate cognitive style.

There is, then, in Johns's work a conventional tension between private and public, between meaning available only to those who have access to the socially-closed code and the larger community which understands and admires Johns's vivid surfaces. What happens to the socially-closed meaning when the painting moves from "private" to "public," when it's exhibited, sold, reshown, reproduced, and discussed in the literature of art? What happens to the private meaning when a painting enters into the public exchange of money and meanings? It enters a community unable to describe or explain it adequately because that community's mode of inquiry and explanation—Modernism—is also socially closed.[16] Modernist criticism and history is comprised of all kinds of interpretive closures like those which work to restrict inquiry and explanation to surface rather than subject, composition rather than signification, style and influence rather than conditions of production and consumption.

So my inquiry starts out from and operates within these two closed spaces of private and public meaning. And in effect I have to admit that these two spaces can't be plausibly fitted together to produce an adequate or coherent account of *Untitled*, 1972. However, I can undertake an inquiry which goes towards opening up the private code by trying to reconstruct the contextual field; to inquire into the significance of hatchings, flagstones, fragments, and imprints, and to establish contiguities which match contexts of use to what can be learned of the world in which they are used. I might then be able to re-pose private and public in a different register. My account will be in a kind of oscillation between the individual and cultural, private and public. These categories will be in a

more viable form because interposed between them will be the relevant coherence of an interpretation located in mechanisms of reference and association, in the trope of metonymy mediating private and public. To justify the relevance of this project I have to go back to two earlier moments of Johns's work: 1954 to 1955 and 1961 to 1962.

V

It's become commonplace to say that Johns emerged as an artist in 1954-1955 with *Flag* (fig. 54), or that his mature work begins with it. He didn't, and his art doesn't. But *Flag* will do as a first painting so long as we bear in mind that this idea—produced by and for Johns and then taken up in criticism and history—of a finished artist sprung from nowhere is dubious, to say the least. *Flag*, a flag and tediously a visual metaphor, has subject matter. It also has an odd surface: pieces of paper and cloth were dipped into hot encaustic wax (colored) and fixed, before solidifying, to the canvas ground. With obvious calculation Johns reintroduced the cultural element which the typical Abstract Expressionist had excluded from painting and produced an "American-Type" painting par excellence: holistic, two-dimensional, with no hierarchy of forms or focus.

The painting which Johns made directly after *Flag* was *Target with Plaster Casts*, 1955 (fig. 14). The main area, concentric bands of blue and yellow set into a square field of red making a kind of neutral target devoid of values and associated with no aim, is also made of encaustic collage. But attached to it, affixed to the top stretcher, is a row of boxes which contain—all but two of them—plaster casts of fragments of the human figure. *Flag* and *Target with Plaster Casts* are usually discussed in terms of their "similarities" as surfaces—the figure fragments regarded as taking a secondary role in the arrangement—and "ready-made" images, "things the mind already knows." I see the two paintings as more significantly distinct. In what Johns wants them to be taken as, and what Modernism takes them to be, his first two mature works—one could say his "masterpieces"—he posited alternative directions to follow. To put it crudely, *Target with Plaster Casts* has a kind of subject matter which inescapably evokes the artist himself; it is also, with its *corps morcelé*, a very loaded image interpellating the psychologist in most Modernist critics and historians.[17] What is of interest here is both the disposition such an enterprise as *Target with Plaster Casts* represented and the reason for the apparent rejection of it in the character of Johns's work over the rest of the decade.

The artistic culture of the mid-1950s in New York has by now been characterized well enough in terms of its distinctiveness from, even reaction against, the culture of the Abstract

Expressionist generation.[18] The difference may not have been that great, but it seems to have been there and represented, for example, in the general apolitical—though not depoliticized—demeanor of social and artistic practices and changes of image and sexuality. If the art historians and gossips have got it right, the self-professed male avant-gardist of the 1950s was likely to be slender, cerebral, philosophical, iconoclastic, and physically and intellectually very different from the Abstract Expressionist. He had a dandy-like elegance of body and manner, delighted in cool and elegant plays of the mind, and was probably homosexual, bisexual, or experimenting with his sexuality. That description, for the most part taken from Moira Roth, can be and is applied to Johns, and to John Cage, Merce Cunningham, and Robert Rauschenberg as members of one socially-closed group among several others in the comparatively socially-open sub-culture which was the New York artistic culture in the 1950s.[19]

It is not my intention here to attempt a sociological account of the New York culture of Johns's generation. It is important, however, to establish some plausible characteristics and tendencies of that culture which will at least serve to relate it to its comparatives. I would propose a tendency to the private exchange of meanings and a matching cultivation of public euphemism and irony; a withdrawal from prevailing forms of self-identification in social behavior (including those which structure sexual relationships); a stance of public indifference towards those issues which invite the parading of commitment and belief; and a protective solidarity between intimates. We need not forget the historical conditions in which this apparent withdrawal was made: the burgeoning of an artistic culture which was geographically and stylistically more diffuse and diverse than any previous artistic culture in New York, accompanied by an enormous increase in public awareness of it; and a pervasive climate of repression including the burning and banning of books in U.S. libraries around the world, the jailing of Communist Party members for "conspiring to teach," the legal establishment of "detention" camps for "subversives" in times of "national security," the censorship of art works in the U.S., the denial of U.S. travel visas to left-wing artists and intellectuals, the congressional intimidation of film-makers as well as writers, and the framing and execution of Ethel and Julius Rosenberg.[20] Here it's important to avoid that form of idealization of the artist which identifies a constant type against a changing background. Different historical and cultural conditions offer and impose the identification "artist" on very different kinds of persons. The "artist" as well as "art" is a socially produced category. In the 1950s in New York the idea of "art" and how it should be made, as well as the idea of what kind of identity "artist" was, and what his or her responsibilities were, were subjects of debate, serious ambition, recategorization, difficulties, and obligations.

One difficulty which seems to have been more of an issue for Cage and Cunningham, Rauschenberg and Johns than for others was how they could, in the pursuit of an expressive but not expressionistic character for their art, arbitrate between the conditions of individual (private) life and the social (public) conditions of art. Hence their concern with and conversation about self-expression and expression, intention and non-intention, subject and object, determinacy and indeterminacy;[21] life (and the gap between it) and art;[22] seeing "it" and painting "it" and painting "it" and seeing "it."[23]

In effect Johns opted for *Flag* and the direction it suggested, withdrawing for the rest of the 1950s from the dangers—real or imagined—of self-exposure which could be identified in the *Target with Plaster Casts*. *Flag* seems to have been understood as nothing more or less than a well-known visual metaphor, not *"of"* Johns at all, except in so much as he fabricated it in art. Wherever it came from, the residue of the day or the lower depths of childhood, the flag was dreamt at the right time and place to function as an appropriate image in art. It resolved or circumvented the antinomies of Modernism, the seemingly antinomic or contrasted concern with surface and subject, by posing the question, "Is it a flag, or is it a painting?"[24] In so doing Johns managed almost completely to distract attention from whether it should or could be read as an endorsement or criticism of a certain kind of patriotic sensibility.[25] *Flag* sign-posted a direction to follow which seemed almost Wittgensteinian, philosophically and personally neutral.

In 1961 Johns's subject matter and mode of representation changed. After the frequent high coloration of the previous years, the works from this moment are subdued in color. They are predominantly gray, and titled to connote emotional conditions like dishonesty, anger, denial, negation, or rejection, feelings lost or recalled. I shall consider two of these paintings, *No* and *In Memory of My Feelings—Frank O'Hara*, both of 1961 (figs. 30 and 31).

In *No* the letters, cut from soft metal, are suspended from a straightened coathanger attached to the surface by a screw. In the top left corner the base of one of a bronze edition of Marcel Duchamp's *Female Fig Leaf* has been pressed into the surface and drawn around. There's a story to the effect that Johns was amused with the idea that "no" in Japanese means "of," and that in *No* the suspended "no," its imprint, and shadows are *"of"* the canvas and each other. With this information we could approach the painting by attending to its surface and the relations between levels of representation. *No* has been taken "to write a new role for the picture plane: not a window, nor an uprighted tray, nor yet an object with active projections in actual space; but a surface observed during impregnation, as it receives a message from real space." "In many ways the word NO seems to caution the observer from jumping to conclusions about the nature of what he is

Fig. 30
NO, 1961
Encaustic, collage, and sculpt-metal
on canvas with objects
68 x 40 inches
Collection the artist

seeing." "'No' is a pun of 'know,' referring to the importance of the conceptual aspect of Johns's work." For Cage, "Someone must have said YES (NO), but since we are not now informed we answer the painting affirmatively."[26] The point is not that such speculation is necessarily informative, but that the almost irresistible invitation to engage in it is *distracting*. Such distraction—induced by the mechanisms of surface—may on one level be what Johns intended.

However, if we focus on mechanisms of surface as subject and ask what it means to quote Duchamp's *Female Fig Leaf* and to do so in relation to the negative "no," we are obliged to consider a work concerned not so much with the production of a vivid, diverting surface, as with the signification of a vivid, perplexing subject. The imprint does not just mark the surface: there is an existential bond between it and its object (a cast which seems to have been taken from the female genitals), and between its object and that from which it was taken (a female body or a representation of a female body). The imprint is a sign which might function metonymically with reference to what the cast reproduces, and even to how in its making it closed the female (negated an area of sexual desire). This is one chain of contiguity which may be produced for the delineated imprint in *No*. It might also refer to—and probably does—the time and place, circumstances and events associated with Johns's acquisition of his *Female Fig Leaf*. In this sense it's a souvenir of a trip to Paris in 1961, of events and feelings, of what caused the visit, and what its effects were—among which we may include the imprinting of *No*.[27] I know the sign is arbitrary, but I also know there is a cultural route from the non-arbitrary trace to the culturally produced sign.

The other painting I want to consider is *In Memory of My Feelings—Frank O'Hara*, 1961 (fig. 31). The title, which is stencilled along the bottom of the painting, refers to a poem by Frank O'Hara written in 1956, published in 1958, and anthologized in 1960.[28] O'Hara was a figure of frenetic centrality in the artistic culture of New York in the 1950s and 1960s, a poet (primarily) and playwright, a chronicler of art and collaborator with artists.[29] Though his friendship with Larry Rivers was and probably still is the most public, his closest friendships were with Joe LeSeur, with whom he lived between 1955 and 1965, and Vincent Warren, the object of the *Love Poems* written between 1959 and 1961. O'Hara also loved and was loved by two women, one of whom, the painter Grace Hartigan, is the dedicatee of the poem "In Memory of My Feelings."

O'Hara and Johns were friends from the late 1950s until the poet's death in 1966. In 1959 O'Hara was writing to Johns about Jack Kerouac's *Doctor Sax*,[30] recommending him to read the work of Gary Snyder, Philip Whalen, and Michael McLure, and comparing Robert Duncan and Charles Olson as West Coast and East Coast poets.[31] Johns turns up in O'Hara's poetry: with O'Hara and Vincent Warren entraining to a week-

Fig. 31
*IN MEMORY OF MY FEELINGS—
FRANK O'HARA, 1961*
Oil on canvas with objects
40 x 60 inches
Stefan T. Edlis Collection

end party at Janice and Kenneth Koch's (where O'Hara will fall in love with Warren);[32] O'Hara "zooming downtown" to see Johns;[33] and Johns in South Carolina, recalled by O'Hara in New York.[34]

Even though *In Memory of My Feelings—Frank O'Hara*, 1961, cannot be interpreted as an *in memoriam* for O'Hara—it was painted some five years before the poet's death—it may well have enabled Johns to make a painting which represented or expressed his own feelings; something he had not been able to do, apparently, since *Target with Plaster Casts* of five years earlier. Reading *In Memory of My Feelings—Frank O'Hara* as a surface of metonymic relationships can produce a painting which represents or expresses Johns's feelings by way of reference to the poem and its author. The poem "In Memory of My Feelings" is an inventory of feelings.[35] It is not a poem recalling events; nor is it about what has happened. What is being remembered by the poet is how he felt, or how he feels about what he felt when something happened. The central theme is the fragmentation and reintegration of the inner self. New feelings generate new selves. And from the poet's many selves a vision of an essential self emerges which is determined to escape fixed limits. Images of death recur throughout the poem which concludes with what the poet regards as a necessary death in order that the poet's true self can survive:

> And yet
> I have forgotten my loves, and chiefly that one, the cancerous
> statue which my body could no longer contain,
> > against my will
> > against my love
> become art,
> > I could not change it into history
> and so remember it,
> > and I have lost what is always and everywhere
> present, the scene of my selves, the occasion of these ruses,
> which I myself and singly must now kill
> > and save the serpent in their midst.

Johns's *In Memory of My Feelings—Frank O'Hara* does not illustrate but refers to O'Hara's poem: none of its imagery is represented in the painting. And by referring to it, the painting alludes contiguously to its main themes of feelings remembered and metaphorical deaths of selves or the self.

A "DEAD MAN" is stencilled in the lower right. Though relatively large, the words are difficult to see because they have been almost obliterated by busy gray brushstrokes. With this "DEAD MAN," Johns returns, albeit referentially, to figuration after years of painting flags and targets, numbers and letters. Cage concluded an essay on Johns with a quotation, a note from one of Johns's sketchbooks: *"A Dead Man.*

Take a skull. Cover it with paint. Rub it against canvas. Skull against canvas."[36] This note relates the "DEAD MAN" in *In Memory of My Feelings—Frank O'Hara* to the paintings *Arrive/Depart*, 1963-64 (Private collection, Munich) and *Evian*, 1964 (Private collection), to the screenprint *Untitled (Skull)* of 1973 (with its erased signature), and the *Tantric Detail* paintings of 1980-81 (all, Private collection). In addition, the relations were made through four drawings Johns executed in 1962 by covering bits of himself with oil and pressing against sheets of drafting paper which were then dusted and rubbed lightly with powdered graphite. One of these, *Study for Skin I* (Collection the artist), eventually provided the prototype ground for the poem "The Clouds Go Soft," in the lithograph *Skin with O'Hara Poem*, 1963-65 (fig. 32). The poem can be read as a meditation on the inexorability of fate, its "holes" to be understood metaphorically not as "armholes" but "graves."[37]

But why the fork and spoon, bound together, used, suspended on the wire screwed to the top of the painting, *In Memory of My Feelings—Frank O'Hara?* Are they connected by some family resemblance to the other household objects— the beer can, the coffee can, the coat hanger, torch, and light bulb—which find themselves in Johns's studio and thence in his art? Or do they signify in some more distinctive sense? I should make it clear that to ask such questions is not to invite a reply which organizes Johns's practice into a rational iconography. The point is rather that coherence might be found in the underlying mechanisms of reference, association, and displacement.

In 1967 Johns illustrated O'Hara's "In Memory of My Feelings" for a posthumous edition of a selection of his poetry published by The Museum of Modern Art, New York.[38] The principal illustration is of a place setting: a knife, fork, and spoon (fig. 33). At the end of the poem there is a single spoon (fig. 34). One of O'Hara's poems, a poem associated by him with "In Memory of My Feelings," was titled "Dig My Grave With a Silver Spoon."[39] It seems likely that there is some private set of associative meanings or references at work in *In Memory of My Feelings—Frank O'Hara* between Johns and O'Hara, Johns and O'Hara's poem, the poem and feelings felt when something happened, the poem and metaphoric death, death (metaphoric or real) and a spoon, fork, and knife; a set of moves in a language which signify to those who know the language and know how to read it.[40] To say that the spoon signifies death (of some sort) is not to say that it signifies death wherever it appears (most recently in the *Fall* panel of *The Seasons*, 1986; Collection the artist). The meaning of the cutlery, which is a leitmotiv in Johns's work after 1961, depends on the context of use in each specific work. However, the genesis of a metonymic *exempla* goes to some kind of consistency, just as the genesis of a word may be what serves to determine appropriate contexts of use.

Fig. 32
SKIN WITH O'HARA POEM, 1963-65
Published by U.L.A.E.
Lithograph
22 x 34 inches

We can now begin to reconstruct the contiguities and relations of human experience which Johns may associate with the cutlery and imprints in these paintings of 1961, and if we can do so in terms of subject rather than surface, then perhaps we can envisage doing the same for the cast fragments, imprints, brushstrokes and surfaces of *Untitled*, 1972.

I have suggested that Johns's work underwent some distinct and discernible change in 1961, and that that change entailed a shift of emphasis from the kind of work in which his initial, and considerable, success was based—the flags, targets, numbers, letters and so forth of 1954-60—to a form of emotionally expressive painting adumbrated in *Target with Plaster Casts* of 1955 but apparently rejected immediately thereafter. In speculating on the causal condition of this shift —and speculation is all it can be—I resort to the reproduction of biographical gossip. The years of 1954 to 1961 were the years in which Johns and Rauschenberg were together. The following excerpt is taken from Calvin Tomkin's biography of Rauschenberg, *Off the Wall*, published in 1980:

> Sometime in 1961, Johns began spending a large part of his time in a house he had bought on Edisto Island, off the coast of South Carolina. Rauschenberg had moved, meanwhile, from Front Street to a huge, fifth-floor loft in a commercial building on Broadway near Twelfth Street, in Greenwich Village. They continued to live together when they were in New York, but their friends felt a growing strain between them. Before, as Ileana Sonnabend once said, they had been "so attuned to one another that sometimes it was hard to tell who was who," but now Johns was guarded and withdrawn, and sometimes bitingly sarcastic.
>
> They both went up to Connecticut College in the summer of 1962, to work with Merce Cunningham, who was there under the college's dance residency program. By the time the summer ended they were no longer together. The break was bitter and excruciatingly painful, not only for them but for their closest associates—Cage and Cunningham and a few others—who felt that they, too, had lost something of great value.[41]

Here is one more bit of gossip. Johns would have known that in 1960, the year prior to the painting, O'Hara's relationship with Hartigan had ended. Marjorie Perloff notes that between 1951 and 1960 Hartigan and O'Hara "saw each other or spoke on the phone almost everyday. They frequently spent weeks—even months—together in the country...In 1960, after a major quarrel with Frank, Grace left New York, married, and settled in Baltimore. She sent him a strongly worded letter breaking off all relations. They did not see each other again for five years, and then only briefly."[42] O'Hara's

Fig. 33
Illustration for "IN MEMORY OF MY FEELINGS." A SELECTION OF POEMS BY FRANK O'HARA (New York: The Museum of Modern Art, 1967) Lithograph 12 x 18 inches Department of Special Collections, University Research Library, UCLA

Fig. 34
Illustration for "IN MEMORY OF MY FEELINGS." A SELECTION OF POEMS BY FRANK O'HARA (detail) (New York: The Museum of Modern Art, 1967) Lithograph 12 x 9 inches Department of Special Collections University Research Library, UCLA

"In Memory of My Feelings," written in 1956, may have been read somewhat differently in 1961. The intimacy between the poet and the poem's dedicatee by then terminated, the poem gained a new context for reading and a context of use which maybe Johns's utilizes. It's also significant to the analysis of the possible references mobilized in *In Memory of My Feelings — Frank O'Hara* that Johns, who was there on the first weekend which O'Hara spent with Warren in July 1959, would have known in the summer of 1961 that their love affair was ending.[43]

I assume that those who knew of and were affected by the break between Johns and Rauschenberg were potentially able to respond to paintings like *No* and *In Memory of My Feelings — Frank O'Hara* on at least two levels: they would be able to admire the mechanisms of surface and read the details as meaningful by reference and association. What is of interest here is not that such readings are exclusive but that they are publicly kept at a distance by metonymy.

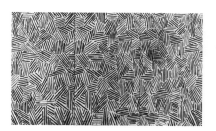

Fig. 35
SCENT, 1973-74
Oil and encaustic on canvas
72 x 126¼ inches
Ludwig Collection, Aachen

VI

As I noted earlier, the hatched surface appears for the first time in Johns's work on the left panel of *Untitled*, 1972. It's been argued that its use there, and the change of style it inaugurated, evidences Johns's late interest in Jackson Pollock and his work and that this led to, or was accompanied by, an interest in Picasso.[44] Philip Leider wrote of Pollock in 1970: "It was as if his work was the last achievement of whose status every serious artist is convinced."[45] This was particularly true for New York artists in the later 1950s and 1960s. Pollock had established American painting as something in relation to which they could establish their practice. Thanks to his legacy they were liberated from the need to go back to Cubism. They had to transcend it, and transcend it by way of Pollock. That's part of the conventional wisdom of Modernism in the late 1950s and 1960s.

Johns seems to have been the exception to that generalization. There is little sign before the early 1970s — that's to say, before he started producing the hatched surfaces — that he was interested in Pollock. Yet in 1973 he gave the first of his independent all-over hatched paintings, *Scent* (fig. 35) — an extended development in oil and encaustic of the surface in *Untitled*, 1972 — the same title as what is generally taken to be Pollock's last or penultimate painting of 1955 (fig. 36). To see the allusion as accidental would be to attribute to Johns an insouciance inconsistent with his persistent and identifiable use of this kind of reference. The title takes a knowledge of Pollock and his art practice back into Johns's *Scent* and the hatched surface of *Untitled*, 1972. It picks up on Pollock's con-

182

cern with subject. According to O'Hara, it was with *Scent* that Pollock "turned again toward his beginning and the manner of *Eyes in the Heat*" of 1946 (Peggy Guggenheim Collection, Venice).[46] I take this to mean that O'Hara thought it was with *Scent* that Pollock resumed his practice of concealing subject matter in between and under the painted activity which made the surface. The idea of concealment and various procedures of concealment, of veiling the imagery, were important to Pollock's practice.[47] They were also important for Johns, and had been for many years prior to *Scent* and *Untitled*, 1972. Both artists seem to have had in common the need to represent or express something in their paintings, then to conceal it; to depict and then cancel. With this in mind we may be alerted to the idea that what is veiled in Johns's work, as it is in Pollock's, is nevertheless alive, signifying, referring.

Taking *Scent* as a key, one may produce a reading of the hatched surface and its use in *Untitled*, 1972 as a kind of homage to Pollock, or as a reference to his concerns with or problems of surface and subject. It may also be a way of creating a lineage and history whereby Johns paints himself into a tradition while differentiating his work from it. Maybe Johns, whose currency and value in the 1970s was fast becoming established as the multinational world's "super-artist,"—as the pre-eminent artist of his generation—was painting on the assumption of coeval status or value, consciously or unconsciously producing the kind of surface which would stake his claim to that status or value.[48] If this reading is correct, if Johns was concerned to acknowledge, refer to, and equate himself with Pollock and to assert the distinctiveness of his own work, he might well have felt the need to adopt a form of holistic, flat, factitious surface as an appropriate reference. However, he would have found this difficult to achieve by means of his normal mechanisms of surface derived from Abstract Expressionist protocols and procedures. He had to "adopt" a novel means of producing such a surface, a new mechanism which would establish some distance.

Johns could not produce his all-over surface by means compatible with Pollock's, but the effect had to be more or less the same. The story of the decorated car on the Long Island Freeway is apt in this sense at least. Johns's mechanisms of surface—as he said with reference to the flagstones— tend to be appropriated rather than invented. But the story of the decorated car is dubious in another sense, because the hatched motif seems to have been appropriated not from it but, via it, from Picasso. If we can defensibly say that the use of the hatched surface and the change of style it occasioned is significant of a late interest in Pollock then there is a sense in which that very lateness renders the reference to Picasso more plausible. In the metonymic chain the mention and use of Pollock refers to Picasso, as does the mention and use of the decorated car.

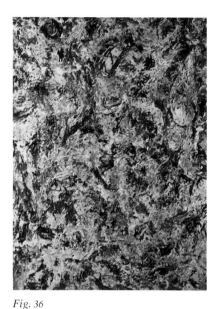

Fig. 36
Jackson Pollock
Scent, *circa 1953-55*
Oil and enamel on canvas
78 x 57½ inches
The Marcia S. Weisman Collection,
Los Angeles

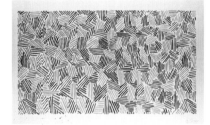

Fig. 37
SCENT, 1975-76
Published by U.L.A.E.
Lithograph Linocut, and Woodcut
31¼ x 47 inches

183

Johns's triptych *Weeping Women* of 1975 (fig. 38) provides a clue to the network of interests within which aspects of Pollock's and Picasso's work were capable of being synthesized on the same picture plane. The title refers to Picasso's *Weeping Woman* of 1937 (Private collection, England) and takes a knowledge of it and its producer back into Johns's painting. There is just enough striation or hatching in Picasso's painting to cast further doubt on the role of the decorated car as a determining factor. However it is relatively unimportant whether the hatchings are derived from Picasso's *Weeping Woman* or from his painting of 1907-09, or from the hatchings in *Women of Algiers, After Delacroix* of 1955, which, as it is in the Victor Ganz Collection, was probably closest to hand and mind in 1972. It's more important to realize why Johns should have been interested in Picasso's use of such a device particularly if I'm justified in calling attention to the surface-subject contrast in Modernist painting and to his disposition towards producing surfaces which represent or express their subject by reference and association. For Picasso, striations or hatchings were a form of autonomous decoration organizing and controlling a surface of a painting with vivid imagery (i.e., nudes, *demoiselles, femmes*). In the literature of art around the time that Johns was working on *Untitled*, 1972, this vivid imagery was being scrutinized with reference to *Women of Algiers, After Delacroix* and questioned as to why Picasso would scar and mangle, dismember and fragment the female body in the process of representing it.[49]

There are no *femmes* in the hatched surface of *Untitled*, 1972, but they are referred to. Here Johns uses Picasso's hatching to refer to the subject it surrounds or edges: the perimeter is used to signify the center. What is present refers to what is absent. In the end (literally) the fragmented figures are there plain enough for all to see, wired, bandaged, and waxed to battens over the right surface. The move from left to right is one of revelation: Johns revealing what is metonymically referred to by the hatchings taken from Picasso, and maybe veiled in the work of Pollock.

Johns's story about the decorated car now has to be seen as a feinting—though not a disingenous—retrodiction, rather than as an adequate explanation of what the hatched surface is *"of."* We may accept that the sight of the eccentrically painted car provided a link in a causal or metonymic chain. But this is far from according that glimpse a privileged status in any explanation of Johns's use of and variations on the hatched surface. It is important, however, to realize the story's usefulness to Johns as a way of talking about the hatching motif in a manner which satisfies and diverts his attention and the attention of would-be explainers from what and how the hatched surface means. The surface of *Untitled*, 1972 may perhaps best be seen as signifying some point of intersection and dispersion in Johns's thinking about Pollock and Picasso

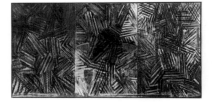

Fig. 38
WEEPING WOMEN, 1975
Encaustic and collage on canvas
50 x 102¼ inches
Collection Mr. and Mrs. S. I.
 Newhouse, Jr., New York

and the means and meanings of certain paintings by them. If so, that intersection and dispersion is a surface and subject—and an explanation of that surface and subject—rendered feasible or possible for Johns by connection with and reference to a decorated car. After *Untitled*, 1972, Johns could not only *"mention"* Picasso he could also *"use"* him.

As far as I know Johns hasn't chosen to comment on the right panel of *Untitled*, 1972 in terms of what it might mean. Here the association of body fragments and now veiled targets suggests that at some point in its genesis this panel reprised the moment in 1955 when Johns made the *Target with Plaster Casts* (fig. 14).[50] However, as we've seen, that moment was not so much periodically reprised but carried forward as an ever present, at least after 1960. The actual wax-cast body fragments used in the mid-1950s persist, not just as imagery but as metonymy; the mutilated body, at first an image, has a life in the 1960s and 1970s as a textual articulation, a figure of speech. The challenge or puzzle presented by *Untitled*, 1972—"What are these surfaces doing together?" or "What does it mean, represent or express?"—is a textual one. The ease with which the problem can be circumvented or disposed of by attending to the mechanisms of surface—identifying its "secrets" as located in the juxtaposition of its four surfaces and in particular in the hidden square formed by the oil and encaustic flagstones or else by reflexivity—evidences the efficacy of the way the dominant narrative closes down on investigation, explanation, and the production of meaning for Johns's work by burying them in the surface.

The traces of meaning on the right panel of *Untitled*, 1972 are several, and I ought to consider, once again, whether the wax casts and imprints are there merely to make the surface or—and this would be much the same strategy—to produce the illusion of meaning. All classical theories of the sign allow for the relative independence of the signifier and for its freedom in relation to its signifying function. If, for instance, there is an imprint of a can or the sole of an iron in a surface, one has to question whether that mark was generated by its property as a signifier, or by its literal or metaphorical or metonymical meanings. It is possible that the imprints have no semantic depth. I acknowledge that possibility but think, as I said earlier, that it's unlikely to be the case. The iron imprint, for example, was first used in 1962, where it seems to function as a kind of *memento mori* in the context of *Passage* (fig. 51)—one of several paintings Johns made at Edisto Island, South Carolina, in 1962 and 1963 which can be read as referring to his life circumstances and art practice and to death (real or metaphorical) by way of association with the poetry and life of Hart Crane. It's certainly much more difficult to make the case that something as vivid, emphatic, and alive in culture as the body fragmented has no semantic depth. However to say what that semantic depth is in the context of

Untitled, 1972 (specifically) and Johns's work (generally) is problematic.

No one is in a position to provide a secure reading of *Untitled*, 1972. How could it be proven? And how could the proof be proven? The production of meaning is social and institutional, differential and dispersed, contestable and continually renewed. All I've been doing is producing possible meanings for some surfaces on the reasoned assumption that we should read them metonymically as meanings evoked by other surfaces, poems, authors, events, and feelings, and defined by even momentary contiguities in time and space. It's in the spirit of this kind of critical inquiry that I refer to some paintings by René Magritte as a means of linking the right panel of *Untitled*, 1972 to the other three panels and the flagstones to the wall in Harlem.

Johns's interest in Magritte is attested to by his ownership of *The Key of Dreams* of 1936. In Magritte's painting *Find the Woman!* of 1928 (Collection, E.L.T. Mesens, Brussels), a naked figure of a woman is embedded, together with four large hands, in a wall of eccentrically shaped and placed stones not unlike—but not that "similar" to—the flagstones of *Untitled*, 1972.[51] "Flagstone" facades appear in other paintings by Magritte from the late 1920s and early 1930s, such as *The Six Elements* of 1928 (Philadelphia Museum of Art, Louise and Walter Arensberg Collection) and *On the Threshold of Liberty* of 1929 (Museum Boymans-van Beuningen, Rotterdam). These are paintings of accumulated and seemingly unrelated surfaces; fragments of things. Some fragments appear more often than others—like the flagstone facades, a fragment of blue sky with clouds is an other constant element —usually in relation to a female torso, breasts, and navel.

As with the hatched surface of *Untitled*, 1972, the flagstones panels are not part of some mechanical action by contact, a painted storefront seen while driving through Harlem, or even a simple case of "influence." Rather, they exploit the fortuitous and exploitable sighting of a wall in Harlem to refer to, and produce meanings from, certain paintings by Magritte. More to the point: by referring to the Harlem wall, Johns could exploit reference for representational or expressive aims and do so obliquely by means of the Modernistic plausibility of his surface and his account of its genesis. The wall in Harlem was adapted, not invented, to refer to Magritte's paintings, paintings in which a wall similar to that one in Harlem—"similarity" is all right on the streets— surrounds or is associated with the female and with the female fragmented.[52]

I have to acknowledge that I have no explanation to offer of the meaning of *Untitled*, 1972. However, it is perhaps not entirely fanciful to suggest that "Find the Woman!" or even "Find the Man!" is a relevant pursuit in front of many of Johns's paintings. The end of such a search is likely to be a

fragment, *corps morcelé*, negation, *rature*, or a surface. This is not simply what may be seen as represented or expressed by individual paintings; it is also the mechanism by which they represent or express the culture they speak from and for.

What can be explained and understood ought to be explained and understood, albeit no explanation is ever sufficient and no understanding ever secure. Closures protect mystiques. If mysteries can be explained they are no longer mysteries, and that's that. But they remain mysteries, if they do, by virtue of their capacity to evade open inquiry. Johns's work has eluded explanation because those who undertake to explain it are constrained by the closed explanatory system with which they approach the job in hand, and because Johns's use of metonymy as a mode of signification is itself a kind of closure. It allows meaning to escape from all but a few readers who know what procedures to carry out, competences to execute, or techniques to apply to produce meaning from his work. Modernist consequentialism restricts inquiry and explanation to "artistic" and "technical" matters, to surface rather than subject or mechanisms of meaning. Those persons who know why Johns's metonymic function is required, and who know what predictive or other technical functions his work is required to perform and who can approach it with the correct competences and techniques, have remained silent. These are the socially-open-but-still-closed and the socially-closed worlds that metonymy mediates in Johns's work: the world of Modernist criticism and history and that distinctive other-world in Modernism where Johns's interests were first formed.

What I've attempted to do is offer some guidelines for the viewer, inquirer. These are intended to suggest that *Untitled*, 1972 and Johns's paintings generally, are *"of"* something, and that that something can be searched for if certain closures are understood, relaxed, and opened up. It doesn't matter much, however, if it is not "found." It is not part of my job to say what *Untitled*, 1972 means. The issue in the end is not what to look for but what to look at and with what disposition to look.

VII

In conclusion I want to blink my gaze back to the etchings which Johns produced for *Foirades/Fizzles*. I said earlier that *Untitled*, 1972 might be seen as a moral and practical or technical studio painting. It could be seen as a kind of meta-language object indexing, exhausting, and remaindering surfaces and details, and generating new ones. The etchings Roman Jakobson, for *Foirades/Fizzles* might have to be seen as part of that meta-linguistic process of finding out what it was that was produced in *Untitled*, 1972 by puzzling its parts and

their relationship further, revisiting them in print, making them more complex or simple, fragmenting them, making details of details, exaggerating, emphasizing, changing, losing. Occasionally Johns associated other bits and pieces of past work with the surfaces and the body fragments. For example, the crossed lines associated with Johns's profile at the start of *Fizzle 1* are also (with three lines from the trial proof, *Face* xii/xii) used redrawn in sharp outline in front of the flagstones in *Fizzle 2*, and the air-brush impact-spray and run gets associated with torsos used for *Fizzle 3*, and spoon shapes pool and dribble in front of the buttocks and knee used for *Fizzle 5*. Presumably some kind of consistency worked to determine that the fragments of *Untitled*, 1972, as represented in the context of *Foirades/Fizzles*, offered appropriate contexts of use for these—what I take to be—metonymic *exempla*. As a result of remaking *Untitled*, 1972 in these and other prints, Johns remaindered much from his practice for some time. However, it is not so important here to register what was eliminated or what was carried forward in terms of surface and semantic detail as it is to point out that metonymy persisted.[53]

> What you say about my tendency to add things is correct. But, how does one make a painting? How does one deal with the space? Does one have something and then proceed to add another thing or does one have something; move into it; occupy it; divide it; make the best one can of it? I think I do different things at different times and perhaps at the same time. It interests me that a part can function as a whole or that a whole can be thrown into a situation in which it is only a part. It interests me that what one takes to be a whole subject can suddenly be miniaturized or something, and then be inserted into another world, as it were.[54]

*My previous discussion of *Untitled*, 1972, co-authored with Charles Harrison, appeared in "Jasper Johns: 'Meaning What You See,' " *Art History* 7 (March 1984):78-101. This essay takes off from that article, uses it, but corrects, amends, extends, and disagrees with it. I want to acknowledge Charles Harrison's contribution to this occasion. And I should like to thank three people whose comments contributed to the present reading of the painting: Michael Baldwin, John R.R. Christie, and Alex Potts.

1. Jasper Johns, in Christian Geelhaar, *Jasper Johns Working Proofs* (London: Petersburg Press, 1980), 55.

2. See Richards Field's account of Johns's prints related to and drawn from *Untitled*, 1972, in his essay in the present catalogue.

3. This, even before he had read Beckett's texts. See his remarks in Geelhaar, *Jasper Johns Working Proofs*, 35 n.34.

4. On what is meant by saying what a painting is *"of"* see Art & Language, "A Portrait of V.I. Lenin," in *Art Language* 4 (June 1980), reprinted in Charles Harrison and Fred Orton, eds., *Modernism, Criticism, Realism*, (New York: Harper & Row, 1984), 145-169.

5. Michael Crichton, *Jasper Johns* (New York: Harry N. Abrams Inc. and the Whitney Museum of American Art, 1977), 59.

6. Crichton, *Jasper Johns*, 54-55.

7. Crichton, *Jasper Johns*, 60.

8. Roberta Bernstein, *Jasper Johns' Paintings and Sculptures 1954-1974: "The Changing Focus of the Eye"* (Ann Arbor UMI Research Press, 1985), 237 n.30.

9. Thomas B. Hess, "Polypolyptychality," *New York Magazine* 6 (February 19, 1973): 73.

10. On studio paintings — and paintings as moral and technical or practical studios — see Art & Language, 'A Cultural Drama: The Artist's Studio' in *Art & Language*, (Los Angeles Institute of Contemporary Art, 1983), 17-19.

11. Hess, "Polypolyptychality," 73.

12. Roman Jakobson, "The Two Aspects of Language and Two Types of Aphasic Disturbances," written in Eastham, Cap Cod, 1954 and published as Part II of *The Fundamentals of Language* (The Hague: Mouton, 1956), and in a somewhat different version in R. N. Anshen, ed., *Language: an Enquiry into its Meaning and Function* (New York: Harper, 1957), 155-173 and Roman Jakobson, *Selected Writings II* (The Hague: Mouton, 1971), 239-259. The metaphor-metonymy distinction hasn't recently been a standard preoccupation of language theorists and Jakobson's formulation of the 1950s is still the focus of what little discussion there is on the subject. Jakobson's works were published when Johns must have been thinking about his mechanisms of signification. He may have read them, but probably — almost certainly — didn't.

13. See, for example, the special issue of *Critical Inquiry* 5 (Autumn 1978) which comprises contributions delivered in earlier versions at a conference on metaphor sponsored by the University of Chicago Extension in February 1978.

14. The distinction between metaphor, metonymy, and synecdoche varies quite alarmingly amongst those who study poetic or figurative language. Hayden White directs the reader to some interesting literature on the subject in *Metahistory: The Historical Imagination in Nineteenth-Century Europe* (Baltimore: The Johns Hopkins University Press, 1973), 31-33. It may be worth pointing out that White's conceptualization of the difference between (reductive) Mechanistic-Metonymic and (synthetic) Organicist-Synecdochic linguistic modes as one of extrinsic and intrinsic relationships between entities in substitution might be relevant for extending my discussion of Johns's mechanisms of meaning.

15. Those of a psychoanalytic bent will know that Jacques Lacan used Jakobson's work on the two major forms of aphasia, metaphor and metonymy, in "The Insistence of the Letter in the Unconscious" (1957), reprinted in Richard and Fernande DeGeorge, eds., *The Structuralists from Marx to Levi-Strauss* (New York: Doubleday, Anchor Books, 1972), 287-323. For Lacan metaphor and metonymy are the two "slopes" of "the effective field of the signifier in the constitution of meaning." Metaphor is based on the substitution of one word for another, metonymy on a word-to-word connection. *"Verdichtung"* or condensation, belongs to the field of metaphor; *"verschiebung,"* or displacement, which Freud described as the main method by which the unconscious gets around censorship, belongs to the field of metonymy. Lacan suggests that the symptom is a metaphor and that desire is a metonymy, that metaphor is linked to the question of being and metonymy to its lack.

16. For a discussion of some of the restrictions which Modernist art history and criticism imposes on explanation and knowledge see Harrison and Orton, "Introduction: Modernism, Explanation and Knowledge," in *Modernism, Criticism, Realism*, xi-xviii and xxiii-xvi.

17. See, for example, Leo Steinberg's reading of the painting in "Jasper Johns: The First Seven Years of His Art," first published in *Metro*, nos. 4/5, 1962; revised version

New York: Wittenborn, 1963. Reprinted in *Other Criteria* (Oxford: Oxford University Press, 1972), 17-54.

18. Moira Roth, "The Aesthetic of Indifference," *Artforum* 16 (November 1977): 46-53. There are numerous accounts of the artistic culture of New York in the 1950s. I've drawn on the following: John Gruen, *The Party's Over Now: Reminiscences of the Fifties—New York Artists, Writers, Musicians and Their Friends* (New York: Viking Press, 1972); John Bernard Myers, *Tracking the Marvellous. A Life in the New York Art World* (London: Thames and Hudson, 1984); Marjorie Perloff, *Frank O'Hara: Poet Among Painters* (New York: George Braziller, 1977); Irving Sandler, *The New York School, The Painters and Sculptors of the Fifties* (New York, London: Harper & Row, 1978); Calvin Tomkins, *Off the Wall: Robert Rauschenberg and the Art World of Our Time* (New York: Doubleday & Co., 1980).

19. Roth, "The Aesthetic of Indifference," 49.

20. This list is taken from David Craven, "The Disappropriation of Abstract Expressionism," *Art History* 8 (December 1985): 502.

21. John Cage, "Experimental Music: Doctrine (1955)," in *Silence*, (Middletown, CT: Wesleyan University Press, 1961), 13-17.

22. Robert Rauschenberg, [Statement], *Sixteen Americans* (New York: Museum of Modern Art, 1959), 58.

23. Jasper Johns, [Statement], *Sixteen Americans*, 22.

24. For a discussion of what conventional artistic wisdom has taken to be the feasible area of ambition in recent painting—say, painting of the last 120 years or so—in terms of the practical and/or conceptual concern with subject and the practical and/or conceptual concern with surface, see Harrison and Orton, "Jasper Johns: 'Meaning What You See,' " and for the way surface and subject can occasion a kind of crisis of evaluation for Modernist art history, see Fred Orton, "Reactions to Renoir Keep Changing," *Oxford Art Journal* 8 (1985): 31-32.

25. In 1958 the Trustees of The Museum of Modern Art, New York, "disapproved its purchase for fears that it would offend patriotic sensibilities." MOMA archives, Johns file, see letter from George Heard Hamilton to Philip Johnson, February 23, 1973, on receiving the gift of the *Flag* in honour of Alfred H. Barr Jr.: "It is hard to imagine that such a mood could have existed only fifteen years ago, but that is what the minutes of the time reveal. I must say we owe you a great debt of gratitude, and I send you my thanks, on behalf of the other Trustees (even those who once voted against the Johns) for this marvellous gift."

26. These fragments from writings—by Leo Steinberg, Richard Field, Roberta Bernstein, and John Cage—are taken from Bernstein, *Jasper Johns's Painting and Sculptures 1954-1974*, 77.

27. Johns went to Paris for an exhibition of his work at the Galerie Rive-Droite, the gallery which, in the same year, produced the edition of Duchamp's *Female Fig Leaf*. Johns stayed on for a performance by David Tudor of John Cage's *Variations II* at the American Embassy Theatre, an event which also involved Rauschenberg, Jean Tinguely and Niki de Saint-Phalle.

28. O'Hara's "In Memory of My Feelings" is dated June 27-July 1, 1956. First published in *Evergreen Review* (1958); reprinted in *The New American Poetry: 1945-1906*, Donald Allen, ed., (New York: Grove Press Inc., 1960).

29. Marjorie Perloff, *Frank O'Hara: Poet Among Painters* and Alan Feldman, *Frank O'Hara* (Boston: Twayne Publishers, 1979) provided me with basic texts on O'Hara and his poetry.

30. Perloff, *Frank O'Hara*, 203 n. 42.

31. Perloff, *Frank O'Hara*, 203 n. 41 and n. 44.

32. "Joe's Jacket" (August 10, 1959), in *The Collected Poems of Frank O'Hara*, Donald Allen, ed., (New York: Alfred A. Knopf), 329-30.

33. "What Appears To Be Yours" (December 13, 1960), in *The Collected Poems of Frank O'Hara*, 380-81.

34. "Dear Jap" (April 10, 1963), in *The Collected Poems of Frank O'Hara*, 470-71.

35. Perloff, *Frank O'Hara*, 141-146; Feldman, *Frank O'Hara*, 91-97.

36. John Cage, "Jasper Johns: Stories and Ideas," in Alan R. Solomon, *Jasper Johns* (New York: The Jewish Museum, 1964), 35.

37. Perloff, *Frank O'Hara*, 167. O'Hara also offered Johns, "Poem (The Cambodian Grass Is Crushed)" (June 17, 1963) and "Bathroom" (June 20, 1963); see *The Collected Poems of Frank O'Hara*, 555-56. Also note that in 1961 Johns made a cast of one of O'Hara's feet and a drawing for a sculpture, *Memory Piece*, 1970 (Collection the artist), in which a footprint could be impressed in sand in the drawers of a specially constructed box. In this regard, note the line in O'Hara's "Dear Jap:" "when I think of you in South Carolina I think of my foot in the sand."

38. *"In Memory of My Feelings." A Selection of Poems by Frank O'Hara*, Bill Berkson, ed., (New York: Museum of Modern Art, 1967), a commemorative volume of O'Hara's poetry illustrated by thirty American artists.

39. Perloff, *Frank O'Hara*, 215 n. 23.

40. Riva Castleman has suggested that Johns concluded making *Voice* (1966-67) by suspending a fork and spoon at its right side in memory of Frank O'Hara. See Riva Castleman, *Jasper Johns: A Print Retrospective* (New York: The Museum of Modern Art, 1986), 24.

41. Calvin Tomkins, *Off the Wall*, 197-198.

42. Perloff, *Frank O'Hara*, 210 n. 5.

43. Perloff, *Frank O'Hara*, 162; Feldman, *Frank O'Hara*, 82.

44. See, for example, Harrison and Orton, "Jasper Johns: 'Meaning What You See;' " and Rosalind Krauss, "Jasper Johns: The Functions of Irony,' *October* 2 (Summer 1976): 91-99.

45. Philip Leider, "Abstraction and Literalism. Reflections on Stella at the Modern," *Artforum* 8 (April 1970): 44-51.

46. Frank O'Hara, *Jackson Pollock* (New York: George Braziller, 1959), 116.

47. "Once I asked Jackson why he didn't stop the painting when a given image was exposed. He said, 'I choose to veil the imagery.' " Lee Krasner, quoted in 'An Interview with Lee Krasner' by B. H. Friedman, in *Jackson Pollock: Black and White* (New York: Marlborough-Gerson Gallery, [Exhibition Catalogue], 1969).

48. See Mark Stevens and Cathleen McGuigan, "Super Artist Jasper Johns, Today's Master," *Newsweek* (October 24, 1977): 38-44.

49. This painting was the subject of a long essay by Leo Steinberg, "The Algerian Women and Picasso At Large," first published in *Other Criteria*, 125-234.

50. The neurotic dimension to metonymy which comes in by way of Jakobson and Lacan is important here. I've deliberately underplayed it in this discussion and left it for the reader to pick up on and make whatever he or she wants to make of it. The way the viewer gets some hints of what the private meanings are, or could be, is by way of the convention whereby absence, presence, or dismemberment of the—more often than not female—body is *the* sign of erotic obsession in modern painting and very emphatically so in the work of Magritte, Picasso, and Duchamp. Those of psychoanalytic persuasion should note the exchange between Johns and Peter Fuller, in "Jasper Johns Interviewed Part II," *Art Monthly* 19 (September, 1978): 7.

> *[PF:]* Crichton wrote that, like Rauschenberg, you shared a belief that art sprang from life experiences. Would you agree with that?
>
> *[JJ:]* Yes.
>
> *[PF:]* What life experiences do images like the shattered body spring from? It haunts so much of your work.
>
> *[JJ:]* I don't think that I would want to propose an answer on the level of subjective experience. I can come up with a substitute.

[PF:] But the body in several parts, which occurs in 'Target with plaster casts,' and later works, can only be derived from your earliest fantasies, if art springs from life experience, surely. You have presumably only experienced such things at the level of fantasy?

[JJ:] I don't know that it can only be that. I would not take that point of view. (Laughs.) I think any concept of wholeness, regardless of where you place it, is... Well, take the 'Target with plaster casts,' the first one. Some of the casts were in my studio. They were things among other things. Then, of course, they were chosen again for use in that way. But I don't feel qualified to discuss it on that level, I must say. I've not been in analysis, and I wouldn't want to give it that meaning in such a specific way as you have done. I believe that the question of what is a part and what is a whole is a very interesting problem, on the infantile level, yes, on the psychological level, but also in ordinary, objective space.

51. The painting is reproduced in Harrison and Orton, "Jasper Johns: 'Meaning What You See,' " fig. 46.

52. See Nelson Goodman, "Seven Strictures on Similarity," reprinted in Harrison and Orton, *Modernism, Criticism, Realism*, 85-92. Goodman points out that "similarity" has its place and its uses, but is usually found where it doesn't belong, professing powers it doesn't possess.

53. Metonymy persists in the cross-hatched paintings of the 1970s and early 1980s, and in the works made after them, including *The Seasons* (1986). However, Johns's recent paintings seem much less euphemistic than his other works.

54. Jasper Johns, in Geelhaar, *Jasper Johns Working Proofs*, 55-56.

Color Plate II

UNTITLED, 1972
Oil, encaustic, and collage on canvas
with objects
72 x 192 inches
Museum Ludwig, Cologne

Voices and Mirrors/
Echoes and Allusions:
Jasper Johns's *Untitled*, 1972

James Cuno
Grunwald Center for the Graphic Arts
Wight Art Gallery, UCLA

I decided to do only what I meant to do, and not what other people did. When I could observe what others did, I tried to remove that from my work. My work became a constant negation of impulses...I had a wish to determine what I was. I had the feeling that I could do anything...But if I could do anything I wanted to do, then what I wanted to do was to find out what I did that other people didn't, what I was that other people weren't...It was not a matter of joining a group effort, but of isolating myself from any group. I wanted to know what was helpless in my behavior—how I would behave out of necessity.

—Jasper Johns[1]

My purpose in this essay is to offer a close and sustained reading of Jasper Johns's *Untitled*, 1972 (color plate II), a picture of generative importance to *Foirades/Fizzles*, the subject of the present exhibition and catalogue. I acknowledge from the outset, however, that the task is not an easy one. When it was first exhibited in the Whitney Annual of 1973, *Untitled* resisted interpretation. Only Thomas Hess gave it any real notice, and then only by describing the motifs and media of the picture's four panels and by offering a brief but prescient reading of its content: "...into this metaphorical scaffolding, Johns has slotted autobiographical elements—analyses of his studio practices, glimpses of Harlem and Long Island that have haunted him, bits and pieces of four or five friends. He seems concerned with preserving memories and re-evoking lost experiences."[2] Since then *Untitled* has been described as a kind of summation or compilation of the artist's visual and conceptual themes, one that refers both to his earlier work and to the work of others he most admires, and one that takes memory or remembering as its central subject: memories of previous work and past experiences; its wax casts as memories of the

forms which modeled for them; the very working of memory rather than a specific memory; its metonymic structure as the form of memory, of the subject separate from that which it desires, desiring what it remembers.

These are fair readings of the picture and right as far as they go. But they do not address the full complexity of memory. They do not see it as a selective process, a way of repicturing the past, or putting the past into a coherent order and protecting that order. Rather, they see it as a means of identifying with the past. If Johns alludes to the art of his past —his own past art as well as the art of past masters—as these readings would have it, it is because he identifies with it and wants to give it form. And if every motif in his recent series of paintings, *The Seasons,* has a special significance for the artist, it is because he has chosen to paint his own life-cycle, the accumulation of his life's work and thought; and if many of these motifs refer to the art of Picasso, it is because Johns identifies with Picasso, just as before he identified with Cézanne and before that, Duchamp. For these readings, meaning—and in Johns's case, *memory* is meaning—is explicit, the accumulation of motifs identified (remembered) and put in proper syntactical order.[3]

I want to rethink the place of memory in Johns's art. I want to consider memory as a form of revision, as the means by which an artist recalls and corrects his past, as the site of tension between rememberance and forgetting. For this is how I understand Johns's remarks cited at the top of this essay. From the start, or rather from 1954 when he decided to stop *"becoming,* and *to be* an artist"* and thus systematically destroyed the art still in his possession, Johns was revising his past, the artistic tradition about which perforce he was anxious.[4] He was striving to find out what he did that others did not, what he was that others were not, what was helpless in his behavior, and how he would behave out of necessity. He was, as Harold Bloom would put it, acting out his own incarnation:

> When a potential poet first discovers (or is discovered by) the dialectic of influence, first discovers poetry as being both external and internal to himself, he begins a process that will end only when he has no more poetry within him …For the poet is condemned to learn his profoundest yearnings through an awareness of *other selves.* The poem is *within* him, yet he experiences the shame and splendor of *being found by* poems—great poems—*outside* him. To lose freedom in this center is never to forgive, and to learn the dread of threatened autonomy forever.[5]

Thus, I want to consider *Untitled,* 1972 as part of the artist's continued and deliberate revision of the tradition that is his to bear: New York painting of the 1950s. I want to look at *Untitled* for the echoes and allusions between it and other pictures by Johns, specifically those of the early 1960s (his

"sea" pictures, I will call them) and between these pictures and pictures by other artists to which they explicitly or implicitly refer. I will argue that Johns's *oeuvre* is a sustained working out or bodying forth of his artistic voice, as it were, one that speaks the language of Whitman, Hart Crane, and, in the language of his own particular tradition, Jackson Pollock.

This is the tradition Johns remembered and tried to forget in 1954 when he withdrew and, as he put it, isolated himself from any group. And it is, of course, the tradition he continued to remember and at times explicitly acknowledged: as in 1963 when he left his handprint in the painting *Periscope (Hart Crane)* (fig. 46), referring to the famous "Cape Hatteras" section of Crane's epic poem, "The Bridge"; or in 1973 when he took the title of one of Pollock's last paintings for one of his own, *Scent* (fig. 35), and thereby recast and revised the earlier artist's all-over drip pattern. It is this tradition, I will argue, that informed—*influenced*—*Untitled*, 1972, the picture under scrutiny here.

I

Untitled, 1972 comprises four panels: from left to right, one of hatchings in oils, one of flagstones in oils, one of flagstones in wax encaustic, and one of wax casts of human fragments affixed to boards (the boards are bolted to the wax-encaustic covered panel by wing nuts). The viewer is drawn first to the two central panels which, by their shared flagstones motif, cover one half of the picture's surface.

Flagstones first appeared in Johns's 1967 picture, *Harlem Light* (Collection, David Whitney), while the idea to use them in two contiguous panels first appeared in the artist's sketchbook notes of 1969:

Flagstone ptg. 2 panels. one in oil.
 " " encaustic

An imagined unit the square of the height of these canvases.

The flagstones enclosed by a border (within this imagined square). The left rectangle (oil?) will inlude area A.B.C.D. The right (encaustic?) will include E.F.G.H. The meeting B.D. and E.G. will not have borders. (Or will they? Aim for maximum difficulty in determining what has happened?) (The possibility of these—or others—in gray.)

Whether to see the 2 parts as one thing or as two things.

Another possibility: to see that something has happened. is this best shown by "pointing to" it or by "hiding" it.[6]

The "imagined square" in the center of the picture, within the two central panels, is formed by imaginatively shifting the left panel over the right one until the left border of

the oil panel is aligned with, matches, covers up the right border of the encaustic panel. This gives one the impression, as Richard Shiff put it, "that a continuous wall of flagstones has, as it were, slid by...."[7] And this is indeed how Johns first saw the motif: painted on a wall in Harlem, glimpsed through the window of the taxi in which he was riding to the airport. When he decided to use the motif in his next picture, a friend returned looking for the Harlem wall but could not find it. Johns was forced to paint from memory what he had glimpsed briefly from a moving car: a flagstone-painted wall passing by his field of vision.[8]

The "imagined square" and the way it compels the viewer to puzzle through the two central panels draws attention to the way the panels read differently. The flagstones of the left panel are cut from silk and pressed into thick, glossy paint, while those of the right panel are fixed to the encaustic surface and their edges incised. This gives the oil panel a plastic opacity in contrast to the pale translucency of the encaustic one, a distinction Johns repeated two years later in *Corpse and Mirror* (fig. 39). Further, Richard Shiff has pointed out that the flagstones panels of *Untitled*, 1972 meet but do not extend into one another, while the borders between adjacent panels— flagstones and hatchings to the left and flagstones and casts to the right—are often transgressed. This implies that "wherever two panels of like medium meet, no matter how heterogenuous the pattern, the physical surface of the painting is to be regarded as homogenuous and continuous; but if the media differ, the physical surface becomes discontinuous."[9] This causes the viewer to distinguish between the panels of *Untitled*, 1972 by media, to divide the picture in two, and to find relations between the two encaustic panels and the two oil ones.

Again one is reminded of *Corpse and Mirror*, 1974 (fig. 39). Both *Untitled*, 1972 and *Corpse and Mirror* are divided between oil panels to the left and encaustic to the right, with the division occurring between panels of the same motif. In addition, the encaustic panel of each picture is distinguished from its oil twin by additional marks: a large, pink "zig-zag" and black "X" in *Corpse and Mirror* and a large pink smudge in *Untitled*, 1972. Richard Field has suggested that the marks in *Corpse and Mirror* are "like a smudge on a mirror that betrays its surface" and that the encaustic panel is the "mirror" to the oil panel's "corpse."[10] If we carry this relation back to *Untitled*, 1972, the encaustic panel reads as mirroring the oil panel and the shift in pattern—the "imagined square"—is the result of angled reflection. Then, if the right encaustic panel is the mirror of the left one in oil, what of the far-right casts panel and its relation to the far-left hatchings panel, given that, as was suggested above, the panels of like medium are homogenous and continuous? Does the casts panel not mirror the hatchings one? Not if we mean by mirroring, the faithful

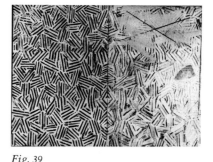

Fig. 39
CORPSE AND MIRROR, 1974
Oil, encaustic, and collage on canvas
50 x 68⅛ inches
Collection Mr. and Mrs. Victor W. Ganz

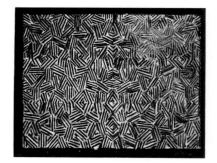

Fig. 40
CORPSE AND MIRROR, 1976
Published by U.L.A.E.
Lithograph
30¾ x 39¾ inches

reduplication of the mirrored subject, the form before the mirror. But what if we mean by it, *reflecting:* the mirror offering a new perspective on its subject (now seen from a new angle), the casts putting the hatchings in a different light and before the mind in a new and perhaps clearer way? Does the casts panel not then reflect the hatchings one?

It does, literally, in that it turns (or casts) our eyes back on that which came first, panel A, the first of four panels reading left to right, ABCD.[11] Having reached panel D, we are suddenly asked to account for the apparent asymmetry of the painting. The two interior panels (BC), to which we were first drawn, promised an obvious order: the same pattern repeated twice, the one shifting to match up with the other, the two cut from the same cloth. But what of the exterior panels, the one so two-dimensional and decorative, the other so plastic and illusionistic? How does the weight of the casts and boards not pull down the right side of the painting, cause the painting to slip on its axis as it becomes increasingly three-dimensional from left to right, from oil to encaustic, from surface design to high relief? In one sense the busyness of the hatchings panel—the way our eyes are drawn up and down, back and forth, in sudden stops and starts—counters the static weight of the casts panel: optical motion countering, balancing, phenomenal stasis; vigorous, highly colored marks countering, balancing, bolted, pinioned forms of neutral color. But this works only if one is drawn back to the hatchings panel; if one is forced to recall it and to consider it again, anew. And one is, by the crossed boards and diagonally aligned fingers and toes of the casts panel which echo, respectively, the cross-hatchings and parallel striations of the hatchings panel. Such echoes resound between the two exterior panels and reveal their common, diagonal structure and distinctly vertical orientation in contrast to—and framing—the lateral structure of the two central panels. Balance is thus achieved by echoing (reflecting) pattern with structure.

But is that all? Is mirroring only a matter of surface relations and common appearances? Or does it look deeper into the more substantial, shared properties of the mirrored forms? The echo of hand/foot and hatchings suggests a different order of relations between the exterior panels. This is brought out by Johns's later painting, *Celine,* 1976 (fig. 41), in which the handprints and hatchings of the upper panels echo and intermingle with each other, as they do in the lithograph with monotype, *Savarin,* 1982: in a later lithograph with monotype, the handprints replace the hatchings and are printed in the very colors of the far-left panel in *Untitled,* 1972.[12] Do these later works then not reveal what was more subtley implied in the mirroring between the casts and hatchings panels of *Untitled,* 1972: that figuration is present in the hatchings panel, that it is indeed the "corpse" mirrored in the fragmented anatomical casts of the far-right panel?

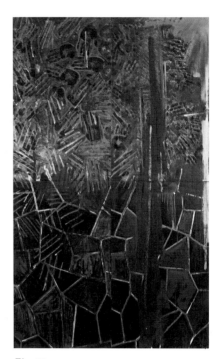

Fig. 41
CELINE, 1978
Oil on canvas
85⅝ x 48¾ inches
Oeffentliche Kunstsammlung Basel,
Kunstmuseum

Consider *Corpse and Mirror*, 1974, again (fig. 39). Thomas Hess first pointed out that the structure of the panels, comprising three horizontal bands folding and unfolding up the picture, alludes to the Surrealist game, *cadavre exquis* or "exquisite corpse," in which each participant draws a section of a body on a piece of paper, folds the paper to conceal the drawing, and passes it on to the next player who does the same. When unfolded, the paper reveals a mysterious, combined figure, the result of collective accident.[13] This reference is undoubtedly there in *Corpse and Mirror*, for an ink, Paintstick, and pastel drawing of 1974-75, simply titled *Corpse* (Private collection), comprises three bands of hatchings, each in a different medium as if by a different hand, fold after fold after fold.[14] But there are other ways "corpse"—or body—is figured among the hatchings. Rosalind Krauss has noted their similarity with (allusion to) the striations in Picasso's pre-Cubist pictures of standing female nudes from 1907 to 1908: perhaps *Nude with Draperies*, 1907 (Hermitage Museum, Leningrad) is the best example; the way the striations mark the body and drapery equally, emphasizing their fragmentation and integrating them into a common surface pattern.[15] Krauss has also related Johns's hatchings in the triptych *Weeping Women*, 1975 (fig. 38) to Picasso's painting of 1937, *Weeping Woman* (Private collection, England) and its use of hatchings to psychologically expressive ends. One might also see in the four iron imprints in the central panel of *Weeping Women* an allusion to Magritte; their color, labelling, and placement in the picture recalling the forms labelled *"miroir"* and *"corpse de femme"* in Magritte's *The Use of Words I*, 1928-29 (Formerly Collection Mme. Jean Krebs, Brussels).[16] The irons themselves, however, allude to Picasso's *Woman Ironing* of 1904 (The Solomon R. Guggenheim Museum, New York), a picture of somber and melancholic tones and short, hatched brushstrokes quite like those of Johns's *The Dutch Wives*, 1975 (fig. 42). And it is in *The Dutch Wives*—on the left, "corpse," perhaps sinister side of the picture—that Nicolas Calas saw the pale reflection of Duchamp's *Nude Descending a Staircase* of 1912 (Philadelphia Museum of Art, the Louise and Walter Arensberg Collection).[17] Not surprisingly, then, in a drawing of 1978, *Tracing* (Collection the artist), Johns reproduced, as if submerged in the dark puddling of his ink, Duchamp's *The Bride*, 1912 (Philadelphia Museum of Art, the Louise and Walter Arensberg Collection), an oddly erotic picture of organic and mechanical forms painted in pink fleshy tones depicting, or so it seems, that which distinguishes a "bride" from a "virgin." (In the same year, Duchamp painted *The Passage from Virgin to Bride* [The Museum of Modern Art, New York] and *The Nude Descending a Staircase*, both pictures of full-length nudes in transition, patterned by the clatter of fragmented forms.)

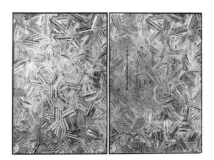

Fig. 42
THE DUTCH WIVES, 1975
Encaustic and collage on canvas
51¾ x 71 inches
Collection the artist

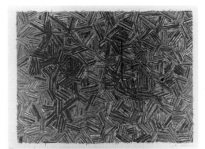

Fig. 43
THE DUTCH WIVES, 1977
Published by Simca Print Artists and
the artist
Silkscreen
42¹⁵/₁₆ x 56 inches

The presence of figuration in the hatchings panel of *Untitled*, 1972, veiled by a pattern so rich in allusions, allows us to turn the mirror around. I have already referred to the temporal implications of mirroring: the mirror as subsequent reflecting its antecedent, the hatchings panel preceding the casts panel, panel A before panel D. In another respect, however, the casts panel precedes the hatchings panel in its obvious references to Johns's very earliest work: its casts and those in *Target with Four Faces* and *Target with Plaster Casts*, both 1955 (figs. 19 and 14) (recall that hatchings first appeared in *Untitled*, 1972). Indeed, as Roberta Bernstein has recorded it, the casts panel once had two white, silkscreened targets on its surface to which the wax casts were attached (the targets were later covered with layers of encaustic and the explicit allusion to the earlier pictures covered up).[18] This would make the casts panel the antecedent of the hatchings panel, and would have the picture begin (from the left) with its ending and end with its beginning.[19] Panel A would become the mirror to panel D, and the figuration of the casts panel would be reflected in (veiled by) the hatchings panel: reflecting in this sense meaning diverting, turning away from or aside, and deflecting the expressive implications of the cast anatomical fragments.

Johns has admitted that the casts in his pictures are psychologically loaded and that he has tried to neutralize their effect by diverting one's attention from them. For example, *Target with Plaster Casts* (fig. 14) was originally intended to have had the various body parts prepared in such a way that when they were touched, noises would come from behind the canvas:

> I thought that what one saw would change as one moved toward the painting, and that one might notice the change and be aware of moving and touching and causing sound or changing what was visible. In such a complex of activity, the painting becomes something other than a simplified image. I don't want to say that I didn't understand thoughts that could be triggered by casts of body parts, but I hoped to neutralize, at least for myself, their more obvious psychological impact.[20]

The busyness of panel A in *Untitled*, 1972 similarly diverts, even neutralizes the expressive nature of the casts panel. Its hatchings are a non-figurative counter to the figurative casts; a decorative, two-dimensional response to the latter's plastic illusionism; a mirror-image that fractures and disfigures panel D, veiling its expressive implications in distant echoes of figuration.

But now look back at the two interior panels (BC) and recall that the flagstones of the left panel (B) are cut from silk and pressed into thick, glossy paint, while those of the right

panel (C) are fixed to the encaustic surface and their edges incised. This gives the oil panel a plastic opacity in contrast to the pale translucency of the encaustic one: in fact, one can see through the layers of encaustic down to a darker layer beneath. The combined effect of the incised flagstones—their edges cut into the encaustic—and the translucency of its surface gives one the sense, quite alarming at first, that in the right panel one is seeing the flagstones from behind, bleeding through, as it were, from the other side.

Johns has long been intrigued by the effect of images or printed texts visible beneath his encaustic surfaces. In *Flag Above White with Collage* of 1955 (fig. 44), newspaper fragments of various sizes and types of print can be seen beneath the surface aligned vertically, horizontally, and diagonally, along with a strip of four snapshots of a man staring straight ahead. Twenty years later, in *The Dutch Wives*, 1975 (fig. 42), Johns similarly allowed newsprint to come up through the picture's surface, as fragments of text and type are aligned to echo the hatchings. In *Untitled*, 1972, however, the flagstones are not set beneath the surface, but seem at once bleeding *through* and reflected *by* it, veiled by the chalky translucence of their medium and figured in the mirror implied by the pale pink smudge left of center. Indeed, one reads the flagstones as both on and *on the other side of* the picture's surface; as if one could see both sides of its support at once. (This is precisely the effect Johns later exploited in *Dancers on a Plane*, 1980 [Tate Gallery, London], when he inscribed the picture's title and subject [Merce Cunningham] in mirrored writing at the base of the canvas, such that one reads the lettering forward and backward, left to right and right to left, as if viewing the painting from in front of and behind it simultaneously.)

In this respect, we should recall that Johns often included the backs of stretched canvases in his pictures: *Canvas*, 1956 (Private collection); *Fool's House*, 1962 (Private collection); *Souvenir 2*, 1964 (Collection, Mr. and Mrs. Victor W. Ganz); and *According to What*, 1964 (color plate I), for example. In the casts panel of *Untitled*, 1972, boards criss-cross the panel in ways not dissimilar to stretcher bars: there are, of course, too many, but they do cross the panel top to bottom and left to right as a stretcher would. Is the casts panel then not a variation on a familiar motif in Johns's work: the stretched canvas turned away from the viewer? We know that in its first state the casts panel was simply a blank canvas ripped in two places through which one could see a stretcher bar and the wall behind.[21] Did Johns not then retrieve this idea when he attached the boards with anatomical fragments to a new canvas, having replaced the torn canvas in the panel's second state? The two encaustic panels—made one homogenous surface by the transgressions of the border between them—would then read together as the backside of a single

Fig. 44
*FLAG ABOVE WHITE WITH
 COLLAGE, 1955*
Encaustic and collage on canvas
22½ x 19¼ inches
Collection the artist

surface: the equally homogenous surface of the two oil panels, A and B. The four panels would become two—like *End Paper,* 1976 (Private collection)—seen from the front and back simultaneously, the picture would bend back on itself, and the casts of panel D would become *buried* beneath the hatchings of panel A, the corpse beneath the mirror.

This is suggested further by the lithographs after the painting. In *Four Panels from Untitled 1972,* 1973–74 (fig. 2), each of the four sheets is embossed with the pattern of the preceding one within the rotational order, ABCD: the hatchings of panel A are embossed in panel B, the flagstones of panel B in panel C, the flagstones of panel C in panel D, and the casts and boards of panel D in the hatchings of panel A. In *Four Panels from Untitled 1972 (Grays and Black),* 1973–75 (fig. 3), the rotational order is signalled by framing each panel with borders replicating one-sixth of the nearest part of the adjacent panels: panel A is framed by borders from panels D and B, panel B by borders from panels A and C, panel C by B and D, and panel D by C and A. Taken together, the prints imply indexical and lateral relations between the panels of the painting, such that one reads them coming through and sliding over one another, the hatchings panel (A) atop successive panels of flagstones (B, then C) and casts (D), and the casts panel embossing the panels in reverse, D through A. One then reads —explicitly in panel A of *Four Panels from Untitled, 1972* (fig. 2) and implicitly in panel A of the painting (color plate II)—the casts buried beneath the hatchings, having first passed through two stages of flagstones. The lithographs thus reinforce—and are reinforced by—our earlier reading of the exterior panels of *Untitled,* 1972, which had the casts of panel D echoed in the hatchings of panel A. More important, the complex structural relations between the panels of *Untitled,* 1972—panel D *echoed* (mirrored) and *buried* in panel A—point to the artist's calculated and sustained project of hiding fragmented figuration in the decorative scheme of hatchings panels. [22]

We need now consider the meaning of this project, not only in *Untitled,* 1972, but in Johns's other hatchings paintings of the 1970s. To do so, we must first recall the mythology of Echo. For it is from these myths that we take the critical metaphor of allusive "echo," the metaphor so significant to the structure and meaning of *Untitled,* 1972.

II

In Longus's third-century romance, Echo was a figure of purity and innocence, a mortal wood-nymph who

> danced with the Nymphs and sung in consort with the Muses, but fled from all males, whether men or Gods,

because she loved virginity. Pan sees that, and takes occaision to be angry at the maid, and to envy her music because he could not come at her beauty. Therefore he sends a madness among the shepherds...and they tore her all to pieces and flung about them all over the earth her yet singing limbs. The Earth in observance of the Nymphs buried them all, preserving to them still their music property, and they by an everlasting sentence and decree of the Muses breathe out a voice. And they imitate all things now as the maid did before, the Gods, men, organs, beasts. Pan himself they imitate too when he plays on the pipe; which when he hears he bounces out and begins to post over the mountains, not so much as to catch and hold as to know what clandestine imitator that is that he has got.[23]

Fig. 45
UNTITLED, 1977
Acrylic, charcoal, and collage with
 objects
41½ x 32½ inches
Collection the artist

In Ovid's myth, however, Echo was a talkative nymph who once kept Juno under her spell while other nymphs escaped to Jove's embraces. Enraged, Juno deprived Echo of her originating voice, leaving her to speak only when spoken to and then only by repeating the last sounds of what she heard. When later Echo spied Narcissus—whom "[m]any a love-sick Youth did him desire;/And many a Maid his beauty set on fire:/Yet, in his tender age his pride was such,/That neither youth nor Mayden might him touch"—her speechlessness was special torture. Unable to call out to him, Echo pursued him madly, silently, until she could stand it no longer. She rushed to him and threw herself upon him only to be rejected immediately and with disdain:

> Despis'd, the wood her sad retreat receaves;
> Who covers her ashamed face with leaves;
> And sculks in desert caves. Love still possest
> Her soule; through griefe of her repulse, increast.
> Her wretched body pines with sleepless care:
> Her skinne contracts: her blood converts to ayre.
> Nothing was left her now but voyce and bones:
> The voyce remaynes; the other turne to stones.
> Conceal'd in Woods, in Mountains never found,
> Yet heard in all: and all is but a Sound.[24]

From these two fables we inherit the two strands of mythographic interpretation that structure the dialectical nature of allusive "echo." On the one hand, Echo is a pure and affirming nymph who distorts the voice of Pan in order to interpret (revise) it and return it whole. On the other, she is a figure of distancing: deprived of an originating voice and condemned to repeat the last phrases of others, she is left to waste away until she becomes voice only, ever heard, ever dimished over time and space. Both Echos, I will argue, the synecdochist on the

one hand and the ironist on the other, are present in the figure buried beneath the hatchings in *Untitled*, 1972, as "[h]er skinne contracts: her blood coverts to ayre./Nothing was left her now but voyce and bones:/The voyce remaynes; the other turne to stones." But to what end is she figured and with what meaning, not only in *Untitled*, 1972 but in the other hatchings paintings of the 1970s?

Rosalind Krauss has described Johns's hatchings paintings as a kind of History Painting: "Looking at these paintings, one finds oneself engaged by an overt allusion to history—to the specific history of art, and particularly modernist art."[25] She sees them alluding—quite rightly, as noted above—to the history of Cubism from its preliminary phases in 1907 to 1909 *(Nude with Draperies*, 1907 [Hermitage Museum, Leningrad]) to its maturity in 1937 to 1939 *(Weeping Woman*, 1937 [Private Collection, England] and *Guernica*, 1939 [The Prado, Madrid]), as well as to the history of all-over patterning from Monet to Pollock. She then relates such allusions to the ironist's attack on the significance of history: "The sorts of values that history itself might be felt to reveal, are greeted by the sceptic with a deep sense of disbelief, expressed as irony. For the sceptic cannot believe in an originating source of value outside of the negative voice with which he questions."[26] Krauss argues that the hatchings paintings are ironic in the sense that they level out or negate the value of history as a generating force. "What is left as always is the performative voice: Johns creating, patiently, this scenario of negation. For the pictures are extremely beautiful; and they convey an extraordinary sense of the autonomy of the visual."[27] But do they? Is the historical voice—whether it be Picasso's or Pollock's, or, as I shall argue below, Picasso's *in* Pollock's—ever negated in Johns's work, ever silenced? Is the allusion ever hidden in (beneath) the surfaces of his pictures however "extremely beautiful" they may be? And do they ever convey the sense of autonomy Krauss suggests they do? I would argue no on all accounts.

In *Corpse and Mirror*, 1974, for example, a large, black "X" marks the surface of the encaustic panel, covering an untidy patch of grayish white brush strokes which, with the pink "zig-zag" and the white over-painting of the panel, betray the mirror's surface (fig. 39). Similar "X"s have appeared before in Johns's work, most frequently in his prints from the same decade as the hatchings paintings: *Bent Blue (Second State)* and *Hinged Canvas* from *Fragments—According to What*, 1971 (fig. 28); *Evion*, 1971–72; *Evion—Black State*, 1972; *Decoy II*, 1971–72; *Untitled (Skull)*, 1973; *Corpse and Mirror* (aquatint), 1975–76; *Corpse and Mirror* (lithograph), 1976 (fig. 40); and *Face* from *Foirades/Fizzles*, 1975–76. Richard Field has pointed to the negative implications of the mark: questioning the authorship of Duchamp's self-portrait in *Hinged Canvas*

and the identity of the skull and face in *Untitled (Skull)* and *Face*, where (in the former) "it crosses out the artist's signature as if to say, 'this is not me'" and (in the latter) it signals that "*Face* is neither the cast from *Untitled*, 1972 nor a picture of the artist; it is simply an imprint of his features."[28] Field then allows in *Face* that the "X" takes on the "dire overtones of artistic death" as it refers to the absence of eyes, that which is "essential of artistic creation." This is closer to the mark's meaning in *Corpse and Mirror:* a gesture in the face of artistic death.

In the painting, the grayish white brushstrokes—crossed out by the "X"—are suggestive of condensation formed on the mirror by breath. This in turn recalls the early medical practice of holding a mirror to the mouth of a corpse: if no breath formed on the mirror, the corpse was declared legally dead. In *Corpse and Mirror* the evidence of life—or rather *presence*—is cancelled, crossed-out, in a powerful attempt to drive the corpse back beneath the hatchings of the oil panel. At stake is the matter of inheritance: only upon the legal declaration of death can a will be read and a legacy turned over. If the corpse breathes, the legacy is held back and one's subsequent relation to it is affirmed. And, indeed, the corpse in *Corpse and Mirror* does breathe. It returns in the form of an iron imprint which, as it is in *Untitled*, 1972, is an allusion to Picasso's *Woman Ironing* of 1904, a painting which, as noted above, is further echoed in the tonality and brushwork of *The Dutch Wives*, 1975 (fig. 42).

By admitting the presence of—*and the struggle with* —the corpse of history in his hatchings paintings of the 1970s, however, Johns is not engaging in a scenario of *negation*, as Krauss would have it, but in one of creative *revision*. For his art derives much of its power from its relation to history, from the way he works references to specific monuments in the history of modernist art into and through a deliberate resume of his own earlier works. Irony is essential to his art, surely; but not as a means of negating history. Rather, it serves to distance his art from history in order to see it again, anew, and then to represent it revised. In Johns's art, irony is a feint against the curse of Echo, a way of engaging and being sustained by history.[29] For Johns is not only a master allusionist, but a master illusionist as well; a painter who can, as he does in *Ventriloquist*, 1983 (Museum of Fine Arts, Houston), throw his voice into others and make the dumb speak. In the first instance he answers the nagging ghosts of history by naming (remembering) them and turning Echo's voice back against itself in a sequence of ever diminishing echoes. In the second, however, he gives mute ghosts speech by revising (forgetting) them and refiguring the mocking, derisive nymph of Ovid's myth into the pure and innocent consort of Pan from Longus's third-century romance.[30]

212

III

When we speak metaphorically of echoes between texts, we imply a correspondence between a precursor and, in the accoustical actuality, a vocal source. What is interesting and peculiar about this is that whereas in nature, the anterior source has a stronger presence and authenticity, the figurative echoes of allusion arise from the later, present text.

—John Hollander[31]

I have already pointed to the iron imprint marking the encaustic panels of *Weeping Woman*, 1975 (fig. 38), *Corpse and Mirror*, 1974 (fig. 39) and *Untitled*, 1972 (color plate II), and I have suggested that it relates the three pictures to Picasso's *Woman Ironing*, 1904. I want now to consider its relations to the art of a specific period in Johns's career: the period from 1961 to 1966 when he was living and working frequently by the sea in Edisto Beach, South Carolina and painting pictures more self-referential, melancholic—even, at times, angry and tumultuous—than any he had painted before. It was a time, as Calvin Tomkins recounts it, when there were dramatic changes in Johns's personal life, when he "was guarded and withdrawn, and sometimes bitingly sarcastic," and when his relationship with Rauschenberg suffered a break that "was bitter and excrutiatingly painful, not only for them but for their closest associates...."[32]

It was also a time when Johns was reading closely in American poetry; particularly the great poets of the sea, Whitman, Crane, and more personally for Johns, Frank O'Hara. These poets—poets of great feeling and poets of origins *(Gnostic* poets, Bloom calls them, with the exception of O'Hara)—offered Johns a way of structuring his feelings and turning them back into pictures, into the making of pictures, pictures made of origins personal and artistic.[33] For it was not only a time of withdrawal and introspection, but also a time, as Leo Steinberg put it, when "[t]he painter past thirty dares to be frankly autobiographical because his sense of self is objectified, and because he feels secure in the strength of his idiom."[34]

To begin, we need to recall that the iron imprint of *Weeping Women, Corpse and Mirror,* and *Untitled,* 1972 first appeared in Johns's work in an encaustic painting of 1962, *Passage* (fig. 51), a picture that takes its title from Hart Crane's poem of 1926, "Passage."[35] Harold Bloom has described the poem as one of Orphic disincarnation—"the movement back to unfindable and fictive origins"—where the rite of passage takes Crane back to Whitman, the daemon thief of the poem's inland hills (who smiles "an iron coffin"—the iron imprint of Johns's *Passage),* and from Whitman to the sea and the broken enchantment of memory.[36]

At stake in the relation of Crane to Whitman, and what must have drawn Johns to Crane's poetry, was the integrity of poetic voice, of Crane's voice and identity in the shadow of Whitman's prior and formative one.[37] In Crane's "Passage," the sulking poet, denied his promise, leaves his memory in a ravine and goes in search of a promised "improved infancy," only to meet his daemon, the "thief beneath, my stolen book in hand." The "my" here is deliberately ambiguous: whether it refers to Crane having stolen the thief's (Whitman's) book or the thief having stolen Crane's is unclear, and ultimately unimportant. For the point is the presence of Whitman's voice in Crane's as "Passage" echoes Whitman's own poem of Orphic disincarnation, "As I Ebb'd with the Ocean of Life":

> But that before all my arrogant poems that real Me
> stands yet untouch'd, untold, altogether unreach'd,
> Withdrawn far, mocking me with mock-congratulatory
> signs and bows,
> With peals of distant ironical laughter at every word I
> have written,
> Pointing in silence to these songs, and then to the sand
> beneath.
> I perceive I have not really understood any thing, not a
> single object, and that no man ever can,
> Nature here in sight of the sea taking advantage of me to
> dart upon me and sting me,
> Because I have dared to open my mouth to sing at all.

Like Whitman before him, Crane has been stung by nature for having sung at all. But the nature that stings Crane is the voice of Whitman:

> He closed the book. And from the Ptolemies
> Sand troughed us in a glittering abyss.
> A serpent swam a vertex to the sun
> —On unpaced beaches leaned its tongue and
> drummed.
> What fountains did I hear? what icy speeches?
> Memory, committed to the page, had broke.
> —("Passage")

For Whitman and the sea are one:

> My own songs awaked from that hour,
> And with them the key, the word up from the waves,
> The word of the sweetest song and all songs,
> That strong and delicious word which, creeping to my
> feet,
> (Or like some old crone rocking the cradle, swathed in
> sweet garments, bending aside,)
> The sea whisper'd me.
> —("Out of the Cradles Endlessly Rocking")

Whitman sings to the sea, but Crane must sing to the sea that is Whitman.

In Crane's "Voyages" poems, "[the] bottom of the sea is cruel" and the sea itself is the "line you must not cross nor ever trust" ("Voyages" I), the "great wink of eternity" ("Voyages" II) that lifts "reliquary hands" ("Voyages" III) and "fatal tides" ("Voyages" IV) leaving only "dead sands flashing" in "that godless cleft of sky" ("Voyages" V). Yet it is the sea to whom Crane sings these songs of love—"Her undinal vast belly moonward bends,/Laughing the wrapt inflections of our love;" ("Voyages" II):

> In signature of the incarnate word
> The harbor shoulders to resign in mingling
> Mutual blood, transpiring as foreknown
> And widening noon within your breast for gathering
> All bright insinuations that my years have caught
> For islands where must lead invioably
> Blue latitudes and levels of your eyes,—
>
> In this expectant, still exclaim receive
> The secret oar and petals of our love.
> —("Voyages" IV)

It is a love that brings both life and death, and life in song, the poetic voice:

> And so, admitted through black swollen gates
> That must arrest all distance otherwise,—
> Past whirling pillars and lithe pediments,
> Light wrestling there incessantly with light,
> Star kissing star through wave on wave unto
> Your body rocking!
> and where death, if shed
> Presumes no carnage, but this single change,—
> Upon the steep floor flung from dawn to dawn
> The silken skilled transmemberment of song;
>
> Permit me voyage, love, into your hands…
> —("Voyages" III)

One's voice comes from touching—from one's hands embracing another's—and through union with but not surrender to another. For "nothing is got for nothing," Bloom reminds us, "and self appropriation involves the immense anxieties of indebtedness, for what strong maker desires the realization that he has failed to create?"[38] Certainly not Crane, however much his poetry turns on the anxiety of indebtedness and invites comparison with that of his great precursor.

In the famous "Cape Hatteras" section of his epic poem, "The Bridge," Crane reaches out to touch the hand of Whitman:

 yes, Walt
Afoot again and onward without halt,—
Not soon, nor suddenly,—no, never to let go
 My hand
 in yours
 Walt Whitman—
 so—

The lines fall away like footprints in the sand, and the hand
reaches out to touch Whitman and to answer "Adam and
Adam's answer in the forest," as Crane put it in "Cape Hat-
teras," alluding to Whitman's "As Adam Early in the
Morning":

 As Adam early in the morning,
 Walking forth from the bower refresh'd with sleep,
 Behold me where I pass, hear my voice, approach,
 Touch me, touch the palm of your hand to my body
 as I pass,
 Be not afraid of my body.

Whitman, as Adam, is the new Adam of America the new Eden,
whose coitus with the muse is a fall from which generations
are born. Crane called him *Panis Angelicus* whom poets hence
(Crane among them) "shall hear/In their own veins uncan-
celled thy sure tread/And read thee by the aureole 'round thy
head/ Of pasture-shine" ("Cape Hatteras"). To hear Whitman
in one's veins is to have internalized his voice fully and to live
by that voice. To make peace with him and to have union with
him is "to resign in mingling/Mutual blood" ("Voyages" IV).
But the terrible truth of Whitman is that he has sworn himself
to chastity, the life he gives will not be borne of union with
another, but will come from himself, alone:

 The great chastity of paternity, to match the great
 chastity of maternity,
 The oath of procreation I have sworn, my Adamic and
 fresh daughters,
 The greed that eats me day and night with hungry gnaw,
 till I saturate what shall produce boys to fill my place
 when I am through,
 The wholesome relief, repose, content,
 And this bunch pluck'd at random from myself,
 It has done its work—I toss it carelessly to fall where it
 may.
 —("Spontaneous Me")

Fig. 46
PERISCOPE (HART CRANE), 1963
Oil on canvas
67 x 48 inches
Collection the artist

To have been plucked at random from the landscape Whit-
man's seed has sown is the curse of belatedness in American
poetry, the curse one hears echoing throughout Crane's beau-

tiful and moving poetry, and the curse Johns heard crying up from the sea at Edisto Beach: "the low and delicious word death,/And again death, death, death, death" ("Out of the Cradle Endlessly Rocking").[39]

Johns gave form to this echoing sea in a group of paintings from 1961 to 1963 that include *By the Sea*, 1961 (fig. 53), *Passage*, 1962 (fig. 51), *Out the Window Number 2*, 1962 (fig. 52), *Diver*, 1962 (The Albert A. List Family Collection), *Land's End*, 1963 (San Francisco Museum of Modern Art), and *Periscope (Hart Crane)*, 1963 (fig. 46). These share a banded structure—quite like Picasso's *Seated Bather* of 1930 (The Museum of Modern Art, New York) with its horizons of beach, sea, and sky—and a pattern of words, RED, YELLOW, BLUE, stencilled from top to bottom (sometimes one over another, one word echoing up through another) often folded back, submerged, even, as in *Diver*, set adrift by the coarse, crashing brushwork so reminiscent of de Kooning's of the 1950s.[40] In addition, with the exception of *Diver*, they share a dark tonality (predominantly blues, grays, pinkish-purples, reds, and greens) and, including *Diver* but not *By the Sea*, handprints and/or scraped semi-circles.

The latter motif, often called "device-circle," from its basic similarity to the wooden stick defining a circumference in his painting *Device-Circle*, 1959 (Collection Mr. and Mrs. Burton Tremaine), is by 1961 a much more suggestive and expressive device, scraping and scarring the painted surface, signifying past (arrested) action, and bringing to the sea pictures the melancholic sentiments of *Good Time Charley*, 1961 (Collection the artist) and *Fool's House*, 1962 (Private Collection). It also echoes the lines in "Cape Hatteras"

Fig. 47
PERISCOPE II, 1979
Published by Gemini G.E.L.
Lithograph
56¹/₄ x 4! inches

..that star-glistened salver of infinity,/The Circle, blind crucible of endless space,/Is sluiced by motion,— subjugated never./Adam and Adam's answer in the forest/ Left Hesperus mirrored in the lucid pool

that follow immediately upon the lines Johns pointed to in *Periscope (Hart Crane)*, 1963:

What whisperings of far watches on the main
Relapsing into silence, while time clears
Our lenses, lifts a focus, resurrects
A periscope to glimpse what joys or pains
Our eyes can share or answer—then deflects
Us, shunting to a labyrinth submersed
Where each sees only his dim past reversed...

The circle, the blind crucible, the round lens that once promised union with another, throws us back upon our own partic-

ular and receding pasts and leaves us gazing upon ourselves—
like "Hesperus mirrored in the lucid pool"—ourselves to be
blinded, our hands to reach out in vain for the other we
cannot see.

Crane's hands, recall, reached out in answer to
Adam's answer in the forest, "never to let go/My hand/in
yours,/Walt Whitman—/so—." But what of Johns's hands in
the paintings of 1962 to 1963? To whom do they reach out? One
is reminded of the personal circumstances of Johns's life in
1962 and his "excruciatingly painful" break that summer with
Rauschenberg. And one hears the song of the mocking-bird
Whitman heard on the shore of Paumanok:

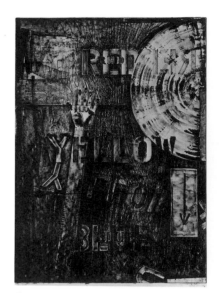

Fig. 48
LAND'S END, 1979
Published by Gemini G.E.L.
Lithograph
52 x 36 inches

> Loud! loud! loud!
> Loud I call to you, my love!
> High and clear I shoot my voice over the waves,
> Surely you must know who is here, is here,
> You must know who I am, my love....

> O past! O happy life! o songs of joy!
> In the air, in the woods, over fields,
> Loved! loved! loved! loved! loved!
> But my mate no more, no more with me!
> We two together no more.
> —("Out of the Cradle Endlessly Rocking")

This may seem melodramatic, but Johns was not above melo-
drama. In his *Map* painting of 1963 (Private collection), he
divided Cape Hatteras from points north by drawing a long,
black line across the top of North Carolina, out across the sea,
to the far edge of the painting. Then, within a square drawn off
the coast of Florida, he printed his name with the date "63"
and the word HELL following, as if—on this map of his feel-
ings in 1963—he saw himself boxed in, isolated from his
friends in New York, and in a kind of personal hell.

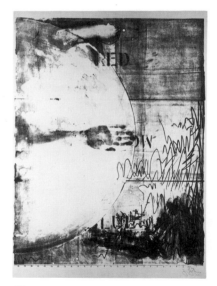

Fig. 49
HATTERAS, 1963
Published by U.L.A.E.
Lithograph
41¾ x 29½ inches

One of those New York friends, with whom Johns
shared a love and knowledge of poetry, was the poet and
MOMA curator, Frank O'Hara, the dedicatee of the painting,
In Memory of My Feelings—Frank O'Hara, 1961 (fig. 31). Johns
and O'Hara had known each other since at least July 1959
when, in a letter to Johns, O'Hara discussed his favorite poets
and commented on the differences between East Coast and
West Coast poets.[41] In August of that year, O'Hara wrote a
poem of their trip with Vincent Warren to Southampton
("Joe's Jacket"), and over the next four years, Johns's name
appeared in two other O'Hara Poems; the latter, in the form of
a letter, "Dear Jap," included the line, "when I think of you in
South Carolina I think of my foot in the sand."

Impressions or imprints of body parts (hands, feet, face) had particular meaning for Johns and O'Hara. In 1961 Johns made a study for a sculpture titled *Memory Piece (Frank O'Hara)* (Private collection), which, when completed in 1970, comprised a rubber cast of O'Hara's foot attached to the under-side of a lid of a wooden box construction filled with sand. (When closed, the cast presses into the sand, marking it with O'Hara's footprint.) Two years later, in 1963, Johns began work on a lithograph that comprised imprints of his own face and hands, to which, two years later, he added the text of O'Hara's poem, "The clouds go soft" (fig. 32).[42] And, in the same year, 1963, he began work on a second lithograph bearing the imprints of his body, *Pinion* (fig. 50), which was to have included the text of a poem by O'Hara (the text was never added and the lithograph was not finished until 1966, after O'Hara's death).

One is tempted to suggest a relation between this coincidence of body imprints and poetry and the idea shared by Crane and Whitman that one's voice comes from touching: "hear my voice, approach,/Touch me, touch the palm of your hand to my body as I pass,/Be not afraid of my body" (Whitman, "As Adam Early in the Morning"). O'Hara thought much of Crane and Whitman: in his "Personism: A Manifesto," written in 1959 but not published until 1961, he cited Crane, Whitman, and William Carlos Williams as the only American poets "better than the movies"; a comment, however much believed by O'Hara, indicative of the manifesto's parodic stance against certain other accounts of the poetic process by Charles Olson, Robert Duncan, and Robert Bly.[43] More important are the echoes between O'Hara's work and Crane's.

"In Memory of My Feelings," O'Hara's poem about the fragmentation and reintegration of the self, takes a serpent (the poetic self) as its central figure. It first appears hunted, hiding beneath leaves "as the hunter crackles and pants/and bursts…" As the trigger is pulled "the aquiline serpent comes to resemble the Medusa" and the poet, who had been one "I" with the serpent, becomes "transparent selves/[which] flail about like vipers in a pail." One is reminded of the daemon thief in Crane's "Passage" which hides beneath the laurel, "my stolen book in hand," only to drive the poet back to the sea where "A serpent swam a vertex to the sun/—On unpaced beaches leaned its tongue and/drummed." For Crane, the thief was Whitman and the serpent, the venomous figure of knowledge that calls memory to break upon the shore. Memory is acknowledged in O'Hara's poem by the lines following those cited above: "The dead hunting/and the alive, ahunted." And the dead return to bring back the serpent "coiled around the central figure,/the heart/that bubbles with red ghosts," until the body, "the naked host to my many selves," is shot and killed. The serpent is then released:

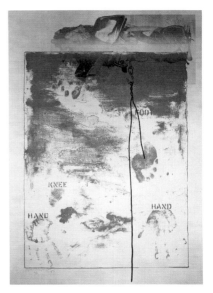

Fig. 50
PINION, 1966
Published by U.L.A.E.
Lithograph
40 x 28 inches

against my will
against my love
become art,
I could not change it into history
and so remember it,
and I have lost what is always and
everywhere present, the scene of my selves, the occasion
of these ruses, which I myself and singly must now kill
and save the serpent in their midst.

The serpent cannot be killed (changed into history) and so is remembered—as for Crane, "Memory, committed to the page, had broke"—and the disguises worn by the poet ("the scene of my selves") are killed to "save the serpent in their midst." And poetry is made.

O'Hara's poetry, his knowledge of poetry in general, and his friendship with other poets, gave Johns access to a world he did not share with Rauschenberg. As Rauschenberg later recalled, "It was my sensual excessiveness that jarred him [Johns]. He was always an intellectual. He read a lot, he wrote poetry—he would read Hart Crane's poems to me, which I loved, but didn't have the patience to read myself—and he was often critical of things like my grammar."[44] Perhaps these are some of the feelings remembered by Johns and shared with O'Hara in *In Memory of my Feelings—Frank O'Hara*, 1961 (fig. 31): feelings about poetry, about certain poems, and about poetry as a sign of the distance between himself and his long-time friend.

As a reader of the same poetry as Johns, O'Hara would have understood the meaning of the coincidence of body imprints and poetry in Johns's work—the bodying forth of artistic voice—just as he would have understood the meaning of their absence in *In Memory of My Feelings—Frank O'Hara* and replacement by the fork and spoon hanging from a wire. In his poem "Dear Jap" of 1963, just five lines below the one cited above—"When I think of you in South Carolina I think of my foot in the sand"—O'Hara recounts that

for Easter
John Myers says
you should have a hard-boiled egg
stuffed with ham
baked in milk
representing the desert

This would mean, he continues, "that small insufferable things become culinary...." I want to see a relation between the culinary representation of insufferable things and the cutlery in Johns's pictures of this period. Recall that a fork is suspended by a wire and chain in *Passage*, 1962 (fig. 51), a spoon by a wire in *Out the Window Number 2*, 1962 (fig. 52),

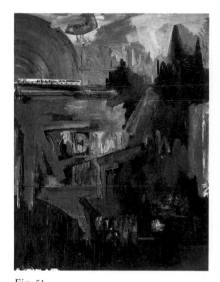

Fig. 51
PASSAGE, 1962
Encaustic and collage on canvas
 with objects
54 x 40 inches
Museum Ludwig, Cologne

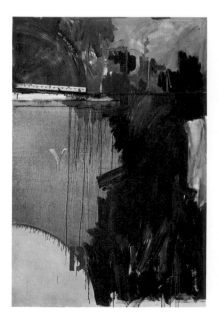

Fig. 52
OUT THE WINDOW NUMBER 2, 1962
Oil on canvas with objects
72 x 48 inches
Collection the artist

220

and a knife, fork, and spoon by a chain and two wires in *Diver*, 1962. Elsewhere I have suggested that such cutlery carries implications of condemnation, imprisonment, and chastity, even sterility, and that it suggests desire, the desire of a child for the father who deserted the family for a "brazenly painted woman" in René Crevel's story *Mr. Knife Miss Fork*, and the desire for love in André Breton's *L'Amour fou*.[45] Are the forks and spoons in Johns's pictures, then, synecdoches, figures of absence, representing the hand that would otherwise hold them—the hands of *Periscope (Hart Crane)* and *Land's End*, both 1963—or the mouth into which they would be put while eating and from which the voice—the artistic voice—would come? Is this their meaning as they hang along the right edge of the painting, *Voice*, 1964-67 (Private collection)? And do the implications of condemnation, sterility, and desire suggest an anxiety about the voice, about *having* a voice, an artistic voice of one's own? Is the lithograph *Voice*, 1966-67, with that great muscular tongue-like form in the center, an image of a scream, a cry against the curse of Echo, the loss of an originating voice?

Recall Johns's statement at the top of this essay—"I decided to do only what I meant to do, and not what other people did…My work became a constant negation of impulses …It was not a matter of joining a group effort, but of isolating myself from any group. I wanted to know what was helpless in my behavior—how I would behave out of necessity"—and think of him on Edisto Island in the early 1960s, on the other side of the black line drawn across his *Map*, 1963, isolated not only from Rauschenberg and a few friends, but also (and equally if not more important) from the New York art scene and all it represented.

Simply put, in the 1960s the New York art scene was still negotiating a relationship with the painters of the previous generation, and Pollock in particular. Pollock had died just four years before, in 1956. The following year, The Museum of Modern Art mounted a large retrospective which it revised and enlarged ten years later. Between these two MOMA exhibitions, 1957 and 1967, critics looked back at Pollock's work and tried to define its special qualities and sort out its legacy.[46] A few years later Johns himself recalled his relationship to the art of the previous generation:

> I have attempted to develop my thinking in such a way that the work I've done is not me—not confuse my feelings with what I produced. I didn't want my work to be an exposure of my feelings. Abstract Expressionism was so lively—personal identity and painting were more or less the same, and I tried to operate the same way. But I found I couldn't do anything that would be identical with my feelings. So I worked in such a way that I could say that it's not me.[47]

Fig. 53
BY THE SEA, 1961
Encaustic and collage on canvas
72 x 54¹/₂ inches
Private collection, New York

221

At issue for Johns, then, working in isolation at the start of his career and at Edisto Beach in the early 1960s, was how to remove the authorial voice from his painting, the unmediated presentation of self that Abstract Expressionism claimed to offer. Or rather, as I have suggested above, how to retain an *original* voice in light of one's precursors's claim on voice as such: how, that is, to paint *Voice*, 1964-67 in light of Barnett Newman's *The Voice*, 1950 and Pollock's *Echo*, 1951 (both, The Museum of Modern Art, New York). Johns's initial answer to these questions was like Crane's answer to Whitman's: take the hand of his precursors, never let them go; paint "touch" into his pictures and find in that touch the source of his own, particular voice.

Clement Greenberg has described Johns's touch and its relation to Abstract Expressionism:

> [Johns] brings de Kooning's influence to a head by suspending it clearly, as it were between abstraction and representation...By means of this "dialectic" the arrival of Abstract Expressionism at homeless representation is declared and spelled out. The original flatness of the canvas, with a few outlines stenciled on it, is shown as sufficing to represent adequately all that a picture by Johns does represent. The paint surface itself, with its de Kooning-esque play of lights and darks, is shown, on the other hand, as being completely superfluous to this end. Everything that usually serves representation and illusion is left to serve nothing but itself, that is abstraction; while everything that usually serves the abstract or decorative—flatness, bare outlines, all-over or symmetrical design—is put to the service of representation.[48]

Greenberg was speaking primarily about Johns's number, letter, target, and flag pictures from 1954 to 1958. With *False Start* (Private collection) and *Jubilee* (Collection S. I. Newhouse), both 1959, however, Johns began to increase the representative value of touch in his pictures—to bring representation home, as it were—until in *Painting with Two Balls*, 1960 (Collection the artist) he acknowledged outright the presence of Abstract Expressionism, particularly the touch of de Kooning, in his work.[49]

That Johns could appropriate de Kooning's touch so easily and so obviously is significant. When Johns was working in New York in the early 1950s de Kooning held enormous power and influence among New York painters. The circle of artists gathered around him was much larger than that gathered around Pollock, and while Pollock worked much of the time out of the city, de Kooning worked and lived downtown. De Kooning was also more verbal and extrovert than Pollock, taking center stage at "The Club" (a gathering of artists and critics like Kline, Newman, Gottlieb, and Harold Rosenberg in a loft on East 8th Street) while Pollock, if in town, remained

around the corner at the Cedar bar. But more important, de Kooning's art offered young painters, like Johns, easier access than Pollock's. Friedel Dzubas made this point in an interview with Max Kozloff in 1965:

> There is something in Bill de Kooning's handwriting, his flick of the wrist that lends itself for other people to take off from. There is a kind of classic predictability in Bill's movement. Now with a truly Baroque talent like Pollock, that is not the case. It would have been much more difficult, or almost impossible, to use Pollock's specific writing without directly copying it.[50]

And Kenneth Noland spoke similarly: "We [he and Morris Louis] were interested in Pollock but could gain no lead from him. He was too personal." While Greenberg, writing in 1948, put it like this: "Without the force of Pollock or the sensuousness of Gorky, more emershed in contradictions than either, de Kooning has it in him to attain a more clarified art and to provide more viable solutions to the current problems of painting."[51] This clarity and these solutions translated themselves into access for the painters of Johns, Noland, and Dzubas's generation, but for the best painters among them—and these three were among the best—the problem remained Pollock and his profound and highly personal handwriting, touch, and voice.

Johns began to work out his relation to Pollock in the "sea" pictures of the period 1961 to 1963. That this should occur at the sea is no surprise. For Pollock was a painter of the sea, for whom "the horizontality...the sense of endless space, and the freedom" it represented were so much a "part of his consciousness," as Lee Krasner once recalled.[52] And many of his most moving paintings take the sea (and its myths) as their subject: *Pasiphaë*, 1943 (originally titled, *Moby Dick*), *The Water Bull*, ca. 1946, perhaps *Blue Unconscious*, 1946, *Full Fathom Five*, 1947, *Sea Change*, 1947, *Ocean Greyness*, 1953, and *The Deep*, 1953. It is a painting simply titled *Number 1A*, 1948 (The Museum of Modern Art, New York), however, that Johns sought to acknowledge in his own "sea" pictures.

Frank O'Hara pointed to this painting in his monograph on Pollock published in 1959. He described it as having "an ecstatic, irritable, demanding force, an incredible speed and nervous legibility in its draftsmanship; and the seemingly bloodstained hands of the painter, proceeding across the top just beyond the main area of the drawing, are like a postscript to a terrible experience."[53] In the same study, O'Hara drew attention to the scale of Pollock's works: "[t]he scale of the painting became that of the painter's body, not just the image of a body, and the setting for the scale, which would include all referents, would be the canvas surface itself."[54]

Johns worked on this scale for the first time in *Diver*, 1962 (The Albert A. List Family Collection). Comprising five separate panels, the picture measures 90 inches high by 170 inches wide. Imprinted on the third and fourth panels are hand and footprints of the artist positioned in such a way as to suggest the movement of the body diving through space. On the first panel, from the left, a semi-circle has been scraped in the paint by a stretcher bar still attached to the picture surface by a wing nut and bolt. A painting of the next year, *Land's End* (San Francisco Museum of Modern Art), also includes a "device-circle" and the painter's handprint (in both pictures the painter's arm is suggested by a scraped area of paint). In *Periscope (Hart Crane)* (fig. 46), also of 1963, however, the semi-circle seems to have been scraped by the painter's arm. The integration of "device-circle" and handprint is crucial here. Michael Fried has suggested that the "device-circle" works in Johns's art as a "mechanical, ironic paradigm of de Kooning's dragging brush and smeared paint-texture."[55] I prefer to see it as a reference to Pollock's use of the stick in his drip pictures, like *Number 1A*, when he would put the stick in the paint can, tilt the can, and let the paint run down the stick onto the canvas. This would make the stick a kind of surrogate of the painter's hand, then, just as in *Periscope (Hart Crane)* it was replaced by the hand. And it would relate the stick to cutlery as synechdoches of the artist's hand, when, as in *Passage* and *Out the Window Number 2*, both 1962 (figs. 51 and 52), a fork and spoon, respectively, are suspended next to the sticks that scraped the semi-circles.

Johns emphasized handprints in his "sea" pictures and related lithographs of this period, I want to argue, as a means of acknowledging his relation to Pollock. As O'Hara wrote in his poem, "Digression on 'Number 1', 1948,"

> There is the Pollock, white, harm,
> will not fall, his perfect hand

> and the many short voyages. They'll
> never fence the silver range.
> Stars are out and there is sea
> enough beneath the glistening earth
> to bear me toward the future
> which is not so dark. I see.[56]

But the future is not so clear for those who follow Pollock and take "his perfect hand." For by reaching out with his hand in these pictures to reach back to take the hand of Pollock—the hands literally printed across the top of *Number 1A*—Johns was risking the loss of his autonomy. The arm in *Land's End*, 1963 might refer to Hart Crane's "arm raised above the water" (from an account of the poet's suicide), but it *is* Johns's hand

(and figured arm). It is *his* suicide—or rather the threat of such—that is represented in these pictures, not an actual but an *artistic* suicide, the loss of an originating voice.[57] For as Whitman warned Crane, and through Crane, Johns:

> Whoever you are holding me now in hand,
> Without one thing all will be useless,
> I give you fair warning before you attempt me further,
> I am not what you supposed, but far different.
> Who is he that would become my follower?
> Who would sign himself a candidate for my affections?
>
> The way is suspicious, the result uncertain, perhaps
> destructive,
> You would have to give up all else, I alone would expect to
> be your sole and exclusive standard…
> Therefore release me now before troubling yourself any
> further, let go your hand from my shoulders,
> Put me down and depart on your way.
> —("Whoever You Are Holding Me Now in Hand")

In O'Hara's "Ode on Causality," a small child takes the poet's hand and shows him Pollock's grave marker—"the bronze JACKSON POLLOCK/gazelling on the rock of her demeanor as a child"—and then says to him, "running/away hand in hand 'he isn't under there, he's out in the woods'" beyond." For Johns in these paintings, Pollock was out in the woods, too. He was the daemon of the inland hills—the thief "my stolen book in hand"—who turned the poet back to the sea in Crane's "Passage" and caused memory to break, suddenly, startingly.

IV

I said above that Johns's reading in American poetry during the early 1960s offered him a way to structure his feelings and turn them back into paintings. I want now, in conclusion, to be more specific. I believe that Johns's close reading of (and identification with) the poetry (and plight) of Hart Crane during this period gave him access to the transumptive mode of allusion by which a late-coming artist, or ephebe, fetches far and back beyond his precursor to the art that influenced his precursor in order to, in effect, correct his precursor's reading or misreading of that influential art. In this way, the late-coming artist gains a kind of *priority* over his precursor and thus escapes from the curse of belatedness which, deriving from the myth of Echo, threatens to deny him an originating voice.[58] In Johns's case, I believe his frequent and obvious allusions to Picasso in the hatchings paintings of the 1970s was not a means of negating the modernist tradition Picasso repre-

sents, but of gaining *priority* over Pollock, fetching far beyond Pollock to the art that influenced him, and revising that part of Pollock's art of which perforce Johns himself was anxious: that is, Pollock's handwriting, a way of working his hand and drawing with paint that was, in Dzubas's words, almost impossible to use "without directly copying it." We need, therefore, to consider briefly the role of drawing in Pollock's art, especially the classic drip pictures of 1947 to 1950.

As John Elderfield has recently described it, the two basic functions of drawing, image-making and the creation of sculptural illusion, are separate and counterposed in Pollock's pre-drip pictures, like *Gothic*, 1944 (The Museum of Modern Art, New York).[59] There line and modelling are effectively independent, the sweeping black, orange, white, and green lines denoting an ensemble of figures against a coarsely textured, blue ground. In a classic drip painting, however, like *Lavender Mist: Number 1, 1950* (National Gallery of Art, Washington, D.C.), the lines have no denotative function or figurative character, but rather weave a painted skein across the picture surface that seems even, in Elderfield's words, "to hang just in front of the resistant plane of the canvas...causing that plane to seem to dissolve into transparency." In a curious way, then, Pollock's drip paintings recombine line and modelling by bringing the modelled ground of the pre-drip pictures—now made one with (of) flowing and interlacing lines—forward to the plane on which line normally figures its descriptive motifs. More important, however, since these lines no longer have denotative functions, they highlight the symbolic and metaphorical nature of their Surrealist automatist origins and fabricate a surface of autographic implications. What Pollock did in this process was to fetch back beyond Picasso and the figure-ground relations that had sustained his pre-drip pictures, to the allover continuum of painterliness that was the lesson of late Impressionism. He then worked into the bargain the relaxed and spontaneous draftsmanship of Surrealism, to the effect that "[t]he very synoptic nature of Pollock's style made it a rich source of future possibilities... [yet] the exactness and individuality of the synopsis made access to it very difficult."[60] Johns's response, then, in his hatchings paintings, was to reconsider the Analytic Cubist origins of the figure-ground relations in Pollock's pre-drip pictures and revise Pollock's art on those terms.[61]

In a typical Analytic Cubist picture like Picasso's *"Ma Jolie,"* 1911-12 (The Museum of Modern Art, New York), a pattern of black lines comprises the contours of motifs whose volume is suggested by the modelled ground against which the motifs are read. The ground, in turn, is made of short, parallel brush strokes of contrasting lights and darks that rise to the surface as fractured planes in a shallow frontal space. Pollock answered Picasso's counterposing of the two basic functions

Fig. 54
FLAG, 1955
Encaustic, oil, and collage on canvas
41¼ x 60⅝ (107.3 x 153.8 cm.)
Collection, The Museum of Modern
* Art, New York.*
Gift of Philip Johnson in honor of
* Alfred H. Barr, Jr. 106.73*

Fig. 55
UNTITLED (Red, Yellow, Blue), 1982
Published by Petersburg Press
Etching and aquatint
Each panel 34¼ x 24⅜ inches

of drawing by pulling the modelled ground forward and combining it with a linear pattern now translated into a painted skein. Johns answered Pollock's answer, as it were, by taking the recombination of line and modelling in the opposite direction and pushing the linear pattern—now restored to its angular relations—into the modelled ground. The surface of such hatchings paintings as *Scent*, 1973 (fig. 35) and *The Dutch Wives*, 1975 (fig. 42) is of a continuous, modelled ground— insistently *of the surface* of the painting rather than seeming to hang in front of it—whose brush strokes are now highly schematized and enlarged: a kind of synthesis of the pre-Cubist striations of *Nude with Draperies*, 1907 (Hermitage Museum, Leningrad) and the buckled surfaces and fractured planes of the Analytic Cubist pictures. By recombining line and modelling in this way, Johns recast the figure-ground relations of Analytic Cubism in opposition to Pollock's recasting of the same: rather than a figured line, as it were, Johns painted a figured *ground*, one which bears little evidence of the personalized handwriting or spontaneous draftsmanship of Surrealism one finds in Pollock's drip paintings.

This is not to say, however, that Johns's hatchings paintings bear no relation to Surrealist sources; only that they do so, as we have seen, in terms of the dissociated objects and words and images of Ernst and Magritte, and the "illustration" of invisible dramas of experience deriving from Duchamp's *The Passage from Virgin to Bride*, 1912 (The Museum of Modern Art, New York) and *The Bride*, 1912 (Philadelphia Museum of Art, the Louise and Walter Arensberg Collection). Put another way, Johns revised the full synoptic nature of Pollock's art by recalling it to the moment when Analytic Cubism was poised on the verge of total abstraction and Surrealism, in all its forms, offered a way out. Pollock went one way, toward the metaphorical automatism of Miro and Masson, and Johns the other.

227

This, then, is the "corpse" figured in the hatched ground of the hatchings panel of *Untitled*, 1972: the revised Pollock held accountable to his origins in Analytic Cubism. The question still remains, why, however; why was Johns so compelled in the 1970s to recall Pollock and, in the process, revisit and revise his own artistic origins? My answer is simple: having worked through his indebtedness to Pollock in the pictures painted at Edisto Beach, he had found his own, strong, originating voice. He could now, on his way back to his own beginnings in 1954, recall the Pollock who had been held up before him as not only the greatest living American painter, but, more important, as the painter most responsible for making advanced, modernist art an American art. This was, in its most eloquent and persuasive form, Clement Greenberg's claim for Pollock, one heard increasingly and debated publicly from 1943 until the artist's death in 1956. And it was the claim Johns must have heard when he settled in New York in 1952 and when in a dream in 1954 he saw himself painting a large American flag and in the same year methodically destroyed all the work in his possession and began the long and arduous task of forgetting (revising) the artistic tradition he could not help but remember in all its influential authority.[62]

Fig. 56
VENTRILOQUIST, 1985
Published by U.L.A.E.
Lithograph
41½ x 27¹⁵/₁₆ inches

Such a close and sustained reading of *Untitled*, 1972 has necessarily taken us back through Johns's art to its origins in the 1950s and early 1960s. It might just as well, had space permitted, taken us in the opposite direction to an account of the artist's more recent work. For in a painting of the following year, *Scent*, 1973 (fig. 35), Johns made clear his revisionary project by taking one of Pollock's last paintings, also *Scent*, 1955 (fig. 36), and subjecting it to a radical reworking in the terms I described above. Then over the next ten years he took the hatchings of *Scent* as his signature pattern and played subtly with various historical allusions, from Duchamp to Picasso to Monet to Munch, always with Pollock there, the "corpse" within the pattern, buried beneath the surface. And at the same time in prints, he continued to rethink and rework his indebtedness to Pollock—in the lithographs *Periscope II* (fig. 47) and *Land's End* (fig. 48), both 1979, and then more freely in the etchings *Untitled (Red, Yellow, Blue)* of 1982 (fig. 55)—until in his most recent lithographs (figs. 56 and 57) he has been able to quote with impunity the American tradition Pollock represented: a reversed copy of Barnett Newman's *Untitled* lithograph of 1960 and the submerged form of Melville's Moby Dick (an allusion to Pollock's *Pasiphaë*, 1946, and an echo of Greenberg's description of Pollock's muddy color in 1943 as the equivalent of "the American chiaroscuro which dominated Melville")[63].

Fig. 57
VENTRILOQUIST, 1986
Published by U.L.A.E.
Lithograph
41½ x 29 inches

In his most recent paintings and the prints that derive from them, *Summer*, 1985 (fig. 58) and *Winter*, 1986 (fig. 59), Johns continues to look back over his own career and the tradition that influenced it. Barbara Rose and Judith Goldman have catalogued the many allusions Johns has painted in these pictures, most of which are to the art of Picasso and need not be repeated here.[64] But there is one echo that is crucial and has been overlooked: the vertical structure of the paintings, their size (life-size), the upright full-length figures, their coloring, even the material presence of their surface; all of these combine to call to mind Pollock's *Male and Female*, ca. 1942 (Philadephia Museum of Art), a quintessential pre-drip picture that betrays Pollock's indebtedness to Cubism. In this way, Johns continues to draw his strength from the scene of instruction that gave him access to the transumptive mode of allusion and the means of gaining priority over Pollock.[65] It is most appropriate then, that he should have chosen one of the prints from these paintings, *Summer* (fig. 58), as the frontispiece for a new volume of Wallace Steven's poetry. For like Crane before him, Stevens was indebted to Whitman and worked through that indebtedness in poems, like "The Idea of Order at Key West," that place the narrator by the sea:

> …she was the maker of the song she sang
> The ever-hooded, tragic-gestured sea
> Was merely a place by which she walked to sing…
>
> It was her voice that made
> The sky acutest at its vanishing.
> She measured to the hour its solitude.
> She was the single artificer of the world
> In which she sang. And when she sang, the sea,
> Whatever self it had, became the self
> That was her song, for she was the maker. Then we,
> As we beheld her striding there alone,
> Knew that there never was a world for her
> Except the one song she sang and, singing, made.[66]

The "she" in this poem is the strong-voiced poet whose rage against the sea is a song of mastery over the curse of Echo. It has been my argument that Johns's art is a similar song of mastery, a bodying forth of his own strong artistic voice, one nourished by the great poets of the American tradition: Whitman, Crane, Stevens, and, in his own particular tradition, Jackson Pollock.

Fig. 58
SUMMER
Frontispiece for POEMS by Wallace Stevens, 1985
Published by The Arion Press
Etching, aquatint, open-bite and drypoint
Page: 11³/₄ x 8⁵/₁₆ inches

Fig. 59
WINTER, 1986
Published by U.L.A.E.
Aquatint, etching, and open-bite
9³/₄ x 6¹/₂ inches

1. Jasper Johns, in Michael Crichton, *Jasper Johns* (New York: Harry N. Abrams and the Whitney Museum of American Art, 1977): 27.

2. Thomas B. Hess, "Polypolytychality," *New York Magazine* 6 (19 February 1973): 73.

3. Typical of these readings is Barbara Rose, "Jasper Johns: *The Seasons*," *Vogue* (January 1987), 193-199, 259-260.

4. Crichton, *Jasper Johns*, 26-27.

5. Harold Bloom, *The Anxiety of Influence* (London: Oxford University Press, 1975), 25-26.

6. Jasper Johns, *0 to 9* 6 (July 1969): 1-2, reprinted in Richard Francis, *Jasper Johns* (New York: Abbeville Press, 1984), 111-112.

7. Richard Shiff, in his essay in the present catalogue, "Anamorphosis: Jasper Johns."

8. Crichton, *Jasper Johns*, 54-55.

9. Richard Shiff, in his essay in the present catalogue, "Anamorphosis: Jasper Johns."

10. Richard S. Field, *Jasper Johns: Prints 1970-1977* (Middletown, CT: Wesleyan University Press, 1978), 50.

11. As the prints after the painting, *Four Panels from Untitled, 1972* (fig. 2), are called A/D, B/D, C/D, and D/D, I refer to the four panels of the painting by the letters A, B, C, and D. This is consistent with Richard Field's use of the letters in his essay in the present catalogue, "The Making of *Foirades/Fizzles*," and in his *Jasper Johns: Prints 1970-1977*, 23-30.

12. The monotypes are reproduced in Judith Goldman, *Jasper Johns: 17 Monotypes* (West Islip, NY: Universal Limited Art Editions, 1982), nos. 5 and 6, respectively. The use of hand prints in the manner of hatching occurred earlier in an untitled drawing of 1977 (ink, watercolor, and crayon on plastic; Collection Margo Leavin, Los Angeles) and in the lithograph, (*Savarin 3 (Red)* of 1978.

13. Thomas B. Hess, "On the Scent of Jasper Johns," *New York Magazine* 9 (9 February 1976): 65-67; and William S. Rubin, *Dada, Surrealism, and Their Heritage* (New York: The Museum of Modern Art, 1968), 83. (Johns's *Target with Plaster Casts*, 1955 [fig. 14] was reproduced on p. 29 of the MOMA catalogue; it was also included in an exhibition of Surrealist art organized by André Breton in 1959.)

14. It may be no coincidence that in 1975 Johns imprinted his upper body, from his thighs to the top of his head, in a charcoal drawing titled *Skin*, which is almost exactly the same size as the drawing *Corpse* of 1974-75: 41³/₄ x 30³/₄ in. as opposed to *Corpse's* 42¹/₂ x 28¹/₂ in. (fig. 25).

15. Rosalind Krauss, "Jasper Johns: The Functions of Irony," *October* 2 (Summer 1976): 96. Krauss does not cite any particular painting from 1907 to 1908, but it is important to note that *Nude with Draperies* was included in the exhibition, "The Cubist Epoch," organized by Douglas Cooper and shown at the Metropolitan Museum of Art from April 7 through June 7, 1971, or the year before Johns's *Untitled*, 1972. See, Douglas Cooper, *The Cubist Epoch* (New York: E.P. Dutton & Co., 1970), 32.

16. *The Use of Words I* was included in Magritte's exhibition at Sidney Janis's gallery in 1954; an exhibition Johns has said he and Rauschenberg studied closely. See Robert Rosenblum, "Magritte's Surrealist Grammar," *Art Digest* 28 (March 1954): 32; and Roberta Bernstein, *Jasper Johns' Paintings and Sculpture 1954-1974: "The Changing Focus of the Eye"* (Ann Arbor: UMI Research Press, 1985), 4. Also in 1928-29, Magritte painted *The Magical Mirror* (Collection L. Monti, Milan) which depicts a large mirror, the face of which is inscribed *"corps humain."*

17. This was pointed out to Calas by Mark Lancaster. See, Nicolas Calas, "Jasper Johns and the Critique of Painting," *Punto de Contacto/Point of Contact* 3 (September-October, 1976): 55.

18. Roberta Berstein, *Jasper Johns' Paintings and Sculptures 1954-1974*, 237, n. 30.

19. Richard Field described this effect as enclosing the panels "in parenthetical allusions to the past and future." He also noted that Johns specified that the Gemini prints, *Four Panels from Untitled, 1972* (fig. 2), if not installed in the order of the panels of the painting, should be kept in proper rotational order: BCDA, CDAB, or DABC. See Field, *Jasper Johns: Prints 1970-1977*, 26, n. 51. For his discussion of Johns's further exploration of these possibilities in the etchings for *Foirades/Fizzles*, see Field's essay in the present catalogue, "The Making of *Foirades/Fizzles*."

20. Jasper Johns, in Roberta Berstein, "An Interview with Jasper Johns," in Lawrence D. Kritzman, ed., *Fragments: Incompletion and Discontinuity* 8-9 (New York: New York Literary Forum, 1981), 287. In the same interview, Johns spoke more generally of cast anatomical fragments in his works: "There's a kind of automatic poignancy connected with the experience of such a thing. Any broken representation of the human physique is touching in some way; it's upsetting or provokes reactions that one can't quite account for. Maybe because one's image of one's own body is disturbed by it."

21. Bernstein, *Jasper Johns' Paintings and Sculptures, 1954-1974*, 137, n. 30.

22. In his words from the sketchbook notes quoted above: "Aim for maximum difficulty in determining what has happened?...Another possibility: to see that something has happened. Is this best shown by 'pointing to it' or by 'hiding' it." Jasper Johns, "Skechbook Notes," *0 to 9*, 6 (July 1969): 1-2, reprinted in Francis, *Jasper Johns*, 112.

23. In George Thornley's Elizabethan version, quoted in John Hollander, *The Figure of Echo: A Mode of Allusion in Milton and After* (Berkeley: University of California Press, 1981), 7-8.

24. George Sandys, *Ovid's Metamorphoses Englished* (Oxford: J. Lichfield, 1632; New York: Garland Publishing, Inc., The Renaissance and the Gods Series, 1976), 88-90.

25. Krauss, "Jasper Johns: The Functions of Irony," 96.

26. Krauss, "Jasper Johns: The Functions of Irony," 94.

27. Krauss, "Jasper Johns: The Functions of Irony," 98.

28. Richard S. Field, in his essay in the present catalogue, "The Making of *Foirades/Fizzles.*"

29. I prefer Barbara Rose's reading of irony in Johns's art to Krauss's: "Irony serves to distance the viewer; it causes second thoughts. Irony is not a tool of superficial ridicule for Johns, but an essential means to emphasize his awareness that history repeats itself: his understanding that repetition is a rule rather than an exception in history, both as autobiography and as abstract record of human events." See her, "Decoys and Doubles: Jasper Johns and the Modernist Mind," *Arts Magazine* 50 (May 1976): 69.

30. In a conversation with Richard Francis, Johns spoke of these nagging ghosts: "Seeing a thing can sometimes trigger the mind to make another thing. In some instances the new work may include, as a sort of subject matter, references to the thing that was seen. And, because works of painting tend to share many aspects, working itself may initiate memories of other works. Naming or painting these ghosts sometimes seems a way to stop their nagging." Jasper Johns, in Richard Francis, *Jasper Johns*, 98.

31. Hollander, *The Figure of Echo*, 62.

32. Calvin Tomkins, *Off the Wall: Robert Rauschenberg and the Art World of Our Time* (New York: Doubleday & Co., 1980), 198. Also see Fred Orton's discussion of this period in his essay in the present catalogue, "Present, the Scene of...Selves, the Occasion of...Ruses."

33. My reading of these poets has been shaped by Harold Bloom's studies, *Poetry and Repression: Revisionism from Blake to Stevens* (New Haven: Yale University Press, 1976) and *Agon: Towards a Theory of Revisionism* (New York: Oxford University Press, 1982).

34. Leo Steinberg, "Jasper Johns: The First Seven Years of His Art," first published in *Metro* 4/5 (1962). Reprinted in *Other Criteria* (Oxford: Oxford University Press, 1972), 53. I cannot help but think of a parallel situation in Cézanne's art during the 1870s when he learned the lesson of Impressionism and overcame the private anxieties recorded in his early paintings. In John Elderfield's words, "Impressionism unsealed the introverted Cézanne—taught him not only how to paint, but what it meant to be a painter; henceforward, making his visions real to himself—what he actually saw, not what he invented—became his primary concern. And here, the screen of the eye became the vehicle through which an emotional response to nature was filtered so as to render nature with a fullness, completeness, and exactness on the screen of the picture

surface, an exactness that was demanded to make it seem real to him. The sensations he received from nature were affective as well as optical: 'I paint as I see, as I feel,' he said, linking the two together, ' — and I have very strong sensations." See Elderfield, "The World Whole: Color in Cézanne," *Arts Magazine* (April 1978): 149. Seeing painting as the thing and task before him, allowed Cézanne to construct order when he could not, otherwise, from his personal fantasies and anxieties. I believe the same was true for Johns in the early 1960s and then again in the 1970s. But it was not only painting that Johns saw, but poetry; specifically the poetry of Whitman, Crane Stevens, and O'Hara, and the transumptive allusions by which they revised and ordered their poetic origins. For Johns's high regard for Cézanne, see Bernstein, *Jasper Johns' Paintings and Sculptures 1954-1974*, 68-74.

35. Evidently Johns made a small painting in 1962 titled simply, *Iron*, with a labeled iron imprint on an encaustic surface. See Bernstein, *Jasper Johns' Paintings and Sculptures 1954-1974*, 104, n.2.

36. Harold Bloom, *Agon: Toward a Theory of Revisionism*, 258.

37. I quote from *The Complete Poems and Selected Letters and Prose of Hart Crane*, ed. Brom Weber (Garden City, N.Y.: Anchor Books, 1966) and *Walt Whitman: The Complete Poem*, ed. Francis Murphy (Harmondsworth: Penguin Books, Ltd., 1975).

38. Bloom, *The Anxiety of Influence*, 5.

39. In his convincing essay, "Whitman's Image of Voice: To the Tally of My Soul," Bloom has argued that Whitman "identifies himself as a voice, a voice overflowing with presence, a presence that is a sexual self-knowledge..." and that his creative act "starts with listening and then regresses to touch, until he achieves both orgasm and poetic release through a Sublime yet quite literal masturbation." He quotes from many sections of Whitman's "Song of Myself," one of which includes the lines: "Blind loving wrestling touch, sheath'd hooded sharp-tooth'd/touch! Did it make you ache so, leaving me?" And he calls this section of the poem, "the most productive masturbation since the ancient Egyptian myth of a god who masturbates the world into being." See his, *Agon: Towards a Theory of Revisionism*, 188-189. This idea Johns has tried to make his own. His reputation for privacy, even, to some extent reclusiveness; his frequent return to and revision of his own earlier works in the making of new ones; even the prominence of the sea horse in his recent painting, *Summer*, 1985 (Private collection) and in his frontispiece for *POEMS* by Wallace Stevens, 1985 (fig.58), which has been identified by Barbara Rose as one of the few species in which the male bears the offspring; all of this has been interpreted as Johns creating himself through and from his art, as if he were as chaste as Whitman. I prefer to think of this Narcissistic pose as a feint by the artist, calculated to veil his true self which is more Crane-like and anxious in the face of tradition. See Barbara Rose, "Jasper Johns: The Seasons," *Vogue* (January 1987): 259.

40. Johns would surely have been familiar with Picasso's *Seated Bather*, not only because it was in the collection of The Museum of Modern Art, but because he once mentioned that his *Three Flags* of 1958 (The Whitney Museum of American Art) reminded him of Picasso's *Bather by the Sea* of 1933 (Collection, Mr. and Mrs. Victor W. Ganz, New York), a picture not unrelated to the earlier *Seated Bather*. See Bernstein, *Jasper Johns' Paintings and Sculptures 1954-1974*, 13.

41. See Marjorie Perloff, *Frank O'Hara: Poet Among Painters* (Austin, TX: University of Texas Press, 1977), 15, ns. 42, 43, 44, and 45, n.30.

42. The addition of O'Hara's poem was prompted by Francine du Plessix who edited an anthology of artists' responses to poems for an issue of *Art in America*. Du Plessix had written to twenty-two American painters during the Winter of 1964 asking them to make a work in response to a contemporary poem of their choice. Three New York painters chose Frank O'Hara but Johns was the first to reply (not just with the choice of O'Hara but the first to reply to the project at all — a sign of his interest in poetry) and so got his choice. See *Art in America* 53 (October-November 1965): 24.

43. The manifesto was initially written for publication in Donald Allen's *New American Poetry* (1960) but then withdrawn. It appeared a year later in *Yūgen* 7 (1961) and is reprinted in Frank O'Hara, *Standing Tall and Walking in New York*, ed. Donald Allen (Bolinas, CA: Grey Fox Press, n.d.), 110-111. See Perloff, *Frank O'Hara*, 15-18.

44. In Tomkins, *Off the Wall*, 119.

45. James Cuno, "Jasper Johns," review of *Jasper Johns: A Print Retrospective* by Riva Castleman, *Print Quarterly* 4 (March 1987): 91-92.

46. Clement Greenberg, "After Abstract Expressionism," *Art International* 6 (October 1962): 25-27; and Greenberg, "Post Painterly Abstraction," *Art International* 8 (Summer 1964): 63-65; Michael Fried, *Three American Painters* (Cambridge, MA: Fogg Art Museum, 1965); and William Rubin, "Jackson Pollock and the Modern Tradition: Part One," *Artforum* 5 (February 1967): 14-22; "Part Two," *Artforum* 5 (March 1967): 28-37; "Part Three," *Artforum* 5 (April 1967): 18-31; and "Part Four," *Artforum* 5 (May 1967): 28-33.

47. Vivien Raynor, "Jasper Johns" (interview) *Art News* 72 (March 1973): 22.

48. Greenberg, "After Abstract Expressionism," 25.

49. *Painting with Two Balls* is generally described as an ironic commentary on the "ballsiness" of Abstract Expressionist painting and the verility of the painted gesture. That is undoubtedly true. The more interesting question is why Johns felt the need to comment on the legacy of Abstract Expressionism and how this painting might represent that feeling. Ronald Paulson has read the two balls of the painting as suggesting that "the male principle is engulfed by the female, which is a long narow cleft. They [the balls] are detached, like the body parts that are always fragmented [in John's works], in the Freudian sense uncanny ('breaking up')." The joke Paulson sees in the painting is far darker than the simple one generally seen there: "essentially a male joke involving the dismembered vagina, the detached part giving pleasure, as well as the vagina that devours and the even more famous vagina dentata that itself dismembers." It is a joke called up by a fear of castration, of losing one's potency. The balls are, it is obvious, under some pressure in the painting, trapped as they are between two panels. See Paulson, "Jasper Johns and Others," *Bennington Review* no.1 (April 1978): 70-71.

50. Max Kozloff, "An Interview with Friedel Dzubas," *Artforum* 4 (September 1965):50. Also see Kozloff, "The Impact of de Kooning," *Arts Yearbook* 7 (1964), 77-88, and contrast this with Allan Kaprow, "The Legacy of Jackson Pollack," *Art News* 57 (October 1958): 24-26, 55-57.

51. Kenneth Noland, quoted in John Elderfield, *Morris Louis* (New York: The Museum of Modern Art, 1986), 13. Clement Greenberg, "Review of an Exhibition of William de Kooning," originally published in *The Nation* (April 24, 1948), reprinted in John O'Brian, ed., *Arrogant Purpose, 1945-1949*, vol. 2 of *Clement Greenberg: The Collected Essays and Criticism* (Chicago: University of Chicago Press, 1986), 230.

52. Lee Krasner, in an interview with B.H. Friedman, published in *Jackson Pollock: Black and White*, intro. William S. Liberman (New York: Marlborough-Gerson Gallery, 1969), 8. We should also note de Kooning's evocation of the sea in an interview with Harold Rosenberg: "As in your lecture about the 'water gazers', do you remember, in the beginning of *Moby Dick?* when Ishmael felt desperate and didn't know what to do he went to Battery Place? That's what I do. There is something about being in touch with the sea that makes me feel good. That's where most of my paintings come from, even when I make them in New York." (*Art News* 71 [September 1972]: 58). And we are reminded of Harold Bloom's remark, "Poets tend to incarnate by the side of the ocean, at least in vision, if inland far they be." (*A Map of Misreading* [Oxford: Oxford University Press, 1975], 13).

53. Frank O'Hara, *Jackson Pollock* (New York: George Braziller, 1959), 24-25.

54. Frank O'Hara, *Jackson Pollock*, 28.

55. Michael Fried, "New York Letter," *Art International* 7 (February 1963): 61.

56. Published in O'Hara's monograph on Pollock (1959), *Jackson Pollock*, 23-24.

57. The suggestion of the arm's reference to Crane's suicide is Bernstein's; see her, *Jasper Johns' Paintings and Sculptures*, 109. On the ambiguity of the hand print in both Pollock's and John's art (that it can be read either as imprinting down from above or up from below), see Charles F. Stuckey, "Another Side of Jackson Pollock," *Art in America* 65 (November-December 1977): 81-91, and Rosalind Krauss, "Jasper Johns," *Lugano Review* 2 (Summer 1976): 92-93.

58. See, Bloom, *The Anxiety of Influence*, 139-155 and Hollander, *The Figure of Echo*, 113-149.

59. Elderfield, *Morris Louis*, 29.

60. Elderfield, *Morris Louis*, 30.

61. Barbara Rose sees Johns's strategy against the influence of Pollock differently: "By reaching straight back behind the modern styles of the 20th century to redeem what was still viable in late-Impressionism, Johns gained access to an all-over style that was one of Pollock's sources without necessarily having to deal with Pollock's art directly." I see Pollock's interest in Impression simply as a means of liberating his art from the influence of Picasso and analytical cubism. Therefore I do not see Johns turning to Impressionism to escape Pollock, when that is precisely where Pollock went to escape Picasso. This would have Johns identifying with Pollock's art rather than revising it. See Barbara Rose, "The Graphic Work of Jasper Johns, Part 1," *Artforum* 8 (March 1970): 39. For another reading of Pollock's relation to Picasso, see Jonathan Weinberg, "Pollock and Picasso: The Rivalry and the 'Escape,'" *Arts Magazine* 61 (Summer 1987): 42-48.

62. That Johns should start *being* an artist by painting an American flag (fig. 54) and thus cast his origins in a distinctly American light is not surprising. For the issue of artistic and national identities were intertwined in the late 1940s and early 1950s. Serge Guilbaut has documented the ideological fit that brought the new liberalism of post-war American politics together with the modernism of Alfred Barr and Rene d'Harnoncourt of The Museum of Modern Art in commom opposition to the conservatism and xenophobia of Senator Joseph McCarthy and Congressman George Dondero. (Serge Guilbaut, *How New York Stole the Idea of Modern Art*, tr. Arthur Goldhammer [Chicago: University of Chicago Press, 1983]; also see Eva Cockcroft, "Abstract Expressionism: Weapon of the Cold War," *Artforum* 12 [June 1974]:39-41). While the former was demanding from writers, actors, filmmakers, and others, evidence of their unimpeachable Americaness and the alleged un-Americaness of their friends, the latter was making speeches before Congress proclaiming that "Cubism aims to destroy by designed disorder" and arguing in interviews to newspapers that "modern art is communistic because it is distorted and ugly, because it does not glorify our beautiful country, our cheerful and smiling people, and our material progress...those who create [modern art] are our enemies" (quoted in William Hauptman, "The Suppression of Art in the McCarthy Decade, "*Artforum* 12 [October 1973]: 48-52). And, as Fred Orton points out in his essay to the present catalogue, the trustees of the Museum of Modern Art acknowledged the political implications of Johns's *Flag*, when they disapproved its purchase for fears that it would offend patriotic sensibilities (see Orton, "Present, the Scene of ... Selves, the Occasion of ... Ruses," n.25). I am inclined to think that the issue of personal and national identities was even more complex in Johns's case. He was, for example, named after his father, Jasper Johns, who once took Johns as a boy to see a stuatue of Sergeant William Jasper and told him that the figure was the namesake of them both. Sergeant Jasper, significantly, distinguished himself by twice recovering the fallen American flag: during the bombardment of Charleston Harbor, June 1776, and in the assault upon Savannah, October 1779 (Charles F. Stuckey, "Johns: Yet Waving?" *Art in America* 64 [May-June 1976]: 5, and Crichton, *Jasper Johns*, 36, n.34). In addition, Johns's learning of his namesake from his father may have been further complicated by the fact that his parents had separated shortly after his birth, leaving him to be raised by his grandparents, an aunt and uncle, and then later his mother and step-father. Perhaps all of these issues of identity comprise "the other levels" Johns claimed he was able "to work on" by using the given design of the American flag in his early pictures (see, Crichton, *Jasper Johns*, 28).

63. Clement Greenberg, "Review of Exhibitions of Marc Chagall, Lyonel Feininger, and Jackson Pollock," originally published in *The Nation* (1943), republished in *Perceptions and Judgments, 1939-1944*, vol. 1 of *Clement Greenberg: The Collected Essays and Criticism*, ed., John O'Brian (Chicago: University of Chicago Press, 1986), 165.

64. Barbara Rose, "Jasper Johns: The Seasons, "*Vogue* 177 (January 1987): 193-199 and 259-260. And Judith Goldman, *Jasper Johns: The Seasons* (New York: Leo Castelli, 1987).

65. The phrase, "scene of instruction," is Harold Bloom's and is in response to Derrida's essay on Freud and the Scene of Writing. See Bloom, *Poetry and Repression: Revisionism from Blake to Stevens* (New Haven: Yale University Press, 1976), 1-11.

66. I quote from the edition of Wallace Steven's poems to which Johns contributed the frontispiece, *Summer* (fig. 58); Wallace Stevens, *Poems*, intro. Helen Vendler (San Franciso: The Arion Press, 1985), 84.

TRIAL PROOFS
FOR
FOIRADES/FIZZLES

Plate 1

FACE, i/xii, 1975-76
Lift-ground aquatint
(cat. no. 35)

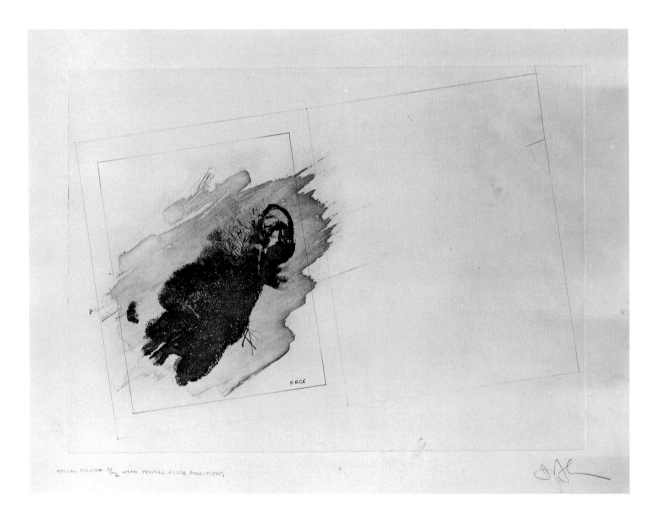

Plate 2

FACE, iii/xii, 1975-76
Lift-ground aquatint, scraper,
and abrasive powder with
graphite and ink additions
(cat. no. 36)

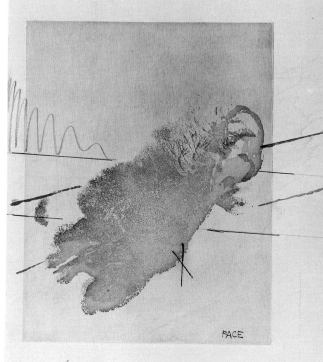

Plate 3

FACE, vi/xii, 1975-76
Lift-ground aquatint, scraper, and
abrasive powder with graphite and
ink additions.
(cat. no. 37)

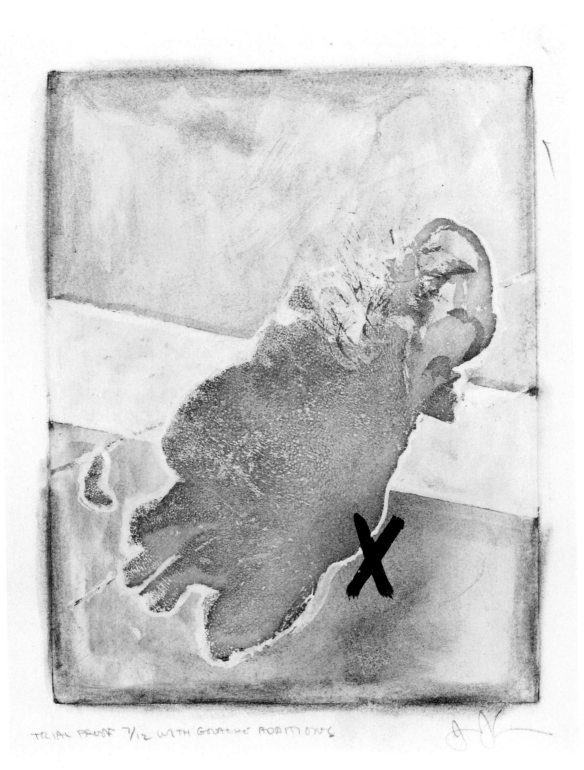

TRIAL PROOF 7/12 WITH GOUACHE ADDITIONS

Plate 4

FACE, vii/xii, 1975-76
Lift-ground aquatint, scraper, and
abrasive powder with gouache
additions
(cat. no. 38)

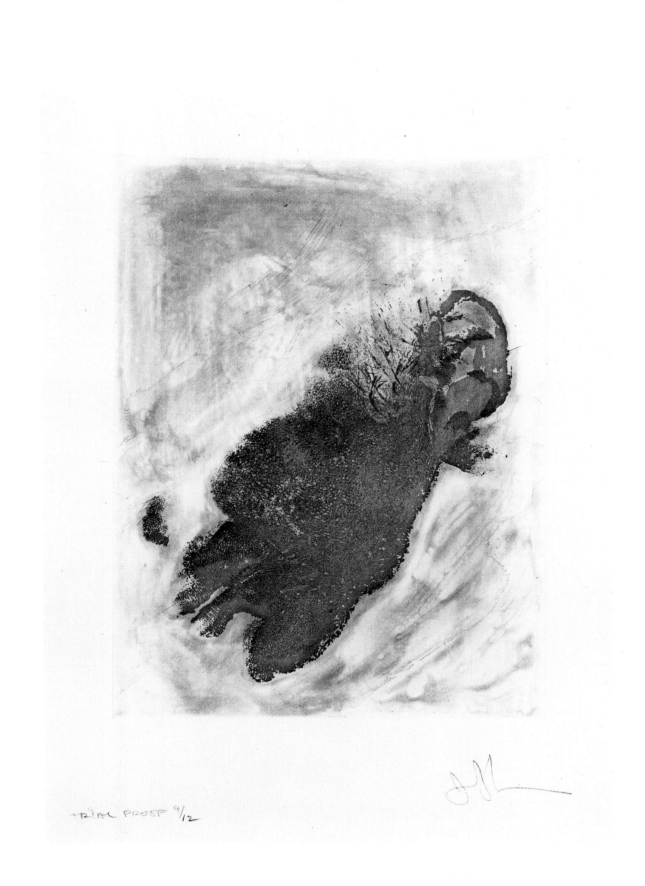

TRIAL PROOF 9/12

Plate 5

FACE, ix/xii, 1975-76
Lift-ground aquatint, scraper, and
abrasive powder
(cat. no. 39)

TRIAL PROOF 12/12 WITH PENCIL ADDITIONS

Plate 6

FACE, xii/xii, 1975-76
Lift-ground aquatint, scraper, and
abrasive powder with graphite
additions
(cat. no. 40)

Plate 7

WORDS, (Buttock Knee Sock…), i/x,
1975-76
Lift-ground aquatint
(cat. no. 41)

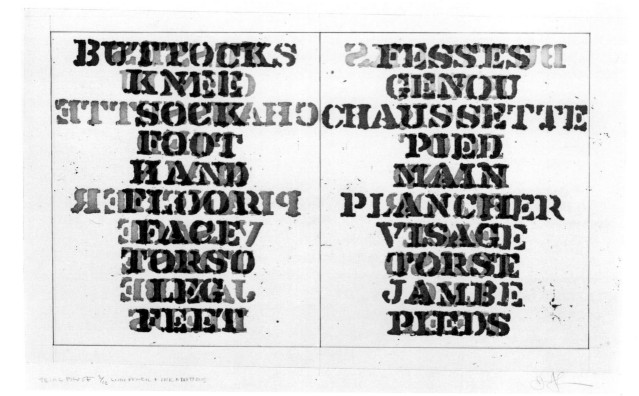

Plate 8

WORDS, (Buttock Knee Sock…),
ii/x, 1975-76
Lift-ground aquatint
with graphite and ink additions
(cat. no. 42)

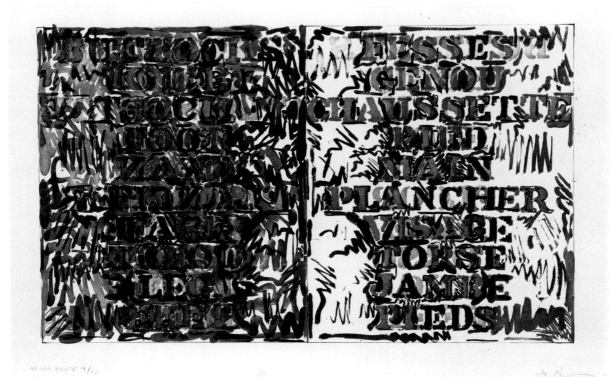

Plate 9

WORDS, (Buttock Knee Sock …), iv/x,
1975-76
Lift-ground aquatint
(cat. no. 43)

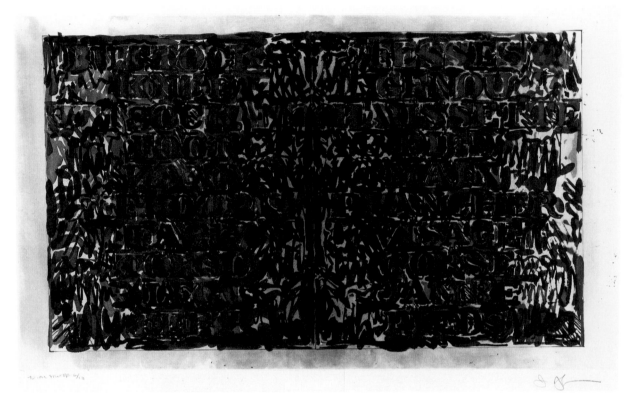

Plate 10

WORDS, (Buttock Knee Sock…), vi/x,
1975-76
Etching and lift-ground aquatint
(cat. no. 44)

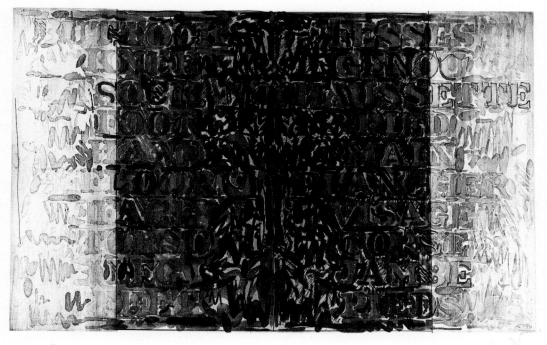

Plate 11

WORDS. (Buttock Knee Sock…),
vii/x, 1975-76
Etching, lift-ground aquatint, and
burnishing with ink additions
(cat. no. 45)

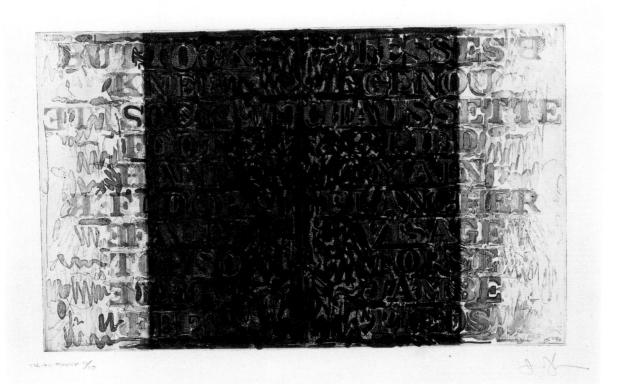

Plate 12

WORDS, (Buttock Knee Sock…), x/x,
1975-76
Etching, lift-ground aquatint,
and burnishing
(cat. no. 46)

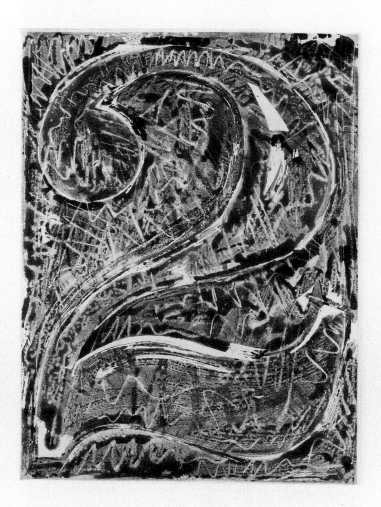

Plate 13

NUMERAL 2, i/iv, 1975-76
Etching, crayon stop-out, and
open-bite
(cat. no. 47)

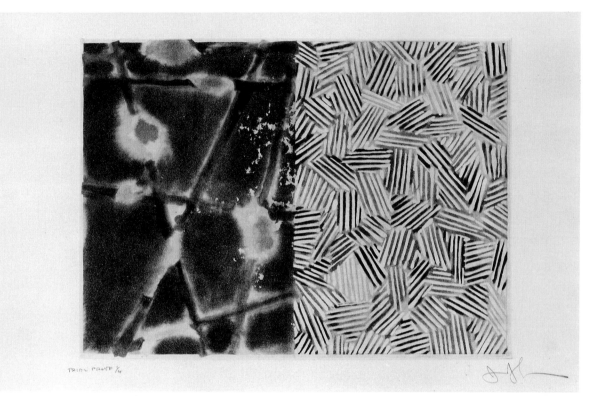

TRIAL PROOF ¼

Plate 14

CASTS AND HATCHING, i/iv, 1975-76
Etching, lift-ground aquatint, and
open-bite
(cat. no. 48)

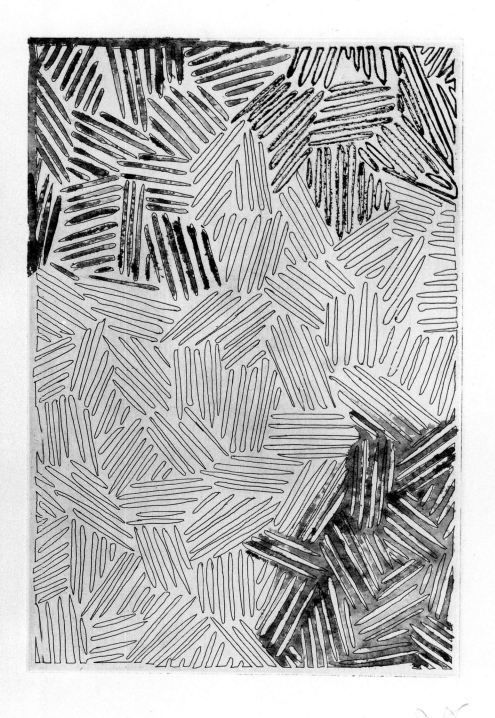

TRIAL PROOF ¼ WITH INK ADDITIONS

Plate 15

HATCHING, i/iv, 1975-76
Etching and lift-ground aquatint
with ink additions
(cat. no. 49)

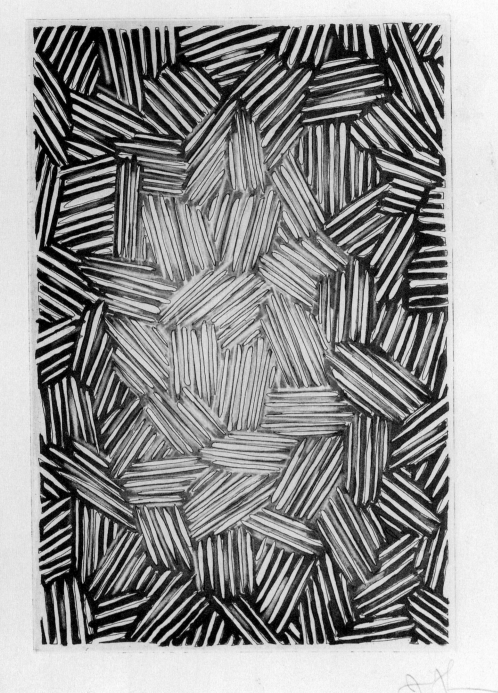

TRIAL PROOF 4/4

Plate 16

HATCHING, iv/iv, 1975-76
Etching, lift-ground aquatint,
and burnishing
(cat. no. 50)

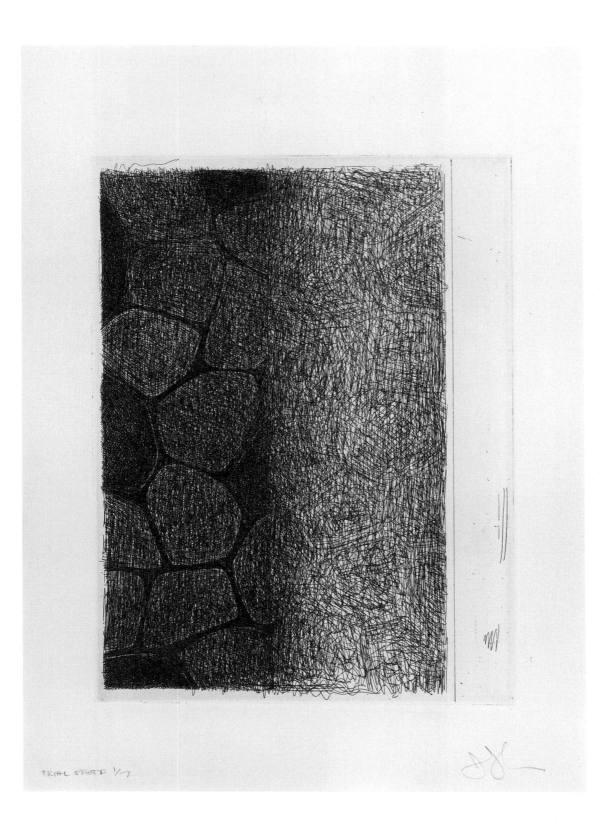

TRIAL PROOF 1/7

Plate 17

FLAGSTONES (a), i/vii, 1975-76
Etching
(cat. no. 51)

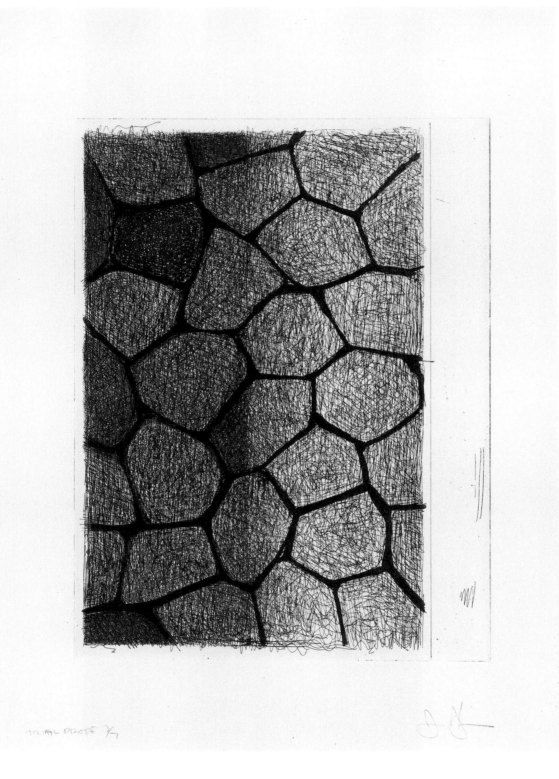

TRIAL PROOF 2/7

Plate 18
FLAGSTONES (a), iii/vii, 1975-76
Etching and lift-ground aquatint
(cat. no. 52)

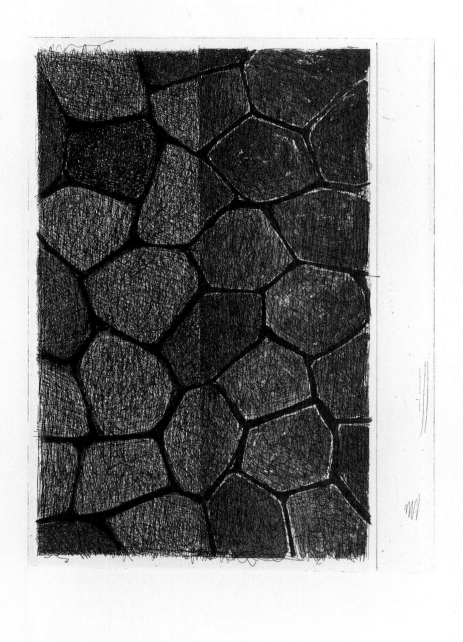

TRIAL PROOF 4/7

Plate 19

FLAGSTONES (a), iv/vii, 1975-76
Etching and lift-ground aquatint
(cat. no. 53)

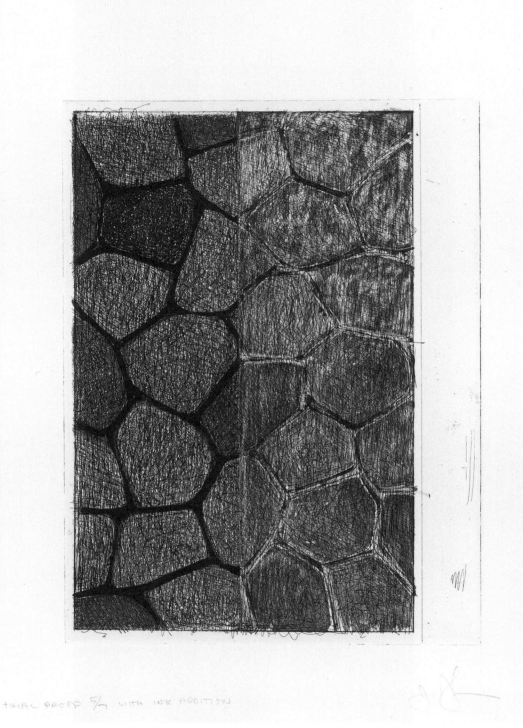

TRIAL PROOF ⁵/₇ WITH INK ADDITION

Plate 20

FLAGSTONES (a), v/vii, 1975-76
Etching, lift-ground aquatint, and
burnishing with ink additions
(cat. no. 54)

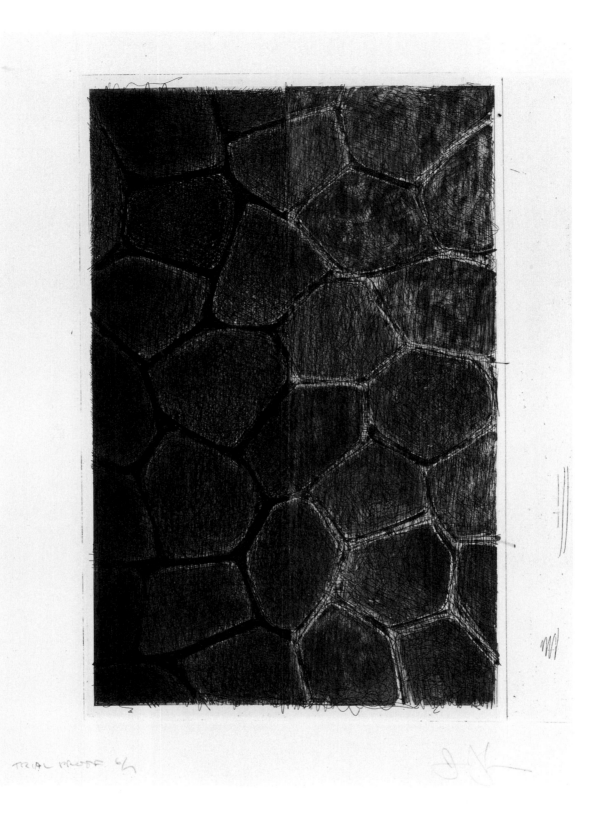

TRIAL PROOF ⁶/₄

Plate 21

FLAGSTONES (a), vi/vii, 1975-76
Etching, lift-ground aquatint,
and burnishing
(cat. no. 55)

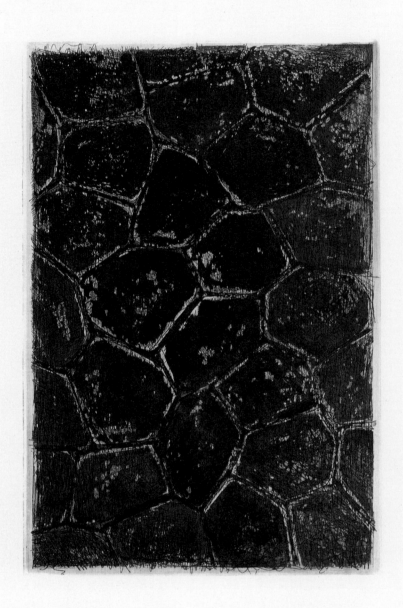

TRIAL PROOF 7/7

Plate 22

FLAGSTONES (a), vii/vii, 1975-76
Etching and lift-ground aquatint
(cat. no. 56)

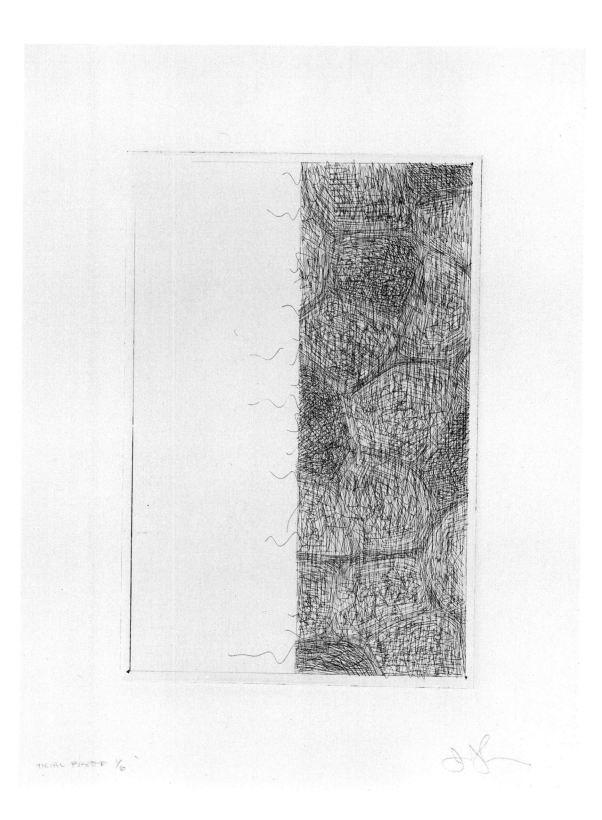

TRIAL PROOF ¹/₆

Plate 23

FLAGSTONES (b), i/vi, 1975-76
Etching
(cat. no. 57)

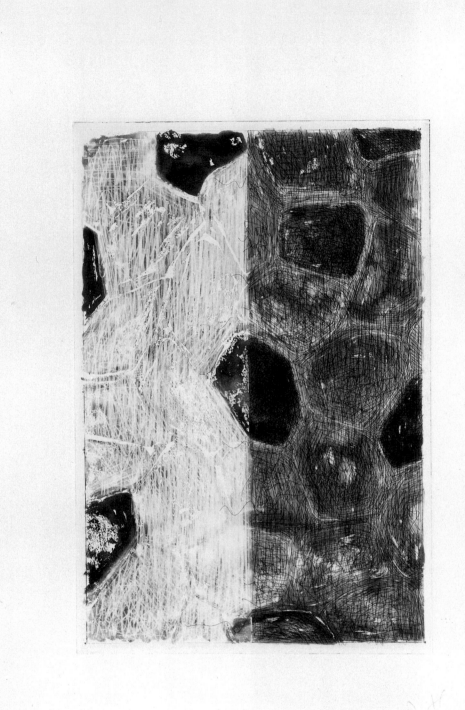

TRIAL PROOF 3/6

Plate 24

FLAGSTONES (b), iii/vi, 1975-76
Etching, lift-ground aquatint,
burnishing, and stop-out
(cat. no. 58)

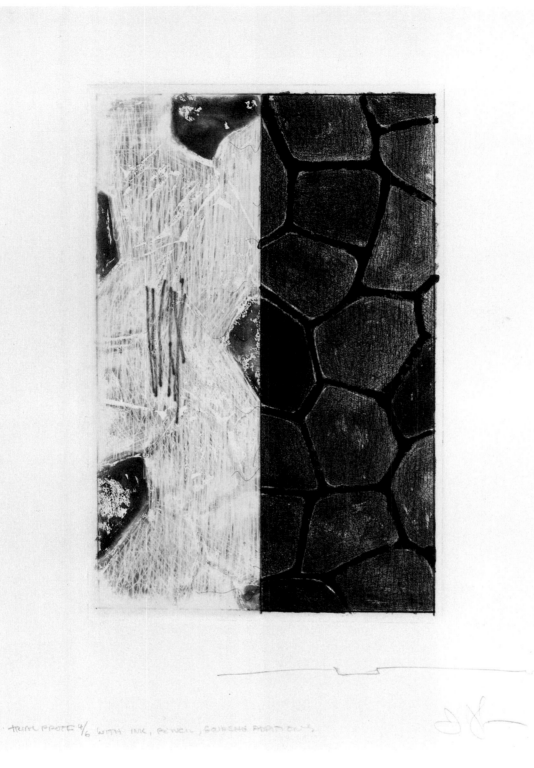

Plate 25

FLAGSTONES (b), iv/vi, 1975-76
Etching, lift-ground aquatint,
burnishing, and stop-out with ink,
graphite, and gouache additions
(cat. no. 59)

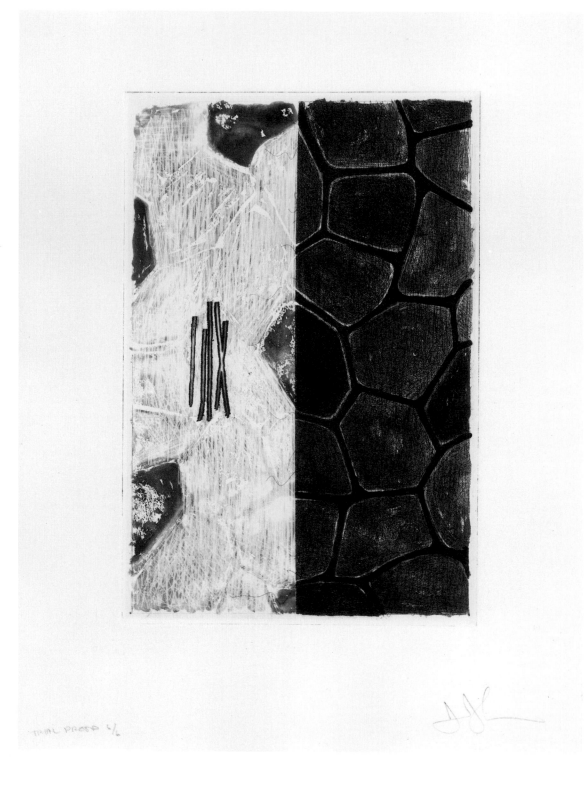

TRIAL PROOF 6/6

Plate 26

FLAGSTONES (b), vi/vi, 1975-76
Etching, lift-ground aquatint,
burnishing, and stop-out
(cat. no. 60)

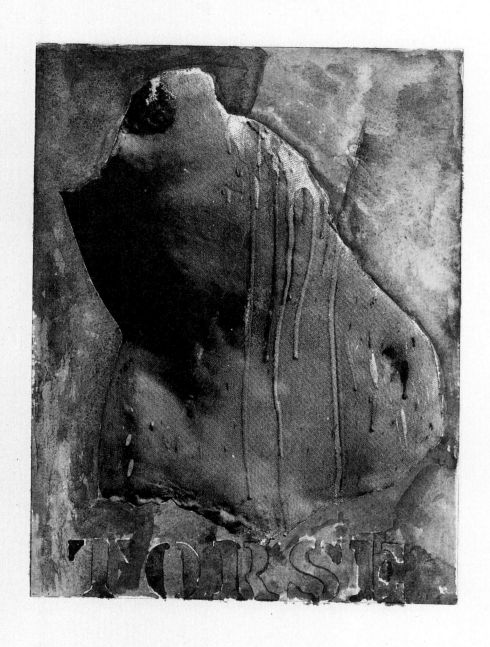

TRIAL PROOF ½ WITH GOUACHE ADDITIONS

Plate 27

TORSE i/ii, 1975-76
Photo-screen squeegeed onto plate
and lift-ground aquatint with
gouache additions
(cat. no. 61)

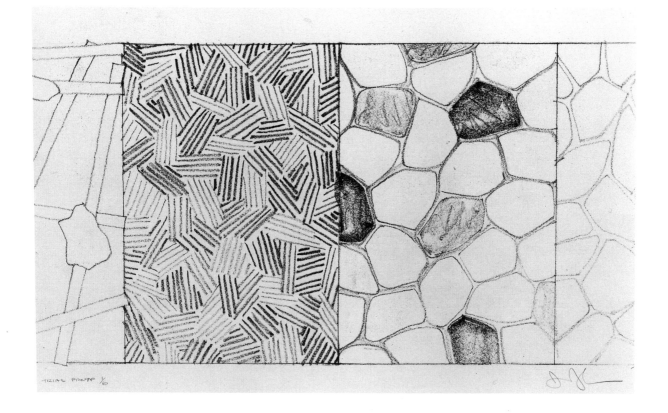

TRIAL PROOF 1/6

Plate 28

HATCHING AND FLAGSTONES, i/vi,
1975-76
Soft-ground etching
(cat. no. 62)

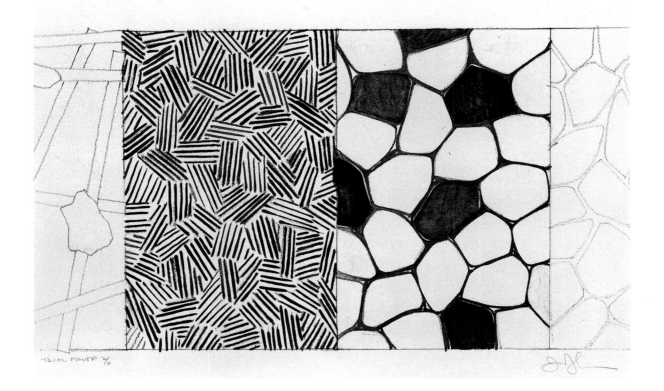

TRIAL PROOF ³/₅

Plate 29
HATCHING AND FLAGSTONES, ii/vi,
1975-76
Soft-ground etching and open-bite
(cat. no. 63)

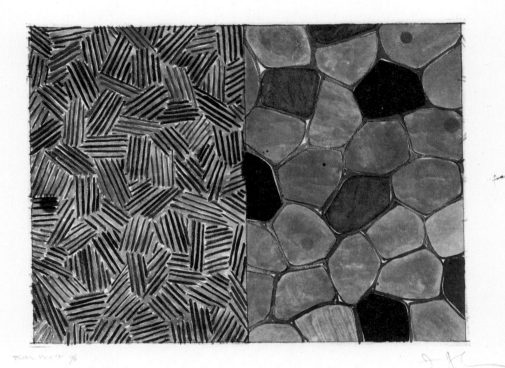

Plate 30
HATCHING AND FLAGSTONES, iv/vi,
1975-76
Soft-ground etching and open-bite
(cat. no. 64)

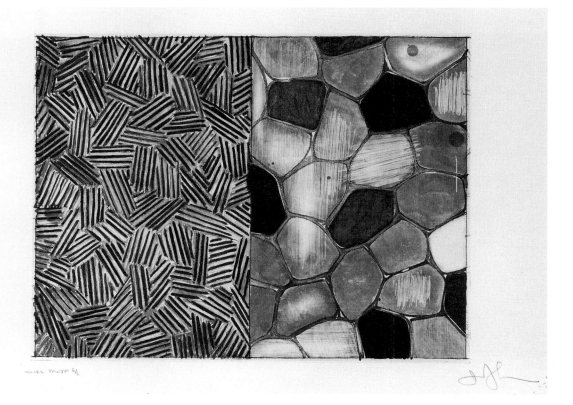

Plate 31
HATCHING AND FLAGSTONES, vi/vi,
1975-76
Soft-ground etching, open-bite,
and burnishing
(cat. no. 65)

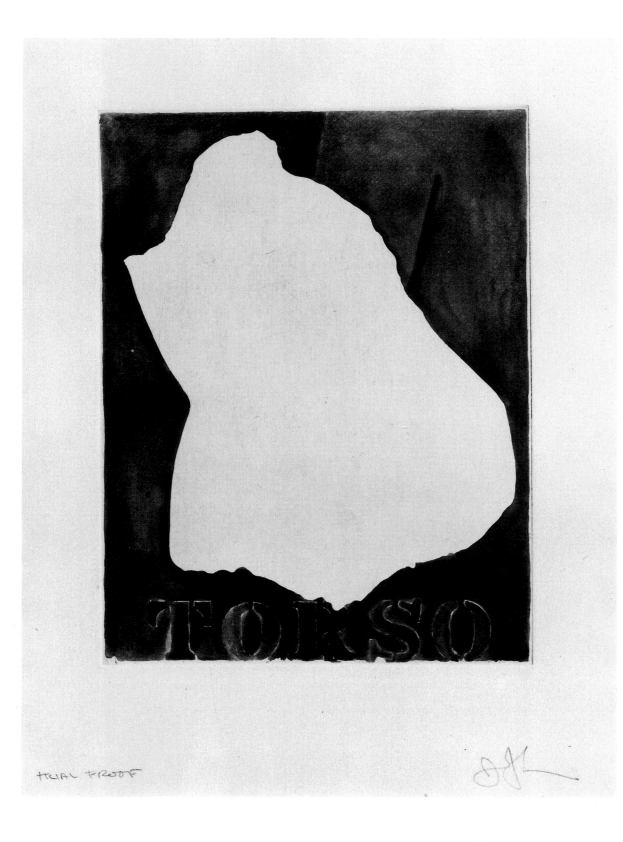

TRIAL PROOF

Plate 32
TORSO i/i, 1975-76
Lift-ground aquatint
(cat. no. 66)

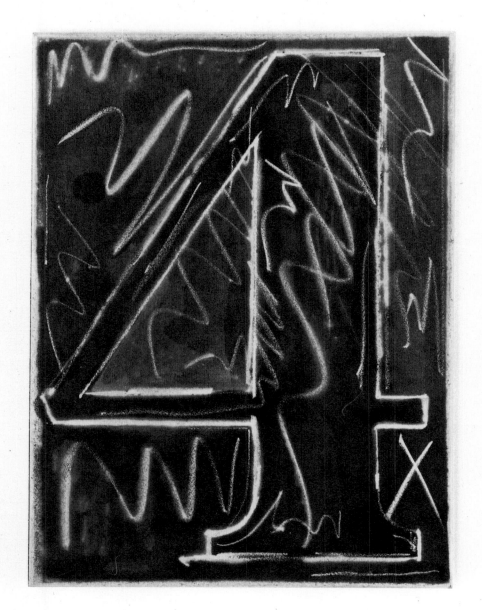

TRIAL PROOF 1/9

Plate 33

NUMERAL 4, i/ix, 1975-76
Lift-ground aquatint and stop-out
crayon
(cat. no. 67)

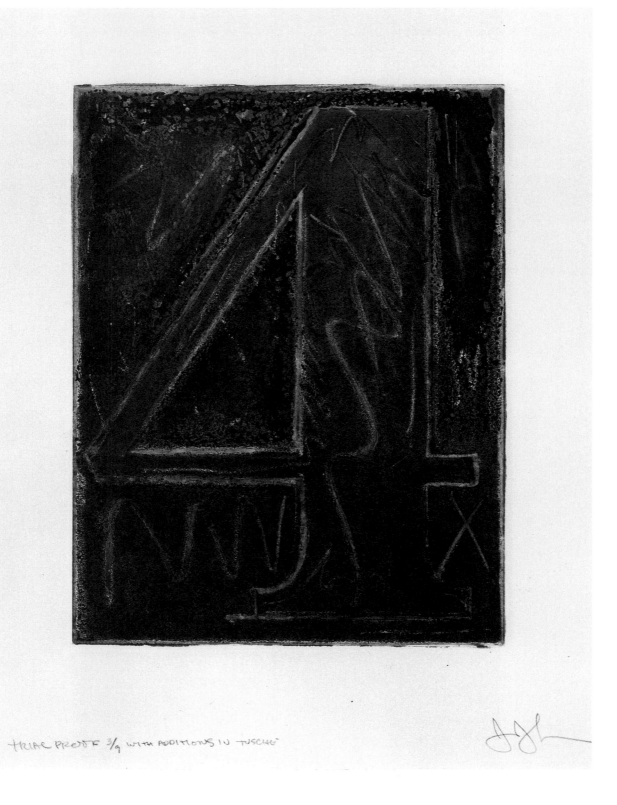

TRIAL PROOF 3/9 WITH ADDITIONS IN TUSCHE

Plate 34

NUMERAL 4, iii/ix, 1975-76
Lift-ground aquatint and stop-out
crayon with additions in tusche
(cat. no. 68)

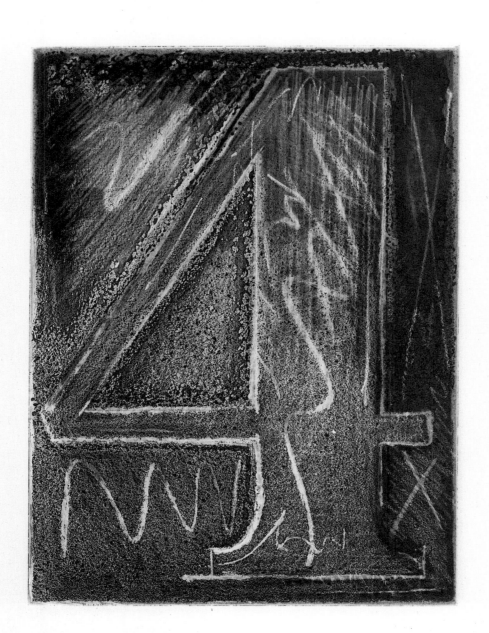

TRIAL PROOF ⁵/₇

Plate 35

NUMERAL 4, v/ix, 1975-76
Lift-ground aquatint, stop-out
crayon, and burnishing
(cat. no. 69)

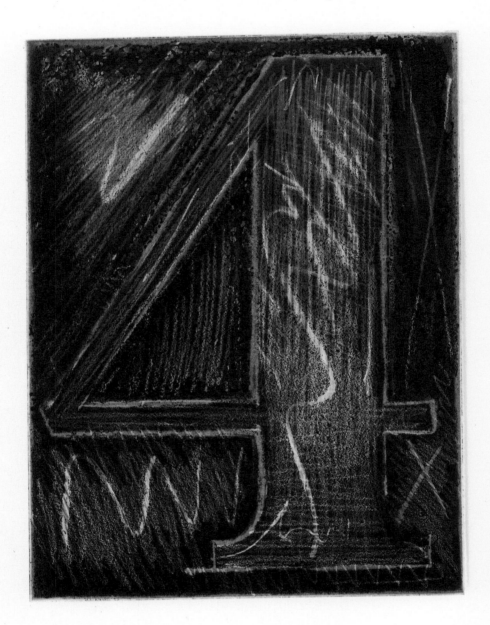

TRIAL PROOF 4/9

Plate 36

NUMERAL 4, vi/ix, 1975-76
Lift-ground aquatint, stop-out
crayon, and burnishing
(cat. no. 70)

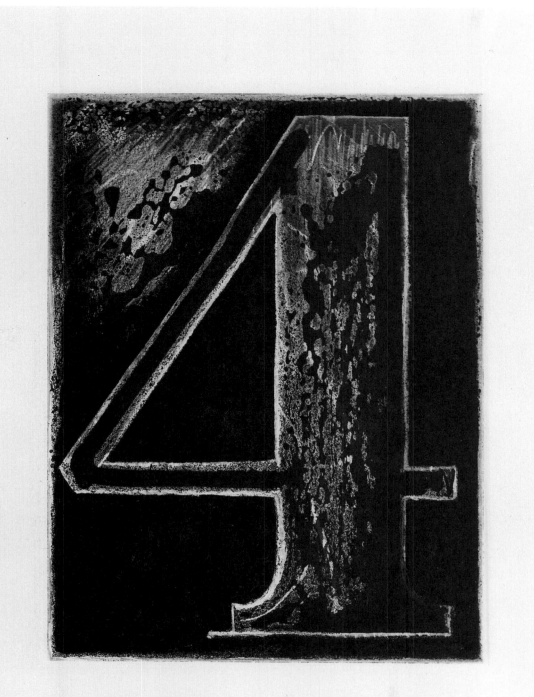

TRIAL PROOF ⅔ WITH ADDITIONS IN GOUACHE

Plate 37

NUMERAL 4, viii/ix, 1975-76
Lift-ground aquatint, stop-out
crayon, and burnishing with
gouache additions
(cat. no. 71)

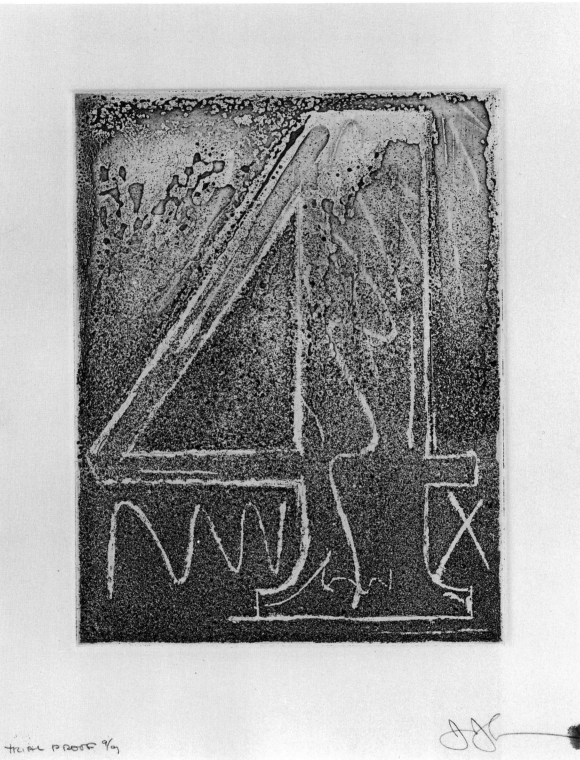

trial proof 9/9

Plate 38

NUMERAL 4, ix/ix, 1975-76
Lift-ground aquatint, stop-out
crayon, and burnishing
(cat. no. 72)

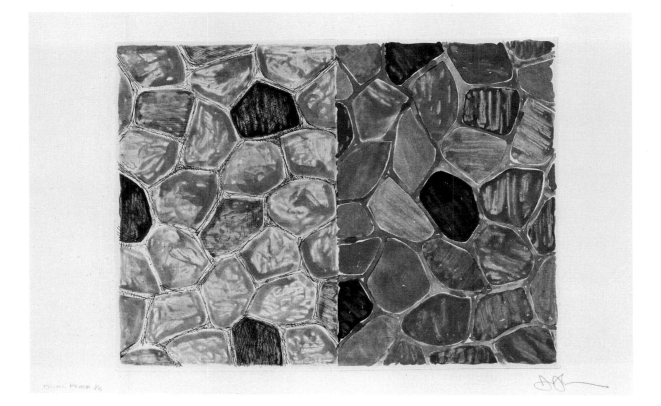

Plate 39

FLAGSTONES AND FLAGSTONES,
i/v, 1975-76
Etching, lift-ground aquatint and
open-bite
(cat. no. 73)

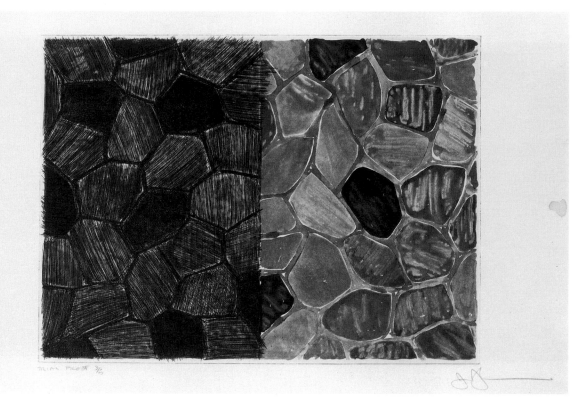

Plate 40
FLAGSTONES AND FLAGSTONES,
iii/v, 1975-76
Etching, lift-ground aquatint and
open-bite
(cat. no. 74)

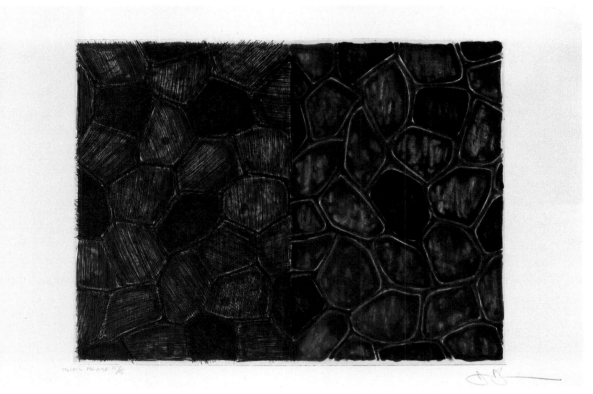

Plate 41

FLAGSTONES AND FLAGSTONES,
v/v, 1975-76
Etching, lift-ground aquatint and
open-bite
(cat. no. 75)

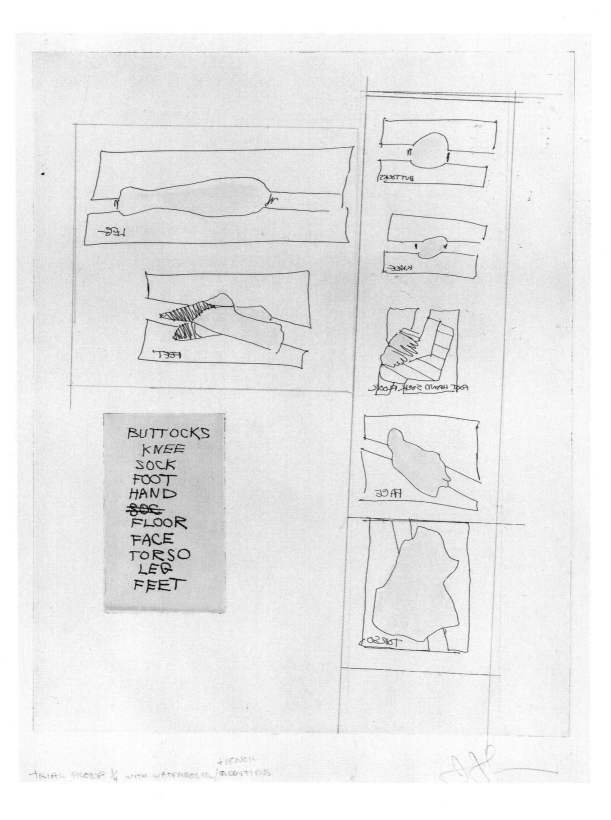

Plate 42

BUTTOCKS-KNEES-
FOOTHANDSOCKFLOOR-FACE-
TORSO, (with LEG [d], FEET [a], and
rejected version of WORDS) i/iv,
1975-76
Etching, soft-ground etching, and
open-bite with watercolor and
graphite additions
(cat. no. 76)

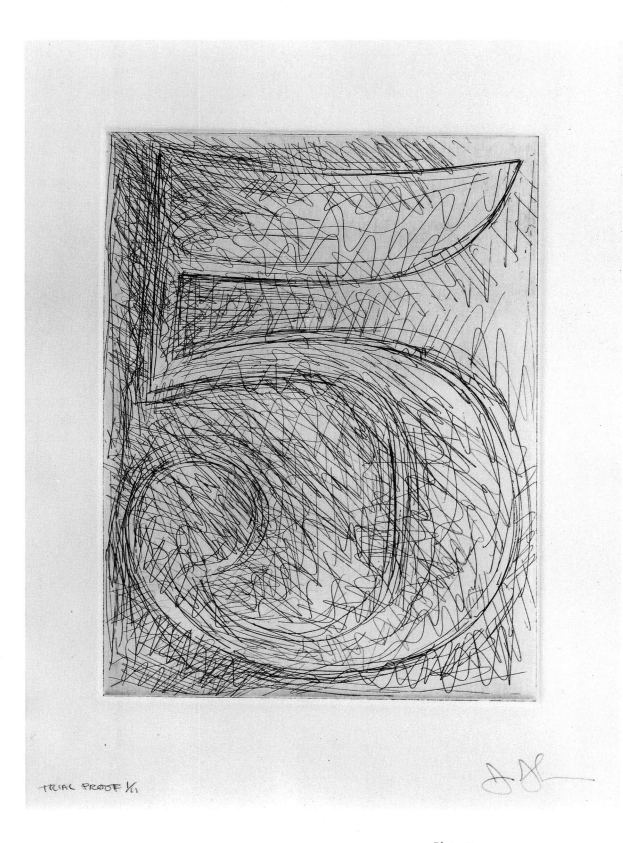

TRIAL PROOF 1/11

Plate 43

NUMERAL 5, i/xi, 1975-76
Etching
(cat. no. 77)

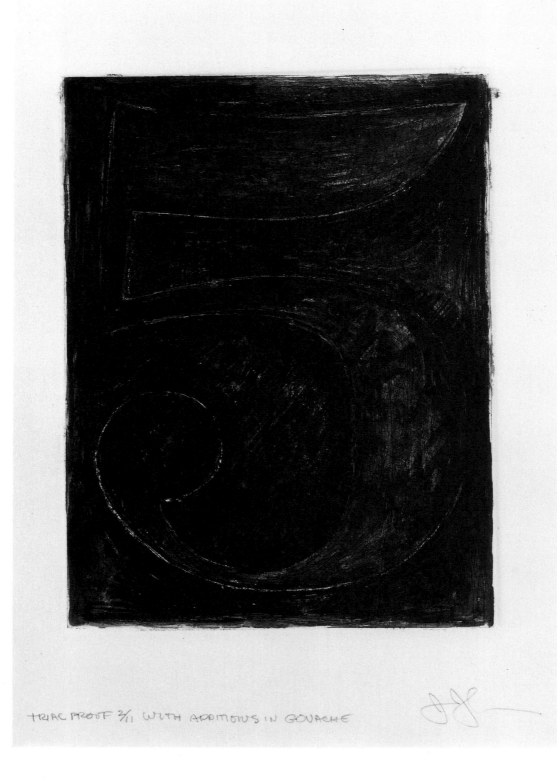

TRIAL PROOF ³/₁ WITH ADDITIONS IN GOUACHE

Plate 44

NUMERAL 5, ii/xi, 1975-76
Etching with gouache additions
(cat. no. 78)

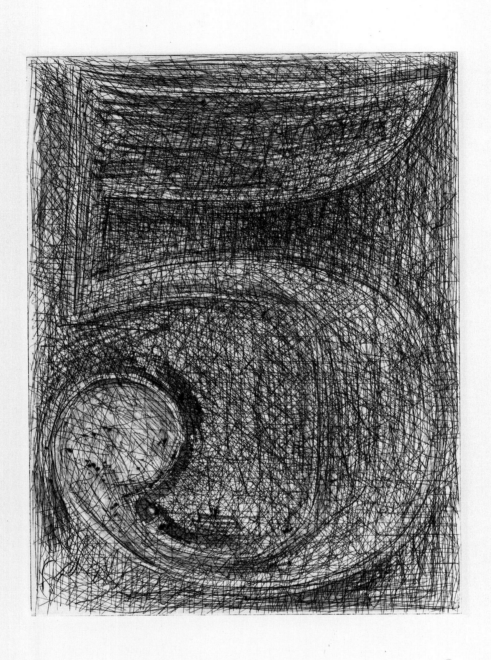

TRIAL PROOF 4/11

Plate 45
NUMERAL 5, iv/xi, 1975-76
Etching and lift-ground aquatint
(cat. no. 79)

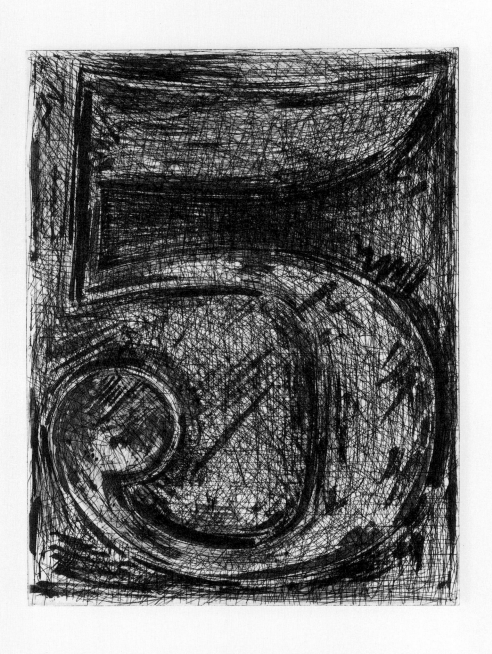

TRIAL PROOF 7/11

Plate 46

NUMERAL 5, v/xi, 1975-76
Etching and lift-ground aquatint
(cat. no. 80)

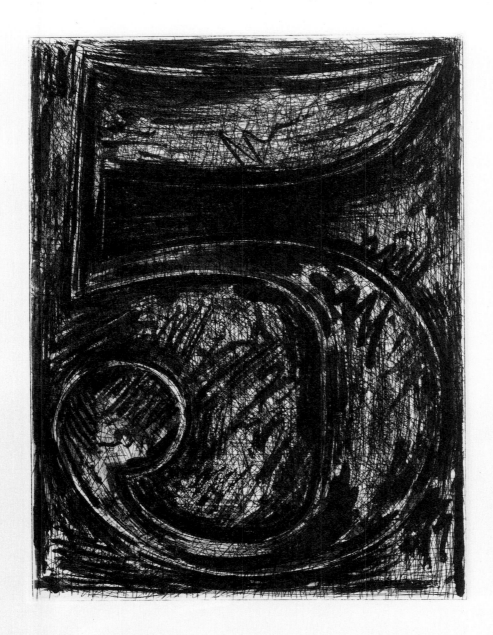

TRIAL PROOF $^b/_{11}$

Plate 47
NUMERAL 5, vi/xi, 1975-76
Etching and lift-ground aquatint
(cat. no. 81)

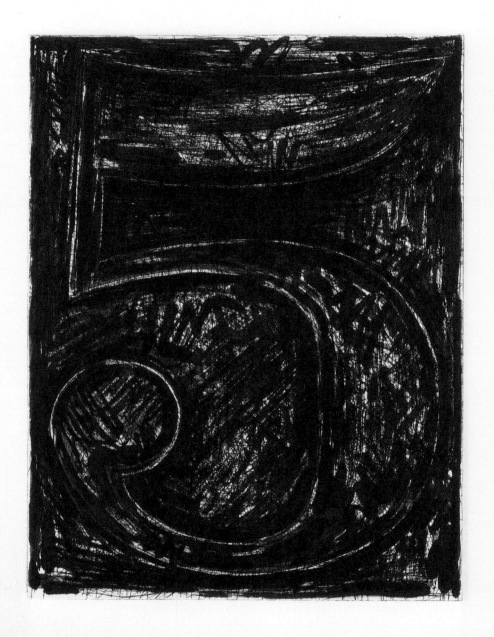

TRIAL PROOF V/ii

Plate 48
NUMERAL 5, vii/xi, 1975-76
Etching and lift-ground aquatint
(cat. no. 82)

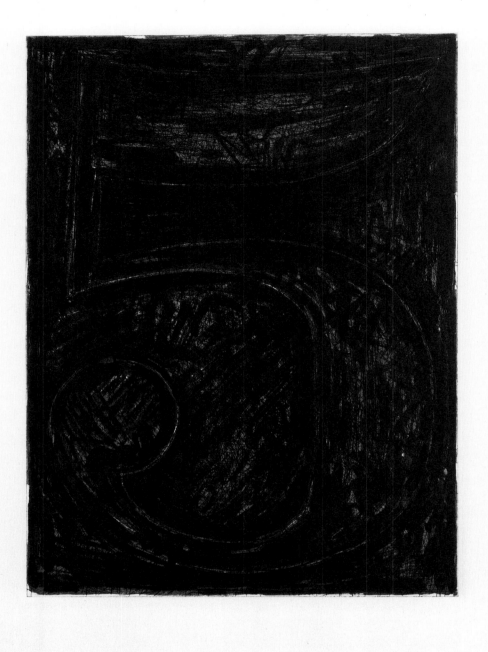

TRIAL PROOF 9/11

Plate 49

NUMERAL 5, ix/xi, 1975-76
Etching and lift-ground aquatint
(cat. no. 83)

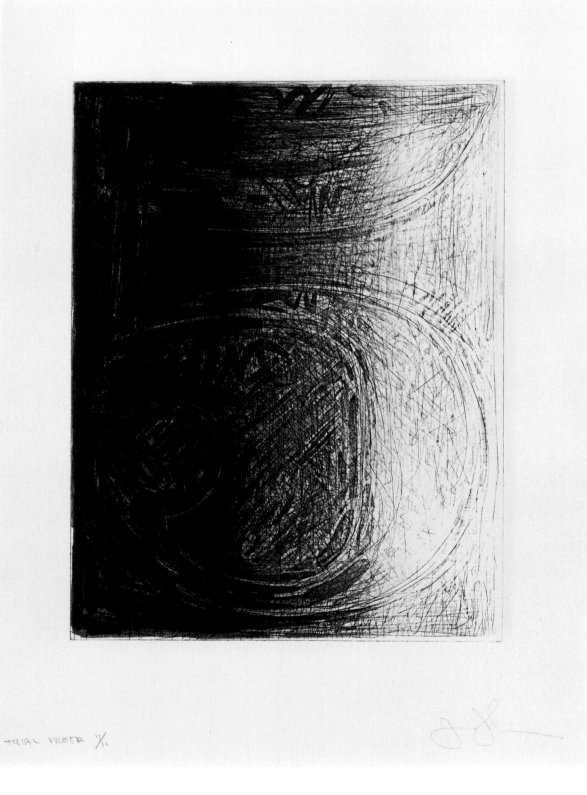

TRIAL PROOF 1/1

Plate 50

NUMERAL 5, xi/xi, 1975-76
Etching, lift-ground aquatint, and
burnishing with sandpaper
(cat. no. 84)

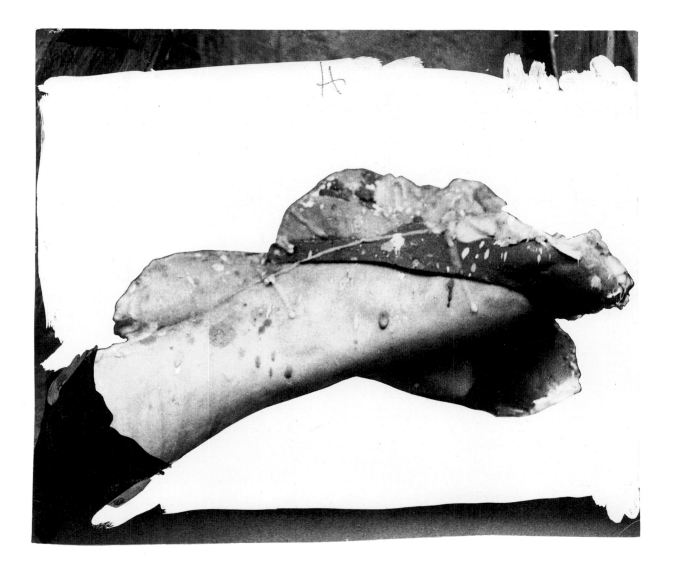

Plate 51

FEET, 1975-76
Hand-touched photograph of ''feet''
from *UNTITLED,* 1972
(cat. no. 85)

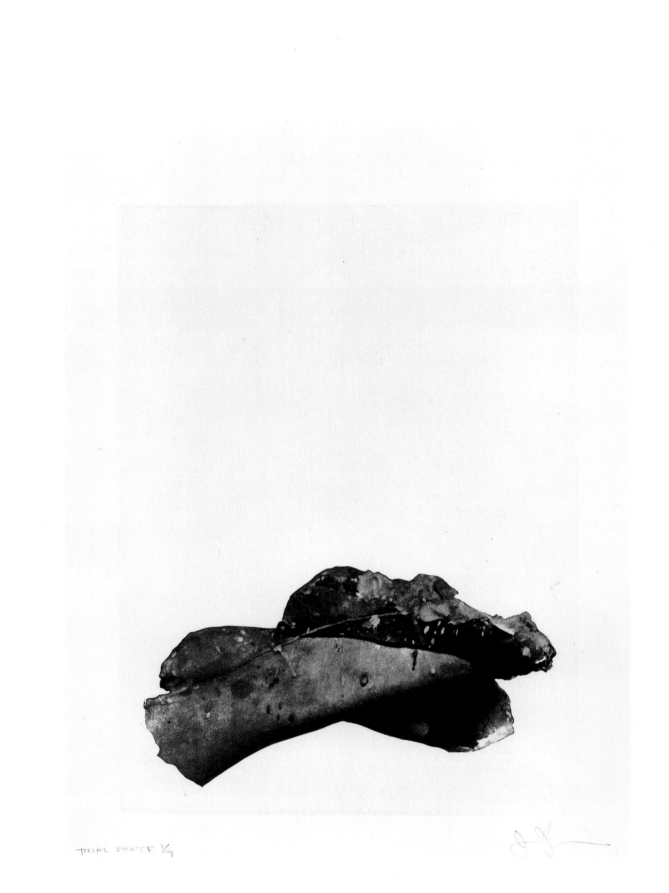

TRIAL PROOF 1/9

Plate 52

FEET (b), i/ix, 1975-76
Photo-engraving and
lift-ground aquatint
(cat. no. 86)

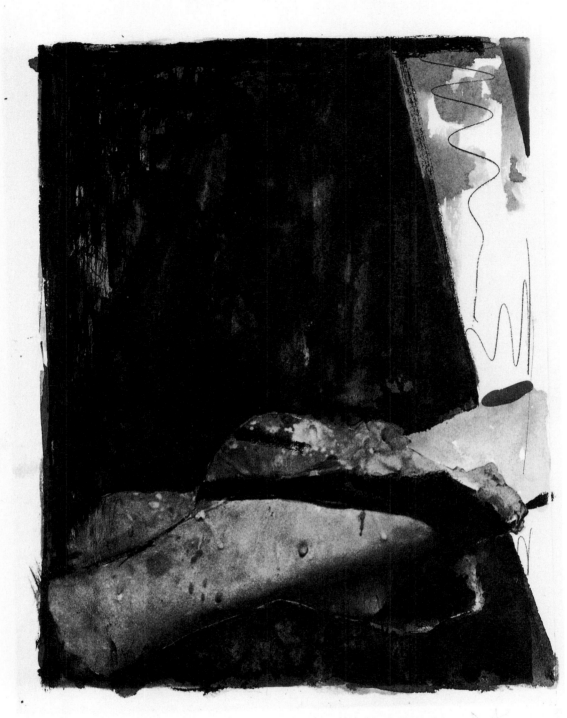

TRIAL PROOF ³/₉ WITH WATERCOLOR + GOUACHE ADDITIONS

Plate 53

FEET (b), ii/ix, 1975-76
Photo-engraving and lift-ground
aquatint with watercolor and
gouache additions
(cat. no. 87)

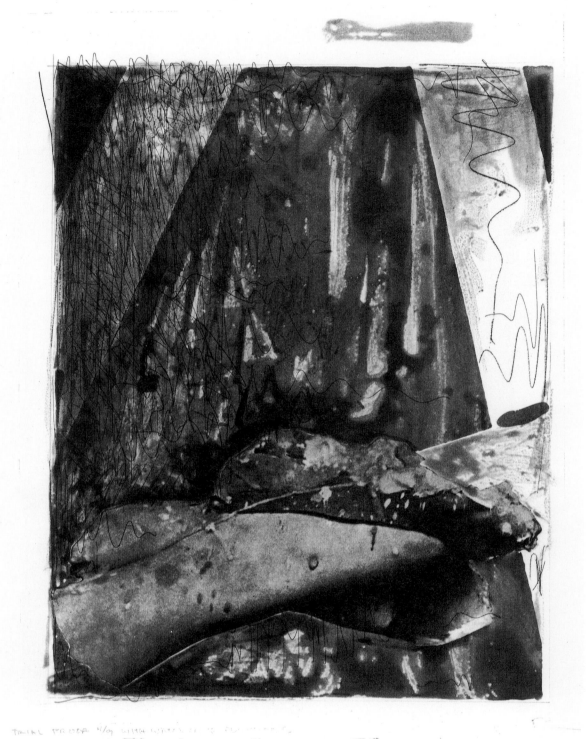

TRIAL PROOF II/IX WITH WATERCOLOR AND GRAPHITE

Plate 54

FEET (b), iv/ix, 1975-76
Etching, photo-engraving,
lift-ground aquatint, and open-
bite with watercolor and
graphite additions
(cat. no. 88)

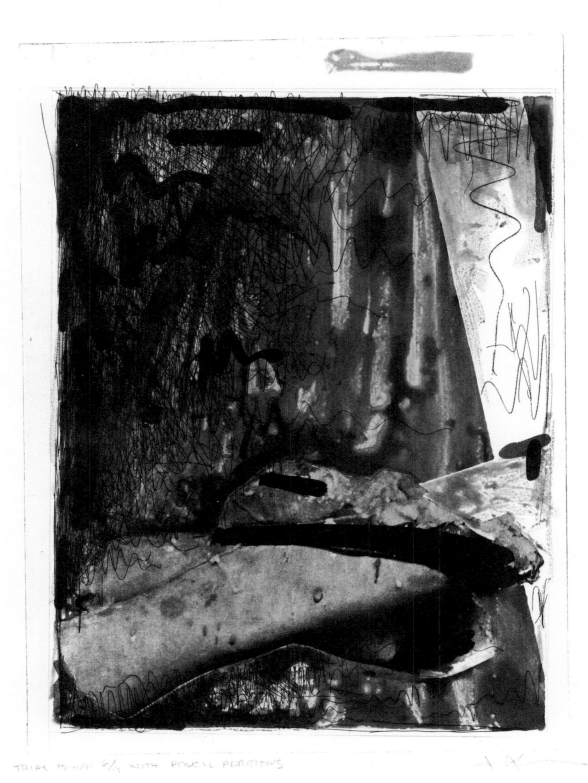

TRIAL PROOF 6/9 WITH PENCIL ADDITIONS

Plate 55

FEET (b), vi/ix, 1975-76
Etching, photo-engraving,
lift-ground aquatint, and
open-bite with graphite additions
(cat. no. 89)

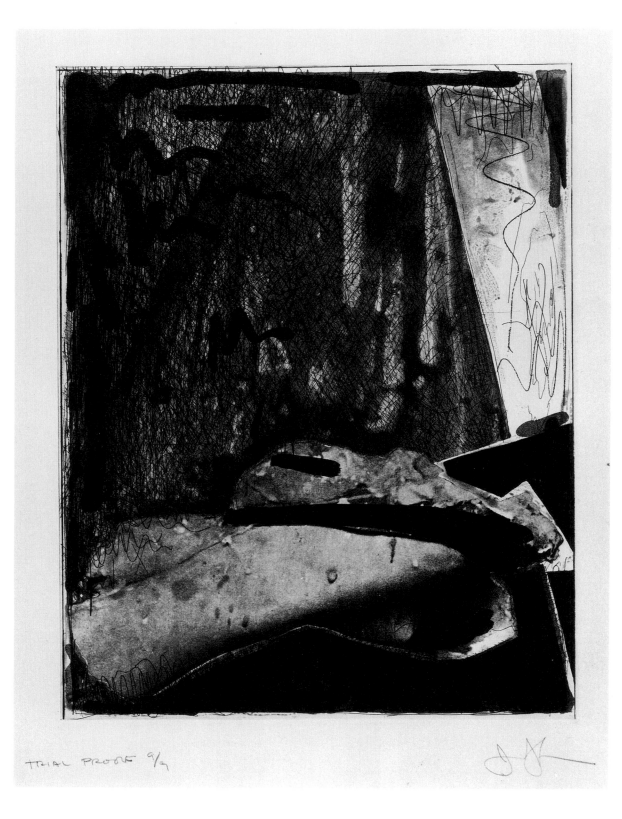

TRIAL PROOF 9/9

Plate 56

FEET (b), ix/ix, 1975-76
Etching, photo-engraving,
lift-ground aquatint, and open-bite
(cat. no. 90)

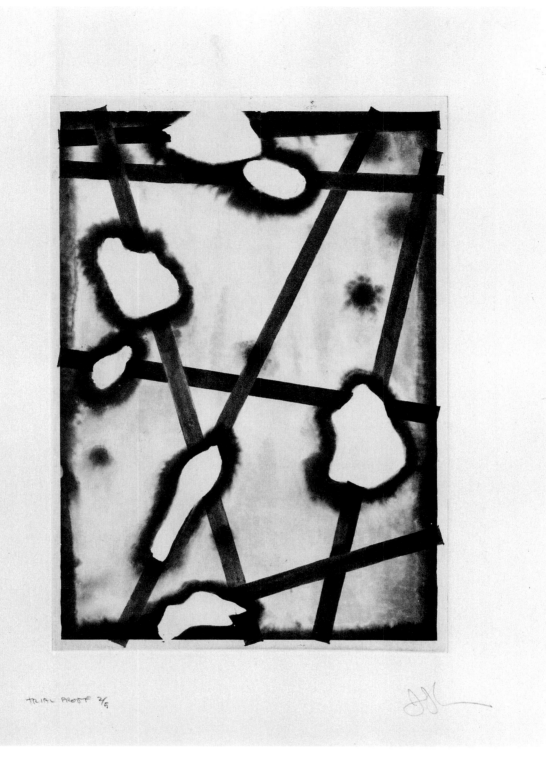

TRIAL PROOF 2/5

Plate 57

CASTS (Words), ii/v, 1975-76
Lift-ground aquatint, stop-out,
open-bite, and burnishing
(cat. no. 91)

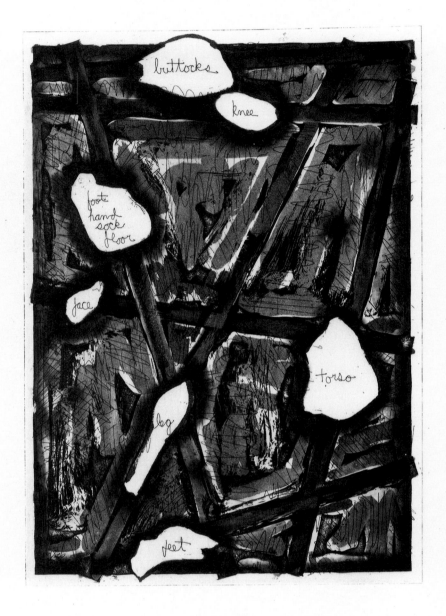

TRIAL PROOF 4/5

Plate 58

CASTS (Words), iv/v, 1975-76
Etching, lift-ground aquatint,
stop-out, open-bite,
and burnishing
(cat. no. 92)

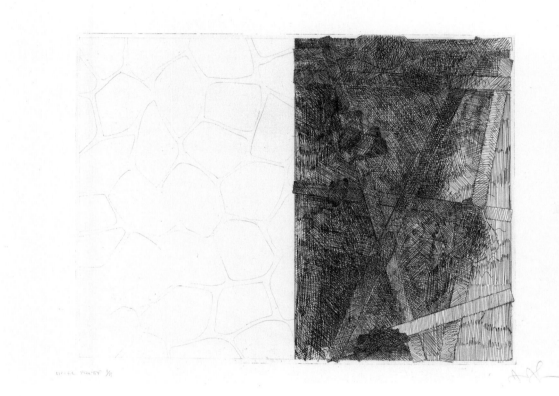

Plate 59

FLAGSTONES AND CASTS, i/v,
1975-76
Etching
(cat. nc. 93)

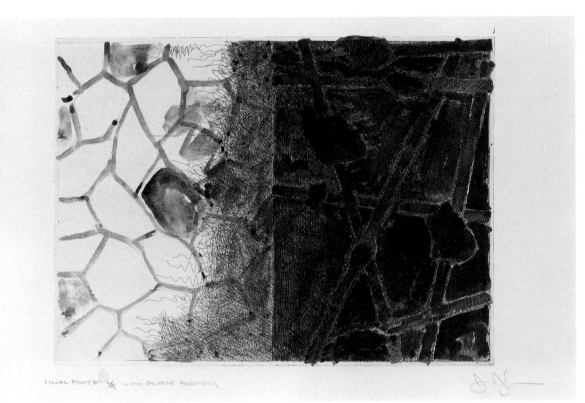

Plate 60
FLAGSTONES AND CASTS, ii/v,
1975-76
Etching with gouache additions
(cat. no. 94)

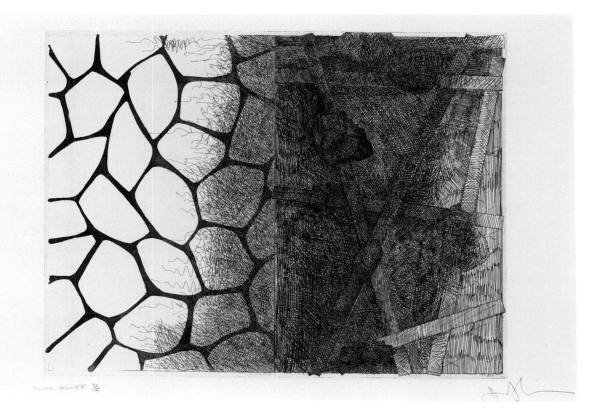

Plate 61

FLAGSTONES AND CASTS, iii/v,
1975-76
Etching and lift-ground aquatint
(cat. no. 95)

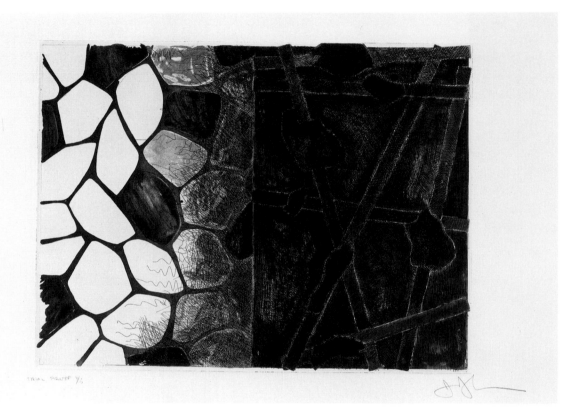

Plate 62

FLAGSTONES AND CASTS, iv/v,
1975-76
Etching and lift-ground aquatint
(cat. no. 96)

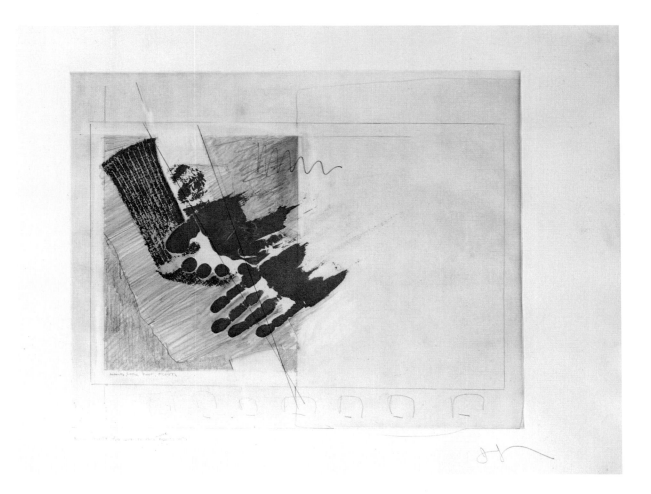

Plate 63

HANDFOOTSOCKFLOOR, i/xvii,
1975-76
Lift-ground aquatint with
graphite and ink additions
(cat. no. 97)

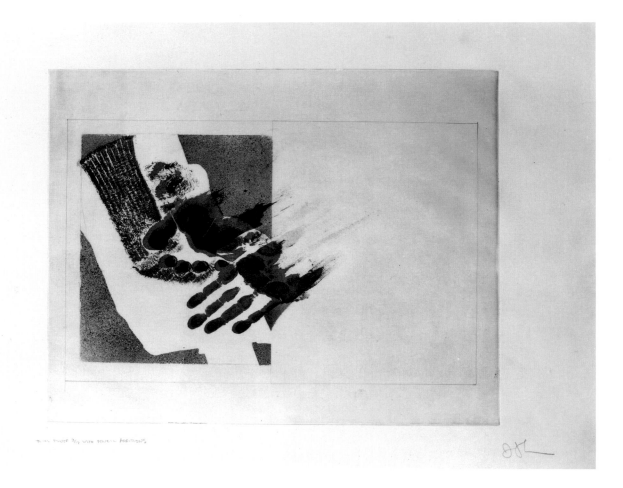

Plate 64

HANDFOOTSOCKFLOOR, iii/xvii,
1975-76
Lift-ground aquatint and burnishing
with graphite additions
(cat. no. 98)

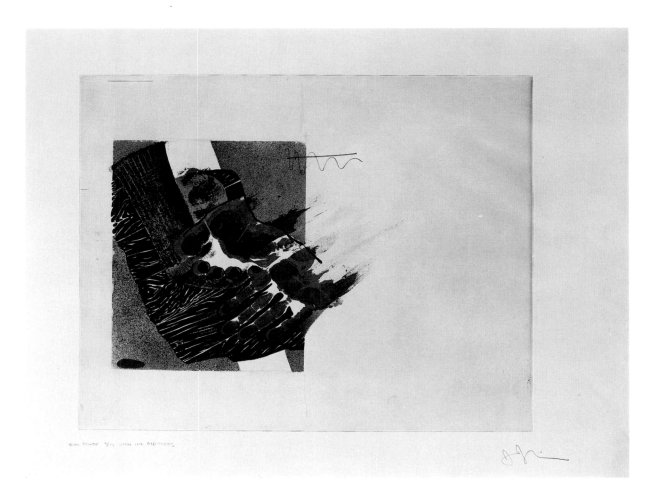

Plate 65

HANDFOOTSOCKFLOOR, iv/xvii,
1975-76
Lift-ground aquatint and
burnishing with ink additions
(cat. no. 99)

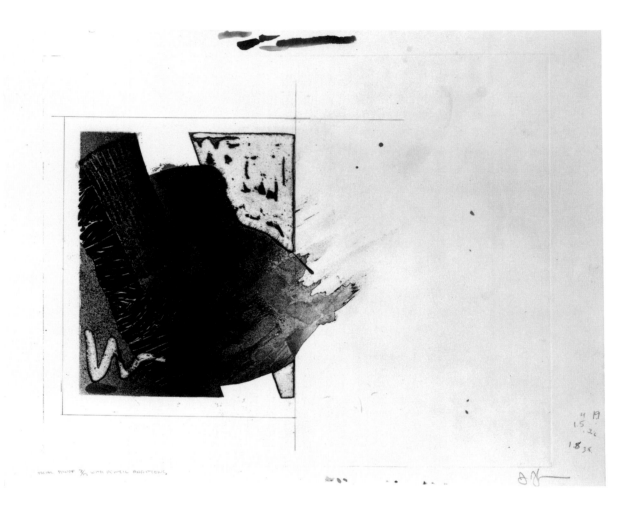

Plate 66

HANDFOOTSOCKFLOOR, vii/xvii,
1975-76
Lift-ground aquatint, stop-out,
and burnishing with watercolor
and graphite additions
(cat. no. 100)

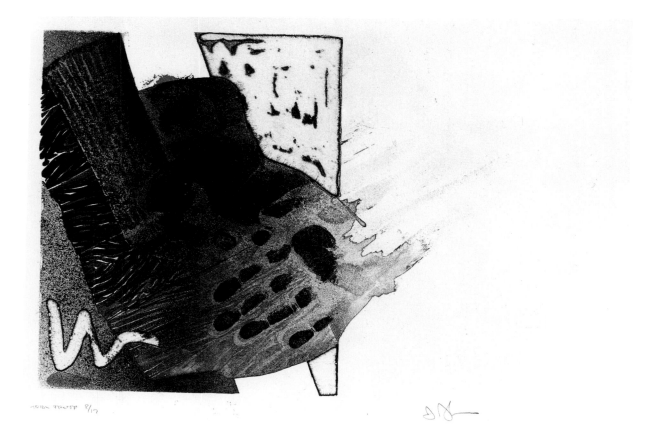

Plate 67

HANDFOOTSOCKFLOOR, viii/xvii,
1975-76
Lift-ground aquatint, stop-out,
and burnishing
(cat. no. 101)

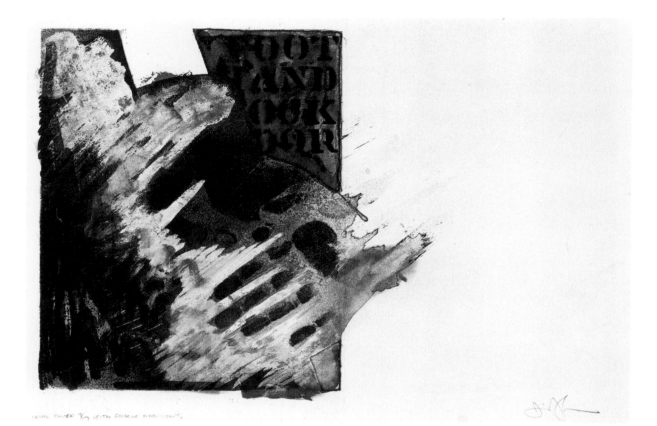

trial proof %₁₄ with gouache additions

Plate 68

HANDFOOTSOCKFLOOR, ix/xvii,
1975-76
Lift-ground aquatint, stop-out,
and burnishing with gouache
additions
(cat. no. 102)

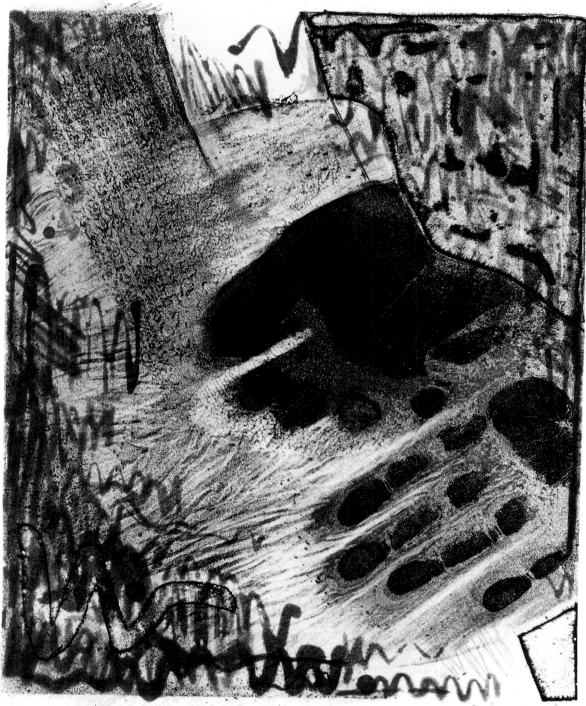

TRIAL PROOF 19/17

Plate 69

HANDFOOTSOCKFLOOR, x/xvii,
1975-76
Lift-ground aquatint, stop-out,
scraper, open-bite, and burnishing
(cat. no. 103)

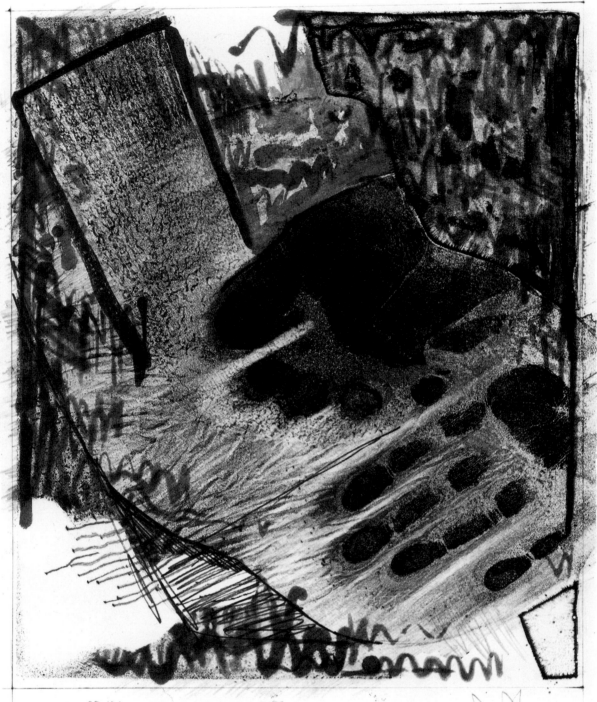

TRIAL PROOF 12/17 WITH INK ADDITIONS

Plate 70
HANDFOOTSOCKFLOOR, xii/xvii,
1975-76
Etching, lift-ground aquatint,
stop-out, scraper, open-bite,
and burnishing with ink additions
(cat. no. 104)

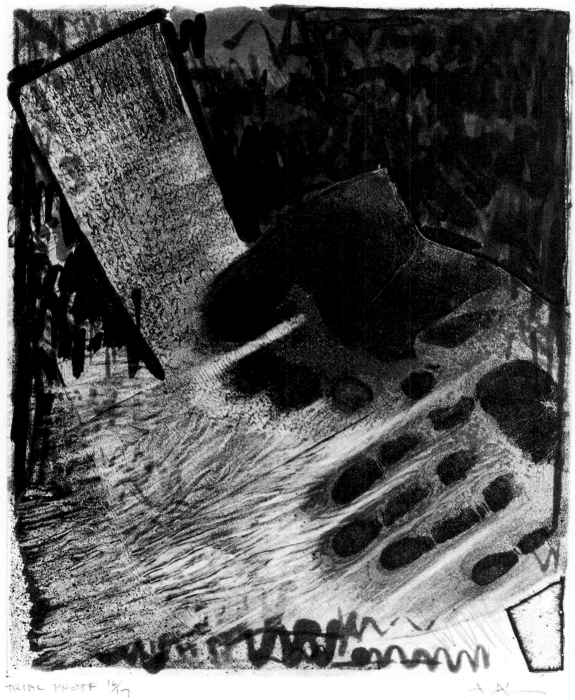

TRIAL PROOF ¹⁶/₁₇

Plate 71

HANDFOOTSOCKFLOOR, xvi/xvii,
1975-76
Etching, lift-ground aquatint,
scraper, and burnishing
(cat. no. 105)

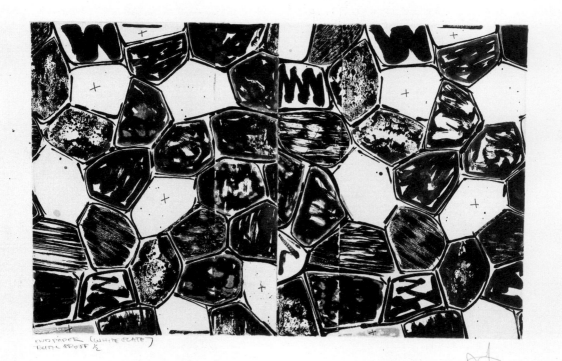

Plate 72

FLAGSTONES (Endpaper-back), i/ii,
1975-76
White plate
Lift-ground aquatint and open-bite
with red pen additions
(cat. no. 106)

Plate 73

FLAGSTONES (Endpaper-back), i/i,
1975-76
Red plate
Lift-ground aquatint and open-bite
(cat. no. 107)

Plate 74

FLAGSTONES (Endpaper-back), i/i,
1975-76
Black plate
Lift-ground aquatint and open-bite
(cat. no. 108)

Catalogue of the Exhibition

FOIRADES/FIZZLES

1. *FOIRADES/FIZZLES*, 1976
Texts by Samuel Beckett
Published by Petersburg Press
Book with 33 etchings and 1 lithograph
Page: 13 1/16 x 9 15/16
Collection of the Grunwald Center for the Graphic Arts, Wight Art Gallery, UCLA
Gift of the UCLA Art Council, Anna Bing Arnold, Charles and Ray Eames, Mr. and Mrs. Wm. Fadiman, Julianne Kemper, Norman Lear, and the L.A. Louver Gallery
(Field 215-247)

2. *FOIRADES/FIZZLES*, 1976
Texts by Samuel Beckett
Published by Petersburg Press
Book with 33 etchings and 1 lithograph
Page: 13 1/16 x 9 15/16
Yale University Art Gallery, Katherine Ordway Fund

3. *FOIRADES/FIZZLES*, 1976
Texts by Samuel Beckett
Published by Petersburg Press
Book with 33 etchings and 1 lithograph
Page: 13 1/16 x 9 15/16
Davison Art Center, Wesleyan University

4. *FOIRADES/FIZZLES*, 1976
Texts by Samuel Beckett
Published by Petersburg Press
Book with 33 etchings and 1 lithograph
Page: 13 1/16 x 9 15/16
Collection of John Cage

5. *FOIRADES/FIZZLES*, 1976
Texts by Samuel Beckett
Published by Petersburg Press
Book with 33 etchings and 1 lithograph
Page: 13 1/16 x 9 15/16
Collection of Gloria and Newton Werner

6. *HATCHING (Endpaper-front)*, 1976
From *Foirades/Fizzles*
Published by Petersburg Press
Lift-ground aquatint and drypoint from four plates printed in orange, green, purple, and white
11 9/16 x 18 5/16
Lent by the publisher
(Field 215)

7. *NUMERAL 1*, 1976
From *Foirades/Fizzles*
Published by Petersburg Press
Etching, soft-ground, and drypoint
9 3/16 x 6 15/16
Lent by the publisher
(Field 216)

8. *FACE*, 1976
From *Foirades/Fizzles*
Published by Petersburg Press
Lift-ground aquatint, scraper, and abrasive powder
10 7/8 x 8 3/8
Lent by the publisher
(Field 217)

9. *WORDS (Buttock Knee Sock...)*, 1976
From *Foirades/Fizzles*
Published by Petersburg Press
Etching, lift-ground aquatint, and burnishing
10 9/16 x 17 1/2
Lent by the publisher
(Field 218)

10a. *FOUR PANELS (ABCD)*, 1976
From *Foirades/Fizzles*
Published by Petersburg Press
Etching, soft-ground, lift-ground
aquatint, and burnishing
2¹³/₁₆ x 7³/₈
Lent by the publisher
(Field 219)

10b. *FOUR PANELS (BCDA)*, 1976
From *Foirades/Fizzles*
Published by Petersburg Press
Etching, soft-ground, lift-ground
aquatint, and burnishing
2¹³/₁₆ x 7³/₈
Lent by the publisher
(Field 220)

10c. *FOUR PANELS (CDAB)*, 1976
From *Foirades/Fizzles*
Published by Petersburg Press
Etching, soft-ground, lift-ground
aquatint, and burnishing
2¹³/₁₆ x 7³/₈
Lent by the publisher
(Field 221)

10d. *FOUR PANELS (DABC)*, 1976
From *Foirades/Fizzles*
Published by Petersburg Press
Etching, soft-ground, lift-ground
aquatint, and stop-out
2¹³/₁₆ x 7³/₈
Lent by the publisher
(Field 222)

11. *NUMERAL 2, 1976*
From *Foirades/Fizzles*
Published by Petersburg Press
Etching, lift-ground aquatint,
crayon stop-out, and open-bite
9⁵/₁₆ x 6¹⁵/₁₆
Lent by the publisher
(Field 223)

12. *LEG (a)*, 1976
From *Foirades/Fizzles*
Published by Petersburg Press
Etching, drypoint, open-bite,
and burnishing
9⁵/₁₆ x 6¹⁵/₁₆
Lent by the publisher
(Field 224)

13. *LEG (b)*, 1976
From *Foirades/Fizzles*
Published by Petersburg Press
Etching and lift-ground aquatint
10⁵/₁₆ x 5³/₈
Lent by the publisher
(Field 225)

14. *LEG (c)*, 1976
From *Foirades/Fizzles*
Published by Petersburg Press
Etching
10⁵/₁₆ x 5³/₈
Lent by the publisher
(Field 226)

15. *CASTS AND HATCHING*, 1976
From *Foirades/Fizzles*
Published by Petersburg Press
Etching, lift-ground aquatint, and
open-bite
10¹¹/₁₆ x 14³/₁₆
Lent by the publisher
(Field 227)

16. *HATCHING*, 1976
From *Foirades/Fizzles*
Published by Petersburg Press
Etching, lift-ground aquatint,
and burnishing
10¹/₂ x 7¹/₁₆
Lent by the publisher
(Field 228)

17. *LEG (d)*, 1976
From *Foirades/Fizzles*
Published by Petersburg Press
Etching and open-bite
2¹/₂ x 5³/₈
Lent by the publisher
(Field 229)

18. *FLAGSTONES (a)*, 1976
From *Foirades/Fizzles*
Published by Petersburg Press
Etching, lift-ground aquatint,
and burnishing
10¹/₂ x 7¹/₁₆
Lent by the publisher
(Field 230)

19. *FLAGSTONES (b)*, 1976
From *Foirades/Fizzles*
Published by Petersburg Press
Etching, lift-ground aquatint,
burnishing and stop-out
10¹/₂ x 7¹/₁₆
Lent by the publisher
(Field 231)

20. *NUMERAL 3*, 1976
From *Foirades/Fizzles*
Published by Petersburg Press
Stop-out varnishes over aquatint
ground
9³/₈ x 7¹/₁₆
Lent by the publisher
(Field 232)

21. *TORSE*, 1976
From *Foirades/Fizzles*
Published by Petersburg Press
Photo-screen squeegeed onto
plate, lift-ground aquatint, and
open-bite
9³/₈ x 7
Lent by the publisher
(Field 233)

22. *HATCHING AND
FLAGSTONES*, 1976
From *Foirades/Fizzles*
Published by Petersburg Press
Soft-ground etching, open-bite,
and burnishing
10³/₄ x 14¹/₄
Lent by the publisher
(Field 234)

23. *TORSO*, 1976
From *Foirades/Fizzles*
Published by Petersburg Press
Lift-ground aquatint
9⁵/₁₆ x 7¹/₁₆
Lent by the publisher
(Field 235)

24. *NUMERAL 4*, 1976
From *Foirades/Fizzles*
Published by Petersburg Press
Lift-ground aquatint, stop-out
crayon, and burnishing
9⁵/₁₆ x 6¹⁵/₁₆
Lent by the publisher
(Field 236)

25. *CASTS*, 1976
From *Foirades/Fizzles*
Published by Petersburg Press
Etching and lift-ground aquatint
10¹/₂ x 7¹/₁₆
Lent by the publisher
(Field 237)

26. *FLAGSTONES AND
FLAGSTONES*, 1976
From *Foirades/Fizzles*
Published by Petersburg Press
Etching, lift-ground aquatint, and
open-bite
10¹³/₁₆ x 14¹/₄
Lent by the publisher
(Field 238)

27a. *BUTTOCKS-KNEES-
FOOTHANDSOCKFLOOR-FACE-
TORSO*, 1976
From *Foirades/Fizzles*
Published by Petersburg Press
Etching and open-bite
11 x 2¹³/₁₆
Lent by the publisher
(Field 239)

27b. *FEET (a)*, 1976
From *Foirades/Fizzles*
Published by Petersburg Press
Etching and open-bite
2³/₈ x 3³/₄
Lent by the publisher
(Field 240)

28. *NUMERAL 5*, 1976
From *Foirades/Fizzles*
Published by Petersburg Press
Etching, lift-ground aquatint, and
burnishing with sandpaper
9⁵/₁₆ x 6¹⁵/₁₆
Lent by the publisher
(Field 241)

29. *FEET (b), 1976*
From Foirades/Fizzles
Published by Petersburg Press
Etching, photo-engraving, lift-
ground aquatint, and open-bite
10¹⁵/₁₆ x 8³/₈
Lent by the publisher
(Field 242)

30. *CASTS (Words)*, 1976
From *Foirades/Fizzles*
Published by Petersburg Press
Etching, lift-ground aquatint,
stop-out, open-bite, and
burnishing
10⁷/₈ x 7³/₄
Lent by the publisher
(Field 243)

31. *BUTTOCKS AND KNEE*, 1976
From *Foirades/Fizzles*
Published by Petersburg Press
Etching, lift-ground aquatint, and
open-bite
6⁷/₁₆ x 8¹/₂
Lent by the publisher
(Field 244)

32. *FLAGSTONES AND CASTS*,
1976
From *Foirades/Fizzles*
Published by Petersburg Press
Etching, lift-ground aquatint, and
open-bite
10¹³/₁₆ x 14¹/₄
Lent by the publisher
(Field 245)

33. *HANDFOOTSOCKFLOOR*,
1976
From *Foirades/Fizzles*
Published by Petersburg Press
Etching, lift-ground aquatint,
stop-out, open-bite, scraper, and
burnishing
9⁵/₈ x 7¹/₂
Lent by the publisher
(Field 246)

34. *FLAGSTONES (Endpaper-
back)*, 1976
From *Foirades/Fizzles*
Published by Petersburg Press
Lift-ground aquatint and open-
bite from three plates printed in
red, black, and white
11⁹/₁₆ x 18⁵/₁₆
Lent by the publisher
(Field 247)

Trial Proofs for
FOIRADES/FIZZLES

35. *FACE*, 1975-76
Trial proof for *Foirades/Fizzles*,
i/xii
Published by Petersburg Press
Lift-ground aquatint
22¹/₁₆ x 29³/₄
15¹⁵/₁₆ x 21³/₄
Collection the artist

36. *FACE*, 1975-76
Trial proof for *Foirades/Fizzles*,
iii/xii
Published by Petersburg Press
Lift-ground aquatint, scraper, and
abrasive powder with graphite
and ink additions
19¹³/₁₆ x 25⁷/₁₆
16³/₁₆ x 21³/₁₆
Collection the artist

37. *FACE*, 1975-76
Trial proof for *Foirades/Fizzles*,
vi/xii
Published by Petersburg Press
Lift-ground aquatint, scraper and
abrasive powder with graphite
and ink additions
12¹²/₁₆ x 19⁷/₈
10¹¹/₁₆ x 8¹/₄ (plate reduced iv/xii)
Collection the artist

38. *FACE*, 1975-76
Trial proof for *Foirades/Fizzles*,
vii/xii
Published by Petersburg Press
Lift-ground aquatint, scraper, and
abrasive powder with gouache
additions
12¹⁵/₁₆ x 9⁷/₈
10¹⁵/₁₆ x 8¹/₄
Collection the artist

39. *FACE*, 1975-76
Trial proof for *Foirades/Fizzles*,
ix/xii
Published by Petersburg Press
Lift-ground aquatint, scraper, and
abrasive powder
14¹⁵/₁₆ x 11
10¹⁵/₁₆ x 8¹/₄
Collection the artist

40. *FACE*, 1975-76
Trial proof for *Foirades/Fizzles*,
xii/xii
Published by Petersburg Press
Lift-ground aquatint, scraper, and
abrasive powder with graphite
additions
12⁷/₈ x 10
10¹⁵/₁₆ x 8⁵/₁₆
Collection the artist

41. *WORDS (Buttock Knee
Sock...)* 1975-76
Trial proof for *Foirades/Fizzles*,
i/x
Published by Petersburg Press
Lift-ground aquatint
12³/₄ x 19³/₄
11⁹/₁₆ x 19¹/₂
Collection the artist

42. *WORDS (Buttock Knee
Sock...)* 1975-76
Trial proof for *Foirades/Fizzles*,
ii/x
Published by Petersburg Press
Lift-ground aquatint with graph-
ite and ink additions
12⁷/₈ x 19⁷/₈
11⁹/₁₆ x 19¹/₂
Collection the artist

43. *WORDS (Buttock Knee
Sock...)* 1975-76
Trial proof for *Foirades/Fizzles*,
iv/x
Published by Petersburg Press
Lift-ground aquatint
12³/₄ x 19¹¹/₁₆
11⁹/₁₆ x 19¹/₂
Collection the artist

44. *WORDS (Buttock Knee
Sock...)* 1975-76
Trial proof for *Foirades/Fizzles*,
vi/x
Published by Petersburg Press
Etching and lift-ground aquatint
12⁵/₈ x 19³/₄
11⁹/₁₆ x 19¹/₂
Collection the artist

45. *WORDS (Buttock Knee
Sock...)* 1975-76
Trial proof for *Foirades/Fizzles*,
vii/x
Published by Petersburg Press
Etching, lift-ground aquatint, and
burnishing with ink additions
12⁷/₈ x 19³/₄
10¹/₂ x 17¹/₄ (plate reduced)
Collection the artist

46. *WORDS (Buttock Knee
Sock...)* 1975-76
Trial proof for *Foirades/Fizzles*,
x/x
Published by Petersburg Press
Etching, lift-ground aquatint, and
burnishing
13¹/₈ x 19⁷/₈
10¹/₂ x 17¹/₄
Collection the artist

47. *NUMERAL 2*, 1975-76
Trial proof for *Foirades/Fizzles*,
i/iv
Published by Petersburg Press
Etching, stop-out crayon, and
open-bite
14¹³/₁₆ x 11¹/₈
9³/₈ x 7
Collection the artist

48. *CASTS AND HATCHING*, 1975-76
Trial proof for *Foirades/Fizzles*, i/iv
Published by Petersburg Press
Etching, lift-ground aquatint, and open-bite
12³/₄ x 19³/₄
10¹¹/₁₆ x 14¹/₄
Collection the artist

49. *HATCHING*, 1975-76
Trial proof for *Foirades/Fizzles*, i/iv
Published by Petersburg Press
Etching and lift-ground aquatint with ink additions
12¹¹/₁₆ x 9¹⁵/₁₆
10⁷/₁₆ x 7¹/₁₆
Collection the artist

50. *HATCHING*, 1975-76
Trial proof for *Foirades/Fizzles*, iv/iv
Published by Petersburg Press
Etching, lift-ground aquatint, and burnishing
12³/₈ x 9¹⁵/₁₆
10⁷/₁₆ x 6¹⁵/₁₆ (plate reduced)
Collection the artist

51. *FLAGSTONES (a)*, 1975-76
Trial proof for *Foirades/Fizzles*, i/vii
Published by Petersburg Press
Etching
14⁷/₈ x 11
10¹¹/₁₆ x 8¹/₁₆
Collection the artist

52. *FLAGSTONES (a)*, 1975-76
Trial proof for *Foirades/Fizzles*, iii/vii
Published by Petersburg Press
Etching and lift-ground aquatint
14⁷/₈ x 11
10¹¹/₁₆ x 8¹/₁₆
Collection the artist

53. *FLAGSTONES (a)*, 1975-76
Trial proof for *Foirades/Fizzles*, iv/vii
Published by Petersburg Press
Etching and lift-ground aquatint
14⁷/₈ x 11¹/₈
10¹¹/₁₆ x 8¹/₁₆
Collection the artist

54. *FLAGSTONES (a)*, 1975-76
Trial proof for *Foirades/Fizzles*, v/vii
Published by Petersburg Press
Etching, lift-ground aquatint, and burnishing with ink additions
14⁷/₈ x 11¹/₈
10¹¹/₁₆ x 8¹/₁₆
Collection the artist

55. *FLAGSTONES (a)*, 1975-76
Trial proof for *Foirades/Fizzles*, vi/vii
Published by Petersburg Press
Etching, lift-ground aquatint, and burnishing
12⁵/₈ x 9³/₄
10¹¹/₁₆ x 8¹/₁₆
Collection the artist

56. *FLAGSTONES (a)*, 1975-76
Trial proof for *Foirades/Fizzles*, vii/vii
Published by Petersburg Press
Etching and lift-ground aquatint
14⁷/₈ x 11¹/₈
10¹/₂ x 6¹⁵/₁₆ (plate reduced)
Collection the artist

57. *FLAGSTONES (b)*, 1975-76
Trial proof for *Foirades/Fizzles*, i/vi
Published by Petersburg Press
Etching
14¹³/₁₆ x 11¹/₁₆
10¹/₂ x 6¹⁵/₁₆
Collection the artist

58. *FLAGSTONES (b)*, 1975-76
Trial proof for *Foirades/Fizzles*, iii/vi
Published by Petersburg Press
Etching, lift-ground aquatint, burnishing, and stop-out
14⁷/₈ x 11
10¹/₂ x 6¹⁵/₁₆
Collection the artist

59. *FLAGSTONES (b)*, 1975-76
Trial proof for *Foirades/Fizzles*, iv/vi
Published by Petersburg Press
Etching, lift-ground aquatint, burnishing, and stop-out with ink, graphite, and gouache additions
14¹³/₁₆ x 11
10¹/₂ x 6¹⁵/₁₆
Collection the artist

60. *FLAGSTONES (b)*, 1975-76
Trial proof for *Foirades/Fizzles*, vi/vi
Published by Petersburg Press
Etching, lift-ground aquatint, burnishing, and stop-out
14⁷/₈ x 11¹/₈
10¹/₂ x 6¹⁵/₁₆
Collection the artist

61. *TORSE*, 1975-76
Trial proof for *Foirades/Fizzles*, i/ii
Published by Petersburg Press
Photo-screen squeegeed onto plate, and lift-ground aquatint with gouache additions
12³/₄ x 9¹⁵/₁₆
9¹/₄ x 7
Collection the artist

62. *HATCHING AND FLAGSTONES*, 1975-76
Trial proof for *Foirades/Fizzles*, i/vi
Published by Petersburg Press
Soft-ground etching
12³/₄ x 19⁷/₈
10³/₄ x 19⁷/₈
Collection the artist

63. *HATCHING AND FLAGSTONES*, 1975-76
Trial proof for *Foirades/Fizzles*, ii/vi
Published by Petersburg Press
Soft-ground etching and open-bite
12⁷/₈ x 19⁷/₈
10³/₄ x 19⁷/₈
Collection the artist

64. *HATCHING AND FLAGSTONES*, 1975-76
Trial proof for *Foirades/Fizzles*, iv/vi
Published by Petersburg Press
Soft-ground etching and open-bite
12³/₄ x 19³/₄
10⁵/₈ x 14¹/₄ (plate reduced)
Collection the artist

65. *HATCHING AND FLAGSTONES*, 1975-76
Trial proof for *Foirades/Fizzles*, vi/vi
Published by Petersburg Press
Soft-ground etching, open-bite, and burnishing
12⁷/₈ x 19³/₄
10⁵/₈ x 14¹/₄
Collection the artist

66. *TORSO*, 1975-76
Trial proof for *Foirades/Fizzles*, i/i
Published by Petersburg Press
Lift-ground aquatint
12³/₄ x 9¹³/₁₆
9¹/₄ x 7
Collection the artist

67. *NUMERAL 4*, 1975-76
Trial proof for *Foirades/Fizzles*, i/ix
Published by Petersburg Press
Lift-ground aquatint and stop-out crayon
12⁷/₈ x 10
9⁵/₁₆ x 7¹/₁₆
Collection the artist

68. *NUMERAL 4*, 1975-76
Trial proof for *Foirades/Fizzles*, iii/ix
Published by Petersburg Press
Lift-ground aquatint and stop-out crayon with additions in tusche
12³/₄ x 9⁷/₈
9⁵/₁₆ x 7¹/₁₆
Collection the artist

69. *NUMERAL 4*, 1975-76
Trial proof for *Foirades/Fizzles*,
v/ix
Published by Petersburg Press
Lift-ground aquatint, stop-out
crayon, and burnishing
12³/₄ x 9⁷/₈
9⁵/₁₆ x 7¹/₁₆
Collection the artist

70. *NUMERAL 4*, 1975-76
Trial proof for *Foirades/Fizzles*,
vi/ix
Published by Petersburg Press
Lift-ground aquatint, stop-out
crayon, and burnishing
12⁷/₈ x 9⁷/₈
9⁵/₁₆ x 7¹/₁₆
Collection the artist

71. *NUMERAL 4*, 1975-76
Trial proof for *Foirades/Fizzles*,
viii/ix
Published by Petersburg Press
Lift-ground aquatint, stop-out
crayon, and burnishing with
gouache additions
12¹/₄ x 9⁷/₈
9⁵/₁₆ x 7¹/₁₆
Collection the artist

72. *NUMERAL 4*, 1975-76
Trial proof for *Foirades/Fizzles*,
ix/ix
Published by Petersburg Press
Lift-ground aquatint, stop-out
crayon, and burnishing
12¹³/₁₆ x 9⁷/₈
9⁵/₁₆ x 7¹/₁₆
Collection the artist

73. *FLAGSTONES AND
FLAGSTONES*, 1975-76
Trial proof for *Foirades/Fizzles*,
i/v
Published by Petersburg Press
Etching, lift-ground aquatint, and
open-bite
12³/₄ x 19³/₄
10¹¹/₁₆ x 14¹/₄
Collection the artist

74. *FLAGSTONES AND
FLAGSTONES*, 1975-76
Trial proof for *Foirades/Fizzles*,
iii/v
Published by Petersburg Press
Etching, lift-ground aquatint, and
open-bite
12⁵/₈ x 19³/₄
10¹¹/₁₆ x 14¹/₄
Collection the artist

75. *FLAGSTONES AND
FLAGSTONES*, 1975-76
Trial proof for *Foirades/Fizzles*,
v/v
Published by Petersburg Press
Etching, lift-ground aquatint, and
open-bite
12⁷/₈ x 19¹³/₁₆
10¹³/₁₆ x 14¹/₄
Collection the artist

76. *BUTTOCKS-KNEES-
FOOTHANDSOCKFLOOR-FACE-
TORSO (with LEG [d], FEET [a],
and rejected version of WORDS)*,
1975-76
Trial proof for *Foirades/Fizzles*,
i/iv
Published by Petersburg Press
Etching, soft-ground etching, and
open-bite with watercolor and
graphite additions
14⁷/₈ x 11¹/₈
13⁵/₁₆ x 10⁵/₁₆
Collection the artist

77. *NUMERAL 5*, 1975-76
Trial proof for *Foirades/Fizzles*,
i/xi
Published by Petersburg Press
Etching
12¹³/₁₆ x 9¹³/₁₆
9¹/₄ x 7¹/₈
Collection the artist

78. *NUMERAL 5*, 1975-76
Trial proof for *Foirades/Fizzles*,
ii/xi
Published by Petersburg Press
Etching with gouache additions
12¹³/₁₆ x 9¹/₈
9¹/₄ x 7¹/₈
Collection the artist

79. *NUMERAL 5*, 1975-76
Trial proof for *Foirades/Fizzles*,
iv/xi
Published by Petersburg Press
Etching and lift-ground aquatint
12³/₄ x 9⁷/₈
9¹/₄ x 7¹/₈
Collection the artist

80. *NUMERAL 5*, 1975-76
Trial proof for *Foirades/Fizzles*,
v/xi
Published by Petersburg Press
Etching and lift-ground aquatint
12³/₄ x 9⁷/₈
9¹/₄ x 7¹/₈
Collection the artist

81. *NUMERAL 5*, 1975-76
Trial proof for *Foirades/Fizzles*,
vi/xi
Published by Petersburg Press
Etching and lift-ground aquatint
12¹³/₁₆ x 9⁷/₈
9¹/₄ x 7¹/₈
Collection the artist

82. *NUMERAL 5*, 1975-76
Trial proof for *Foirades/Fizzles*,
vii/xi
Published by Petersburg Press
Etching and lift-ground aquatint
12³/₄ x 9³/₄
9¹/₄ x 7¹/₈
Collection the artist

83. *NUMERAL 5*, 1975-76
Trial proof for *Foirades/Fizzles*,
ix/xi
Published by Petersburg Press
Etching and lift-ground aquatint
12³/₄ x 9⁷/₈
9¹/₄ x 7¹/₈
Collection the artist

84. *NUMERAL 5*, 1975-76
Trial proof for *Foirades/Fizzles*,
xi/xi
Published by Petersburg Press
Etching, lift-ground aquatint, and
burnishing with sandpaper
12⁷/₈ x 9⁷/₈
9¹/₄ x 7¹/₈
Collection the artist

85. *FEET*, 1975-76
Hand-touched photograph of
"feet" from *Untitled*, 1972
In preparation for *Foirades/
Fizzles*
7¹/₁₆ x 9¹¹/₁₆
Collection the artist

86. *FEET (b)*, 1975-76
Trial proof for *Foirades/Fizzles*,
i/ix
Published by Petersburg Press
Photo-engraving and lift-ground
aquatint
14⁷/₈ x 11¹/₁₆
12¹/₁₆ x 9
Collection the artist

87. *FEET (b)*, 1975-76
Trial proof for *Foirades/Fizzles*,
ii/ix
Published by Petersburg Press
Photo-engraving and lift-ground
aquatint with watercolor and
gouache additions
12³/₄ x 9⁵/₈
12 x 9
Collection the artist

88. *FEET (b)*, 1975-76
Trial proof for *Foirades/Fizzles*,
iv/ix
Published by Petersburg Press
Etching, photo-engraving, lift-
ground aquatint, and open-bite
with watercolor and graphite
additions
12³/₄ x 9⁷/₈
12 x 9
Collection the artist

89. *FEET (b)*, 1975-76
Trial proof for *Foirades/Fizzles*,
vi/ix
Published by Petersburg Press
Etching, photo-engraving, lift-
ground aquatint, and open-bite
with graphite additions
12⁷/₈ x 10
12 x 9
Collection the artist

90. *FEET (b)*, 1975-76
Trial proof for *Foirades/Fizzles*,
ix/ix
Published by Petersburg Press
Etching, photo-engraving, lift-
ground aquatint, and open-bite
12³/₄ x 9⁷/₈
10¹³/₁₆ x 8⁷/₁₆ (reduced plate viii/ix)
Collection the artist

91. *CASTS (WORDS)*, 1975-76
Trial proof for *Foirades/Fizzles*,
ii/v
Published by Petersburg Press
Lift-ground aquatint, stop-out,
open-bite, and burnishing
14¹³/₁₆ x 11¹/₁₆
10¹⁵/₁₆ x 7¹¹/₁₆
Collection the artist

92. *CASTS (WORDS)*, 1975-76
Trial proof for *Foirades/Fizzles*,
iv/v
Published by Petersburg Press
Etching, lift-ground aquatint,
stop-out, open-bite, and
burnishing
14⁷/₈ x 11
10¹⁵/₁₆ x 7¹¹/₁₆
Collection the artist

93. *FLAGSTONES AND CASTS*,
1975-76
Trial proof for *Foirades/Fizzles*,
i/v
Published by Petersburg Press
Etching
12¹⁵/₁₆ x 19³/₄
10¹¹/₁₆ x 14¹/₄
Collection the artist

94. *FLAGSTONES AND CASTS*,
1975-76
Trial proof for *Foirades/Fizzles*,
ii/v
Published by Petersburg Press
Etching with gouache additions
12³/₄ x 19¹³/₁₆
10¹¹/₁₆ x 14¹/₄
Collection the artist

95. *FLAGSTONES AND CASTS*,
1975-76
Trial proof for *Foirades/Fizzles*,
iii/v
Published by Petersburg Press
Etching and lift-ground aquatint
12⁷/₈ x 19³/₄
10¹¹/₁₆ x 14¹/₄
Collection the artist

96. *FLAGSTONES AND CASTS*,
1975-76
Trial proof for *Foirades/Fizzles*,
iv/v
Published by Petersburg Press
Etching and lift-ground aquatint
12¹⁵/₁₆ x 19¹³/₁₆
10¹¹/₁₆ x 14¹/₄
Collection the artist

97. *HANDFOOTSOCKFLOOR*,
1975-76
Trial proof for *Foirades/Fizzles*,
i/xvii
Published by Petersburg Press
Lift-ground aquatint with ink and
graphite additions
22¹/₄ x 29³/₄
17³/₈ x 21⁷/₈
Collection the artist

98. *HANDFOOTSOCKFLOOR*,
1975-76
Trial proof for *Foirades/Fizzles*,
iii/xvii
Published by Petersburg Press
Lift-ground aquatint and burnish-
ing with graphite additions
22 x 29³/₄
17³/₈ x 21⁷/₈
Collection the artist

99. *HANDFOOTSOCKFLOOR*,
1975-76
Trial proof for *Foirades/Fizzles*,
iv/xvii
Published by Petersburg Press
Lift-ground aquatint and burnish-
ing with ink additions
22¹/₈ x 29³/₄
17¹/₄ x 21⁷/₈
Collection the artist

100. *HANDFOOTSOCKFLOOR*,
1975-76
Trial proof for *Foirades/Fizzles*,
vii/xvii
Published by Petersburg Press
Lift-ground aquatint, stop-out,
and burnishing with watercolor
and graphite additions
19³/₄ x 25¹/₂
17¹/₂ x 21¹/₂
Collection the artist

101. *HANDFOOTSOCKFLOOR*,
1975-76
Trial proof for *Foirades/Fizzles*,
viii/xvii
Published by Petersburg Press
Lift-ground aquatint, stop-out,
and burnishing
12³/₄ x 19 (irregular)
11¹/₄ x 14⁵/₈
Collection the artist

102. *HANDFOOTSOCKFLOOR*,
1975-76
Trial proof for *Foirades/Fizzles*,
ix/xvii
Published by Petersburg Press
Lift-ground aquatint, stop-out,
and burnishing with gouache
additions
12³/₄ x 18³/₄
11¹/₄ x 14⁵/₈
Collection the artist

103. *HANDFOOTSOCKFLOOR*,
1975-76
Trial proof for *Foirades/Fizzles*,
x/xvii
Published by Petersburg Press
Lift-ground aquatint, stop-out,
scraper, open-bite, and burnish-
ing
12³/₄ x 9³/₈
11¹/₈ x 9³/₈ (plate reduced)
Collection the artist

104. *HANDFOOTSOCKFLOOR*,
1975-76
Trial proof for *Foirades/Fizzles*,
xii/xvii
Published by Petersburg Press
Etching, lift-ground aquatint,
stop-out, scraper, open-bite, and
burnishing with ink additions
12⁷/₈ x 10
12⁷/₁₆ x 10
Collection the artist

105. *HANDFOOTSOCKFLOOR*,
1975-76
Trial proof for *Foirades/Fizzles*,
xvi/xvii
Published by Petersburg Press
Etching, lift-ground aquatint,
scraper, and burnishing
12⁵/₈ x 10
11¹/₂ x 9⁵/₈
Collection the artist

106. *FLAGSTONES (ENDPAPER-
BACK)*, 1975-76
Trial proof for *Foirades/Fizzles*
White plate, i/ii
Published by Petersburg Press
Lift-ground aquatint and
open-bite with red pen additions
14⁷/₈ x 22¹/₄
11¹/₂ x 18¹/₁₆
Collection the artist

107. *FLAGSTONES (ENDPAPER-
BACK)*, 1975-76
Trial proof for *Foirades/Fizzles*
Red plate, i/i
Published by Petersburg Press
Lift-ground aquatint and
open-bite
14⁷/₈ x 22¹/₈
11¹/₂ x 18
Collection the artist

108. *FLAGSTONES (ENDPAPER-BACK)*, 1975-76
Trial proof for *Foirades/Fizzles*
Black plate, i/i
Published by Petersburg Press
Lift-ground aquatint and
open-bite
14³/₄ x 22¹/₈
11¹/₂ x 18¹/₈
Collection the artist

Related Prints

109. *HATTERAS*, 1963
Published by U.L.A.E.
Lithograph from one stone
41¹/₄ x 29¹/₂
Philadelphia Museum of Art:
anonymous gift
(Field 15)

110. *SKIN WITH O'HARA POEM*,
1963-65
Published by U.L.A.E.
Lithograph from two stones
22 x 34
Collection of Tony Ganz
(Field 48)

111. *PINION*, 1963-66
Published by U.L.A.E.
Lithograph from two stones and
one photographic (aluminum)
plate
40 x 28
Philadelphia Museum of Art:
Haney Foundation Fund
(Field 49)

112. *WATCHMAN*, 1967
Published by U.L.A.E.
Lithograph from five stones
36 x 24
Collection of Ronald and Victoria
DeFelice
(Field 60)

113. *FLAGS*, 1967-68
Published by U.L.A.E.
Lithograph from five stones, one
aluminum plate, and two rubber
stamps
34 x 25⁷/₈
Collection Walker Art Center,
Minneapolis; Art Center
Acquisition Fund, 1968
(Field 70)

114. *FLAGS II*, 1967-70
Lithograph published by U.L.A.E.
from five stones, five plates, and
two rubber stamps
34 x 25
Mr. and Mrs. Harry W. Anderson
(Field 130)

115-117. *FRAGMENTS--
ACCORDING TO WHAT*, 1971
Published by Gemini G.E.L.
(Field 136-142)

115. *LEG AND CHAIR*
Lithograph from one stone
and six plates
35 x 30
Grunwald Center for the
Graphic Arts, Wight Art
Gallery, UCLA
Gift of Stephen Schapiro
(Field 136)

116. *HINGED CANVAS*
Lithograph from one stone
and seven plates
36 x 30
Grunwald Center for the
Graphic Arts, Wight Art
Gallery, UCLA
Gift of Michael Crichton
(Field 139)

117. *COATHANGER AND
SPOON*
Lithograph from two stones
and five plates
34 x 25¹/₄
Grunwald Center for the
Graphic Arts, Wight Art
Gallery, UCLA
Gift of Stephen Schapiro
(Field 142)

118. *FLAGS I*, 1973
Published by Simca Print Artists
and the artist
Screenprint from thirty-one
screens
27¹/₂ x 35
Collection of Michael Crichton
(Field 173)

119. *FLAGS II*, 1973
Published by Simca Print Artists
and the artist
Screenprint from thirty screens
(identical to those employed in
Flags I, minus the varnish
screen), printed in transparent
graphite ink
27¹/₂ x 35
The Marcia S. Weisman
Collection, Los Angeles
(Field 174)

120-123. *CASTS FROM
UNTITLED*, 1973-74
Published by Gemini G.E.L.
Lithograph
Lent courtesy Gemini G.E.L.,
Los Angeles, CA
(Field 177-190)

120. *FACE*
Lithograph from one stone
and two plates
30³/₄ x 22³/₄
(Field 177)

121. *FACE–BLACK STATE*
Lithograph from one stone
and two plates
15³/₄ x 13³/₄
(Field 178)

122. *TORSO*
Lithograph from one stone
and two plates
30³/₄ x 22³/₄
(Field 183)

123. *TORSO–BLACK STATE*
Lithograph from one stone
and two plates
16 x 18¹/₄
(Field 184)

124-127. *FOUR PANELS FROM
UNTITLED 1972*, 1973-74
Published by Gemini G.E.L.
Lithograph
Each panel 40 x 28¹/₂
Lent courtesy Gemini G.E.L.,
Los Angeles, CA
(Field 194-197)

124. *A/D HATCHING (Colors)*
Lithograph from fourteen
plates and embossing
(Field 194)

125. *B/D FLAGSTONES
(Colors)*
Lithograph from ten plates
and embossing
(Field 195)

126. *C/D FLAGSTONES
(Colors)*
Lithograph from eleven plates
and embossing
(Field 196)

127. *D/D CASTS (Colors)*
Lithograph from one stone
and thirteen plates and
embossing
(Field 197)

128-131. *FOUR PANELS FROM
UNTITLED 1972
(Grays and Black)*, 1973-75
Published by Gemini G.E.L.
Lithograph
Each panel 41 x 32
Lent courtesy Gemini G.E.L.,
Los Angeles, CA
(Field 198-201)

128. *A/D HATCHING (Grays
and Black)*
Lithograph
(Field 198)

129. *B/D FLAGSTONES (Grays
and Black)*
Lithograph from five plates
(Field 199)

130. *C/D FLAGSTONES (Grays and Black)*
Lithograph from five plates
(Field 200)

131. *D/D CASTS (Grays and Black)*
Lithograph from one stone and four plates
(Field 201)

132. *SCENT*, 1975-76
Published by U.L.A.E.
Lithograph from four plates, lino-cut from four blocks, woodcut from four blocks, printed in white, orange, green, and purple
31¼ x 47
Lois and Michael Torf Collection
(Field 208)

133. *CORPSE AND MIRROR*, 1976
Published by U.L.A.E.
Lithograph from twelve plates
30¾ x 39¾
Lois and Michael Torf Collection
(Field 210)

134. *THE DUTCH WIVES*, 1977
Published by Simca Print Artists and the artist
Screenprint from twenty-nine screens
42¹⁵/₁₆ x 56
Private Collection,
Cambridge, MA

135. *LAND'S END*, 1979
Published by Gemini G.E.L.
Lithograph
52 x 36
Private Collection,
Cambridge, MA

136. *PERISCOPE II*, 1979
Published by Gemini G.E.L.
Lithograph from seven plates
56¼ x 41
Grunwald Center for the Graphic Arts, Wight Art Gallery, UCLA
Gift of the UCLA Art Council

137. *UNTITLED (Red)*, 1982
Published by Petersburg Press
Hard-ground etching and sugar-lift aquatint, printed in two colors
42⅛ x 29¾
34¼ x 24⅜
Grunwald Center for the Graphic Arts, Wight Art Gallery, UCLA
Gift of the UCLA Art Council

138. *UNTITLED (Yellow)*, 1982
Published by Petersburg Press
Hard-ground etching and sugar-lift aquatint, printed in two colors
42⅛ x 29¾
34¼ x 24⅜
Grunwald Center for the Graphic Arts, Wight Art Gallery, UCLA
Gift of the UCLA Art Council

139. *UNTITLED (Blue)*, 1982
Published by Petersburg Press
Hard-ground etching and sugar-lift aquatint, printed in two colors
42⅛ x 29¾
34¼ x 24⅜
Grunwald Center for the Graphic Arts, Wight Art Gallery, UCLA
Gift of the UCLA Art Council

140. *POEMS* by Wallace Stevens, 1985
Published by The Arion Press
Frontispiece: *Summer*
Etching, aquatint, open-bite, and drypoint
Page: 11¾ x 8⁵/₁₆
Collection of Gloria and Newton Werner

141. *VENTRILOQUIST*, 1985
Published by U.L.A.E
Lithograph from eight plates
33⁷/₁₆ x 23⅛
Collection of Tony Ganz

142. *VENTRILOQUIST*, 1986
Published by U.L.A.E
Lithograph from eleven plates
41½ x 29
The Marcia S. Weisman Collection, Los Angeles

143. *WINTER*, 1986
Published by U.L.A.E
Aquatint, etching, and open-bite
Image: 9¾ x 6½
Collection the artist

Selected Bibliography

Abbott, H. Porter. *The Fiction of Samuel Beckett: Form and Effect.* Berkeley: University of California Press, 1973.

Alloway, Lawrence. "Jasper Johns' Map." *The Nation.* November 22, 1971, 541-542. Reprinted in *Topics in American Art Since 1945*, 136-139. New York: W. W. Norton and Co., 1975.

Ashbery, John. "Brooms and Prisms." *Art News* 65 (March 1966): 58-59.

Bair, Deirdre. *Beckett: A Biography.* New York: Harcourt Brace Jovanovich, 1978.

Beckett, Samuel. *Proust: Three Dialogues between Samuel Beckett and Georges Duthuit.* London: J. Calder, 1965.

_____ . "Dante...Bruno. Vico..Joyce." In *Disjecta, Miscellaneous Writings and a Dramatic Fragment*, edited by Ruby Cohn, 19-33. London: John Calder, 1983.

_____ . "Peintres de l'Empechement." In *Disjecta, Miscellaneous Writings and a Dramatic Fragment*, edited by Ruby Cohn, 133-137. London: John Calder, 1983.

_____ . "La Peinture des van Velde." In *Disjecta, Miscellaneous Writings and a Dramatic Fragment*, edited by Ruby Cohn, 118-132. London: John Calder, 1983.

_____ . *Fizzles.* New York: Grove Press, 1976.

Ben-Zvi, Linda. "Samuel Beckett, Fritz Mauthner, and the Limits of Language." *PMLA* 95 (March 1980): 183-200.

Bernard, April and Mimi Thompson. "Johns On...." *Vanity Fair* (February 1984): 64.

Bernstein, Roberta. "Johns and Beckett: *Foirades/Fizzles.*" *Print Collector's Newsletter* 7 (November-December, 1976): 141-145.

_____ . "Jasper Johns and the Figure: Part One—Body Imprints." *Arts Magazine* 52 (October 1977): 142-144.

_____ . "An Interview with Jasper Johns." In *Fragments: Incompletion and Discontinuity*, edited by Lawrence D. Kritzman, 279-290. New York: New York Literary Forum, 1981.

_____ . *Jasper Johns' Paintings and Sculptures, 1954-1974: "The Changing Focus of the Eye."* Ann Arbor: UMI Research Press, 1985.

Brater, Enoch. "Still Beckett: The Essential and the Incidental," *Journal of Modern Literature* 6 (Summer 1977): 3-16.

Cage, John. "Jasper Johns: Stories and Ideas." In *Jasper Johns's Paintings, Drawings and Sculpture 1954-1964*, edited by Alan R. Solomon, 21-26. New York: Jewish Museum, 1964.

Calas, Nicolas. "Jasper Johns and the Critique of Painting." *Punto de Contacto/Point of Contact* 3 (September-October, 1976): 50-57.

Calas, Nicolas and Elena Calas. "Jasper Johns: And/Or," in *Icons and Images of the Sixties*, 72-82. New York: E. P. Dutton, 1971.

Carpenter, Joan. "The Infra-Iconography of Jasper Johns." *Art Journal* 3 (Spring 1977): 221-227.

Castleman, Riva. *Jasper Johns: Lithographs.* New York: The Museum of Modern Art, 1970.

_____ . *Jasper Johns. A Print Retrospective.* New York: The Museum of Modern Art, 1986.

Cohn, Ruby. *Back to Beckett.* Princeton: Princeton University Press, 1973.

Copeland, Hannah. *Art and the Artist in the Works of Samuel Beckett.* The Hague: Mouton, 1975.

Coplans, John. "Fragments According to Johns, An Interview with Jasper Johns." *Print Collector's Newsletter* 3 (May-June 1972): 29-32.

Crichton, Michael. *Jasper Johns.* New York: Harry N. Abrams, Inc. and the Whitney Museum of American Art, 1977.

Cuno, James. "Jasper Johns." Review of *Jasper Johns: A Print Retrospective* by Riva Castleman. *Print Quarterly* 4 (March 1987): 83-92.

Davvetas, Demosthène. "Jasper Johns et sa famille d'objets." *Art Press* (Paris) 80 (April 1984): 11-12.

Elam, Keir. "Not I: Beckett's Mouth and the Ars(e) Rhetorica." In *Beckett at 80/Beckett in Context*, edited by Enoch Brater, 124-148. New York and Oxford: Oxford University Press, 1986.

Feinstein, Roni. "Jasper Johns' *Untitled* (1972) and Marcel Duchamp's Bride." *Arts Magazine* 57 (September 1982): 86-93.

_____ . "New Thoughts for Jasper Johns' Sculpture." *Arts Magazine* 54 (April 1980): 139-145.

Field, Richard S. *Jasper Johns: Prints 1960-1970*. New York: Praeger Publishers and Philadelphia: Philadelphia Museum of Art, 1970.

_____ . "Jasper Johns' Flags." *Print Collector's Newsletter* 7 (July-August 1976): 69-77.

_____ . *Jasper Johns, Screenprints*. New York: Brooke Alexander, 1977.

_____ . *Jasper Johns: Prints 1970-1977*. Middletown, Ct: Wesleyan University, 1978.

Fletcher, John. *The Novelty of Samuel Beckett*. London: Chatto and Windus, 1964.

Francis, Richard. *Jasper Johns*. New York; Abbeville Press, 1984.

Fried, Michael. "New York Letter." *Art International* 7 (February 25, 1963): 60-64.

Fuller, Peter. "Jasper Johns Interviewed," Parts 1, 2. *Art Monthly* (London) 18 (July-August, September 1978): 6-12, 5-7.

Gablik, Suzi. "Jasper Johns's Pictures of the World." *Art in America* 66 (January 1978): 62-69.

Geelhaar, Christian. *Jasper Johns Working Proofs*. London: Petersburg Press, 1980.

Gidal, Peter. "Beckett and Others and Art: A System." *Studio International* 188 (November 1974): 183-187.

Goldman, Judith. *Foirades/Fizzles*. New York: The Whitney Museum of American Art, 1977.

_____ . *Jasper Johns: Prints 1977-1981*. Boston: Thomas Segal Gallery, 1981.

_____ . *Jasper Johns: 17 Monotypes*. West Islip, NY: Universal Limited Art Editions, 1982.

_____ . *Jasper Johns: The Seasons*. New York: Leo Castelli, 1987.

Graver, Lawrence and Raymond Federman, eds. *Samuel Beckett: The Critical Heritage*. London: Routledge and Kegan Paul, 1979.

Greenberg, Clement. "After Abstract Expressionism." *Art International* 6 (October 25, 1962): 24-32.

Harrington, John P. "Samuel Beckett's Art Criticism and the Literary Uses of Critical Circumstance." *Contemporary Literature* 21 (Summer 1980): 331-348

Harrison, Charles and Fred Orton. "Jasper Johns: 'Meaning what you see'." *Art History* 7 (March 1984): 76-101.

Harvey, Lawrence E. *Samuel Beckett, Poet and Critic*. Princeton, NJ: Princeton University Press, 1970.

Heller, Ben. "Jasper Johns." In *School of New York: Some Younger Artists*, edited by B. H. Friedman, 30-55. New York: Grove Press, 1959.

Herrmann, Rolf-Dieter. "Johns the Pessimist." *Artforum* 16 (October 1977): 26-33.

_____ . "Jasper Johns' Ambiguity: Exploring the Hermeneutical Implications." *Arts Magazine* 52 (November 1977): 124-129.

Hess, Thomas B. "Polypolyptychality." *New York Magazine* 6 (19 February 1973): 73.

_____ . "On the Scent of Jasper Johns," *New York Magazine* 9 (9 February 1976): 65-67.

_____ . "Jasper Johns, Tell a Vision." *New York Magazine* 10 (7 November 1977): 109-111.

Higginson, Peter. "Jasper's Non-Dilemma: A Wittgensteinian Approach." *New Lugano Review* 8/9 (Fall 1976): 53-60.

Hoffman, Frederick J. *Samuel Beckett: The Language of Self*. New York: Dutton, 1964.

Hopkins, Henry. Preface to *Jasper Johns: Figures 0 to 9*. Los Angeles: Gemini G.E.L., 1968.

Hopps, Walter. "An Interview with Jasper Johns." *Artforum* 3 (March 1965): 32-36.

_____ . *Jasper Johns: Fragments—According to What/Six Lithographs*. Los Angeles: Gemini G.E.L., 1971.

Iser, Wolfgang. "The Patterns of Negativity in Beckett's Prose." *Georgia Review* 29 (Fall 1975): 706-719.

Johns, Jasper. [Statement]. In *Sixteen Americans*, edited by Dorothy C. Miller, 22-27. New York: The Museum of Modern Art, 1959.

Johns, Jasper. Interview with David Sylvester for the BBC, December, 1964. Excerpted in *Jasper Johns Drawings*. Arts Council of Great Britain, 1974.

_____ . "Sketchbook Notes." *Art and Literature* 4 (Spring 1965): 185-192.

_____ . "Marcel Duchamp (1887-1968): An Appreciation." *Artforum* 7 (November 1968): 6.

_____ . "Sketchbook Notes." *Julliard* 3 (Winter 1968-69): 25-27.

_____ . "Thoughts on Duchamp." *Art in America* 57 (July-August 1969): 31.

_____ . "Sketchbook Notes." *0 to 9* 6 (July 1969): 1-2. Reprinted in Richard Francis, *Jasper Johns*, 111-112. New York: Abbeville Press, 1984.

Kaplan, Patricia. "On Jasper Johns' *According to What*." *Art Journal* 35 (Spring 1976): 247-250.

Kenner, Hugh. *A Reader's Guide to Samuel Beckett*. New York: Farrar, Strauss and Giroux, 1973.

_____ . *Samuel Beckett: A Critical Study*. Berkeley: University of California Press, 1968.

_____ . "Shadows of Syntax." In *Samuel Beckett: A Collection of Criticism*, edited by Ruby Cohn. New York: McGraw Hill, 1975.

Knowlson, James and John Pilling. *Frescoes, Skull, The Later Prose and Drama of Samuel Beckett*. New York: Grove Press, 1980.

Kozloff, Max. "Johns and Duchamp." *Art International* 8 (March 1964): 42-45.

_____ . "Jasper Johns: The 'Colors,' The 'Maps,' The 'Devices.' " *Artforum* 6 (November 1967): 26-31.

_____ . *Jasper Johns*. Meridian Artists Series. New York: Harry N. Abrams, Inc. 1974.

_____ . *Jasper Johns*. New York: Harry N. Abrams, Inc., 1969.

_____ . "The Division and Mockery of the Self." *Studio International* 179 (January 1970): 9-15.

Krauss, Rosalind. "Jasper Johns." *New Lugano Review* 1 (1965): 84-113.

_____ . "Jasper Johns: The Functions of Irony." *October* 2 (Summer 1976): 91-99.

Masheck, Joseph. "Jasper Johns Returns." *Art in America* 64 (March-April 1976): 65-67.

McMillan, Dougald. "Samuel Beckett and the Visual Arts: The Embarassment of Allegory." In *Samuel Beckett: A Collection of Criticism,* edited by Ruby Cohn. New York: McGraw-Hill, 1975.

Mercier, Vivian. *Beckett/Beckett* New York: Oxford University Press, 1977.

Michelson, Annette. "The Imaginary Object: Recent Prints by Jasper Johns." *Artist's Proof* 8 (1968): 44-49.

Morot-Sir, Edouard, Howard Harper and Dougald McAllister, eds. *Symposium on Samuel Beckett: The Art of Rhetoric*. North Carolina Studies in the Romance Languages and Literatures. Chapel Hill, NC: University of North Carolina Press, 1976.

Paulson, Ronald. "Jasper Johns and Others." *Bennington Review* no. 1 (April 1978): 62-71.

Perloff, Marjorie. " 'The Space of a Door': Beckett and the Poetry of Absence." In Marjorie Perloff, *The Poetics of Indeterminancy: Rimbaud to Cage,* 200-247. Princeton, NJ: Princeton University Press, 1981.

Pilling, John. *Samuel Beckett*. London: Routledge and Kegan Paul, 1976.

Pincus-Witten, Robert. "Theater of the Conceptual: Autobiography and Myth." *Artforum* 12 (October 1973): 40-46.

Pohlen, Annelie. "Interview mit Jasper Johns." *Heute Kunst* 22 (May-June 1978): 21-22.

Porter, Fairfield. "The Education of Jasper Johns." *Art News* 62 (February 1964): 44-45, 61-62.

Prinz, Jessica. "Foirades/Fizzles/ Beckett/Johns." *Contemporary Literature* 21 (1980): 480-510.

Rabinovitz, Rubin. *The Development of Samuel Beckett's Fiction*. Chicago: University of Illinois Press, 1984.

Raynor, Vivien. "Jasper Johns: 'I Have Attempted to Develop My Thinking in Such a Way That the Work I'm Doing is Not Me'." *Art News* 72 (March 1973): 20-22.

Robinson, Michael. *The Long Sonata of the Dead, A Study of Samuel Beckett*. New York: Grove Press, 1969.

Rose, Barbara. "The Graphic Work of Jasper Johns," Parts 1, 2. *Artforum* 8 (March and September 1970): 39-45, 65-74.

_____ . "Decoys and Doubles: Jasper Johns and the Modernist Mind." *Arts Magazine* 50 (May 1976): 68-73.

_____ . "Jasper Johns: Pictures and Concepts." *Arts Magazine* 52 (November 1977): 148-153.

_____ . "To Know Jasper Johns." *Vogue* 167 (November 1977): 280-285.

"Jasper Johns: The Seasons," *Vogue* 177 (January 1987): 193-199, 259-260.

Rosen, Steven. *Samuel Beckett and the Pessimistic Tradition*. New Brunswick, NJ: Rutgers University Press, 1976.

Russell, John. "Jasper Johns and the Readymade Image." In *The Meanings of Modern Art,* 12 vols. New York: The Museum of Modern Art, 1975. Vol 11, 15-23.

Skerl, Jennie. "Fritz Mauthner's 'Critique of Language' in Samuel Beckett's *Watt*." *Contemporary Literature* 15 (1974): 474-487.

Solomon, Alan R. *Jasper Johns*. New York: The Jewish Museum, 1964.

Steinberg, Leo. "Jasper Johns: The First Seven Year of His Art," first published in *Metro* 4/5 (1962). Reprinted in *Other Criteria: Confrontations with Twentieth Century Art,* 17-54. London: Oxford University Press, 1972.

Swenson, G. R. "What is Pop Art?" Part 2. *Art News* 62 (February 1964): 40-43, 62-67.

PHOTOGRAPH CREDITS

We wish to thank the owners and custodi-
ans for permitting the reproduction of the
works of art in their collections. The pho-
tographers and/or sources of the illustra-
tions, whose courtesy is gratefully
acknowledged, are listed alphabetically
below, followed by figure and/or plate num-
bers.

Agence Photographique TOP, Paris, fig. 1
©The Art Institute of Chicago. All Rights
 Reserved, fig. 18
The Baltimore Museum of Art, fig. 17
Rudolph Burkhardt, figs. 12, 13, 30, 31, 46,
 51, 52, 53
Leo Castelli Gallery, New York: color plates
 I and II, figs. 12, 14, 23, 25, 30, 31,
 35, 38, 39, 41, 42, 44, 51, 52, 53
Bevan Davies, fig. 41
D. James Dee, fig. 43
Larry du Pont, *Foirades/Fizzles* and plates
 1-74
©Gemini G.E.L., Los Angeles, CA, figs. 2-7,
 21, 22, 26, 27, 28, 47, 48
Jasper Johns, figs. 13, 20, 45, 46, 51
©Jasper Johns and Petersburg Press
 (Foirades/Fizzles)
©1967 The Museum of Modern Art, New
 York, figs. 33, 34
The Museum of Modern Art, New York,
 figs. 19, 60
National Portrait Gallery, London, fig. 29
Petersburg Press, fig. 57
Eric Pollitzer, figs. 25, 35, 38, 39, 42, 44
Pollitzer, Strong & Meyer, fig. 20
The Art Museum, Princeton University,
 fig. 56
Ernest Scott, figs. 2, 3, 26, 27, 28
SIMCA Print Artists, figs. 10, 11, 43
Sogetsukai Foundation, fig. 23
Yoshitaka Uchida, fig. 23
Department of Special Collections, Univer-
 sity Research Library, UCLA, figs. 33
 and 34
Universal Limited Art Editions, West Islip,
 New York, figs. 8, 9, 15, 16, 24, 32, 37, 40,
 49, 50, 54, 55, 58, 59
Marcia S. Weisman, Los Angeles, fig. 36

PERMISSIONS

"Mesostic" by John Cage reprinted with
 permission of *Formations.*
Foirades/Fizzles reproduced with permis-
 sion of Jasper Johns, Samuel Beckett,
 Petersburg Press, and Grove Press.

CATALOGUE CREDITS

Designer *Robin Weisz*
Production Coordinator *Judy Hale*
Design Coordinator *Thomas Hartman*
Printing *Dai Nippon Co., Ltd., Japan*
Typesetting *Central Typesetting Company*

Produced by UCLA Publications Services
Department